Templum
Iouis custodis

Templum Iouis
Capitolini

Arcus
Porticus et Atrium

Arx
Capitolina

Ædes
Concordiæ

Asylum

Templum
Monetæ

Clivus
iuxta Asyli

Ædes Concordiæ

Templum Vespasiani

THE
VIRTUAL TOURIST
IN RENAISSANCE
ROME

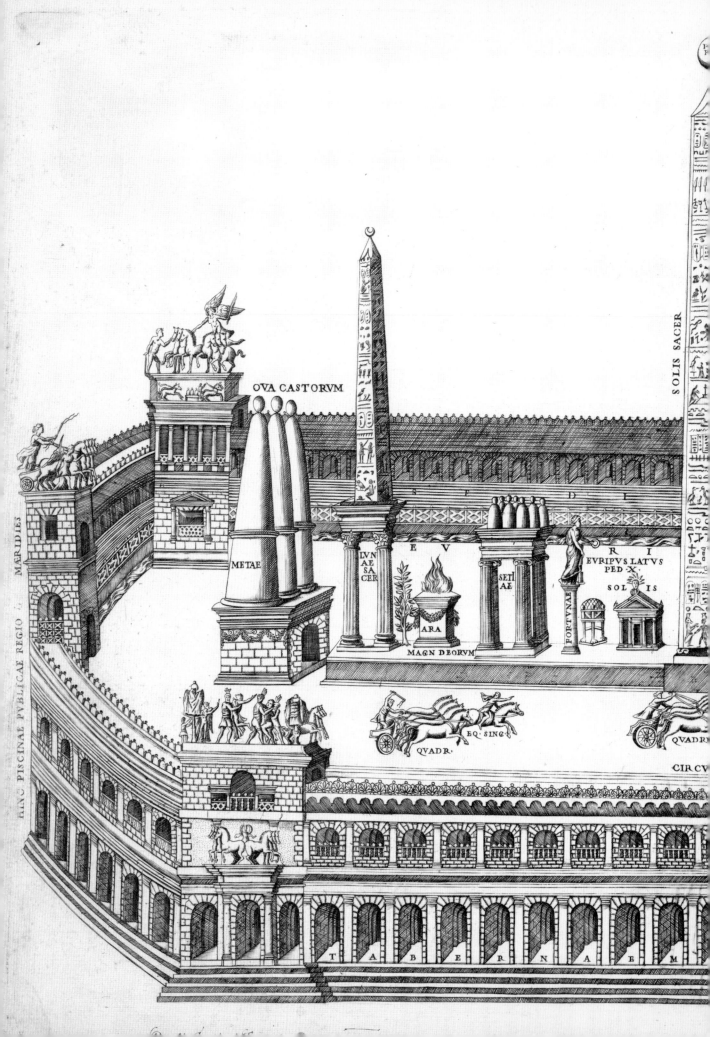

RING PISCINAE PVBLICAE REGIO I:

MAERIDIES

OVA CASTORVM

SOLIS SACER

METAE

S P D E

LVN
AE
SA
CER

EV

R I

SETI
AE

EVRIPVS LATVS
PED X

FORTVNAE

SOL IS

ARA

MAGN DEORVM

QVADR.

EQ SING.

QVADR

CIR CV

T A B E R N A E M

THE VIRTUAL TOURIST IN RENAISSANCE ROME

PRINTING AND COLLECTING THE SPECULUM ROMANAE MAGNIFICENTIAE

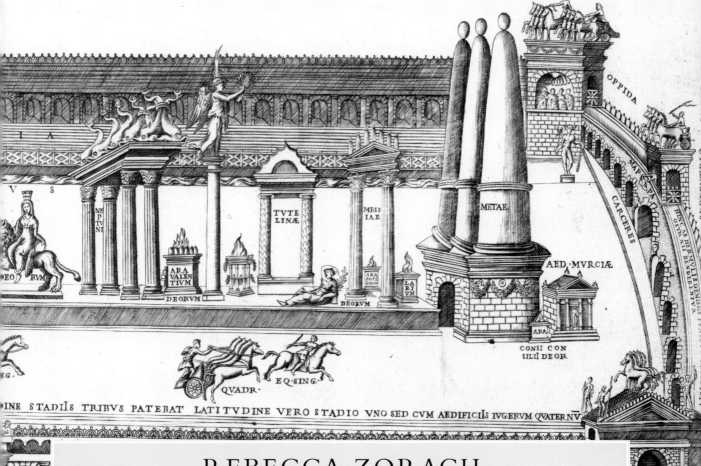

REBECCA ZORACH

with contributions by Nina Dubin, David Karmon,
Birte Rubach, Rose Marie San Juan

and Ingrid Greenfield, Kristine Hess, Iva Olah, Ann Patnaude, and Rainbow Porthé

UNIVERSITY OF CHICAGO LIBRARY 2008

1750 copies of this catalogue were published in conjunction with an exhibition held in the Special Collections Research Center, University of Chicago Library, September 24, 2007–February 11, 2008.

Support for this publication was provided by the Gladys Krieble Delmas Foundation, the Graham Foundation for Advanced Studies in the Fine Arts, and the University of Chicago Library Society.

ISBN: 0-943056-37-3

Design and typesetting by Joan Sommers Design
Copy-editing by Michael W. Phillips, Jr.
Photography by Michael Kenny
Distributed by the University of Chicago Press
http://www.press.uchicago.edu/
Printed in China through Asia Pacific Offset

Rebecca Zorach is Associate Professor of Art History and the College at the University of Chicago

Front cover: detail, figure 39; inset images, top to bottom: figures 76, 19, and 43. Back cover: detail, figure 62.

Endsheets: detail, figure 62.

Frontispiece: detail, figure 38; page 6: detail, figure 39; page 8: detail, figure 118; page 24: detail, figure 12; page 36: detail, figure 16; page 52: detail, figure 31; page 62: detail, figure 42; page 84: detail, figure 55; page 94–95: detail, figure 104; page 172: detail, figure 45.

CONTENTS

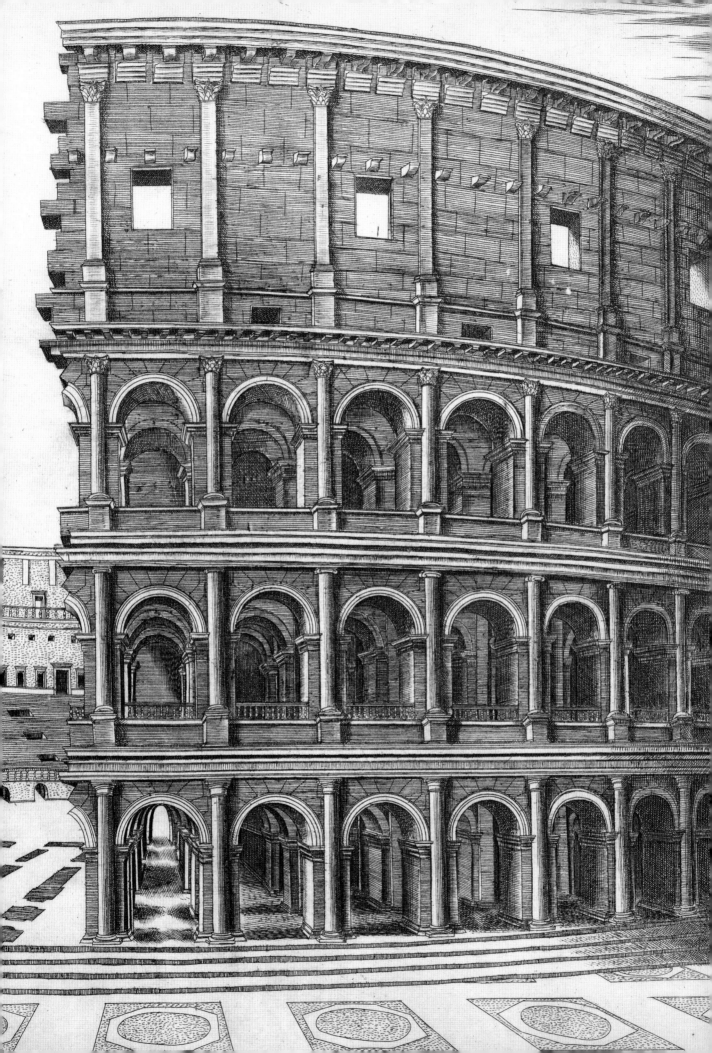

THE STUDY OF EARLY MODERN PRINTS often inter-sects with that of illustrated books. The fields share reproductive processes, practitioners, and images themselves. Artists, engravers, and printers produced work for both genres; separately published prints were bound together by print dealers or collectors into book form; book illustrations have routinely been removed from their codex form to be displayed as individual prints. Because of these interconnections, print culture research depends on collections in both art museums and research libraries.

Nowhere is this relationship more rich and com-plex than in the *Speculum Romanae Magnificentiae*, which began life as a series of independent prints for which a title page was later produced, and to which other individual prints, print series, and illustrated books were added. Over time some collectors bound their prints into book form, and sometimes—as in the case of the University of Chicago Library's *Speculum*—the volumes were later disbound for reasons of preservation or use.

The University of Chicago Library fosters innova-tive approaches to teaching and research through use of primary sources and the application of technology. Partnering with Rebecca Zorach to create a digital *Speculum*, organize an exhibition with graduate students based on Chicago's collection, and publish this catalogue exemplifies the collaborative activities that are at the core of the Library's mission.

A number of staff members in the Library's Preser-vation Department, Digital Library Development Center, and Special Collections Research Center worked closely with Professor Zorach and her students to digitize the *Speculum*, create and enhance metadata from an existing inventory, design the Web site and interface, facilitate research on the prints, and produce the exhibition. Kathleen Arthur and Michael Kelly, Preservation Depart-ment; Elisabeth Long, Charles Blair, and John Jung, Digital Library Development Center; and Christine Colburn, Julia Gardner, Barbara Gilbert, David Pavelich, Kerri Sancomb, and Catherine Uecker, Special Collec-tions Research Center, all contributed to the success of this multiyear collaboration.

The digitization and publication also benefited from several sources of funding. I extend sincere thanks to the Gladys Krieble Delmas Foundation, the Graham Foun-dation, and the University of Chicago Library Society for their support of this catalogue.

Professor Zorach envisions a digital *Speculum* that will integrate images and data from copies around the world to stimulate research into print production, distribution, and collecting. The University of Chicago Library is proud to hold the largest known compilation of *Speculum*-related prints and to be a partner in this exciting project.

Alice Schreyer
DIRECTOR
SPECIAL COLLECTIONS RESEARCH CENTER

ACKNOWLEDGEMENTS

I WOULD LIKE HERE TO CONVEY MY THANKS first of all to the staff of the Special Collections Research Center, who facilitated, in every possible way, the exhibition project that produced this catalogue. Without their cheerful and efficient contributions, the exhibition and catalogue could never have happened. I especially want to thank Kerri Sancomb for her expert direction of exhibition planning and installation, and Alice Schreyer for her unwavering faith in the project's potential, which she backed up with concrete support. Because of the collaborative nature of the project and the combination of books and prints (many of them requiring new cataloguing work), the project was a bigger and more complicated one than most exhibitions undertaken at the SCRC, and I wish to echo Alice's thanks to the many staff members who contributed their time, energy, ideas—and patience—to the project.

My own research toward the exhibition began several years ago, and many institutions have contributed (whether they knew it or not) to this project. I wish in particular to thank the Yale Center for British Art, the Houghton Library, and the Franke Institute for fellowship support that enabled research on this exhibition. I especially wish to thank the staff of each institution for helping make my work pleasant and efficient. Similar thanks must be extended for help received at the Newberry Library, the Beinecke Library, Columbia University's Avery Library, the Metropolitan Museum, the British Museum, the British Library, the Bibliothèque Nationale de France, the Bibliothèque de l'INHA (where staff kindly allowed me to see the *Speculum* volume without the required advance appointment), and the Vatican Library.

The exhibition and catalogue are the product of collaboration and form only one part of a larger collaborative project. As part of his MA thesis for the Master of Arts Program in the Humanities, Marc Gartler developed the XML scheme for the digital *Speculum*; and Kristine Hess and Stephen Kim did further work in description and translation to enrich the metadata. The Digital Library Development Center, especially Elisabeth Long and John Jung, has created the remarkably attractive and user-friendly interface and guided work on the metadata. The Library's Preservation Department scanned the prints, a task made more complicated by the need to remove them from and replace them in their mats. The Preservation Department also assisted in important ways in the planning and production of the exhibition.

The larger project has been supported by the Provost's Program in Academic Technology Innovation; I wish especially to thank Richard Saller and Chad Kainz, and, in Humanities Computing, Lec Maj and Arno Bosse. My own work was also funded by fellowships at the Yale Center for British Art and the Houghton Library and by research and project funding from the University of Chicago's Division of the Humanities.

Several scholars gave generous and enlightening consultations to the student curatorial group: these included essay authors Nina Dubin and David Karmon as well as Jonathan Sachs and Jaś Elsner. Irene Backus was an enthusiastic early participant in discussions on the project.

Itinerary authors Suzanne Boorsch, Evelyn Lincoln, Christopher Heuer, Nicole Bensoussan, and Martha Pollak contributed important additional information for both metadata and catalogue. Research help was provided by Sarah Cree, Annie Labatt, and Rainbow Porthé (above and beyond her own work on the catalogue). Michael W. Phillips, Jr. copy-edited the manuscript, and Iva Olah provided additional editing help. Information, assistance, and suggestions of various kinds were provided

by Danielle Allen, Gerald Beasley, Charles Burroughs, Susan Dackerman, Surekha Davies, Wilson Duprey, Caroline Duroselle-Melish, Jaś Elsner, Michael Gaudio, Suzanne Karr-Schmidt, Stephanie Leitch, Eckhardt Leuschner, Emmanuel Lurin, Opher Mansour, Amy Meyers, Lia Markey, Kirstin Noreen, Katy Park, Peter Parshall, Birte Rubach, Katherine Taylor, Martha Tedeschi, Martha Ward, Ben Weiss, and Henri Zerner. In particular, I want to thank Peter Parshall, Elizabeth Rodini, and Alice Schreyer for drawing my attention to the collection and encouraging our work on it. In the course of my research I was privileged to present portions of it to audiences at Harvard, Yale, and the University of Chicago, and I am grateful for their questions and comments, which helped hone ideas involved in the project.

Rebecca Zorach

THE VIRTUAL TOURIST IN RENAISSANCE ROME— AND BEYOND

THE BAROQUE ART CRITIC G. P. Bellori, in his *Lives of the Modern Painters, Sculptors, and Architects,* explained how it came to be that Nicolas Poussin, despite the inherent disadvantage of growing up in France, could have become one of the most brilliant exponents of seventeenth-century classicism. Not finding a good master in Paris, he profited from his acquaintance with a certain mathematician by the name of Courtois:

> This Lord delighting in drawing (*disegno*), and having collected the rarest prints of Raphael and Giulio Romano, was generous with them, and insinuated them into Nicolas's soul, who imitated them with such ardor, and the most exact diligence, that the forms and design impressed themselves in him no less than the movements, inventions, and other marvelous gifts of these masters.[1]

Bellori must be talking primarily about prints after the original compositions of these Italian Renaissance masters. But it may well be that the collection also contained prints after antiquities that allowed the young artist to begin an acquaintance with the monuments of Rome—the city where he would spend most of his adult life. As Renaissance artists, scholars, clergy, and nobility enthusiastically excavated the city for ancient remains, comparing ancient texts with ancient monuments, their discoveries were documented not only in texts but also in images. As printed images, antiquities could travel to distant places and reach the hands and eyes of those who could not afford to travel or to establish collections of ancient medals, reliefs, and gems (let alone major sculpture). Sixteenth-century print publishers recognized and exploited the market for collectible prints after antiquities. Along with major monuments and the canon of classical statues (which they in no small measure helped constitute), prints communicated the contents of major collections, the continuing enigmas of antiquarianism, and fanciful Renaissance elaborations on classical themes.

The *Speculum Romanae Magnificentiae* was, at its outset, a way to constitute such images as a collection. Antonio Lafreri, a native of Besançon, had established himself in Rome and begun publishing prints after major Roman monuments in around 1540. After he published a title page [FIGURE 1, CAT. A1] in the mid-1570s, collections of these prints, bound with the title page, came to be known as the *Speculum Romanae Magnificentiae,* the "Mirror of Roman Magnificence." The term "mirror" connects the work to a longstanding tradition of referring to comprehensive and didactic texts as mirrors; in this context it also stresses visuality. Over the centuries, Lafreri's prints, and those of his contemporaries and successors, provided Europeans and others with images of Rome that could be put to many different uses. Monuments included in "Lafreri" automatically

11

FIGURE 1

Etienne Dupérac (engraver). *Speculum Romanae Magnificentiae (Title page)*. Etching with engraving, ca. 1574–1577. Antonio Lafreri, publisher. CAT. A1.

acquired a certain prestige: collections of *Speculum* prints presented a comprehensive view of Roman antiquity— or at least, the impression of a comprehensive view.

At the head of a bound volume, the title page creates the appearance of a book, and therefore the *Speculum* has sometimes been viewed that way: as a continuous text with an established composition and order. In the nineteenth and twentieth centuries as these collections began to enter public institutions, mainly libraries, they were often catalogued as if such a standard edition existed. Comparative copies that would have demonstrated the extent of variation were rarely available for consultation. In fact, although late sixteenth-century volumes do share many features, individual volumes contain significant variation and can more properly be thought of as closely related but individualized collections of prints.[2] But the existence of the title page, which resulted in idiosyncratic institutional paths

for these prints, also resulted in the serendipitous preservation of some interesting evidence of Renaissance print collecting practices.

I will have more to say on collecting at the end of this introduction, but first it would useful to give a brief introduction to the Lafreri workshop and its practices. This is a complex history that is difficult to trace. One index of how little we know—at least about its beginnings—is that we do not know how much, if at all, Lafreri himself engraved copper plates.[3] Lafreri—whose name may originally have been Antoine Lafrère or La Frère—was established in Rome by 1540, but we do not know exactly when he arrived.[4] By the 1540s, around the time of his earliest dated plates, Lafreri had already become a competitor of the established antiquarian publisher Antonio Salamanca—largely, it seems, by copying his prints.[5] In 1553 he contracted a partnership with Salamanca; some of their joint efforts from this period bear both names. From existing sixteenth-century print compilations, it seems that many actual Salamanca prints, and not only copies, were sold by Lafreri's shop. Notably, Lafreri employed many northern (French and Flemish) engravers—Etienne Dupérac, Nicolas Béatrizet, Jacob Bos, and others; his workshop formed a vital (but not always, as we will see, well regarded) part of the large community of northern artists and publishers working in Rome.

Other artists and publishers had been making prints after antiquities since the early sixteenth century.[6] Printmakers such as Andrea Mantegna, Agostino Veneziano, and Marco Dente made prints after antiquities, some of which Lafreri's shop copied. Book illustration also included reconstructed monuments and topographies of Rome.[7] Another type of bound image "collection" was the print series—numbered, thematically linked prints, often with a frontispiece (from which, probably, Lafreri drew inspiration). Many such series dealing with Roman views and antiquities have been incorporated into the Chicago *Speculum*. While many artists and authors had thus laid the groundwork for Lafreri, what is significant about his project is the ambition associated with the scale and archaeological pedigree of his prints, and their consistent format and appearance. Although the title page appeared in the mid-1570s, the prints of the 1540s already look designed to be collected. They are of a large and fairly standard scale. They emphasize scholarly knowledge, superior accuracy, and vividness.[8] Although they do not constitute a numbered series, and although actual arrangements vary, their claims to prestige and relatively standard format suggest that they were intended

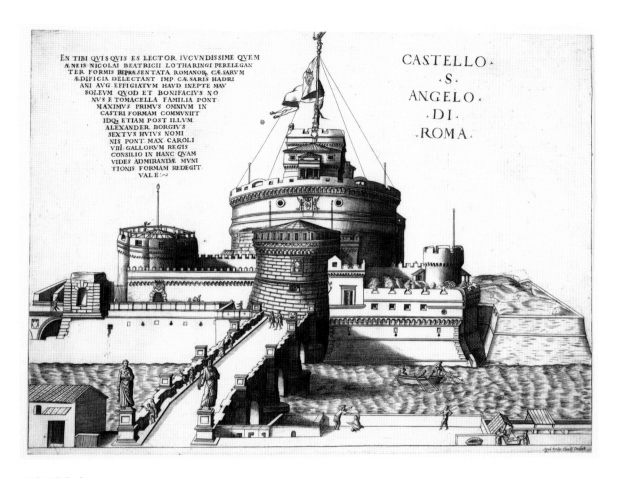

In the image (engraving):

EN TIBI QVISQVIS ES LECTOR. IVCVNDISSIME QVEM
ÆNEIS NICOLAI BEATRICII LOTHARINGI PERELEGAN
TER. FORMIS REPRÆSENTATA ROMANOR. CÆSARVM
ÆDIFICIA DELECTANT IMP. CÆSARIS HADRI
ANI AVG. EFFIGIATVM HAVD INEPTE MAV
SOLEVM QVOD ET BONIFACIVS NO
NVS E TOMACELLA FAMILIA PONT.
MAXIMVS PRIMVS OMNIVM IN
CASTRI FORMAM COMMVNIIT
IDQ₃ ETIAM POST ILLVM
ALEXANDER. BORGIVS
SEXTVS HVIVS NOMI
NIS PONT. MAX. CAROLI
VIII GALLORVM REGIS
CONSILIO IN HANC QVAM
VIDES ADMIRANDÆ MVNI
TIONIS FORMAM REDEGIT.
VALE

CASTELLO.
.S.
ANGELO.
.DI.
.ROMA.

FIGURE 2

Nicolas Béatrizet (engraver). *Castel Sant'Angelo*. Engraving, originally published 1559–1565, republished 1590–91. Heirs of Claudio Duchetti, publishers. CAT. A46.

to be collected in quantity. And whereas a single print might be within the reach of a person of limited means, and artisans in particular must have had moderate-sized collections, a folio-sized bound album of large-scale prints requires a certain amount of wealth not only because of the cost of the prints and binding themselves, but, even more, because of the need to transport and house such a volume.

Tracing the states and destinations of *Speculum* prints is complicated by their great quantity. Along with, but perhaps even more than, the shop's presses, the copper plates constituted the major form of capital of any print shop. While it is obvious that multiple impressions could be made from any given plate, what is perhaps less obvious today is that there was no sense of the "limited edition" we tend now to expect of artists' prints. Nor did artists typically retain much claim on the printed images they designed or engraved. Prints could continue to be struck from any given copper plate until the image

incised on the plate wore out, and then it could be "refreshed" with the burin. When plates changed hands, the publisher's address was often changed as well by burnishing a portion of the plate (flattening out its ridges) and reincising.[9] Many of Lafreri's plates later appear with other publishers' names and dates from the 1580s, 1590s, and beyond.

Some prints required other forms of updating, such as the Castel Sant'Angelo, originally the mausoleum of the emperor Hadrian, but by the sixteenth century the fortress of the popes. Because it displayed the papal arms, republications of the print required updating of those arms for different popes. One engraving by Nicholas Béatrizet in Chicago's collection [FIGURE 2, CAT. A46] was first published during the pontificate of Pius IV (1559–1565) and updated with new papal arms and republished during the pontificate of Gregory XIV, giving a date range for republication of 1590–1591. The Castel also appears in many other prints, both copies and

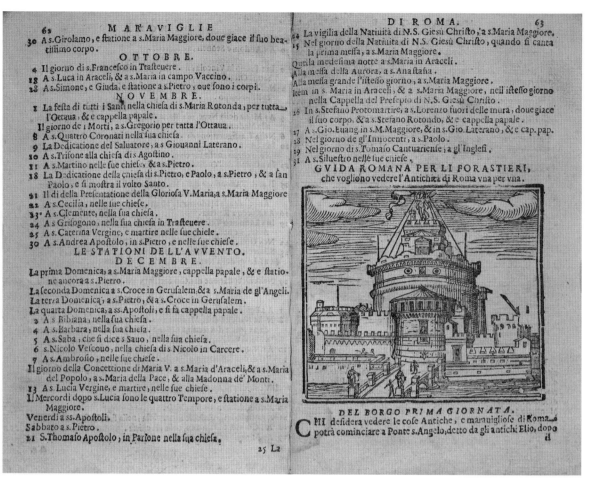

FIGURE 3

Anonymous. *Castel Sant'Angelo.* Woodcut in *Le cose maravigliose dell'alma Città di Roma* (1644). CAT. 1.

independent versions. As with many *Speculum* prints it came to be copied in smaller, cruder woodcuts in guidebooks. A woodcut of the Castel Sant'Angelo appears in a 1644 edition of the *Cose maravigliose* at the head of a section entitled "guide to Rome for foreigners who want to see the antiquities of Rome one by one" [FIGURE 3, CAT. 1]. Opposite, the end of the previous section displays Catholic feast days. Many images in these guidebooks, like this one, derive from *Speculum* and other large-scale prints, as is evident from a comparison of the guidebook image and the Béatrizet engraving.

Upon Lafreri's death in 1577, the shop's stock was split among multiple heirs. The bulk of the inheritance went to Claudio Duchetti, Lafreri's nephew, but not all of it—in some cases Duchetti was in possession only of printed impressions on paper and not of the copperplates from which they were made.[10] This meant he had to commission copies of his own shop's prior production,

usually etchings by Ambrogio Brambilla, who was not as adept an artist as Dupérac or Béatrizet.[11] There were thus a variety of generations represented among the stock sold by Duchetti. He sold prints bearing Lafreri's address. He changed some of Lafreri's original plates, burnishing out Lafreri's address and replacing it with his own. Finally, he had new copies made (from prints) in the case of plates that were either absent or too deteriorated to use. Duchetti's workshop (perhaps following a late practice of Lafreri) produced fairly standard albums of prints that constitute almost all the existing sixteenth-century compilations of *Speculum* prints.[12] In the Chicago collection, the composition of *Speculum* prints, narrowly defined (the large-scale prints of Roman antiquities that originated with the Lafreri/Duchetti operation), reflects this diversity and probably derived from one volume put together in the Duchetti era. The Chicago *Speculum* does not, unlike some other *Speculum*

collections, contain quantities of examples of later generations of the same prints.[13]

Artistic "ownership" was understood differently in the sixteenth century than it is today. The print privilege—a state (or papal) grant of monopoly on a particular image to a publisher or printmaker—was developing at just this time, though it appears on few of the prints in this exhibition.[14] Freely copying the works of others, as Lafreri did, and replacing an earlier publisher's address with one's own, were common practices. Large-scale engravings like Lafreri's, too, were frequently copied both as engravings and as smaller woodcuts, appearing in both antiquarian texts and cheaper tourist guidebooks. This does not mean, however, that such actions did not engender hostility. The printmaking trade was known as intensely competitive and overly concerned with profit—at least this is the case in Giorgio Vasari's account, speaking specifically of Lafreri.[15] Court cases, anecdotes, and accusations show that printmaking was a highly competitive business, and nowhere more than in Lafreri's milieu in Rome. In 1577, a case unfolded in Rome involving Lafreri's heirs and rivals. In the court documents, testimony refers constantly to the envy felt by other printmakers for the Lafreri bottega.[16] After Lafreri's death, rivals apparently tried to steal from his stock and materials; one of his workers, the young Girolamo of Modena, was found dead in the Tiber. His heir Claudio Duchetti testified that he asked around to find out what sort of company the boy kept, and found that he frequented only other printmakers. Duchetti "then turned it around in [his] mind [fantasia] and imagined that this was an assassination against the workshop, which is envied by many in the profession."[17] Personal and collective envy are intertwined: another printmaker states that "Messer Geronimo was murdered through envy of his being in the workshop of Messer Claudio, because the workshop is envied because it is the biggest in Rome and has the most beautiful works in this medium."[18] Something else that emerges in the testimony, however, is not so flattering to Lafreri's shop: Lorenzo della Vaccheria testifies that Lafreri counterfeited some of his prints, and that he did not do the same in return. He states, perhaps disingenuously, that this was not especial cause for ire or vengefulness, for "it was Messer Antonio who counterfeited all the new prints of the rest of us shopmasters, because that was the kind of man he was and he had the means more than any of the rest of us did."[19] Certainly copying the prints of other artists and publishers was a cheap way to establish

one's business, and little regulation of the trade seems to have occurred.

Although competitors (and Vasari) may have judged Lafreri negatively, those publishing in the area of Roman antiquities in later years continued to cite him. Jean-Jacques Boissard, referring to him as a "papal sculptor" (perhaps meaning engraver), mentioned his excavations in the Monte Testaccio, in which, Boissard states, he uncovered intact vases.[20] Franciscus Schottus wrote in 1600 that "Antonio Lafreri and Antonio Salamanca published copperplates of Roman antiquities in worthy form; others did the same in a lesser fashion."[21] John Evelyn, writing later in the seventeenth century, offers a mixed judgment, referring to the quantity of Lafreri's production, and most favorably to his "divers grotescos, antiquities, and pieces serving to architecture. . ." He mistakenly suggests that Serlio used Lafreri's prints as a source; Serlio's book of antiquities was first published in 1537.[22] A seventeenth-century edition of Onofrio Panvinio's De triumpho commentarius cites "Lafrerius" among its scholarly sources.[23]

Lafreri might also be credited with inspiring the notion, common among Grand Tourists, that a visit to Rome should be accompanied by the purchase of a comprehensive volume of prints—whether the prints they acquired were Lafreri's or not. In 1764 the Duke of York, on a visit to Rome, was presented with "a collection of all the prints of everything valuable at Rome finely bound."[24] On an even grander scale, when the architect James Adam negotiated the purchase by George III of the Albani collection, he brought back what the London Chronicle called "collections of the most capital engravings."[25] Whereas annotations make clear that Speculum prints continued to be viewed and used in the eighteenth and nineteenth centuries, it is difficult to know whether they were prized as artworks, viewed as utilitarian information, or considered a bit out of date. In 1923, David Lindsay, the earl of Crawford, sold his Speculum collection. This is the one now at Columbia; it had come to the Crawford collection from the same Berlin book dealer, S. Calvary Co., as Chicago's. Lindsay does not seem to have thought very highly of it, writing in his journal that "In mutilating the Library however I have only excised the uninteresting books; all the volumes of historic or artistic interest are now gathered into a noble apartment, where there are displayed with a dignity and care they have never received before."[26]

Perhaps the earl's statement reflects his own public relations finesse—explaining away what might have

seemed an embarrassment—more than the artistic judgment of his age. A major *Speculum* collection had certainly been presented as a collection highlight a generation earlier, when, in 1891, William Rainey Harper began negotiating the purchase of large quantities of books and other materials for the library of the new University of Chicago. The Berlin book dealer whose stock was to constitute the library's core offered the university's first president a "unique set of Lafreri's Speculum Romanae Magnificentiae consisting in 1100 plates of which no public library has a set over 120 plates."[27] The first figure would prove to be exaggerated, while the second was too low; perhaps the grandiose claim was calculated to appeal to the American taste for bigness.

This collection of prints now at the University of Chicago Library's Special Collections Research Center is considered the largest single *Speculum*, though just what that means might be debated. Collectors often added to *Speculum* volumes, combining and recombining them with other prints and groups of prints. Thus, most of the 994 prints that eventually arrived as part of the Berlin collection were neither published by Lafreri nor part of an original set put out by his shop, but were collected together because they depicted similar views of Roman landscape, monuments, and statues.[28] Like many other large collections, its prints have been separated from their bindings, matted, and boxed. Collections of prints from the sixteenth century until the early twentieth century were generally bound together as albums, but few of the earliest bindings or original ordering principles remain. In the interim, most compilations were separated and reorganized by later generations of collectors. Many were finally unbound by dealers, collectors, and museums in order to mat and box them and classify them according to national "school" and artist—or by subject matter, when its own importance (Roman antiquities are a good example) took precedence over the printmaker's. Because information about the priorities and interests of earlier collectors was often considered irrelevant, records of earlier principles of classification and ordering were rarely kept.

Between the late sixteenth and late nineteenth century, indeed, little evidence remains of the priorities and interests of print collectors. Eclectic volumes from the seventeenth and eighteenth centuries, though they must have been relatively common, are now rare. One example is a pair of volumes in the Vatican Library (Barberini XII.1–2), which contain Lafreri prints but also a great number of non-Lafreri, non-Rome-themed

prints of many different sizes. The Chicago *Speculum* acquired its present form sometime after the death of Thomas Lawrence, whose collection mark appears on the three prints of *Loves of the Gods* after Caraglio. It is probable that these prints were among those that Colnaghi purchased at the Lawrence estate auction; it has not yet been possible to trace their route to Berlin.[29]

The prints of the Chicago *Speculum* were removed from their deteriorating nineteenth-century bindings in the 1960s, following the rediscovery of the prints on the shelves of the Classics library in around 1950–1951.[30] In 1966, the Library first exhibited some of these prints, choosing a group of major ancient architectural monuments. The exhibition celebrated the rediscovery and also heralded the long-term project of cataloguing the prints that would, in 1973, result in a typescript finding aid.[31] Monuments were especially relevant, at that moment, to the Library's plans to build a new library— what would become the Regenstein.

The Printed and Digital Speculum

The *Virtual Tourist* exhibition focuses on the prints as material objects in the cultural context of Renaissance Rome and the centuries that followed, examining how they were made and collected and what influence they had. Alongside prints, it displays numerous related books whose illustrators often directly copied images originally published as independent prints. It asks what kinds of interest Renaissance people took in ancient Rome; how images were circulated, collected, and used; with what purposes scholars and travelers came to Rome; and how they navigated once there. By tracing one iconographic motif, it is often possible to show how a given print or series was copied, quoted, or adapted by other print-makers, but an understanding of the entire landscape of such practices is not easy to come by. Images "traveled" from engraving to engraving, engraving to woodcut, single-sheet print to illustrated book, edition to edition, and print to painting or sculpture. Accommodating multiply linked authors and generations of prints, the digital project may eventually be able to trace more of these lineages.

The current exhibition also draws on the study of museums and their history, and growing interdisciplinary collaboration between the history of art and the history of science. Keeping a dialogue between art and science in mind makes particular sense for studying Lafreri: along

with architecture and antiquities, he also published, with Antonio Salamanca, the first large anatomical book to be illustrated with engravings (Valverde's *Historia de la composición del corpo humano*, CAT. 90). Thus, an additional focus of this exhibition and catalogue is in the ways prints conveyed knowledge—to tourists, scholars, artists, and others—and how this function was viewed in the Renaissance and beyond.

The exhibition attempts to reconstruct typical and atypical paths taken by images (and groups of them) among different media in Italy and, via albums and books, to other parts of Europe. These images were published and republished, inserted into new contexts, and given new interpretations. Scholars appreciated them for the antiquarian knowledge they conveyed; artists for the inspiration they provided; tourists for their practical guidance. Virtual tourists—those who had not yet traveled, could not travel, or had returned home—used them as the basis for the work of the imagination.

Much of what we can reconstruct about the interests and priorities of collectors comes from marks made on individual prints in volumes in Europe and the United States. Many of the title pages bear marks of ownership, generally identifying high-ranking nobles or monastic or collegiate (often Jesuit) libraries. Collectors also made interventions on pictorial prints. They wrote annotations, giving titles to sculptures and monuments. They copied relevant text from books, filling the white spaces around the depicted objects with handwriting in ways that are sometimes startling to modern viewers. They censored statues' genitalia with carefully drawn and painted drapery; they also painted bodies of water blue. They gridded images for transfer in order to copy them at a larger scale.[32] One collector—or dealer?—even attempted to alter the date on a 1773 impression of a Béatrizet engraving after Michelangelo to make it look like 1573 [FIGURE 4]! All this implies a very active approach to viewing, one that assumes that prints can be used as the basis both for knowledge and for other kinds of image-making.

Along with the *Speculum* collection, the Library is fortunate to possess numerous other volumes (some of them also from the Berlin collection) that demonstrate the richness of the uses and collecting of images in bound volumes. They include albums composed of collected prints like the eclectic *Speculum* volumes, artists' or publishers' print series (that is, those composed by the producer as opposed to the consumer), and books that incorporate prints (these include scholarly treatises,

antiquarian guides to Rome, and cheap pilgrims' guidebooks). Renaissance viewers probably hung prints on walls and may have kept loose prints in boxes or other receptacles, not only in bound volumes; and buyers of prints certainly included many who could afford only a small number of sheets. But those sixteenth-century prints still in existence today—even if they now appear in institutional collections as individual prints—were most probably collected in bound volumes for a significant portion of their lifespan. It is essentially in this way that prints survived, and this is the case for earlier woodcuts as well.[33]

A certain number of eclectic collectors' volumes from the sixteenth century do still exist.[34] Prints were bound into collections that exclusively held prints, but they were also bound with books—not too surprising, because books were also often bound together with other books. At the Center for British Art at Yale, an early volume includes Labacco's and Vignola's treatises on architecture, along with a sampling of *Speculum* and related prints.[35] Multiple series of prints were sometimes bound together in one volume, as is the case in the exhibition with two of the Dupérac volumes (one bound with della Vaccheria's *Ornamenti* and the other with both the *Ornamenti* and the della Vaccheria collection of statues), as well as Dosio's views published by Cavalieri and bound with Cavalieri's statues, and Cartaro's *Prospettive* (bound with the *Ornamenti*).[36] In most cases, these involve print series published by the same shop. The Special Collections Research Center also possesses a seventeenth-century miscellany including the Maggi *Ornamenti* and other prints published by the della Vaccheria family, but also others published by van Schayck, the de' Rossi family, Thomassin, and Aegidius and Marcus Sadeler (most of which are copies of Dupérac's *Vestigi*), and many direct copies of *Speculum* prints.[37]

We will encounter many prints that were copied and republished by a sequence of other printmakers, and by publishers of guidebooks and other kinds of antiquarian books. Hieronymus Cock's prints were directly copied by Jacques Androuet Ducerceau and Giovanni Battista Pittoni, and the latter prints were incorporated into a book published by Girolamo Porro, with commentaries by Vincenzo Scamozzi. Giovanni Antonio Dosio's drawings would be the basis for images in several generations of different guidebooks, and were recopied in a more piecemeal way by authors such as Louis de Montjosieu and Jean-Jacques Boissard. Etienne Dupérac's views were republished by Goert

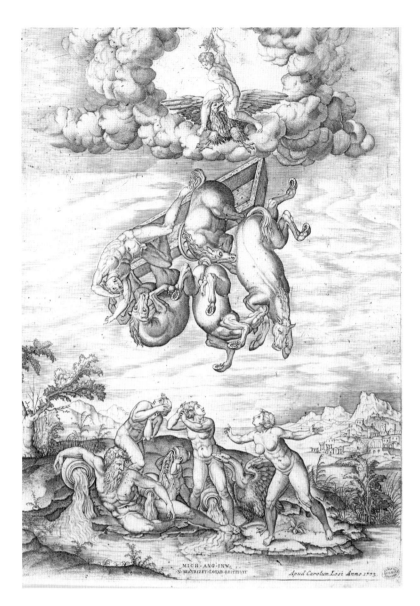

FIGURE 4

Nicolas Béatrizet (engraver). *Fall of Phaeton,* after Michelangelo. Engraving, mid-16th c., and detail. Republished by Carlo Losi in 1773.

van Schayck and copied by the Sadeler family and also in piecemeal fashion. Lafreri's were reprinted by a series of successive owners of his plates over the centuries; they were, as we have seen, copied in Duchetti's workshop, and they also appear in later books by Boissard, Donati, and Deseine.[38]

The novelty, interactivity, replicability, and multiple uses of prints find an echo today in digital technology. The exhibition also forms one part of a project to use technology to enrich the field of print studies. The Provost's Program in Academic Technology Innovation is supporting a partnership with the Library to develop a digital collection of Speculum prints (http://speculum .lib.uchicago.edu) that will be accessible on-line and will provide high-quality, zoomable digital images as well as updated catalogue information, and "virtual itineraries" that provide paths through a thematically related selection of images.

Research for the exhibition was conducted by a team of graduate students who worked with the books and original prints in the Special Collections Research Center and could study and compare digital images of the prints from a distance. The essays and short entries we produced in this project, along with book and print checklists, constitute the catalogue proper, which begins with introductory sections on prints, publishing, and topographic approaches to Rome. It then deals with some of the subject matter of prints, including architecture, sculpture, Egyptian antiquities, and Roman material culture. Along the way, questions of theatricality, imagination, artistic self-consciousness, and reception emerge. We end with a discussion of movement through the city: Sixtus V's urban planning schemes and travel to Rome by pilgrims and connoisseurs.

This is by no means a comprehensive study of Lafreri's *Speculum* or the Chicago *Speculum*. The other major piece of the *Speculum* project at Chicago is the *Speculum Romanae Magnificentiae Digital Collection*. This should be understood as a crucial complement to the exhibition and as an ongoing resource for scholarship on the *Speculum*. All Chicago *Speculum* prints are now available to be viewed in high resolution. Viewers may navigate to individual prints directly by adding the Chicago Speculum Number (A107, etc.) with a slash after this URL (e.g., http://speculum.lib.uchicago.edu/A107). They may also avail themselves of ample searching and browsing options. More complete and constantly updated catalogue information on the prints can be found there. The "metadata" or catalogue information available online is an updated version of the 1973 finding aid. As of this writing it is still in progress. We invite readers of the catalogue and viewers of the site to contribute their own findings—updates, corrections, and amplifications. Contact information is available on the site.

Not as apparent in this catalogue, but an especially important feature of the digital project, is a series of "virtual itineraries" (http://speculum.lib.uchicago.edu/itineraries) commissioned from scholars who were invited to choose a selection of prints and provided commentary on them. At this writing, itineraries have been authored by Nicole Bensoussan, Suzanne Boorsch, Christopher Heuer, Evelyn Lincoln, Martha Pollak, and me. These itineraries have been imagined in a variety of ways: as a visit to a collection, an approach to a theme, or a journey through an artist's career. Users may follow the itinerary's sequence or choose one of their own; likewise, itinerary authors have provided zoom instruc-

tions that point the viewer to specific points of interest, but users may also travel around each image and zoom in and out at will. This Web feature affords a flexible forum for scholarship, and we hope it will expand over time. Several of the catalogue essays collected here were also produced with reference to the digital collection.

These essays provide distinctive approaches to Lafreri and his projects and to the antiquarian culture and imagination for the sixteenth to the eighteenth century. Birte Rubach's essay details Lafreri's ambitions to incorporate, through contacts with scholars, the most up-to-date antiquarian knowledge into his shop's production, including not only the more obvious buildings and statues but also inscriptions, a particular interest of Renaissance scholars. She addresses Lafreri's innovative technical experiments that enabled him to make particularly accurate prints of use to scholars, and the sometimes surprising epigraphical biases of his transcriptions. David Karmon's essay deals with the protection of ancient monuments in the Renaissance—"protection" being a term carefully chosen to contrast with modern notions of preservation or conservation. Prints played an important role in publicizing the state of monuments: they not only invented techniques for the careful documentation of monuments' current state, but also suggested possibilities for their physical protection, or imagined a more conceptual kind of protection available through the print itself. Rose Marie San Juan's essay focuses on Juan Valverde de Amusco's *Historia de la composicion del cuerpo humano,* published by Lafreri and Salamanca during the period of their partnership. The engraved plates are relatively close copies—San Juan uses the term "translations"—of Vesalius's woodcuts. In using engraving rather than woodcut—plates that had to be printed separately from the text—the author and publishers effected a substantial change in the status of the images. Rather than fragmenting the body, the images, gathered into sections at the end of each chapter, represent an attempt at restoring the wholeness and physicality of the body (a change also signaled in the disappearance of Vesalius's ruined landscapes and contained, if imperfectly, within the contours of statues like the Belvedere Torso). The human body stands between human artifice and nature. Yet these acts of narrative reconstitution of the fragmented body also insist on violence and militarism, suggesting a close link between restoration, representation, and violent death and dismemberment. My essay examines the evidence of prints in books to consider the discourses of utility and

pleasure, appropriation and evocation, asking how it was that, in the second half of the sixteenth century, artists began claiming a "public" or "common" utility for their engravings, including ornamental ones. The evidence of prints in books allows for some understanding of the reception of prints, for book authors who copied and incorporated prints into their books, and used them as sources of knowledge, can also be thought of as collectors. Nina Dubin's essay deals with an eighteenth-century artist, Jean Barbault, several of whose prints are found in the Chicago *Speculum* collection. Barbault, a collaborator with Piranesi and a competitor of Vasi, worked in the tradition of the Roman *veduta* in which Lafreri and his contemporaries had played such a formative, popularizing role. But Barbault responded to trends and ideas current in France that reimagined the city as a post-monarchical, Enlightenment space, managing and rationalizing unruly bodies and buildings. His work both breaks with the past and looks to it—but in looking to it, imagines the city of the future.

NOTES

1. G. P. Bellori, *Le vite de' pittori scultori e architetti moderni* (Rome: Mascardi, 1672): "Non per questo Nicolò restò senza maestri, e gli fù fauoreuole la sorte nella conoscenza del Cortese Matematico Regio, il quale all'hora haueua luogo nella galeria del Louro. Questo Signore dilettandosi del disegno, & hauendo raccolto le più rare stampe di Raffaele, e di Giulio Romano, ne fece copia, e le insinuò nell'animo di Nicolò, il quale con tanto ardore, & essattissima diligenza le imitaua che non meno s'impresse il disegno, e le forme, che li moti, e l'inuentioni, e l'altri parti mirabili di questi maestri. Per tel cagione nel modo d'historiare, e di esprimere, parue egli educato nelle scuola di Rafaelle, da cui certamente bibbe il latte, e la vita dell'arte."

2. On the *Speculum* and Lafreri, basic sources include Christian Hülsen, "Das Speculum Romanae Magnificentiae des Antonio Lafréri," in *Collectanea variae doctrinae Leoni S. Olschki* (Munich: J. Rosenthal, 1921), 121–70; Francesco Ehrle, *Roma prima di Sisto V: la pianta di Roma Du Pérac-Lafréry del 1577* (Rome: Danesi, 1908); François Roland, "Un franc-comtois editeur et marchand d'estampes a Rome au XVIe siecle: Antoine Lafrery," *Memoires de la Societe d'emulation du Doubs* 7 (1910): 320–70; Bates Lowry, "Notes on the *Speculum Romanae Magnificentiae* and related publications," *Art Bulletin* 34 (1952): 46–50; Lawrence McGinniss and Herbert Mitchell, *Catalogue of the Earl of Crawford's Speculum Romanae Magnificentiae, now in the Avery Architectural Library* (New York: Columbia University, 1976); Stefano Corsi and Pina Ragionieri, *Speculum Romanae Magnificentiae: Roma nell'incisione del Cinquecento* (exh. cat.) (Florence: Mandragora, 2004), and most recently Peter Parshall, "Antonio Lafreri's *Speculum Romanae Magnificentiae*," *Print Quarterly* 23, 1 (2006). I have examined several *Speculum* albums that appear to retain a nearly original ordering. The order of Lafreri's stocklist was observed to varying degrees. What follows is a rough survey of a sample of prints of architecture appearing early in the stocklist (numbers 9 to 18): Tempio di Antonino et Faustino; Tempio della Fontana virile [Fortuna virilis] detto santa Maria Egipyiaca; Battes[i]mo di Costantino [Balnei Laterani]; Arco di Tito Vespasiano; Arco di Lucio Settimio Seuero; Arco di Galieno; Arco di Costantino; Due tauole di diuerse figure sculpite nel medesimo arco; Theatro di Vespasiano detto il Coliseo, in forma come era antichamente; Altra forma del medesimo, come si uede hora). The volume at the Bibliothèque de l'Institut National de l'Histoire de l'Art in Paris (Fol. Est. 175) omits the Lateran baptistery, one of the Arch of Constantine reliefs, and the reconstructed Colosseum. The Beinecke volume is also close but not exact: it omits the Lateran baptistery, reverses the arches of Gallienus and Constantine and omits the reliefs from the latter and the reconstructed Colosseum. The arches of Septimius Severus and Constantine are Duchetti imprints from 1583. The BNF's volume (Res J-1052), which contains no print dated after 1579 (and only one in 1579), replicates the stocklist exactly and is the only one to do so, although the Vatican's volume Riserva S.7 contains a nearly exact replication (simply adding one extra version of the reconstructed Colosseum). In the same collection Riserva S.6 contains all the same prints but in a different order. Starting at fol. 34, contains a sequence from the stocklist (from the Temple of Fortuna virilis to the reliefs from the Arch of Constantine). Arch of Gallienus and two versions of the Colosseum (ordered in reverse vis-à-vis the stocklist) are fols. 28–30. Temple of Antoninus and Faustina is fol. 46. Balnei Laterani is fol. 54. The British Library

volume (Map Collections, Maps 7 TAB.1.) has a modern binding and may have been reordered. In it, the Temple of Antoninus and Faustina together with the Temple of Fortuna virilis (fols. 37 and 38) are near each other, as are the arches of Titus, Septimius Severus, Constantine, and Gallienus (fols. 62, 63, 65, and 66). Wilson Duprey has compiled a comprehensive list of the contents of *Speculum* collections in North America. Given sufficient funds, it should be possible to enter it into the *Speculum* database.

3. Hülsen, 124.

4. Roland, 16–17. Since spelling varies so widely in the French documents, we have chosen to use the Italian Lafreri, which consistently appears on those prints with a vernacular (as opposed to Latin) address. Lafrery with a "y" seems likely to have been a misreading of the commonly used Latin "Lafrerij."

5. On Lafreri's copies of Salamanca, see the Rubach essay in this volume.

6. On Salamanca, see Rodolfo Lanciani, *Storia degli scavi di Roma e notizie intorno le collezioni romane di antichità* (1902; Rome: Quasar, 1990), 2:59–60.

7. Marco Fabio Calvo's 1527 *Simulacrum* of Rome presented a series of woodcut maps: reconstructed, highly schematic historical views of the growth of the ancient city. In the 1530s, several of Charles Estienne's editions of Lazare de Baïf's essays on ancient material culture were illustrated with images drawn from Roman monuments. And in 1540 Sebastiano Serlio published the *terzo libro* of his architectural treatises, an illustrated compendium of reconstructed Roman monuments, in which he attempted to show the monuments as they would have looked when new.

8. Interestingly, they frequently use the term "ad vivum" of architectural reconstructions. Although this term is usually translated "from the life" by art historians when speaking of portraits or still life, the usage in *Speculum* prints places a particular spin on the notion. In speaking of ruined monuments, I think "vivid" is the best translation.

9. "Address" is the term used for a publisher's signature on a print; in this period simply a name and sometimes a brief indication of publication activity and date.

10. Ehrle, *Roma prima,* presents the extant documents relating to the Lafreri succession.

11. Within this corpus, one might argue, there are essentially three types of etchings. The most aesthetically adventuresome are often those made by nonprofessionals, painters or architects who were often gifted draftsmen but had not learned the specialized craft of engraving, and took full advantage of the freedom of the etched line. Some etchings, on the other hand, were made as a way of producing a quick copy without the effort involved in engraving. Finally, others were painstakingly designed to mimic the marks of the engraving technique (more prized in some circles because more difficult).

12. Their composition has been studied by Parshall in "Antonio Lafreri's *Speculum Romanae Magnificentiae.*"

13. Unlike, for instance, the Ashby volume at the Vatican, BAV Stampe VI.2. The Chicago *Speculum* has been disbound and reordered. Bates Lowry numbered the prints when he began work on them. Graduate students Marc Gartler and Rainbow Porthé have inventoried a substantial subset of the manuscript numbers on the versos of the prints, but it has not yet been possible to determine how these might relate to Lowry's, and when the other numbers were added. Several of the blue numbers certainly do not correspond to Lowry's (e.g., blue number 312 on Chicago Speculum Number C742, where 312 in Lowry's article corresponds to C792). Large blue pencil numbers and large and small graphite pencil numbers (sometimes close to the blue numbers, sometimes not) appear on the verso of many of the prints, and the relationship among the numbers is not obvious. Lowry describes four bound volumes, produced in the nineteenth century (perhaps by S. Calvary Co.) and organized loosely by subject matter: "*I Roma antiqua 1. Architectura,* 126 (128) pages, 170 (172?) engravings; *II Roma antiqua 2. Sculptura. Pictura,* 179 pages, 434 engravings; *III Roma nova. Icones region. Ornamenta. Sculpturae,* 222 pages, 236 engravings; *IV Roma nova 2. Icon. Personar. Oper Pictor. Vita Romana,* 97 pages, 156 engravings. The contents are not quite so clearly separated as the titles might indicate." Lowry, 47n11. Despite the confusing and often conflicting information represented by the pencil numbering systems, it is possible to surmise from the blue numbers that some print series that contained views of architectural monuments (specifically Cock, Dosio, and Dupérac) were at some point taken apart and redistributed in order to classify prints according to subject matter. Thus images of the Pantheon from Lafreri, Dosio, and Dupérac appear close in number.

14. One example is the privilege granted to Michele Tramezzino for the engraving of the Circus Flaminius by Nicolas Béatrizet: "Iulii III Pont Max Et Senat Venet Privilegio Cautum Est Ne quis praeter Michaelem Tramezinum Intra Proximum Decennium Hanc Circi Flaminii Formam Imprimat Sive Ab Aliis Excussam Impressamque Vendat Cal Mart MDLIII." BAV volume Cicognara XII. 3886, fol. 30. See Lisa Pon, *Raphael, Dürer, and Marcantonio Raimondi: Copying and the Italian Renaissance Print* (New Haven: Yale University Press, 2004); Eckhard Leuschner, "The Papal Printing Privilege," *Print Quarterly* 15, 4 (1998): 359–70; and Christopher L. C. E. Witcombe, *Copyright in the Renaissance: Prints and the Privilegio in Sixteenth-Century Venice and Rome* (Leiden; Boston: Brill, 2004).

15. Vasari speaks of prints that are "badly done through the greed of printers, drawn more to profit than to honor" ("mal condotte dall'ingordigia degli stampadori, tirati piu dal guadagno, che dall'honore."), Giorgio Vasari, *Le vite de' piu eccellenti pittori, scultori, e architettori. . .* (Florence: Appresso i Giunti, 1568), 307. He also complains about the proto-industrial production Lafreri used, hiring large

numbers of engravers and "reducing everything in the worst manner," 307–08.

16. Gian Ludovico Masetti Zannini, "Rivalità e lavoro di incisori nelle botteghe Lafréry-Duchet e de la Vacherie," in *Les Fondations nationales dans la Rome pontificale* (Rome: Académie de France, 1981), 547–66. Zannini is citing the case "Romana suffocationis. Contra Michaelem Angelum incisorem et complices" in A.S.R. (Archivio di Stato di Roma) Tribunale Criminale del Governatore, *Costituti*, v. 255 (1577). The case is discussed in Parshall, "Antonio Lafreri's *Speculum Romanae Magnificentiae*," and a forthcoming book by Christopher Witcombe.

17. "Io puoi sono andato girando con la fantasia e mi son imaginato che questo sia stato un assasinamento fatto alla bottega, la qual è invidiata da alcuni de l'arte," Zannini, 562. Other testimony mentions envy: "lui . . . ha portato odio e invidia alla nostra botega. . . . Quelli. . . si sono mostrati invidiosi a nostra botega. . ." (both 563).

18. Egidio Fiammingo testified that "messer Geronimo fosse stato ammazzato per invidia per star lui in botega di messer Claudio, perché quella botega è invidiata dagl'altri perché veramente quella botega è la più grande di Roma et ha le più belle opere di Roma di quest'arte." Zannini, 560.

19. "anzi era messer Antonio che contrafaceva tutte le stampe nuove de noi altri botegari, perché era un huomo così fatto et havea più il modo di noi altri." Zannini, 555. "Così fatto" is a bit ambiguous, and might refer only to the fact that Lafreri was well established (and thus had the means to hire copyists).

20. Jean-Jacques Boissard, *III pars Romanae vrbis topographiae* (Frankfurt: Theodor de Bry, 1597–1602), 13r.

21. Franciscus Schottus, *Itinerarii Italiae rervmq. Romanarvm libri tres* (Antwerp: Moretus, 1600), 292: "Tabulas aeneas Antiquitatum Romanarum edidere Ant. Lanfrerius, & Ant. Salamanca, augusta forma; minore alii. Tabulas Urbis, Onuphrius Panuinius, Pyrrhus Ligorius Neapolit. Michaël Tramezinus, allique veterem novamque Romam expressere. Statvas Urbis Romae exhibuit N. de Cavalleriis, & Theodor Bry, Leodiens. Cum Io Iacobo Boissardo."

22. John Evelyn, *Sculptura: or, The History and Art of Chalcography, and Engraving in Copper* (London: J. Murray, 1769), 54, "ANTONIO LANFERRI, and TOMASO BARLACCHI graved divers things after Michael Angelo, and procured so many as were almost numberless; but what they published of better use, were divers *grotescos, antiquities,* and peices [sic] serving to *architecture,* taken out of the old buildings and ruins yet extant; which afterwards SEBASTIANO SERLIO refining upon, composed the better part of that excellent book of his: and of this nature are the things published by ANTONIO LABBACO, and BAROZZO DA VIGNOLA." p. 56, "ANTONIO SALAMANCA did put forth *some very good things.*"

23. Onofrio Panvinio, *Onuphrii Panvinii de Triumpho commentarius,* ed. Joachim Johannes Madero (Helmstedt: 1676), 51, addenda, last page.

24. *Horace Walpole's Correspondence with Sir Horace Mann*, vol. 6, ed. W. S. Lewis (New Haven: Yale University Press, 1954) (vol. 22 of *Horace Walpole's Correspondence*). Mann to Walpole, 24 April 1764, 6:229.

25. It may be that these acquisitions include the *Speculum* prints now in the British Museum and/or British Library. Mann to Walpole, 4 December 1762, "Have you heard what a quantity of things have been bought and are buying for the King? Cardinal Albani's collection of drawings and prints were paid 14,000 crowns," 6:107. The *London Chronicle* refers to the acquisition as "collections of the most capital engravings" (*London Chronicle* 18–20 Nov., xii, cited in *Horace Walpole's Correspondence with Sir Horace Mann*, 6:495n12).

26. From the diary of David Lindsay, earl of Crawford [1871–1940], 19 May 1923, in *The Crawford Papers,* ed. John Vincent (Manchester: Manchester University Press, 1984).

27. University of Chicago Archive. University Presidents' Papers, Box 21, Folder 8 (Berlin). August 23, 1891, Simon (Berlin) to Harper (Chicago).

28. Counting small prints mounted on a single sheet, one could argue that there are 1022 prints in the collection. The eclecticism of the Chicago collection is consistent with Columbia's. The Metropolitan Museum's collection, and Thomas Ashby's collection at the Vatican, adheres more closely to Lafreri's production and its content and later echoes. The Ashby volumes preserve a late-nineteenth-, early-twentieth-century approach that groups together many prints produced by different artists and publishers over many centuries because they are depictions of the same monument.

29. Christie, *A Catalogue of the First Part of the Very Valuable and Extensive Collection of Engravings: In the Portfolio of Sir Thomas Lawrence* (London: Christie, 1830), 11 (second day): "152. Twenty—the Loves of the Gods, by Ditto [Caraglius], after Pierino del Vaga and Rosso, several of them unknown to Bartsch, extra rare." Copy exists with ms. note "Colnaghi" next to this item. Yale University, Mudd Library, X348 C46.

30. Personal communication, Alan Fern to Alice Schreyer, January 2006.

31. The finding aid, Department of Special Collections, *A Descriptive Catalogue of Engravings from the University of Chicago Library's Speculum Romanae Magnificentiae* (Chicago: University of Chicago Library, 1973), was the starting point for the digital *Speculum* now being created by Regenstein Library's Digital Library Development Center. Its original compilation was an enormous work of research carried out with great care by library staff—who, though they developed expertise in the process of doing the research, were not art historians.

32. Artists such as Giovanni Antonio Dosio also made drawings directly from prints. Dosio's drawing of the relief of the Triumph of Marcus Aurelius (Berlin sketchbook. f. 45, plate LVIII of facsimile) is a drawing of the triumph of Marcus Aurelius, which greatly resembles the Lafreri

print; in the same sketchbook he notes that he has copied another image "da un disegnio ch'era in un libro del salama(n)ca, el qual disegnio era stato ritratto da u(n) basso rilievo di stucchi nell'a(n)toniana," f.43.

33. Peter Parshall and Rainer Schoch, *Origins of European Printmaking: Fifteenth-Century Woodcuts and Their Public* (exh. cat.) (Washington, DC: National Gallery of Art, 2005).

34. These include one at the Fogg Museum that contains a selection of ornament prints, many of them published by Salamanca (Selection of 16th century prints, M26624). For the reference and for assistance in viewing the album I wish to thank Susan Dackerman and Suzanne Karr-Schmidt. For the print collection at Schloss Ambras, see Peter Parshall, "The Print Collection of Ferdinand, Archduke of Tyrol," *Jahrbuch der Kunsthistorischen Sammlungen in Wien* 78 (1982): 139–84. For a mid-sixteenth-century album at the British Library [C.46.k.1(1)], which contains many prints of ruins and antiquities along with van Heemskerck's *Victories of Charles V,* see Antony Griffiths and Anne Puetz, "An Album of Prints c. 1560 in the British Library," *Print Quarterly* 13, 1 (1996): 3–9. For an album in Philip II's collection see Mark P. McDonald, "The Print Collection of Philip II at the Escorial," *Print Quarterly* 15 (1998): 15–35. For a major dispersed but inventoried Renaissance collection see also McDonald, *The Print Collection of Ferdinand Columbus (1488–1539): A Renaissance Collector in Seville* (London: British Museum Press, 2004). The Burndy Collection now at the Huntington Library (currently being catalogued) contains two eighteenth-century albums, numbered 27697 and 27698, which contain prints by Nicolaus van Aelst, Béatrizet, and Enea Vico. I thank Ben Weiss for this information.

35. These include twelve military trophies by Enea Vico (some signed Lafreri); Michelangelo's designs for St Peter's, engraved by Dupérac (the side view, section, and plan); a close-up of the same (Vincenzo Luccini, 1564);

the Theater of Marcellus, the Arch of Vespasian (Lafreri, 1548); Trajan's column (Salamanca); the two scroll designs by Diana Mantovana discussed in my essay; the Tomb of Constantia (Lafreri, 1553); a large Farnese bull ("Eugenius Blancus Placent. . . s, disegnauit. C.R.F.," 1579); the Tomb of Julius II (Salamanca, 1554).

36. See Thomas Ashby, "Antiquae Statuae Urbis Romae," *Papers of the British School at Rome* 9, 5 (1910): 127, and Ehrle, 10n9.

37. Catalogued as Pietro Ferrerio, *Palazzi di Roma de piv celebri architetti* (Rome: Giovanni Giacomo de' Rossi, n.d.).

38. Deseine's *Description of New and Old Rome,* especially in the large-scale 1704 Dutch edition, includes numerous copies of other prints. Deseine gives a somewhat contradictory but revelatory account of the sources of images in his preface to the second French edition, which already contains a series of clever images. This edition is endowed with figures, he writes, "to illuminate the descriptions and make them more comprehensible. The Antiquities are represented in their natural state, and engraved from drawings made right on site, of which many are borrowed from the beautiful and very faithful Prints of the famous *Jacopo Lauro* and the famous *Filippo de' Rossi,* both from *Rome,* where they published their works." unpaginated "Avis de l'auteur": "à éclaircir & à faire mieux comprendre les Descriptions. Les Antiquitez sont représentées au naturel, & gravées sur les desseins qui ont été faits sur les lieux mêmes; dont un bon nombre sont empruntées des belles & très fidéles Estampes du célébre *Jacobus Laurus* & le fameux *Filippo de Rozzi,* tous deux de *Rome,* où ils ont publié leurs ouvrages." The Dutch edition, product of work by many artists, is an imaginative and multilayered compilation of images, with self-conscious artifice and framing. Incorporated copies include rather recherché images like Willem van Nieuwlandt's drawing of the Arch of Septimius Severus and the plan of the ancient Capitoline Hill from Donati's *Roma vetus ac recens.*

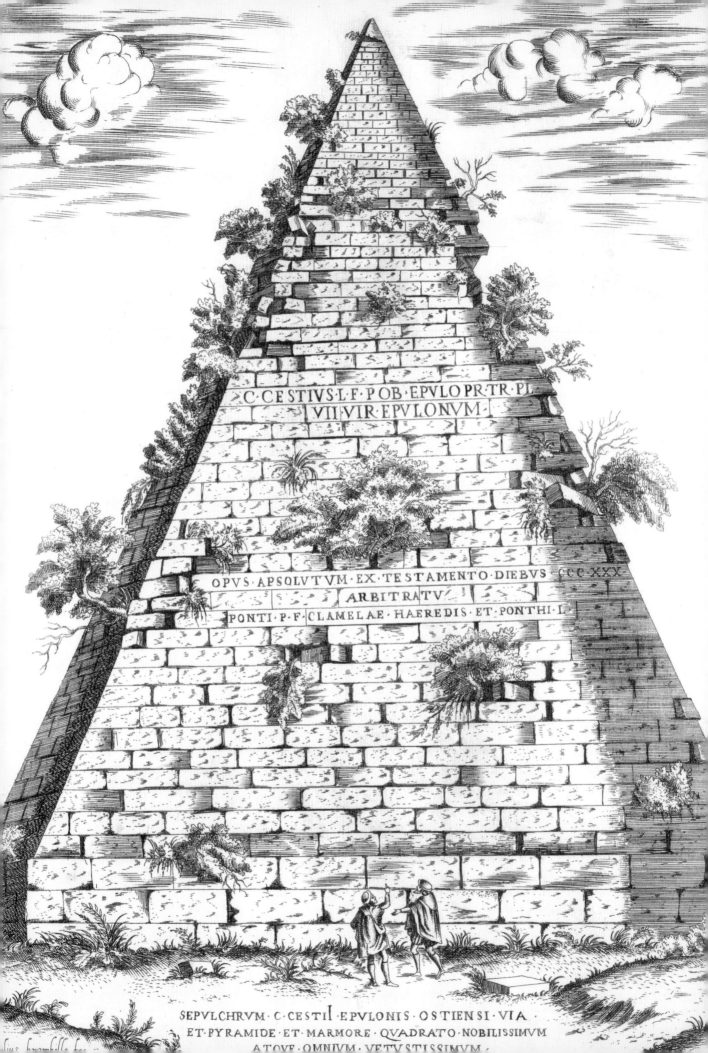

C·CESTIVS·L·F·POB·EPVLO·PR·TR·PL
VII·VIR·EPVLONVM

OPVS·APSOLVTVM·EX·TESTAMENTO·DIEBVS·CCCXXX
ARBITRATV
PONTI·P·F·CLAMELAE·HAEREDIS·ET·PONTHI·L

SEPVLCHRVM·C·CESTII·EPVLONIS·OSTIENSI·VIA
ET·PYRAMIDE·ET·MARMORE·QVADRATO·NOBILISSIMVM
ATQVE·OMNIVM·VETVSTISSIMVM

BIRTE RUBACH

THREE PRINTS OF INSCRIPTIONS— ANTONIO LAFRERI AND HIS CONTACT WITH JEAN MATAL

WHEN CONSIDERING Antonio Lafreri and the *Speculum Romanae Magnificentiae,* our mind's eye opens upon a number of pictures of the greatest and most important creations of architecture and sculpture of Roman antiquity and the Renaissance: buildings such as the Colosseum, the Pantheon, the triumphal arches for the emperors, triumphal columns and temples, palaces of the Renaissance and St. Peter's, or sculptures such as the Laocoön, the Apollo Belvedere, and the Farnese Hercules. It is above all these monuments—which have long since become tourist attractions—that we have in mind when we think about the activities of the print publisher Antonio Lafreri. But anyone who leafs through a *Speculum* album may be puzzled by the presence of certain prints of apparently obscure Roman inscriptions.

In what follows I will discuss three engravings of epigraphical remains that represent less popular motifs for the wider public but were of high interest for antiquarians in the middle of the 16th century. These prints present high-quality scholarly information. I will show that it was contact with the lawyer and collector of inscriptions Jean Matal and his circle that influenced Lafreri to incorporate such motifs in his program of Roman prints. I will argue that Lafreri's choice of subjects for his prints was driven not only by his desire

for profit, but also by his ambition to present up-to-date and correct antiquarian information.

During the first years of his career, Antonio Lafreri patterned his business on the ventures of more experienced publishers such as Antonio Salamanca, who had compiled a broad range of works by purchasing older plates and having new ones made depicting Roman subject matter.[1]

The dated prints of Lafreri's workshop indicate that during his first years Lafreri also focused his print production on Roman motifs.[2] Lafreri often took inspiration for his works—both in content and in formal aspects—from the prints of the older and more experienced Salamanca; Salamanca, too, showed interest in the works of the newcomer and used them in his depictions.[3]

The motifs that both publishers chose for their prints of Rome initially belonged to the extensive repertory of ancient and modern monumental architecture and colossal sculptures. At the beginning of the 1550s, Lafreri issued three prints bearing a prominent inscription. These prints share a common subject matter and thematic approach that break from Salamanca's practice of representing well-known sights. The inscriptions reproduced by Lafreri in the prints of the *Tomb of Publius Varius Marianus* [FIGURE 5], *Tomb of Antonius Antius Lupus*

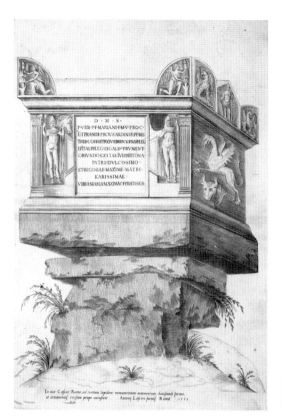

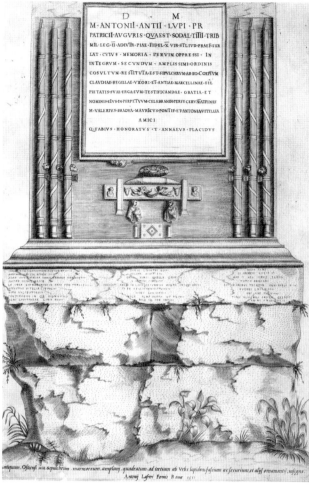

FIGURE 5

Anonymous. *Sepulchre of P. Vibius Marianus.* Engraving, 1551.
Antonio Lafreri, publisher.

FIGURE 6

Anonymous. *Sepulchre of M. Antonius Antius Lupus.*
Engraving, 1551. Antonio Lafreri, publisher.

[FIGURE 6], and *Funeral relief of M. Pompeius Asper*
[FIGURE 7] caught the interest of epigraphical and
antiquarian scholars occupied in the same period with
intensive studies of inscriptions. As I will discuss next,
the contact between Antonio Lafreri and Jean Matal
(ca. 1517–1597) is documented in three instances. I will
argue that Matal's studies or those of his circle influenced
Lafreri's print production in the case of the three
aforementioned tomb engravings in particular.

The Circle of Jean Matal

The lawyer Jean Matal, born in the Franche-Comté, had
come to Rome in 1545 with the retinue of the Spanish
lawyer and humanist Antonio Agustín (1517–1586).[4] As
early as 1538, when they met in Bologna, Matal assisted
Agustín with his research in Roman law.[5] In Rome
Matal soon turned his interest from the intense study of

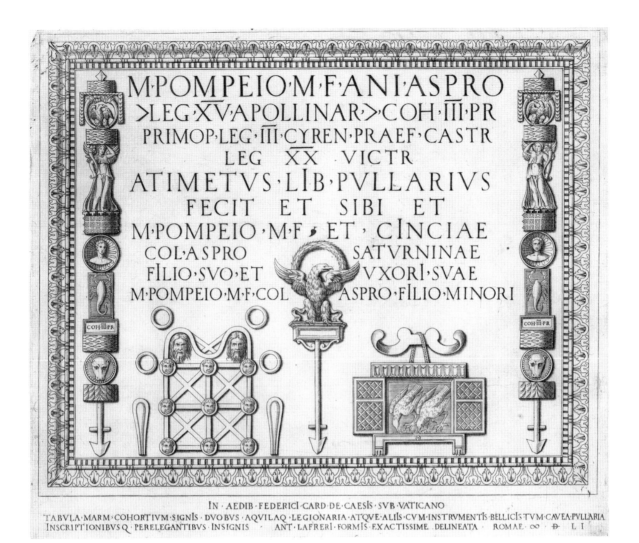

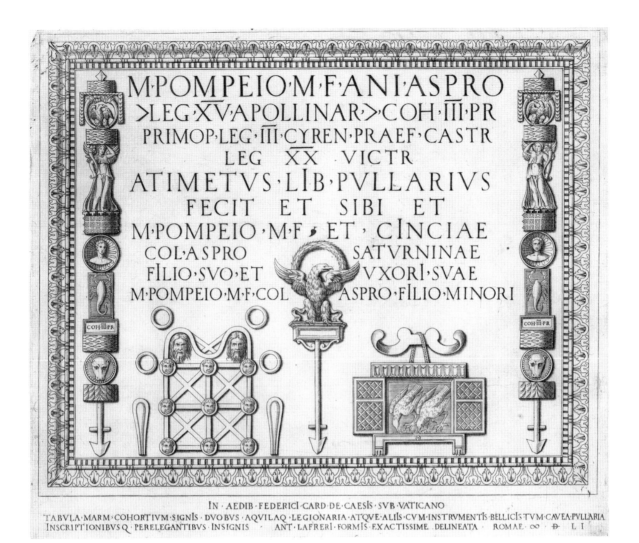

MPOMPEIO·M·F·ANI·ASPRO
>LEG·XV·APOLLINAR·>·COH·IIII·PR
PRIMOP·LEG·III·CYREN·PRAEF·CASTR
LEG XX VICTR
ATIMETVS·LIB·PVLLARIVS
FECIT ET SIBI ET
M·POMPEIO·M·F·ET·CINCIAE
COL·ASPRO SATVRNINAE
FILIO·SVO·ET VXORI·SVAE
M·POMPEIO·M·F·COL ASPRO·FILIO·MINORI

IN·AEDIB·FEDERICI·CARD·DE·CAESIS·SVB·VATICANO
TABVLA·MARM·COHORTIVM·SIGNIS··DVOBVS·AQVILAQ·LEGIONARIA·ATQVE·ALIIS·CVM·INSTRVMENTIS·BELLICIS·TVM·CAVEA·PVLLARIA
INSCRIPTIONIBVSQ·PERELEGANTIBVS·INSIGNIS··ANT·LAFRERI·FORMIS·EXACTISSIME·DELINEATA··ROMAE·∞·Ð·LI·

FIGURE 7

Anonymous. *Funeral relief of M. Pomponius Asper.* Engraving, 1551. Antonio Lafreri, publisher.

manuscripts to inscriptions and from 1546 on he dealt exclusively with epigraphical matters.[6]

Inscriptions were valued as historical, literary, or linguistic documents as early as the second half of the fourteenth century and were transcribed in many compilations, which were then published in the fifteenth century onward.[7] Fra Giovanni Giocondo (1443–1515) first introduced a systematical approach to the study of epigraphy. Later, Andrea Alciati's (1492–1550) collection, produced over his lifetime, in which inscriptions were commented on and accompanied by drawings of the monuments on which they appeared, introduced a historical perspective to the study of epigraphy and enabled the inscription to be interpreted with the aid of documentation from its monumental context.[8] Antiquarian

studies developed from the initial recording and surveying of antique art and monuments to encompass their historical understanding as well. Agustín and Matal, both disciples of Alciati, were conscious of the importance of epigraphic and numismatic research for the interpretation of antique juridical texts: only by knowing the context of their origin and development could the ancient sources be judged and appraised correctly.[9] Therefore, only with the aid of inscriptions, medals, and coins could the institutional hierarchies of the political system and the social structures of private life during the antiquity best be explored. At that point the interests of the two lawyers Agustín and Matal matched the ambitions of antiquarian scholars in other disciplines. In the 1530s many like-minded individuals joined the sphere of

the cardinals Bernardino Maffei and Marcello Cervini, later Pope Marcello II (1555), to revive the tradition of Pomponio Leto's (1427–1498) and Andrea Colocci's (1474–1549) humanist scholarly circle, the *Accademia Romana,* in the so-called Vitruvian academy or *Accademia della virtù.*[10] In 1542 Claudio Tolomei (1492–1556), leader of the daily meetings, prepared a programmatic letter delineating the projects of the academy, namely, the publication of twenty scientific books, eight on Vitruvius's *De architectura,* and others on Roman topography, monuments, sculpture, inscriptions, painting, and coins. Aside from its sheer size, the distinctiveness of the endeavor was characterized by its goal not only to compile a corpus of several objects of art, but also to understand their meaning by critically classifying the works' form and style.[11] The academy dissolved the same year that Matal came to Rome.[12] This occurrence, however, did not put the studies of the former members (such as Luis de Lucena or Guillaume Philandrier) to an end, for other scholars such as Stephen Pigge (Pighius), Martin Smet (Smetius), and Antoine Morillon enriched the circle, which now held its meetings in the Garden of Cardinal Rodolfo Pio da Carpi on the Quirinal hill. Matal and Agustín soon came into contact with this group, in which humanists, antiquarians, physicians, and artists from Flanders, Spain, France, and Italy addressed similar scholarly interests to theirs. Most likely inspired by the variety of studies in that renowned circle, and convinced of the usefulness of their results for his own law research, Matal started his own comprehensive collection of inscriptions, considered pioneering for all later *syllogai.*[13] The older collection of inscriptions by Jacopo Mazochi, *Epigrammata antiqua urbis* (1521), formed Matal's starting point. At the time, the scholarly community raised the awareness of regional differences in spelling and of letter-forms as a dating criterion for epigraphical text. Thus, in his own copies Matal corrected false transcriptions, eliminated invented ornaments, and added more information.[14] Scholars and friends from all regions of Italy, France, and the Roman Empire supported Matal's research by sending him more transcriptions, which he assembled in other notebooks,[15] and in Rome a fertile exchange of epigraphical research occurred within the circle of scholars around Cardinal Pio da Carpi. Matal always recorded in his notations the name of the person who transmitted the inscription. Foremost among these names can be found those of his compatriots, Frenchmen and Flemings such as Pierre Varondel, Guillaume Philandrier, Antoine Morillon, Louis Boudé, Simon de Vallembert, and

Martin Smet. Stephen Pigge, Pirro Ligorio, and Onofrio Panvinio also exchanged their transcriptions with Matal. Although Matal's work was never published, the collective epigraphical studies and discussions on paleography, datings, and falsifications laid the foundations for subsequent works, some of which were published by Ligorio, Panvinio, Smet, and Pighius.[16]

The Association Between Jean Matal and Antonio Lafreri

Antonius Lafrerius una cum pictore quodam Flandro, et Varondello, descripsimus ex ipso saxa, et pinximus: ∞ DLVIII Martio[17]

This note appears at the end of a very detailed description of an antique sarcophagus in one of Matal's manuscripts, now in the Vatican Library. It documents the excursion Antonio Lafreri and Jean Matal, their compatriot Pierre Varondel, and an anonymous Flemish painter undertook in March 1548 to the *tomba di Nerone,* the tomb of Publius Vibius Marianus, located on the *via Cassia,* one of the roads coming from the north and leading into the eternal city [FIGURE 8].

Like Jean Matal and Pierre Varondel, Antonio Lafreri came from the Franche-Comté. Nothing has been documented on Lafreri's education or training before his arrival in Rome. The first notice of his presence and activity in Rome is given by three prints published with his address, *Antonio Lafreri Sequani Formis Romae 1544.*[18] How Lafreri and Matal first met each other is not known either. Both men came from the dioceses of Besançon and were about the same age when they met in Rome.[19] It cannot be ruled out that they had known each other previously, but their association is first documented by their excursion in March 1548. It is, however, unlikely that Lafreri contributed to Matal's collection of inscriptions, because Lafreri's name—except in the case of the note at the end of the sarcophagus description, cited above—never occurs next to a transcription as the names of other collaborators do.[20]

Nevertheless, it was Lafreri who introduced Matal to the French antiquarian Guillaume Duchoul, otherwise known as Le Bailly de Montaignes, who was living in Lyon and by that means initiated their scientific interchange. One of Matal's notebooks contains a letter dated the eleventh of April, 1548, that indicates that Duchoul was apprised of Matal's project by Lafreri

FIGURE 8

Tomb of Publius Vibius Marianus, Rome.

FIGURE 9

"Squeeze" in Jean Matal notebook, Rome, Biblioteca
Apostolica Vaticana, ms. Vat. Lat. 6034, f. 6–7.
With permission.

and subsequently had sent Matal some of his own transcribed inscriptions.[21]

A very concrete and completely different sort of collaboration between Matal and Lafreri is documented in another passage of Matal's notebook. Matal describes how Lafreri took an imprint of an inscription engraved on a bronze plate [FIGURE 9].[22] Matal details the working process Lafreri undertook to make the hardly legible lines visible. The description appears on the back of the imprint, which Matal had bound within his other papers. Because the bronze plate was bent too much, Lafreri could not run it under the press. In order to remedy this situation, Lafreri placed the plate atop a pile of sand, filled the engraved letters with ink, put a sheet of paper on top of the plate, and spread yet more sand over the sheet. The weight of the sand lying upon the plate and the flexibility and malleability of the sand beneath it enabled a successful print from the bent plate. He placed the still-wet paper under the printer's press and made a reversed counterproof that would finally produce a legible version.[23]

Different techniques to make such "squeezes" of barely legible inscriptions seem to have been experimented with this time. Agustín described a procedure similar to Lafreri's in his notebook, where he experimented with oil instead of ink.[24] The method that Matal described and that generated a legible print of an inscription could be executed only in a printer's workshop. One can assume that Matal had found in his compatriot Lafreri a sympathetic collaborator. Lafreri had the equipment and technical skills as well as the insight and patience to develop innovative ideas to support the inscription collector's special needs.

The trip together to the via Cassia, the introduction of Matal to Duchoul by Lafreri, and the practical collaboration in making the imprint from the bent bronze plate provide concrete evidence for close contact between Lafreri and Matal. That their contacts had a certain influence on Lafreri's activities does not seem very surprising and can be explored on the basis of the three aforementioned engravings of inscriptions.

The Influence of Epigraphical Studies on Lafreri's Prints

The engraving *Tomb of Publius Vibius Marianus* [FIGURE 5] shows a sarcophagus positioned on top of four layered slabs. In contrast to the crumbling layers through whose

gaps weeds are growing, the sarcophagus is in an almost perfectly preserved condition. The inscription on the front is flanked by the two *dioscuri*. The horse head next to the left youth remains intact, whereas the one near the right youth is no longer extant. Corinthian pilasters stand at each outer edge. Winged victories are also shown writing on the exterior shield of a trophy. The two side faces of the sarcophagus are decorated with reliefs as well. The print shows one foreshortened side, with a bull's head and a griffin; an armed warrior and two eagles fighting snakes are depicted in the upper register of this right-hand side.

The print illustrates the monument that Lafreri and Matal visited on their trip to *via Cassia* in March 1548. Only two other sixteenth-century drawings documenting this tomb exist: a drawing of the Codex Destailleur at the Hermitage in St. Petersburg is a study of one of the winged victories; in the second known drawing, Pirro Ligorio's record of the whole monument fell short of the accuracy of Lafreri's print.[25] This engraving was issued in 1551, thus the publication did not directly follow Lafreri and Matal's excursion to the monument. However, together with the detailed description and transcription in Matal's notebook, the connection still remains very probable.

The engraving *Tomb of Antonius Antius Lupus* [FIGURE 6] exhibits strong formal similarities with the aforementioned print of the sarcophagus. Besides the two-zone composition of the monument, both prints possess characteristics of a *veduta*, evoked by the vegetation and the dilapidation of the monument's base, and bear a similar version of Lafreri's address and the year in their inscription. The monument is represented not three-dimensionally but in a frontal view: on the base, composed of four rough-hewn blocks and a plinth, sits a square marble tablet. Three fasces or bundles of rods decorated with animal heads and small axes run vertically up on either side of a smaller square bearing a Latin inscription. Beneath the inscription tablet are placed more figurative elements: under the frame of the tablet is a scepter with a bust, while further below is depicted a decorated *sella curulis* or magistral chair with a cushion and a crown on top of it.[26] This funeral monument that was located on the via Ostiense until it was demolished in the seventeenth century had been integrated into collections of inscriptions since Niccolò Signorili began this practice in the fifteenth century. The tomb is also documented in the early-sixteenth-century drawings of Giuliano and

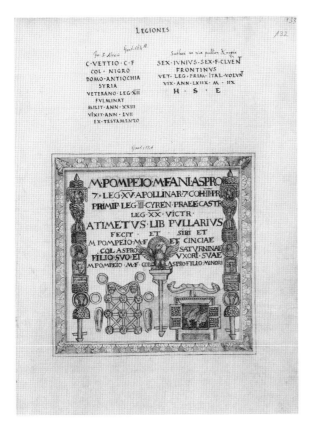

FIGURE 10

Codex Pighianus. Berlin, Staatsbibliothek zu Berlin –
Preußischer Kulturbesitz, Ms. lat. fol. 61, f. 132r.
With permission.

FIGURE 11

Jean Matal (notebook), Rome, Biblioteca Apostolica Vaticana,
ms. Vat. Lat. 6039, f. 219 (22 new). With permission.

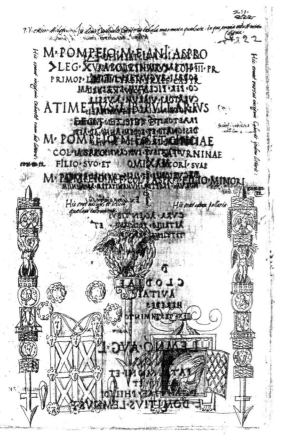

Antonio da Sangallo the Younger.[27] Baldassare Peruzzi,
too, was more interested in the architectural form of the
tomb and its decorative reliefs than the inscription, hardly
mentioned by these previous students of the monu-
ment.[28] At this early point, according to the drawings,
on top of the tomb a special crowning gable could be
detected, which no longer existed in 1551, when Lafreri's
print was made. A drawing in the Codex Coburgensis
shows the tablet with the inscription and reliefs but
without the base represented in the print.[29] In com-
paring the print with the drawing, we must classify some
discrepancies in the print as misunderstandings that
occurred during the transfer of the image to the copper
plate: the crown of oak leaves is clearly discerned in the
drawing, whereas in the print some sort of oak leaves are
discerned but a crown is no longer visible. An even more
evident visual discrepancy is the incorrect position of the
sceptre, which in the drawing reposes on the crown but
in the print seems fixed above on the tablet framing.
Compared with Matal's emendations of the image in his
copy of Mazochi's *Epigrammata,* the inscription in the
Codex Coburgensis is partially incorrect while the
inscription in the engraving accurately reflects Matal's
corrections concerning, in particular, the style of the
letter-forms.[30] Next to the inscription, Matal noted both
his name and the names of his collaborators, as well as
the date 1550, the year he added the emendations.

The engraving *Funeral Relief of M. Pompeius Asper*
[FIGURE 7] shows a rectangular tablet with a Latin
inscription that is framed by elaborate enrichments: a
lesbian cymation or leaf and dart patterned band is
followed by a bead and reel band and a dentil band. On
either side of the face of the tablet, a *signum* of the third
cohort runs up the entire height; the eagle sign of the
legion in the central axis travels from the lower border
to the middle of the tablet. Some military signs of honor
are placed to the left of the legion sign: around the
representation of a pectoral decoration (*phalerae*) are
grouped four bangles (*armillae*) and two leg splints. To

FIGURE 12

Ambrogio Brambilla (etcher). *Pyramid of Caius Cestius.*
Etching with engraving, 1582. After an engraving published
by Antonio Lafreri in 1547. Claudio Duchetti, publisher.
CAT. A33.

FIGURE 13

Anonymous. *Sepulchre of Metella.* Engraving, 1549. Antonio
Lafreri, publisher; republished by Hendrick van Schoel
after 1602.

two chickens. In this instance, the additional inscription
under the relief and Lafreri's address is unlike the afore-
mentioned inscription, which was written in majuscules,
although its year of publication is also 1551. In this print
only the plate of the relief without any indication of the
geographical origin of the inscription is represented. The
location could not be ascertained because the work was
housed in the palace of Cardinal Federico Cesi. The
print is the first document locating the inscription,
already known since the fifteenth century in the Palazzo
Massimi in Grottaferrata, at Cesi's palace.[31] Since around
1600 it has been housed in the Palazzo del Drago
(Palazzo Albani alle Quattro Fontane) in Rome.
Drawings of the tablet have been preserved in the
sketchbook of the circle of Giovanantonio Dosio in
Florence, in the Codex Coburgensis as well as in the
Codex Pighianus in Berlin [FIGURE 10].[32] The anony-
mous draftsman of the Sienese sketchbook was interested
only in the military emblems on the monument and
made several studies on different folios.[33] Likewise in
Matal's notebook, a skilful drawing of the figurative
reliefs is preserved beneath the transcription of the
inscription [FIGURE 11].[34] The drawing, however, erro-
neously represents the bangles as wreaths. In compari-
son with the Lafreri print, the drawings in the Codices
Coburgensis and Pighianus demonstrate a closer adher-

Coburgensis and Pighianus demonstrate a closer adherence to the original image.[35] The inscription is treated with more care in the engraving, so that no error occurs in the transcription of the letters. Furthermore, the print equalizes the somewhat dense ensemble of writing and decoration, particularly in the area of the legion eagle, and the better proportions create a more harmonic ornamental impression of the whole composition.

The three engravings published by Lafreri in 1551 mark a new episode within his production of prints of Rome. Lafreri chose to represent monuments whose main feature was the intact inscription, and he represented them in an aesthetically appealing way.

On the one hand, the depictions in the three engravings are connected to those of other funeral monuments like the pyramid of Cestius [FIGURE 12, CAT. A33] or the tomb of Cecilia Metella [FIGURE 13], particularly in the case of the Publius Vibius Marianus and Antonius Antius Lupus prints, which still adhere to the *veduta* manner of the earlier prints. On the other hand, the funeral monuments of Cecilia Metella and the emperor Cestius became well-known sights not because of the inscriptions they bear, but because of their special form, size, and importance. In the picturesque representations of Cestius's pyramid and Cecilia Metella's tomb published by Lafreri in 1549, the artist highlighted the visible traces of time's effects on the monument and the surrounding landscape; the scene was enhanced by inserted figures admiring the monument. In the prints of the tombs of Publius Vibius Marianus and Antonius

Antius Lupus, figures are no longer present. Finally, in the print of the relief of Pompeius Asper, the tablet is reproduced isolated from its surroundings as an independent fact rather than a viewed artifact.

The inscriptions on these monuments were entirely preserved at the time the print was produced and at times their transcriptions in the prints were treated with more care than the figural reliefs, as has been demonstrated by the strange position of the sceptre in the *Antonius Antius Lupus* print. Lafreri's criteria for the selection of a motif from a myriad of possibilities seems to have been based on the good condition of the inscription and its usability in terms of a congenial pictorial composition.

It cannot be said in what way Lafreri made direct use of Matal's notations, but a connection is undoubtedly conceivable, taking into consideration the correlations of Matal's emendations with, for example, the inscription in the print of the tomb of Antonius Antius Lupus. However, the only drawing in Matal's notebook of the relief of Pompeius Asper was not the model for Lafreri's print.

What is certain is that that the subjects Matal and the epigraphical scholars of the period dealt with found their visual realization in the print production of Antonio Lafreri; Lafreri's three prints of Latin inscriptions issued in 1551 not only mark a change in the range of Lafreri's Roman topographical prints, but also rank today among the most faithful sources for the epigraphical research of his era.

NOTES

I thank David Greenaway, Iva Olah, and Mike Phillips for correcting my English.

1. For Antonio Salamanca, see Sylvie Deswarte-Rosa, "Les gravures de monuments antiques d'Antonio Salamanca à l'origine du *Speculum romanae magnificentiae*," *Annali di Architettura* 1 (1989): 47–62; David Landau and Peter Parshall, *The Renaissance Print 1470–1550* (New Haven: Yale University Press, 1994), 302–09; Valeria Pagani, "Documents on Antonio Salamanca," *Print Quarterly* 17, 2 (2000): 148–55.

2. For Antonio Lafreri, see note 2 in the introduction.

3. For Lafreri's copies of Salamanca, see Christian Hülsen, "Das Speculum Romanae Magnificentiae des Antonio Lafréri," in *Collectanea variae doctrinae Leoni S. Olschki* (Munich: J. Rosenthal, 1921), and Deswarte-Rosa; for Salamanca's copies of Lafreri, see Michael Bury, *The Print in Italy 1550–1620* (exh. cat.) (London: British Museum, 2001), 122, 141, cat. 89.

4. Peter Arnold Heuser, *Jean Matal: Humanistischer Jurist und europäischer Friedensdenker (um 1517–1597)* (Cologne/Weimar/Vienna: Böhlau, 2003), 84, 89.

5. Heuser, 61–88; Anthony Hobsen, "The *iter italicum* of Jean Matal," in *Studies in the Book Trade: In Honour of Graham Pollard,* ed. Richard William Hunt et al. (Oxford: Oxford University Press, 1975), 33–61. A project they finished together before moving to Rome was an edition with

commentary on the Codex Pisanus, the Florentine manuscript of the sixth-century digests (*Emendationum et opinionum libri IV*, Venice 1543). Agustín's next big projects were commentaries to the Roman as well as the canonical law; see Heuser, 90–91.

6. Richard Cooper, "Epigraphical Research in Rome in the Mid-Sixteenth Century: The Papers of Antonio Agustín and Jean Matal," in *Antonio Agustín between Renaissance and Counter-Reform,* ed. Michael H. Crawford (London: Warburg Institute, 1993), 95–111, here p. 97.

7. Roberto Weiss, *The Renaissance Discovery of Classical Antiquity* (Oxford: Blackwell, 1969), 154–66.

8. William Stenhouse, *Reading Inscriptions and Writing Ancient History: Historical Scholarship in the Late Renaissance* (London: Institute of Classical Studies, University of London School of Advanced Study, 2005), 28.

9. Heuser, 91; Stenhouse, 14–15.

10. Stenhouse, 34; Margaret Daly Davis, "Zum Codex Coburgensis: frühe Archäologie und Humanismus im Kreis des Marcello Cervini," in *Antikenzeichnung und Antikenstudium in Renaissance und Frühbarock*, ed. Richard Harprath and Henning Wrede (Akten des internationalen Symposions 8–10, September 1986 in Coburg) (Mainz: Philipp von Zabern, 1989), 185–99; Henning Wrede and Richard Harprath, *Der Codex Coburgensis: Das erste systematische Archäologiebuch. Römische Antiken-Nachzeichnungen aus der Mitte des 16. Jahrhunderts* (exh. cat.) (Coburg: Kunstsammlungen der Veste Coburg, 1986).

11. Wrede and Harprath, 190–94. In the famous letter to Leo X, prepared by Raphael with the help of Baldassare Castiglione and Angelo Colocci, the scientific method of modern archaeology had already been formulated. (For the authors of the letter, see Ingrid Rowland, "Raphael, Angelo Colocci and the Genesis of Architectural Orders," *The Art Bulletin* 76 (1994): 81–104.) By confronting form and style Raphael was able to identify the reliefs of the Arch of Constantine, which are not from Constantine's times, as *spolia* and to assign them to the period of their origin (except for the Hadrianic works); see Arnold Nesselrath, "Raphael's Archaeological Method," in *Raffaello a Roma: Atti del Convengno del 1983* (Rome: Edizioni dell'Elefante, 1986), 357–71, here, p. 364–65.

12. Only a few works that can be assigned to the circle of the academy have been realized. Besides the *Annotationes* (1544) to Vitruvius by Guillaume Philandrier, the connection to the academy for works such as the second edition of Bartolomeo Marliani's *Urbis Romae topographia* (1544) or the Codex Coburgensis is controversial, see Daly Davis, "Zum Codex Coburgensis"; Margaret Daly Davis, *Archäologie der Antike 1500–1700 aus den Beständen der Herzog August Bibliothek* (cat.) (Wiesbaden: Harrassowitz, 1994), 11–16; Heuser, 110–23.

13. Cooper, 107; Heuser, 99–100; Stenhouse, 44–46.

14. Today Matal's copy of the *Epigrammata* is in the Vatican Library in Rome (BAV, Vat. Lat. 8495); see also Cooper,

95–111, and Michael H. Crawford, "Appendix II: The Epigraphical Manuscripts of Jean Matal," in Crawford, *Antonio Augustín*, 279–89, here p. 279.

15. The notebooks, too, were kept in the Vatican Library (BAV, Vat. Lat. 6034, 6037–6040), see also Crawford, 279–89.

16. Stenhouse, 45.

17. Rome, BAV, Vat. Lat. 6039, f. 245r (41 new).

18. These are: *Sacrifice and Death of Abel* (Adam von Bartsch, *Le peintre graveur* (Vienna: J.V. Deggin, 1803–1821), 15:9, no. 4), *Birth of Adonis* (Bartsch, 15:42, no. 12), and *Trajan's Column* (Hülsen, no. 30).

19. Lafreri's year of birth is not known. Without proof the years 1510 and 1512 are cited, see Jean-Pierre Baverel and François Malpé, *Notices sur les graveurs qui nous ont laissé des estampes marquées de monogrammes, chiffres, rébus, lettre initiales, etc.* (Besançon: Taulin-Dessirier, 1807/1809); Giorgio Vasari, *Le vite de' più eccellenti pittori, scultori ed architettori*, ed. Gaetano Milanesi (Firenze: G.C. Sansoni, 1906), 5:430n5. In some notarial acts from October and November 1577 Lafreri is called "il vecchio" so one can assume that he had reached a certain age by the time of his death on 20th of June 1577 and a year of birth around 1510 to 1512 seems realistic, see Archivio di Stato, Rome, Tribunale Criminale del Governatore, Costituti, vol. 245, f. 57v. Matal's year of birth is not known either. It has been set between 1510 and 1520. As Matal declared himself once as about the same age as Agustín, Heuser fixed his birth around 1517; see Heuser, 26.

20. Cooper, passim; Crawford, passim.

21. Rome, BAV, Vat. Lat. 6038, f. 91: "A Monsieur, Monsieur Metel. A Rome. Monsieur Metel. Encores que je ne vous aye jamais veu, je ne lesseray pour cela à vous escripre, ayant entendu de mr Anthoine Lafreri que vous estez amateur des bonnes lettrez et de l'antiquité. Parquoy suivant vostre memoire je vous envoye troys epitaphes de Nimes et de Narbonne . . . n'ayant peu trouver celluy que demandez. Vous adviserez au demeurant où je vous pourey faire plaisir et je le feray d'aussy bo cueur que je me vois recommander à vous, en priant le createur, Monsieur Metel, qu'[il] vous ayt en sa garde. De Lyon, ce unzieme jour d'avril 1548. Vostre meilleur frere et amy Le Bailly des Montaignes", cited after Cooper, 106; see also Crawford, 282.

22. Rome, BAV, Vat. Lat. 6034, fol. 7, Crawford, 279; see Stenhouse, 53, for the full passage in Latin and a translation in English. The inscription is CIL IX, 3429.

23. Stenhouse, 53n24. Another copy of this paper "squeeze" is preserved in the Codex Pigianus (f. 187, Staatsbibliothek Berlin); see also the following note.

24. Stenhouse, 53n25–26. According to Stenhouse, these techniques were used regularly only in the seventeenth century with Raffaello Fabretti. See also Patrick Kragelund, "Rostgaard, Fabretti and Some Paper Impressions of Greek and Roman Inscriptions in the

Danish Royal Library," *Analecta Romana Instituti Danici* 29 (2003): 155–73. The imprints treated there are not taken with ink but by wetting the paper. Kragelund does not explain the technique, but Hübner does for his own time, see Emil Hübner, *Über mechanische Copieen von Inschriften* (Berlin: Weidmann, 1881), 5–10. Hübner considers the aforementioned Pighianus copy (n. 22) unlike Stenhouse as such a paper "squeeze," see Hübner, 19.

25. Eugenia Equini Schneider, *La "Tomba di Nerone" sulla Via Cassia: Studio sul sarcofago di Publio Vibio Mariano* (Rome: G. Bretscheider, 1984), 27–31; Eremitage, St. Petersburg, Codex Destailleur B, f. 76v and Pirro Ligorio, Oxford Bodleian Library, f. 146; see Equini Schneider, 27–28. The detailed studies of the sarcophagus in the University Library of Ghent, Belgium, which prove a distinct dependency on the Lafreri print, are considered here as drawings after the engraving not as models for the print. The opposite view is held by Maurits Vandecasteele, "Two Presumed Drafts for Engravings Belonging to Antonio Lafrery's Speculum Romanae Magnificentiae," *Zeitschrift für Kunstgeschichte* 3 (2004): 427–34.

26. See CIL VI, 1343; Wrede and Harprath, 125.

27. Giuliano da Sangallo, Biblioteca Comunale, Siena, Taccuino Sienese, IV, fol. 32v; Antonio da Sangallo the Younger, Offices, Florence, inv. 1129r; see Wrede and Harprath, 125; CIL VI, 1343; for images, see www.census.de/censusID=153394 [visited July 22, 2007].

28. Baldassare Peruzzi, Offices, Florence, inv. 477v; see Heinrich Wurm, *Baldassare Peruzzi: Architekturzeichnungen* (Tübingen: Wasmuth, 1984), plate 470.

29. Veste Coburg, Codex Coburgensis, no. 181; see Wrede and Harprath, 125–26, no. 142; censusID 49443.

30. BAV, Rome, Vat. Lat. 8495, f. CLXIIIIv; see CIL VI. 1343 and Wrede and Harprath, 125–26.

31. Friedrich Matz and Friedrich Karl von Duhn, *Antike Bildwerke in Rom, mit Ausschluss der grösseren Sammlungen* (Leipzig: Breitkopf & Härtel, 1881–1882), 3:174–75, Nr. 3873; Wrede and Harprath, 125; censusID 157295.

32. Biblioteca Nazionale Centrale, Florence, Dosio-Circle Sketchbook, f. 2r; Veste Coburg, Codex Coburgensis Nr. 173; Staatsbibliothek Berlin, Codex Pighianus (Ms. lat. 2° 61), f. 132r, see censusID 157295.

33. Biblioteca Comunale, Siena, inv. S. IV.7, f. 33r and v, 34v, 39v, see censusID 228322.

34. BAV, Rome, Vat. Lat. 6039, f. 219 (22 new).

35. E.g., the device for suspending the cage ends in animal heads; this detail is not transmitted in the engraving. The drawings of the Codex Pighianus were copied from the Codex Coburgensis; see Wrede and Harprath, 29.

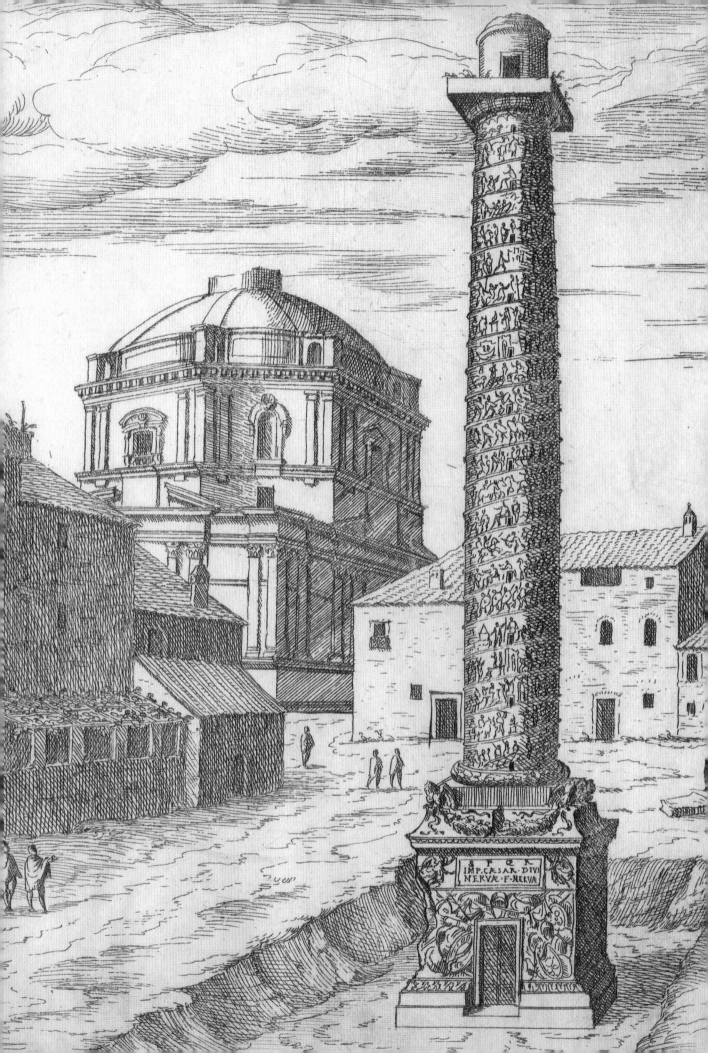

DAVID KARMON

PRINTING AND PROTECTING ANCIENT REMAINS IN THE *SPECULUM ROMANAE MAGNIFICENTIAE*

LEAFING THROUGH THE PRINTS of the *Speculum Romanae Magnificentiae*—and now calling up the images on-line through the *Speculum* digital collection at the University of Chicago—we can rapidly survey numerous views depicting ancient monuments as they appeared in sixteenth-century Rome.[1] But even as digitization allows high-resolution details to fill our computer screens, the *Speculum* still presents the monuments of Rome as discrete, isolated artifacts. From the outset, the artists working on the project, coordinated by the industrious publishers Antonio Salamanca and Antonio Lafreri, extracted the ancient monuments of Rome from their urban settings and inscribed them within the framing device of the folio for the viewer's edification and pleasure. The notion of enclosing a valuable artifact within a protective boundary can be seen as a defining feature of the *Speculum,* and in this essay I argue that these prints depicting prominent ancient monuments also shed light on how the safeguarding of artifacts was understood in early modern Rome. As we will see, the very nature of the *Speculum* project as a compendium of images, and the process of translating these images into the medium of print, called attention to the fragile conditions of the monuments, as well as to potential solutions for their protection and repair.[2]

The use of the term "protection" in this essay is intended to underscore the difference between the early modern approach to ancient remains and our own contemporary conservation strategies. The modern concept of "architectural conservation" refers to a whole set of practices aimed at the integration and restitution of historic buildings and sites, which cannot be casually transposed to the context of early modern Rome.[3] Although "preservation" may be less restrictive in its use, in this case "protection" has been selected as an appropriate term. This not only avoids contemporary associations, but it specifically reminds us that any interventions upon historic structures involve claims to power and legitimacy. The decision to protect an artifact, the privileging of certain elements to the detriment of others, the judgment and imposition of penalties on those who do not adhere to established rules: in all these cases, power is at stake. If our contemporary use of "conservation" invokes scholarship and scientific principles, "protection" communicates the early modern experience of such interventions as a blunt assertion of control.

In this essay, I will present a series of documents relating to sixteenth-century protective efforts undertaken at or envisioned for three of the best preserved ancient monuments in Rome: the Column of Trajan, completed in 113 AD; the Pantheon, constructed circa 125 AD; and the Arch of Constantine, dedicated in 315 AD. The purpose of this study is not only to offer critical evidence for protective strategies in the sixteenth-century capital, but to make protection issues more legible in the visual records of these monuments that survive in the *Speculum*. As I examine these sources, I will consider both how sixteenth-century interventions may anticipate

our contemporary approach to preservation issues, and how at the same time they suggest alternative solutions.

The Column of Trajan

In September 1558, the Conservators, secular magistrates of the civic administration of Rome, affirmed that they intended to take action to improve existing conditions around the Column of Trajan. Regulating the physical environment of Rome had long provided these magistrates with a vital means to challenge powerful adversaries such as the pope and the Roman nobility; in 1162, less than twenty years after the foundation of the civic government, the magistrates had championed the defense of the Column of Trajan, thereby claiming this potent symbol of ancient Rome as their own.[4] Now, almost exactly four hundred years later, they declared that conditions at the Column required their immediate attention:

> As the Column of Trajan is one of the most beautiful and best-preserved antiquities in this city, it is fitting that the site where it stands should be adorned and arranged to correspond with the beauty of the Column itself; and for this purpose a drawing by Michelangelo has been acquired, as you may see; and so that this praiseworthy project be carried to completion, the neighboring residents shall provide half the cost, while the other half shall be provided by the civic government, as this is a public work.[5]

On one hand, this document provides a glimpse into different strategies used to finance urban interventions in early modern Rome, where the civic magistrates assumed half of the economic burden of this "public work," while collecting contributions from the owners of neighboring properties for the remainder.[6] On the other hand, the document implicitly refers to the underlying political value of protective interventions in the early modern papal capital.

By the sixteenth century, the civic government had been firmly subordinated to papal power. Yet by proposing to take action at the Column of Trajan, the civic magistrates not only aligned themselves with prestigious Roman tradition, but could still lay claim to a measure of independent authority.[7] There had been recent papal interventions at the site; in 1536 Paul III demolished an adjacent medieval church to reveal the base of the Column of Trajan for the visiting Holy Roman Emperor Charles V.[8] By insisting that the site needed to be improved, the Conservators delivered an oblique criticism of the pope's care of the Column of Trajan; thanks to the papal demolitions, it now stood surrounded by a barren patch of exposed earth. Moreover, if the pope could claim to have liberated the Column of its accretions, this document revealed that the Conservators considered the prestigious site to be under their jurisdiction.[9]

This symbolic value of protection for the Conservators may also throw light upon their reported acquisition of a drawing from Michelangelo. While no trace of this drawing has been recovered, it is likely Michelangelo would have taken some interest in the project, given that he lived next to the structure.[10] Moreover, the reference to the greatest living artist of the day may reflect the ambitions of the civic officials: Michelangelo's participation would not only underscore the prestige of the project, but also reinforce their own status and influence.

A comparison of prints from the *Speculum* suggests that contemporary artists were also exploring similar issues regarding improvements to the surroundings of the Column of Trajan. Where the Conservators made little reference to the form these proposed interventions would assume—other than claiming possession of a purported design by Michelangelo—these prints provide us with explicit visual evidence for the different kinds of solutions under consideration by sixteenth-century designers. Whether these designs were actually under consideration for execution is of secondary importance for our purposes; rather, the key issue is that these prints suggest how a more appropriate and dignified setting for this ancient monument might have been conceived by a contemporary viewer.

The print showing the Column of Trajan published by Lafreri between 1544 and 1562 depicts the Column dominating a low horizontal backdrop of vernacular buildings [FIGURE 14].[11] Figures robed in classicizing togas and tunics admire the sculptured reliefs of the ancient monument from below, while others gesticulate from its summit. This celebratory view also made a small but significant insertion at the base of the Column, where the artist differentiated the point where the Column rested upon the earth from its surrounding context with sloping lines. This had the effect of creating a small bounded area immediately below the Column, reinforced by the absence of the hatching used to define the irregular topography elsewhere. The low horizon line served to emphasize the great height of the column shaft, nearly all of which was silhouetted against

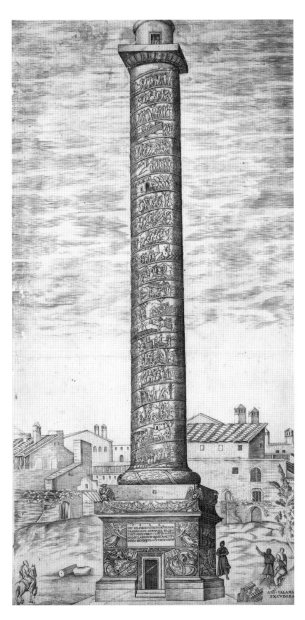

FIGURE 14

Attributed to Enea Vico (engraver). *Trajan's Column.*
Engraving, mid-16th c. Antonio Salamanca, publisher.

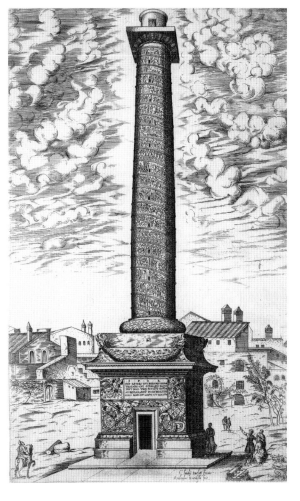

FIGURE 15

Ambrogio Brambilla (etcher). *Trajan's Column.* Etching,
1581–86. Claudio Duchetti, publisher.

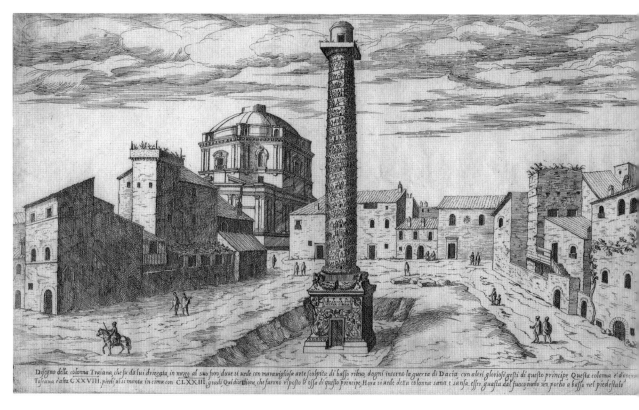

FIGURE 16

Etienne Dupérac (etcher). *Trajan's Column*. Plate 33 of Dupérac, *Vestigi dell'antichità di Roma*. Originally published by Lorenzo della Vaccheria, 1575; republished by Goert van Schaych in 1621.

the sky. This technique, not unlike the sloping lines used at the base, further set off the structure from its humble modern surroundings.

Another print, engraved by Ambrogio Brambilla and published by Claudio Duchetti in the 1580s, was closely dependent on the earlier version [FIGURE 15].[12] This included a number of significant alterations, such as a more bulbous rendering of the column shaft and the projecting entablature of the base.[13] However, this engraver also reworked the way the column base touched the earth. Where the earlier print marked a separation using sloped lines, Brambilla introduced shallow, rectangular steps below the monument. His invention of a raised podium further underscored the separation between the monument and its surroundings, elevating the structure even more emphatically from its context.

While the Conservators argued that the best-preserved of Rome's antiquities deserved a more dignified setting, the *Speculum* prints help us to better understand how contemporaries envisioned the appearance of such an improved environment. Both prints introduced more precise boundaries between the ancient monument and its surroundings. A 1575 print by Etienne Dupérac indicated that the Column of Trajan stood inside a deep, roughly excavated pit [FIGURE 16]; in 1569 the Conservators had debated enclosing this pit with retaining walls to prevent further deterioration to the Column, and to give it a more defined architectural shape.[14] By strengthening the boundary between the Column of Trajan and its surroundings, these interventions reinforced the identity of the monument as a precious relic. The *Speculum* prints described a protective precinct, even a kind of reliquary setting. While this had the effect of improving the visibility of the Column of Trajan, it also affirmed the separation of the monument from the ordinary world. Certainly such an approach is very familiar to the contemporary tourist who often experiences historic sites—including the Column of Trajan of today—from behind a guardrail.[15]

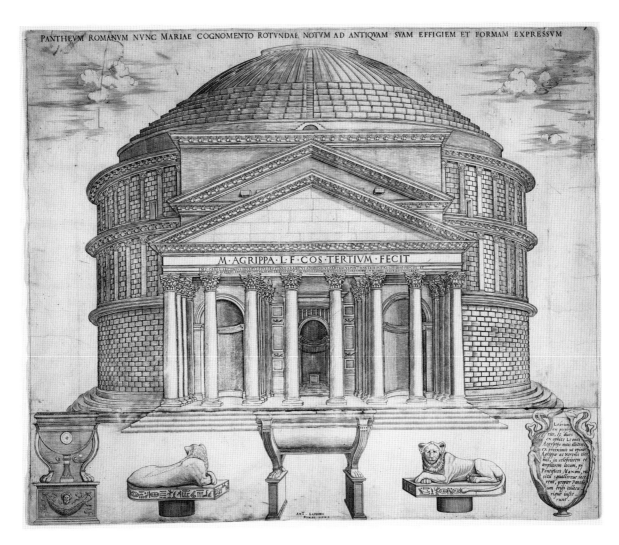

FIGURE 17

Anonymous. *The Pantheon.* Engraving, 1549. Antonio Lafreri, publisher.

The Pantheon

Today at the Pantheon, a rectangular white marble inscription with a decorative relief has been immured in the large brick niche of the entry portico. In Roman majuscules it reads:

> LEO X PONT MAX PROVIDENTISSIMUS / PRINCEPS VAS ELEGANTISSIMUM / EX LAPIDE NUMIDICO NE POLLUTUM / NEGLIGENTIE SORDIBUS OBSOLESCERET / IN HUNC MODUM REPONI EXORNARIQ / IUSSIT / BARTHOLOMEUS VALLA / RAMUNDUS CAPOFERREUS / AEDILES FAC CUR.[16]

Leo X, Pontifex Maximus, the most provident prince, restored and adorned this most elegant basin of Numidian stone, so that it would not be worn out by pollution and squalid neglect; the *aediles* Bartolomeo Della Valle and Raimondo Capodiferro conducted this work.

The exceptional preservation of the Pantheon attests to the constant papal interest in the care of the famous landmark since its conversion into a church in the early seventh century. This particular inscription dating from the reign of Leo X (1513–1521) shows that papal care could also extend to the monument's surroundings, where the pope ordered the recuperation of the large porphyry sarcophagus that stood immediately before the portico.

As the inscription reported, Leo X as well as the so-called *aediles,* the urban officials also known as the *maestri di edifici e di strade,* took an instrumental role in rescuing this impressive artifact from decay and deterioration.[17]

Indeed, the inscription itself can be understood as a forceful assertion of the pope as guardian of Rome's antiquities. The involvement of the *maestri* in this work also reminds us that protective measures in early modern Rome often can be viewed within the broader context of urban interventions. It is very likely that the protection of this sarcophagus was folded into a larger project of urban viability, considering that a license for the repaving of the piazza and streets surrounding the Pantheon was also issued by these two *maestri* in 1517.[18]

The engraving of the Pantheon published by Lafreri in 1549 gives us some idea of the nature of this intervention upon the sarcophagus [FIGURE 17].[19] The sarcophagus, its short side shown in elevation at the bottom left corner of the page, and its longer side viewed in single-point perspective at the center, stands on the marble plinths installed by the *maestri*. In the elevation at the bottom left, we see the decorative relief that ornamented the exterior face of the plinth; from this angle the interior face that carried the inscription is invisible.[20] Thus the *Speculum* print did not include the textual evidence that revealed that these plinths were a contemporary intervention, but only their *all'antica* ornament.

The print also attests to the persistent early modern interest in returning the Pantheon to an ideal earlier condition, stimulated no doubt by the very fact that the Pantheon was so well preserved. With a little tinkering, it could soon be returned to its "original" condition. The artist of this print removed obvious solecisms such as the medieval brick campanile above the portico, and eliminated other signs of decay and age, suggesting how the monument should be—and eventually would be—restored.[21] At the same time, he also introduced new elements more consonant with the classical vocabulary of antiquity. These included invented features, such as the decorative brick orders surrounding the exterior of the rotunda as well as its raised stepped base, but also modern additions, namely, the new marble plinths inserted under the ancient sarcophagus during the reign of Leo X.

Today, both archaeologists and conservators employ a broad range of techniques to distinguish the chronology of successive layers of material evidence.[22] But Lafreri's engraver revealed a diametrically opposite approach to the ancient artifact in his depiction of the Pantheon. Rather than pointing to the nature of the Pantheon as a palimpsest, he used a uniform classical language to elide these very distinctions. This was the same attitude expressed by the many Renaissance architects who sought to correct the Pantheon's perceived blemishes by regularizing the alignment of the coffers in the vault or reordering the columns of the portico.[23] Such viewers sought to achieve a seamless blending of old and new at the Pantheon, emphasizing not its hybrid, aggregate nature, but its timelessness and its harmonious integrity.

The Arch of Constantine

A papal excavation license of 1565 issued to Sicinio Capisucco in the area surrounding the Arch of Constantine reveals how particular procedures to protect ancient landmarks emerged in the context of proposed excavations.[24] The license defined the Arch of Constantine as a protected enclave within a vast landscape that offered potentially inexhaustible sources of buried treasures.

While authorizing Capisucco to excavate materials around the Arch of Constantine, the license also imposed key limiting conditions on this work to protect the existing site. He was prohibited from using tunnels to excavate, which could undermine building foundations and cause disastrous collapse.[25] In conducting his excavations, he was obliged to remain at least fifteen *canne* from the Arch of Constantine (nearly 33.5 meters), and afterwards, he was required to return the excavated site to its original condition.[26] Even though the Arch of Constantine stood in an unpopulated setting, Capisucco was required to backfill his abandoned trenches, so they would not threaten the occasional passersby.

A print published by Claudio Duchetti around 1583 presents the Arch of Constantine as ideally restored [FIGURE 18, CAT. A37].[27] The only exception to the crisp edges and precise profiles so characteristic of this print were the four Dacian warriors in the attic storey; these are shown as unrestored fragments. This depiction highlights two different impulses: one that sanctioned the active restoration of damaged elements, and another that left damaged elements unchanged. If modern conservation practice tends to view these as opposing tendencies, this print indicated that such approaches might coexist at the same monument.[28]

The engraver also positioned the Arch of Constantine on a platform of rectangular tiles viewed in receding perspective. Sylvie Deswarte-Rosa has discussed how this kind of view revealed a conscious choice by the publishers of the *Speculum*, a mode of representation based on scenographic and painterly traditions, one that was more likely to appeal to a broad audience than a

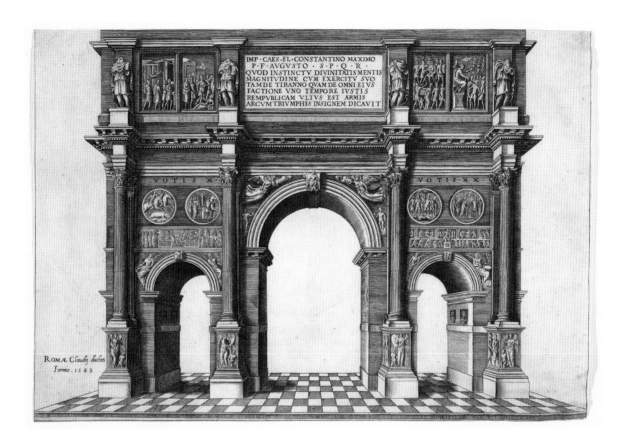

FIGURE 18

Anonymous. *Arch of Constantine.* Etching with engraving, 1583. Claudio Duchetti, publisher. CAT. A37.

pure architectural elevation or plan.[29] Yet this image may also speak to the protected status of the ancient monument. The 1565 license, by stipulating that the terrain surrounding the Arch of Constantine was off-limits to excavation, literally turned the monument into an island, much as it appears in this print. The detailed rendering of the monument, set in a neutral, even generic field, also suggests a correspondence with the priorities of sixteenth-century protective policies. These focused on creating a real or imagined space from which to view the monument, emphasizing it as an isolated object set within a visual frame, rather than as part of a specific historical context.

Visual Records and the Protection of Ancient Remains

A related issue raised by the *Speculum* prints is that of protecting and preserving ancient remains not just in physical form, but through visual means. Although archaeologists now often employ photographs to document archaeological evidence, it is clear that the issue of chronicling less-than-pristine ancient objects was also familiar to sixteenth-century audiences. In fact, the *Speculum*, as a graphic record of the ancient monuments of Rome, foregrounds the question of how visual information can also preserve and protect material evidence.

In his discussion of early modern print media, Christopher Wood noted the problem of "visual drift," where visual information about an ancient artifact was vulnerable to gradual deviation as it was transmitted from one copyist to another.[30] Whereas texts are relatively stable—alphabet forms can vary without loss of intelligibility—an artist must necessarily make selections when translating an artifact into a drawing. The resulting choices can profoundly transform this documentary evidence, distorting key visual information beyond recognition or even omitting it altogether.

FIGURE 19

Anonymous. *The Colosseum* (detail). Engraving, before 1558. Antonio Lafreri, publisher.

FIGURE 20

Anonymous. *The Pantheon* (detail). Engraving, 1553. Antonio Lafreri, publisher.

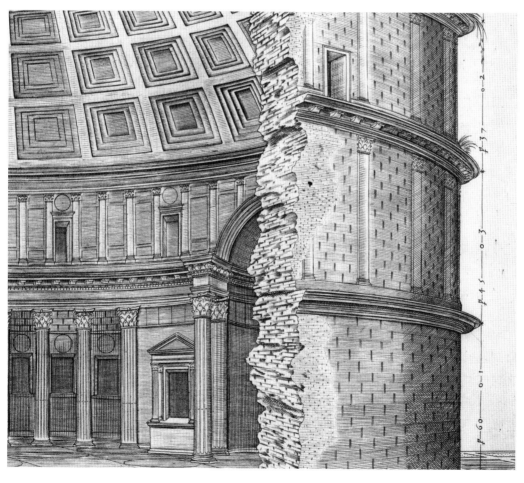

FIGURE 21

Master with the bird's wing monogram (engraver). *Obelisk and Column of Antoninus Pius* (detail) after Enea Vico. Engraving, mid-16th c. Antonio Lafreri, publisher.

The publishers of the *Speculum* project would have witnessed these problems at first hand. The visual records reveal the difficulty of providing a reliable graphic account of the ancient remains when these renderings were each dependent upon arbitrary choices made by individual engravers. To some extent the common format of large-scale axial views mitigated the problem. But close examination of the prints—facilitated by the on-line database—suggests a possible solution that may have emerged in response to this problem. For in several cases, it appears that the *Speculum* engravers made use of a special linear syntax to communicate the distinctive qualities of breakage characteristic of ancient remains.

We can see evidence for this technique in the rendering of the ruined Colosseum published by Lafreri, dated prior to 1558 [FIGURE 19].[31] In contrast to the undamaged curving profile of the structure, which the engraver rendered in smooth continuous lines, the point where the structure was sheared open, exposing its travertine construction assembly, reveals a consistent use of feathery hatch marks. Oriented horizontally on the vertical and vertically on the horizontal, these short hatched lines delineate the broken profiles of the individual blocks, dissolving the edges of the individual stones and making the hard exterior contour of the Colosseum unexpectedly permeable.

There is also evidence for this technique in another view of the Pantheon, also published by Lafreri and dated 1553, which shows a cutaway view of the monument, opened to reveal the interior [FIGURE 20].[32] This print employed two systems of visual notation: a hard-edged contour line for much of the jagged masonry profile of the rotunda and vault, and a fainter, dotted line to denote the thin stucco ashlar revetment applied to the rotunda exterior. Thus the notion of conveying broken surfaces appeared even in a depiction of the Pantheon, despite the prevailing tendency to present the monument as if it were ideally restored.

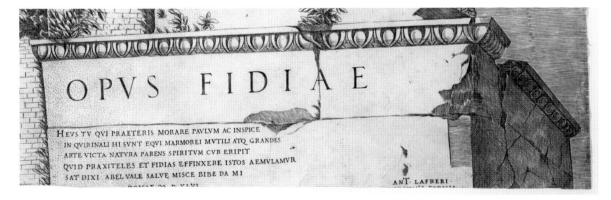

FIGURE 22

Anonymous. *Statues of the Dioscuri at the Quirinal* (detail). Engraving, 1546. Antonio Lafreri, publisher.

FIGURE 23

Anonymous. *Pasquino* (detail). Engraving, 1550. Antonio Lafreri, publisher.

However, the technique was typically used to communicate signs of wear and damage. For example, in the engraving of the Column of Marcus Aurelius published by Lafreri between 1544 and 1577, the artist used a series of hatched lines, rendering the fissures in the marble surface in a more delicate and ambiguous way than with an uninterrupted contour line [FIGURE 21].[33] One could cite other examples as evidence of this technique, such as the breaks in the marble plinth of the statues of the Dioscuri on the Quirinal Hill [FIGURE 22][34] or the rendering of a broken nose in the famous Pasquino sculpture group near the Piazza Navona [FIGURE 23].[35]

Certainly the use of hatched lines to render a broken edge was not adopted as a uniform standard by all artists. Printmakers such as Ambrogio Brambilla, who flourished after 1579, largely dispensed with this convention. The more cursory nature of these later prints may be related to a shift in priorities to cater to a general audience interested in souvenirs, rather than the smaller group of specialists attentive to the value of more precise antiquarian records.[36]

Earlier prints used more careful techniques, which revealed greater attention to the quality of broken surfaces. In particular, it is significant that this technique can be traced to the early sixteenth-century prints produced by Marcantonio Raimondi, the printmaker and collaborator with Raphael whose work provided a crucial precedent for many engravers in sixteenth-century Rome. William Ivins credited Marcantonio with the invention of a syntax of discontinuous flicks and strokes of the burin that allowed for a systematic depiction of three-dimensional surfaces, and certainly this technique was also uniquely suited to depicting the irregular, broken edges of ancient stones.[37]

To examine Marcantonio's use of this technique, we turn to *Il Morbetto*, a two-part narrative taken from the *Aeneid,* engraved after a drawing by Raphael [FIGURE 24].[38] The right half of the print reveals prominent ancient ruins: in the foreground two massive fluted column drums lie on their sides, positioned relative to each other at a ninety-degree angle. The monuments in the background include a round structure with projecting brackets and arched openings that recalls the Colosseum. Although the print features meticulous, closely laid lines, the use of the discontinuous line technique to render a broken edge is visible where the two column drums overlap. Here, the horizontal lines across the face of the column drum parallel with the picture plane simultaneously define the angled contour of the adjacent column drum. This broken and irregular marble edge is articulated using hatching, not unlike the technique used to define the broken edge of the Colosseum in the Lafreri print.

As Howard Burns has noted, the preparatory drawing at Windsor made for *Il Morbetto* provides valuable evidence for Raphael's prescient attention to documenting ancient remains.[39] The precise analysis and documentation of ancient artifacts in the print also suggest an intriguing link between Marcantonio and Raphael. We know that Raphael took an active role in fixing the visual record of ancient remains through his development of the canonical sequence of drawings—the plan, section, and elevation—for his famous proposed plan of ancient Rome. Yet perhaps the technique of rendering broken edges, and thereby conveying the distinctive qualities of breakage and wear in the new print media, also bore the mark of Raphael's pictorial intelligence. *Il Morbetto* was the fruit of collaboration between Marcantonio and Raphael, and certainly it is reasonable to assume that Raphael would have favored

FIGURE 24

Marcantonio Raimondi (engraver). *Il Morbetto,*after Raphael. Engraving, ca. 1515. Reproduced with permission from Walter Straus, ed., *The Illustrated Bartsch* 27 (Abaris Books: New York, 1978), 105.

the notion of developing a more explicit visual syntax to document ancient remains.[40] Whether or not Raphael contributed to the development of this particular method, it is clear that it offered a useful artistic convention for Marcantonio, as well as many *Speculum* engravers, by providing a means to translate and convey information about imprecise broken surfaces using a precise graphic technique.

This survey of interventions upon ancient remains in early modern Rome reminds us that each generation defines the protection of the material remains of the past in a distinctive way, responding to different goals and contemporary concerns. Certainly there are continuities between the sixteenth century and the present; for example, some of the boundaries separating us from ancient artifacts, as we saw in the *Speculum* prints of the Column of Trajan, seem to have only become more

rigid with time. In most cases a guardrail now physically separates us from archaeological sites to limit further damage to fragile ancient remains.

But at the same time, this investigation also demonstrates that protective efforts are also a process of transmission, one that in itself shapes and transforms artifacts as they move through time. The range of approaches to protection is infinite, even transcending the notion of physical preservation. We can see this expansive concept of preservation in the prints of the *Speculum Romanae Magnificentiae*. By disseminating visual information about the antiquities of Rome to a vast audience, the *Speculum* prints cemented a visual record of the ruins of the city in our collective memory. The digital *Speculum* promises to release us further from protective limitations by opening up new ways to gain access to this compendium of visual knowledge.

I thank Rebecca Zorach for inviting me to contribute this essay, and for further discussion of the work in progress, including an enlightening session with her exhibition seminar. I have also greatly benefited from comments by friends and colleagues at the Newberry Library and the University of Chicago, including Paul Gehl, Diana Robin, Vicky Solan, and Carla Zecher. Translations (and errors) are my own.

1. For key studies on the *Speculum Romanae Magnificentiae*, see Introduction, note 2. On early prints of ancient monuments produced under Antonio Salamanca, see Sylvie Deswarte-Rosa, "Les gravures de monuments antiques d'Antonio Salamanca, à l'origine du *Speculum Romanae Magnificentiae*," *Annali di Architettura* 1 (1989): 47–62, and the Rubach essay in this volume. On the target audience for the *Speculum*, see David Landau and Peter Parshall, *The Renaissance Print: 1470–1550* (New Haven: Yale University Press, 1994), 304–08. I have found Landau and Parshall's analysis to be very informative; however, see the caveat regarding the pejorative use of the term "reproductive prints" as noted by Evelyn Lincoln, *The Invention of the Italian Renaissance Printmaker* (New Haven: Yale University Press, 2000), 15.

2. Traditionally, scholars have judged the destruction of classical antiquity that occurred in the Renaissance a tragic paradox; see the assessment of Roberto Weiss, *The Renaissance Discovery of Classical Antiquity* (Oxford: Blackwell, 1969), 104. The foundations for a critical reevaluation have since been laid by Salvatore Settis, ed., *Memoria dell'antico nell'arte italiana* (Turin: G. Einaudi, 1984–1986); see in particular *Nota dell'editore*, 1:xxiii–xxvii. Further key efforts to evaluate early modern interventions on ancient artifacts in a more objective light include Gisella Wataghin Cantino, "Archeologia e 'archeologie': il rapporto con l'antico fra mito, arte, e ricerca," in Settis, *Memoria dell'antico*, 1:171–217; Enrico Guidoni, "Antico e moderno nella cultura urbanistica romana del primo Rinascimento," in *Roma, centro ideale della cultura dell'Antico nei secoli XV e XVI: da Martino V al sacco di Roma, 1417–1527*, ed. Silvia Danesi Squarzina (Milan: Electa, 1989), 477–88; Ilaria Bignamini, ed., *Archives and Excavations: Essays on the History of Archaeological Excavations in Rome and Southern Italy from the Renaissance to the Nineteenth Century* (London: British School at Rome, 2004).

3. For a recent overview of contemporary conservation practices and terminology, see Salvador Muños Viñas, *Contemporary Theory of Conservation* (Oxford: Oxford University Press, 2005).

4. The civic government of Rome was a popular institution founded in 1143 in rebellion against the pope, which claimed legitimacy as heir of the republican traditions of ancient Rome and successor of the *Senatus Populusque Romanus*. Originally the elected officials included members of the popular classes, but by the sixteenth century the local nobility of Rome dominated these positions. For the 1162 edict see Alain de Boüard, "Gli antichi marmi di Roma nel medio evo," *Archivio della reverenda società romana di storia patria* 34 (1911): 240–41; Anna Cavallaro, "Una colonna a modo di campanile facta per Adriano imperatore: vicende e interpretazioni della colonna Traiana tra Medioevo e Quattrocento," in *Studi in onore di Giulio Carlo Argan*, ed. Silvana Macchioni and Bianca Tavassi La Greca (Rome: Multigraphica, 1984), 1:73–74. On the civic government's use of ancient remains as a source of political legitimacy, see Norberto Gramaccini, "La prima riedificazione del Campidoglio e la rivoluzione senatoriale del 1144," in Squarzina, *Roma, centro ideale*, 33–47, with the literature cited there. The duty of protecting ancient remains was also enshrined in the fourteenth-century civic statutes.

5. ASC, Cred. I, vol. 37, p. 7 (7 September 1558). "Inoltre perché la colonna Traiana è una delle più belle et integre antichità che siano in questa città, siccome li SS. VV. sanno pare conveniente cosa che selli adorni et accomodi il loco dove ella sta che corrisponda alla bellezza di essa; e perché si è havuto sopra di ciò un disegno di Michelangelo quale le SS. VV. potranno vedere; et acciò questa opera tanto lodevole se mandasse ad effetto, si contentano i convicini contribuire alla metà della spesa, e [desiderano che] nell'altra metà contribuisse il popolo, essendo cosa pubblica." See Rodolfo Lanciani, *Storia degli scavi di Roma e notizie intorno le collezioni romane di antichità* (1902; Rome: Quasar, 1990), 2:137; Giovanni Agosti and Vincenzo Farinella, "Nuove ricerche sulla colonna Traiana nel Rinascimento," in *La Colonna Traiana*, ed. Salvatore Settis (Turin: G. Einaudi, 1988), 584. This document was most likely the first addressing the proposed re-ordering or systematization of the Column of Trajan by the Conservators.

6. This collection of revenue, known as the *gettito* or a "betterment tax," was standard procedure to finance urban improvement projects in early modern Rome; see especially Emilio Re, "Maestri di strada," *Archivio della reverenda società romana di storia patria* 43 (1920): 54–60; see also Rodolfo Lanciani, "La via del Corso drizzata e abbellita nel 1538 da Paolo III," *Bullettino della commissione archeologica comunale di Roma* (1902): 229–30.

7. For the renewed emphasis by the civic government upon the protection of antiquity in sixteenth-century Rome, following its subordination to supreme papal power, see especially Massimo Miglio, "Roma dopo Avignone: la rinascita politica dell'antico," in Settis, *Memoria dell'antico nell'arte italiana*, 1:73–111; Michele Franceschini, "La magistratura capitolina e la tutela delle antichità di Roma nel XVI secolo," *Archivio della società romana di storia patria* 108 (1986): 141–50; Kathleen Christian, "The De' Rossi Collection of Ancient Sculptures, Leo X, and Raphael," *JWCI* 65 (2002): 160–62.

8. Some further clearing appears to have taken place at the site in the intervening years; see Lanciani, *Storia*, 2:70, 2:131.

9. It is telling that the document of 1558 made no reference to the pope at all; rather, this intervention was presented exclusively in reference to the competency and authority of the civic magistrates.

10. Not only did Michelangelo live adjacent to the Column of Trajan in Via Macel de' Corvi, but there is a drawing after its ancient reliefs by Antonio Mini, an artist in Michelangelo's circle. On this (as well as Gianlorenzo Bernini's assertion that Michelangelo judged the Column of Trajan to be unique, even among the wonders of ancient Rome), see Giovanni Agosti and Vincenzo Farinella, *Michelangelo: studi di antichità dal Codice Coner* (Turin: UTET, 1987), 54; Agosti and Farinella, "Nuove ricerche," 584.

11. Chicago Speculum Number A47. Hülsen attributed the print to Enea Vico; see Christian Hülsen, "Das Speculum Romanae Magnificentiae des Antonio Lafréri," in *Collectanea variae doctrinae Leoni S. Olschki* (Munich: J. Rosenthal, 1921), 148n30f. On Vico, see Alfredo Petrucci, *Panorama della incisione italiana: il cinquecento* (Rome: C. Bestetti, 1964), 60–62; Landau and Parshall, 284–88; also C. Höper, "Enea Vico," in *Dictionary of Art*, ed. Jane Turner (New York: Grove, 1996), 32:412–13.

12. Chicago Speculum Number A41; Hülsen, 148n30d. On Brambilla, see Clelia Alberici, "Ambrogio Brambilla," in *Dizionario biografico degli italiani* (Rome: Istituto della Enciclopedia italiana, 1971), 13:729–30 with bibliography.

13. Brambilla's decision to depict the figures in contemporary rather than classicizing costumes suggests the print was also directed at a different audience; I will return to this point below (see note 36).

14. For the Conservators' debate, see ASC, Cred. I, vol. 38, p. 161 (8 December 1569); transcribed by Francesco Cerasoli, "La colonna traiana e le sue adiacenze nei secoli XVI e XVII," *Bollettino della commissione archeologica comunale di Roma* (1901): 300. The view of the Column of Trajan by Etienne Dupérac (Chicago Speculum Number B279) was issued as part of separate publication, the *Vestigi dell'antichità di Roma*, published by Goert van Schaych in 1621, which forms part of the collection of the *Speculum Romanae Magnificentiae* at the University of Chicago.

On this edition, see Thomas Ashby, "Le diverse edizioni dei *Vestigi dell'antichità di Roma*," *Bibliofilia* 16 (1915): 417–20.

15. The Hegelian term "sublate" (*aufhebung*), which simultaneously can be interpreted as to elevate, to efface, and to preserve, may be of interpretive value in this context; see Robert Audi, ed., *Cambridge Dictionary of Philosophy* (Cambridge: Cambridge University Press, 1999), 368. While such an intervention was obviously intended to preserve (and elevate) the monument, it also had the consequence of undercutting and even effacing the connections between this artifact and its setting. The approach has much in common with modern protective strategies that insulate ancient artifacts within a protective cocoon or "tourist bubble"; on this phenomenon see especially Robert Nelson, "Tourists, Terrorists, and Metaphysical Theater at Hagia Sophia," in *Monuments and Memory, Made and Unmade*, ed. Robert Nelson and Margaret Olin (Chicago: University of Chicago Press, 2003), 59–82. On the continuing associations between archaeological remains, reliquaries, and treasures, see Wataghin Cantino, 178–84.

16. Transcribed by Giovanni Eroli, *Raccolta epigrafica storica bibliografica del Pantheon di Agrippa* (Narni: Tip. Petrignani, 1895), 452.

17. The statutes of the *maestri di strade* record that their duties extended to include the protection of ancient remains; however, the primary function of the office was to judge and decide property disputes and to ensure the viability of the city streets. The most important recent studies on the *maestri* include Orietta Verdi, "Da ufficiali capitolini a commissari apostolici: i maestri delle strade e degli edifici di Roma tra XIII e XVI secolo," in *Il Campidoglio e Sisto V*, ed. Luigi Spezzaferro and Maria Elisa Tittoni (Rome: Ed. Carte Segrete, 1991), 54–62; Orietta Verdi, *Maestri di edifici e di strade a Roma nel secolo XV, fonti e problemi* (Rome: Roma nel Rinascimento, 1997).

18. For this license see Verdi, 164.

19. Chicago Speculum Number A15; Hülsen, 143n5a. Hülsen indicates that this is a version following an earlier engraving by Nicholas Beatrizet for Antonio Salamanca; the earlier print included only the longer front of the sarcophagus.

20. The original position of these inscriptions is visible in a drawing by Francesco da Holanda (*Codex Escurialensis* 28-I-20, fol. 16v); see Lanciani, *Storia*, 2:36.

21. The portico was in fact badly damaged: brick infill supported its left edge where the columns and entablature had been destroyed, while centuries of progressive interment had buried the entire structure deep below grade level. The lost columns were restored, and the ground level of the piazza lowered, in a renovation completed in 1666 by Alexander VII; see Tod Marder, "Alexander VII, Bernini and the Urban Setting of the Pantheon in the Seventeenth Century," *Journal of the Society of Architectural Historians* 50, 3 (1991): 283.

22. On the uses of stratigraphy in modern archaeological practice, see Colin Renfrew and Paul Bahn, *Archaeology: Theories, Methods, and Practice* (New York and London: Thames and Hudson, 2004); on techniques employed by Italian practitioners to distinguish between original material artifacts and later restorations, see Cesare Brandi, *Teoria del restauro* (Turin: G. Einaudi, 1977).

23. Tilmann Buddensieg, "Criticism and Praise of the Pantheon in the Middle Ages and the Renaissance," in *Classical Influences on European Culture, AD 500–1500,* ed. R. R. Bolgar (Cambridge: Cambridge University Press, 1971), 259–68.

24. ASV, *Diversa cameralia,* vol. 217, p. 142 (4 January 1565), "Licentia effodiendi pro domini Licinio Capisucco." The license has been transcribed by Francesco Cerasoli, "Usi e regolamenti per gli scavi di antichità in Roma nei secoli XV e XVI," *Studi e documenti di storia e diritto* 18 (1897): 149.

25. "dummodo fovea in cripte modum non fiat. . ." An explicit prohibition would have been necessary as tunneling was a preferred technique for many early modern excavations. For a discussion of the problems posed by eighteenth-century tunnel excavations in the Bay of Naples, see Christopher Parslow, *Rediscovering Antiquity: Karl Weber and the Excavation of Herculaneum, Pompeii, and Stabiae* (New York: Cambridge University Press, 1995).

26. ". . .nec eminentibus antiquitatibus a quibus quindecim cannarum spatio distare debeat. . . . Volumus autem quod statim perfecto opera foveam in publico solo factam replere, locumque in pristinum statum reducere."

27. Chicago Speculum Number A37; see Hülsen, 145n15d.

28. This view can be contrasted with the view taken from the opposite side of the arch, published by Antonio Salamanca and attributed to Agostino Veneziano, which depicted the Arch of Constantine fully restored, with the Dacian statues entirely intact. See Hülsen, 145; Deswarte-Rosa, 48. For shifting approaches to sculptural restoration in sixteenth-century Rome, see Orietta Rossi Pinelli, "Scultura antica e restauri storici," in Settis, *Memoria dell'antico,* 1:209–14. Certain sculptures such as the Belvedere Torso were never restored, suggesting an appreciation for these works in their fragmentary form; see Leonard Barkan, *Unearthing the Past: Archaeology and Aesthetics in the Making of Renaissance Culture* (New Haven: Yale University Press, 1999), 188–191. For an alternative hypothesis about the Dacian prisoners' heads, see catalogue, note 138.

29. These representation conventions were already established in the early prints produced by Domenico Giuntalodi for Antonio Salamanca in the 1530s; see Deswarte-Rosa, 55–60.

30. Christopher Wood, "Notation of Visual Information in the Earliest Archeological Scholarship," *Word and Image* 17 (January 2001): 94–118.

31. Chicago Speculum Number B181; see Hülsen, 146n19a.

32. Chicago Speculum Number A19; see Hülsen, 143n6a.

33. Chicago Speculum Number A27, engraved by the Master with the bird's wing monogram, after Enea Vico; see Hülsen, 148n31f.

34. The detail shown here is taken from Chicago Speculum Number A89 (published by Lafreri, dated 1546); see Hülsen, 153n53a. The detail is less carefully executed in later editions; see A117 (published by Duchetti, in the manner of Brambilla, dated 1584); A139 (reprint of Lafreri by Van Aelst, dated 1594–1602).

35. Chicago Speculum Number A93 (published by Lafreri, dated 1550); see Hülsen, 157n71a.

36. An analysis of the subject matter of the surviving prints issued by Antonio Salamanca suggests that in the early stages of production the publishers focused on erudite customers who were familiar with classical history and myth. The continuing growth of religious imagery in subsequent years—as noted already in Lafreri's index of 1572—suggests that the *Speculum* publishers increasingly directed their attentions toward a more general audience. See Landau and Parshall, 303–05. For the transcription of Lafreri's index, see Franz Ehrle, *Roma prima di Sisto V: la pianta di Roma Du Pérac-Lafréry del 1577* (Rome: Danesi, 1908), 53–59.

37. William Ivins, *Prints and Visual Communication* (Cambridge: Cambridge University Press, 1953), 65. Ivins suggests that Marcantonio's use of broken outlines may have been derived from copying Dürer's work. On Marcantonio Raimondi, see Petrucci, 19–35; Innis Shoemaker, "Marcantonio and His Sources," in *The Engravings of Marcantonio Raimondi,* ed. Innis Shoemaker and Elizabeth Broun (Lawrence, KS and Chapel Hill, NC: Spencer Museum of Art, 1981), 3–18; Landau and Parshall, 117–120; Clay Dean, Theresa Fairbanks, and Lisa Pon, *Changing Impressions: Marcantonio Raimondi and Sixteenth-Century Print Connoisseurship* (New Haven: Yale University Press, 1999); Lisa Pon, *Raphael, Dürer, and Marcantonio Raimondi: Copying and the Italian Renaissance Print* (New Haven: Yale University Press, 2004).

38. Carolyn Wood, "The Morbetto," in Shoemaker and Broun, *The Engravings of Marcantonio Raimondi,* 118–19; Sylvia Ferino Pagden, "Il morbetto, o la peste di Frigia," in *Raffaello a Firenze: dipinti e disegni delle collezioni fiorentine,* ed. Caterina Marmugi (Florence: Electa, 1984), 308–09; Landau and Parshall, 124–25; Dean et al., *Changing Impressions,* 64–65. Another example of Marcantonio's use of this technique is *Holy Family with the Young St John the Baptist,* also called *Virgin with the Long Thigh;* Shoemaker and Broun, 178–79. The Madonna rests her elbow upon a masonry block that Marcantonio depicted not with a finite outline, but with a permeable and stippled contour, created using the tail ends of the surrounding vertical hatching strokes.

39. As Burns observes, the preparatory drawing (now at the Royal Library at Windsor) placed greater emphasis on the archaeological elements than is conveyed by the print: these include three column drums, of a variety of sections (both channeled and smooth), as well as a Doric cornice

with mutules. The drawing gives evidence for Raphael's strong interest—even as early as 1512—in documenting and analyzing ancient remains. See Howard Burns, "I marmi antichi," in *Raffaello architetto*, ed. Christoph Luitpold Frommel et al. (Milan: Electa, 1984), 400.

40. For Marcantonio's collaboration with Raphael on *Il Morbetto*, see Landau and Parshall, 125. On the notion of pictorial intelligence, and Raphael and Marcantonio's collaboration in print manufacture more generally, see Pon, *Raphael,* especially chapter 4.

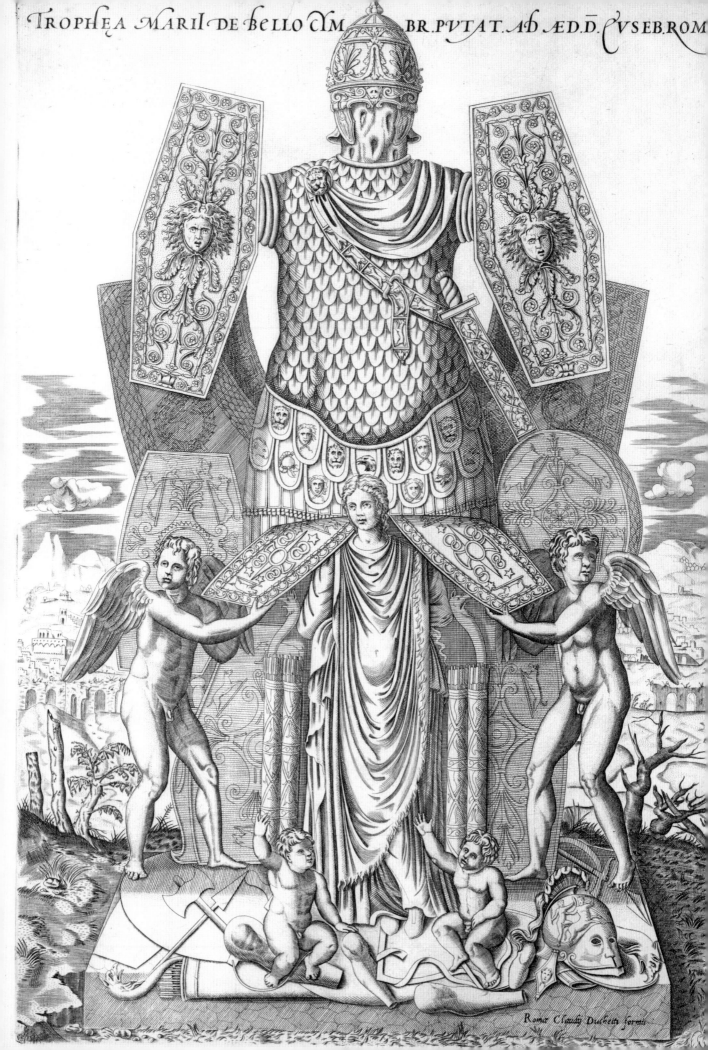

Romæ Claudij Duchetti formis

ROSE MARIE SAN JUAN

RESTORATION AND TRANSLATION IN JUAN DE VALVERDE'S *HISTORIA DE LA COMPOSISION DEL CUERPO HUMANO*

IN THE EARLY MODERN anatomical print, the human body seems to confront the future with much more conviction than the past. The dissection of the human body promises the accumulation of knowledge through which all mysteries will ultimately be revealed, but the framing of body parts within antique fragments brings back the uncertainty of long-buried secrets. If these different forms of fragmentation are to produce a newly restored body, then it must be by taking into account concepts of fragmentation that are at odds with each other.[1] In order to be fully realized, each implies a different movement in time, and it is only in the here and now that is the space of the print that the body is situated between an optimistic future and an uncertain past. This space of the present is made possible by the anatomical print precisely because the new reproductive technology of print was already well versed in practices of restoration, offering both the precise descriptive vocabularies of dismemberment and the opportunities of animation and mutability necessary for reassemblage.

The publication in Rome of Juan Valverde de Amusco's *Historia de la composision del cuerpo humano*, both in Spanish (1556) and in Italian (1560),[2] by the printing shop of Lafreri and Salamanca is one such point of encounter between dissection and restoration. Strategic in their approach to the production and marketing of prints, the publishers devised the *Speculum Romanae*

Magnificentiae as diverse assemblages of existing prints pertaining to the city's antiquities. In some respects, Valverde's publishing project also entailed the reworking of established prints into a new structure. Cynthia Klestinec has argued that Valverde acted as a kind of editor to Andrea Vesalius's 1543 *De Humani corporis fabrica* and reconceptualized the anatomist's celebrated treatise.[3] This is in contrast to most interpretations, be it within art history or the history of science, which tend to regard Valverde as a plagiarist who copied Vesalius's images, added superfluous details, and failed to contribute anything new to the study of the body.[4] Yet even Klestinec's perceptive study, while questioning the binary opposition between original and copy, argues that Valverde's treatise served to detach the production of anatomical prints from the serious study of the human body and especially from actual practices of anatomy.[5] The implication is that a scientific enterprise was transformed into a marketing opportunity, which ironically devalued the role of the visual image.

Although Valverde's book was marketed to a broader readership, its attention to both the study and representation of the human body should not be underestimated. There have been attempts to consider Valverde's contribution, especially with the claim that some of his images are new inventions rather than copies.[6] The standing flayed male figure holding a knife and a sack of skin [FIGURE 25, CAT. 90] is the main evidence for this

argument, although the fascination provoked by this image has also led to the assumption that it is one of Vesalius's own. The image tends to be associated with Michelangelo's St. Bartholomew in the Sistine Chapel, and has even been regarded as an overt critique of the normalizing tendencies of Vesalius's images.[7] Yet considered in the context of the treatise as a whole and its relation to Vesalius's treatise, this image is no different from the others. A comparison between the illustrated 1543 Basel editions of *Fabrica* with the Roman editions of Valverde's *Historia* reveals that each image was transposed in strict synchronic order, and in relation to the text on each topic.[8] Although the images no longer are embedded within the text and instead are clustered at the end of each section, the order remains unchanged, and Valverde's own descriptions always refer back to the Vesalian counterpart. In effect, each is like the counterpart but has also changed, some apparently to the extent that they have become unrecognizable outside of the sequence.

The relation between the two sets of images has never been in question. In a letter Vesalius accused Valverde of stealing his images and of caring more for profit than scientific research.[9] Valverde, however, makes the case for a project of accumulative knowledge in which Vesalius and his images provide the crucial baseline.[10] For Valverde, the use of the images is crucial for the new direction in the study of the human body introduced by Vesalius and acknowledges his key role in this collective enterprise. He boldly claims that it is easier to improve Vesalius's images than to separate oneself from their prominent status. Even so, he is constantly trying to clarify the relationship between the two. In the introduction to the Spanish edition, Valverde explains that his aim is to contribute to Spanish medicine, which continued to resist new practices of dissection;[11] he then justifies the Italian edition on the grounds that people who could not read Spanish presumed that his book was a literal translation of Vesalius's treatise precisely because of the images.[12] But it is through the translation of Vesalius's images that Valverde sought to make his contribution, starting with a move toward "more readable and accommodating" images. Initially, he attributes an increased visibility for the images to their relocation from woodcut to engraving on copper, and from the space of the text to autonomous clusters at the end of each section.

Yet Valverde's larger argument that the images are neither copies nor originals, but a kind of translation,

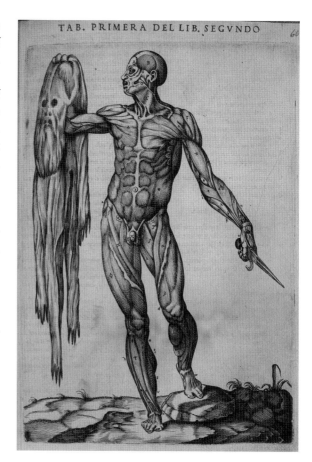

FIGURE 25

Anonymous. *Self-flaying figure.* Engraving, Book 2, Plate 1, in Juan Valverde de Amusco, *Historia de la composision del cuerpo humano* (1556). CAT. 90.

depends on the ways his images confront Vesalius's appropriation of the antique fragment. My aim is to consider how Valverde's translation of Vesalius's images take up strategies of restoration of antiquities in the *Speculum Romanae*, acknowledging both the process of dismemberment and the speculative character of reconstruction. To compare the male figure holding a knife and a sack of skin [see FIGURE 25] with its Vesalius counterpart [FIGURE 26] is to recognize that this figure has the key role of starting the process of peeling away the layers of the body from outside to inside.[13] Valverde's image turns

FIGURE 26

Anonymous. *Flayed figure.* Woodcut, p. 170, in Andreas Vesalius, *De humani corporis fabrica libri septem.* Basel: Iohannes Oporinus, 1543.

PRIMA
MVSCVLO-
RVM TA-
BVLA.

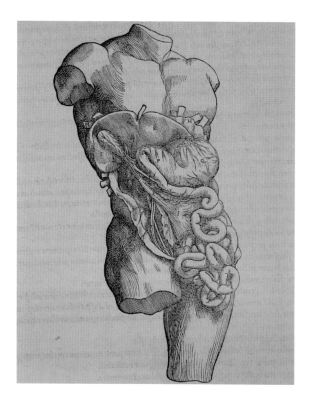

FIGURE 27

Anonymous. *Belvedere torso with stomach and intestines.*
Woodcut, p. 361, in Andreas Vesalius, *De humani corporis
fabrica libri septem*. Basel: Iohannes Oporinus, 1543.

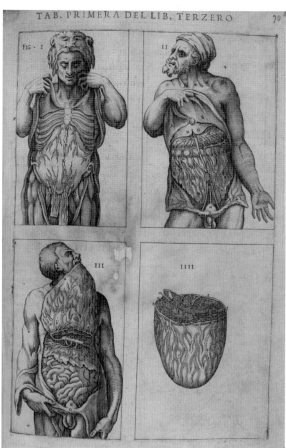

FIGURE 28

Anonymous. *Self-dissecting figures.* Engraving, Book 3, Plate 1,
in Juan Valverde de Amusco, *Historia de la composision del
cuerpo humano* (1556). CAT. 90.

the act of dissection into a narrative, arming the figure
with the means—the knife—and the results—the
removal of the skin. As with Vesalius's image, the figure
retains its classical form though its exterior surface has
been removed, and this incongruity is heightened by
the implied self-infliction of the wound. In effect, the
narrative of dissection works both to enhance the figure
and to make overt the implications of its material loss.
Leonard Barkan has argued that the restoration of antiq-
uities always entailed a double procedure since the estab-
lishment of a narrative subject for a newly unearthed
fragment was always tied to the beholder's awareness of
the process of decipherment.[14] Thus, in this instance the
move to restore the figure through a potential narrative
becomes a way to confront and ponder on the material
practice of dissection and its effects on the status of the
human body. It may well lead one to consider the myth

of Marsyas, or even St. Bartholomew, but only by first
evoking the loss of identity that comes with the breach
of bodily boundaries.

It is intriguing that in Valverde's treatise the restora-
tion of the fragmented body through narrative is accom-
panied by the consistent evacuation of ruins. The male
figure [see FIGURE 25] that starts the process of dissec-
tion is typical in being detached from a landscape of
ruins and presented against what is effectively a blank
page. Valverde's translation seems to subvert the idea of
the ruin, seeking instead to reveal the potential that the
restoration of the antique fragment might bring to
Vesalius's images. The unearthing of antique statues and
the production of anatomical prints shared an interest in
the reconception of the human body in relation to
nature and technology.[15] The setting of anatomical
figures within a ruinous landscape locates the human

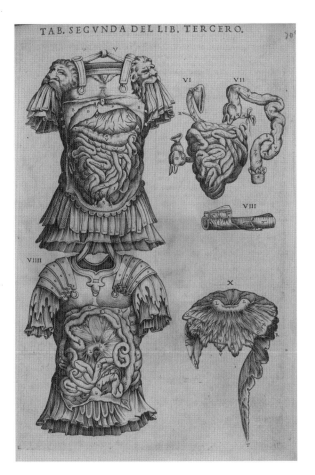

TAB. SEGVNDA DEL LIB. TERCERO.

FIGURE 29

Anonymous. *Intestinal cuirasses.* Engraving, Book 3, Plate 2, in Juan Valverde de Amusco, *Historia de la composision del cuerpo humano* (1556). CAT. 90.

body between nature and human intervention, and ruins become a reminder of human intervention in nature but also of nature's own intervention in the human achievement.[16] Horst Bredekamp proposes that unlike ruins, which hark back to the prehistoric powers of nature that oppose the mechanical, statuary provided an important site for reflecting on the crucial new relation between nature and scientific technologies.[17] In the context of the cabinet of curiosities, antiquities were categorized as fossils as well as art because they came from the ground and had undergone further transformations. Antique statuary blurred the distinction between the creative powers of god, nature, and man, and in offering a striking interface between nature and technology opened up a new relation between them.

It is always acknowledged that Vesalius's anatomical images draw on classical antiquities, and even that the antique is used to establish a normative ideal for the scientific project;[18] what has not been considered is how the stages of dismemberment of the body are both marked and contained through the use of antiquity's fragments. In each section of the treatise, the antique is appropriated in particular ways. For instance in the section that deals with the muscles, the still-animated body is contained within the idealized contours of the Apollo Belvedere. The body's new visibility, however, is evoked by the surrounding landscape of ruins, which recalls that the hidden structure of body and buildings alike is revealed through some degree of fragmentation.[19] As the treatise progresses and the body loses its coherence, the dissected parts frequently appear inserted into antiquity's most famous fragment, namely the torso Belvedere. According to Barkan, the torso gained its celebrity long after its discovery, with the many sixteenth-century attempts at imaginative reconstructions that reasserted its status as a fragment, and countered any desire to restore the actual statue.[20] In Vesalius's images, the torso enables the body part to gain visibility, both by asserting its firmness and permanence and by recalling the whole while evoking the fragment.

In Vesalius's book five, the torso Belvedere does a great deal of work to contain an increasingly fragmented body [FIGURE 27], and it is in this section that Valverde's treatise enacts its project of restoration with greatest force. The restoration of antiquities was, because of the fragmented character of the remains, quite speculative and dependent on a complicated mixture of textual sources and visual observation.[21] The desire to make the fragment speak was strong, but most antiquities retained a high level of indecipherability.[22] If the restoration of antiquities rarely reached a point of fixing meaning, it tended to activate a range of interpretations and to encourage a historical imagination.[23] Restoration as an exercise of the historical imagination is most evident through drawings and prints, in which even the torso Belvedere received multiple possible completions while retaining its status as fragment.[24] The process of change itself is frequently incorporated into this kind of imaginary restoration, for instance in many prints from the *Speculum Romanae*; in these the focus is on practices of observation, copying, and assessment, and the fragment is retained even as different restoration possibilities are attempted.

Valverde's strategies of restoration resemble those practiced in Rome, but enacted on the printed page. First, in keeping with the assemblage of small antique

fragments, the separate entities of the body found strewn throughout Vesalius's text are gathered together and organized within a single frame. The grouping is not haphazard in that it keeps to the order of the text, but the discordant items become visually integrated. The torso Belvedere is at the center of these restorations, and in each instance the torso is completed through the addition of limbs and attributes that suggest a sequence of heroic warrior figures who aggressively enact their own dissection [FIGURE 28].[25] In one case, the torso becomes Hercules, an established association due to the animal skin covering what remains of the right leg.[26] The sequence seems to suggest multiple variations on the restoration of the same fragment, with changes of headdress and costume but all implying their own participation in what might be a self-sacrifice. Two pages later there is another variation, one that evokes the Laocoön by the addition of a turned head and an arm that contains the snakelike intertwined intestines, and connects the classicizing body with physical pain.[27]

Evidently the reconstitution of the body through the restoration of antiquity could become a way to counter the fragmentation of the body through scientific procedures.[28] But it is telling that Valverde's restorations tend to stress the antique body as shaped by the violent physical struggles of war and athletics. Perhaps the most evocative example is one in which two of Vesalius's antique torsos [see FIGURE 27] and four separate body parts, all pertaining to the intestines, are brought together within one plate [FIGURE 29].[29] Each torso is translated into a Roman cuirass, the two interconnected through an internal support. The stomach and intestines are inserted into each cuirass, which itself retains the human form but recalls its absence. Together they evoke the spilling out of body parts that comes with the body's violent demise through both warfare and anatomical dissection. While the dissected part remains the same as the one inserted into the torso Belvedere in Vesalius's treatise, it now seems to pour out of the body, no longer holding its firmness and stability.

The double cuirass, one surmounting the other and implying the death and evacuation of the body, calls up the Roman war trophy, a recurrent feature in several of the prints usually included in the *Speculum Romanae*. The trophies of Marius, represented in two separate prints, are perhaps the best example [FIGURES 30, 31]. These are mentioned by Aldrovandi, who saw them in the Esquiline and believed them to have been erected in relation to violent military action.[30] The large-scale

sculptures were removed in 1590 on the order of Sixtus V and installed at the Campidoglio as part of the systematization of the space by Giacomo della Porta.[31] The trophies continue to raise much debate on their identity and history,[32] but within the *Speculum Romanae* they stand for a conception of both heroic warfare and bodily restoration. Each trophy presents an elaborate reassemblage of the fragmented body. Hung from a tree within an open field, this assemblage of armor and weapons of war takes the form of a gigantic and monstrous human body. The body is both fragmented in that it is composed of incongruous parts, and it is extended in that it is composed of multiple bodies, especially those made captive or dismembered in the process of battle. The trophy is imagined not as form of commemoration or even triumph but as a substitute warrior, planted on a battlefield in order to mark the end of violent engagement and bring into control the demons unleashed by war.[33]

How does Valverde's translation of the torso Belvedere into a kind of double body consecrated to death in warfare enable one to see and accommodate the body of medical science in a new way? Perhaps it is useful to probe further the implications of the war trophy as a site in which to address an agitated, bodiless soul. The heroic warrior who is consecrated into battle and enters into a pact with divine powers in order to save his community offers an intriguing concept through which to consider the early modern project of anatomy.[34] In Roman military ritual, if the warrior's body was lost or excessively mutilated during battle, and especially if it remained alive, then it could not be given a proper funeral because the warrior had not fulfilled his vow of death. The Romans would construct an effigy—a double—that enabled the relations between the living and the dead to be realigned. In this narrative, the dismembered body may be visualized within the honorific associations of the Roman warrior. It also raises the question of the sacrifice of the individual body for the collective good, and perhaps translates this ideal from the sacred into the secular. Yet it also produces anxieties about the implications of the dismemberment of the human body and its troubled transition into death, and makes issues of mutilation and pain an overt part of the narrative of dissection.

The idea of revealing that an unstable interiority is at work within the visual display of the human body is quite at odds with Vesalius's own project. Vesalius is famous for introducing practices of dissection that had

TROPHÆA MARII DE BELLO AMBR PVTAT AD ÆD D CVSEB ROMÆ

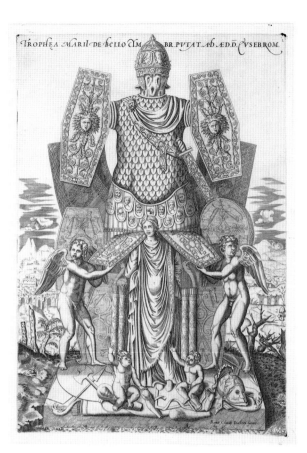

TROPHÆA MARII DE BELLO AMBR PVTAT AD ÆD D CVSEBROM

FIGURE 30

Anonymous. *Trophies of Marius*. Engraving, ca. 1581–86.
Claudio Duchetti, publisher.

FIGURE 31

Anonymous. *Trophies of Marius*. Engraving, ca. 1581–86.
Claudio Duchetti, publisher.

to negotiate visual observation of the body with the actual body's mutability.[35] Anatomical demonstrations would now use human bodies, but these were displayed only briefly since they would soon enter unpleasant states of deterioration.[36] In Vesalius's performance of anatomical dissection, the body changed from a particular corpse into categories of knowledge about the body, which were primarily conveyed through the image.[37] Vesalius's innovative use of images as a tool for study was based on the assumption of the synchronicity between text and image and by implication between image and practices of dissection. His treatise presumes the oral transmission of knowledge to a small local group of academically trained physicians and an unmediated relation between the dissected body and the image of the body.[38] Yet, while Vesalius's text openly avows his recourse to pain as a way to get to know the body, and he did demonstrations of pain reaction in live animals, and

according to some in humans, the images draw on antiquity precisely as a way to avoid such direct contact with the body.[39] As has been noted, the rituals of dissection first took apart the body, and then by transforming these parts into knowledge performed a kind of restoration. Vesalius's images also serve as a kind of restoration, seeking to produce a body that is idealized through its fragmentation but never in a state of decay or pain.

Yet the interest in the recently rediscovered Laocoön introduced a contradiction between the surface of the ideal body and the corporeal experience of pain.[40] This contradiction would become increasingly more overt, but the relation was already at work in the sixteenth century, with artistic discussions relying on the invisibility of the ideal while pain reasserted itself through its very visibility.[41] To return once more to Valverde's flayed man holding a knife and a sack of skin [fig. 25], it may now be possible to suggest why the

restoration of the figure through the narrative of Marsyas is so significant for Valverede's translation. In Vesalius's version, the figure takes the familiar idealized form of the Apollo Belvedere, the exemplar of classical beauty. By reconfiguring Apollo as Marsyas, the image raises the hidden issue of pain not only within the classical ideal but also within the dissected body.[42]

Valverde, who is said to have been less involved in practices of dissection, is in fact more attentive to the image's relation to the dissected body. In his introduction he argues for a mediated process between body, image, and knowledge precisely by addressing the problems raised by the use of actual human bodies in medical research. He insists that anatomists tend to disagree about many aspects of the body because bodies themselves are all different, corpses are in constant state of decay, and even the stages of decay in each are different. It is indicative of this insistence on an unfixed interiority that whereas for Vesalius the cut of dissection is visualized through the split in the antique body, containing the messy flesh by being turned visually into marble, for Valverde the split in the antique body is returned to the cut of dissection by revealing in it the larger blood vessels that have been severed and now leak fluids.[43] The disturbance of an idealized exterior by an embodied interior is also evident in the figures that take the form of the Apollo Belvedere and demonstrate the muscles of the body. Among the changes introduced by Valverede to Vesalius's images, the most intriguing is the disruption of the contours of the Apollo Belvedere by stressing the ragged edges of skin left by the knife's cut.[44]

As a kind of translation, Valverde's images seek to restore the antique body by animating it and returning it to a memory of its embodied state. In other words, rather than transforming the dissected body completely into categories of knowledge, Valverde's images provide a site of reflection on the contradictions involved in turning embodiment into visual representation. Perhaps Valverde's focus on the suffering and violence of embodiment is accommodated by the heroic narrative of the Roman warrior. Yet the latter itself raises anxieties about the social and religious implications of bodily dismemberment. Returning to Bredekamp's notion that the ruin and the statue represent a split between a prehistoric idea of an all-powerful nature and a historicized nature that both enacts and is enacted upon by technology, Valverde's restoration of the embodied anatomical figure can be regarded as a confrontation with the implications of this future. The restoration of the ancient statue, with its discernible gaps and uncertainties, brings new questions to a future in which knowledge of the human body, and hence disembodiment, is the starting point for the human effort to mold nature.[45] Valverde's images, arguing for the physicality of the body while working with the Vesalian tradition of constructing knowledge through visual observation, reveal that the early stages in modernity's dismemberment of the body were not without conflict.

NOTES

1. On the conjunction of fragmentation and reconstruction, see Leonard Barkan, *Unearthing the Past: Archaeology and Aesthetics in the Making of Renaissance Culture* (New Haven: Yale University Press, 1999), 209–31.

2. The 1560 Italian edition is entitled *Anatomia del corpo humano.*

3. Cynthia Klestinec, "Juan Valverde de (H)Amusco and Print Culture: The Editorial Apparatus in Vernacular Anatomy Texts," *Zeitsprünge: Forschungen zur Frühen Neuzeit, Band* 9 (2005): 78–94; on Vesalius and his treatise, see Andrew Cunningham, *The Anatomical Renaissance: The Resurrection of the Anatomical Projects of the Ancients* (Aldershot, UK: Scolar Press, 1997), 88–148; Glenn Harcourt, "Andreas Vesalius and the Anatomy of Antique Sculpture," *Representations* 17 (1987): 28–61.

4. Klestinec, 78.

5. Klestinec, 91.

6. Susan Wolf, "Peeling off the Skin: Revealing Alternative Meanings of Valverde's Muscle Man," http://www.bronwenwilson.ca/body.catalogue; Stephanie Nadalo,

"Armed with Scalpel and Cuirass: Violence, Masculinity and Juan de Valverde de Amusco," http//anatomyof gender.northwestern.edu/essays01.html.

7. Lola Szladitz, "The Influence of Michelangelo on Some Anatomical Illustrations," *Journal of the History of Medicine* 9 (1954): 420–27.

8. Andreas Vesalius, *De humani corporis fabrica libri septem* (Basel: Johannes Oporinus, 1543).

9. Klestinec, 83–87.

10. Valverde, in unpaginated preface to reader.

11. Valverde, in the dedication to Giovanni da Toledo, Cardinal archbishop of Santiago, dated Sept. 13, 1554.

12. Valverde, 1560; in the dedication to Phillip II, dated May 20, 1559.

13. Vesalius, "Prima Musculorum Tabula," in *De humani corporis fabrica*, 170; Valverde, book 2, plate 1.

14. Leonard Barkan, "The Beholder's Tale: Ancient Sculpture, Renaissance Narratives," *Representations* 44 (1993): 136–38.

15. Simon Richter, *Laocoon's Body and the Aesthetics of Pain* (Detroit: Wayne State University Press, 1992), 16.

16. Michael S. Roth, *Irresistible Decay: Ruins Reclaimed* (Los Angeles: Getty Research Institute, 1997), 2.

17. Horst Bredekamp, *The Lure of Antiquity and the Cult of the Machine: The Kunstkammer and the Evolution of Nature, Art and Technology*, trans. Allison Brown (Princeton, NJ: Markus Wiener Publishers, 1995), 11–19.

18. Harcourt, 53.

19. Roth, 2.

20. On the torso Belvedere, see Barkan, *Unearthing the Past*, 189–203.

21. On restoration of antiquities, see Barkan, *Unearthing the Past*, 173–207; Richard Brilliant, *My Laocoön: Alternative Claims in the Interpretation of Artworks* (Berkeley: University of California Press, 2000), 29–30; Michael Koorbojian, "Pliny's Laocoön?" in *Antiquity and its Interpreters*, ed. Alina Payne, Ann Kuttner, and Rebekah Smick (Cambridge: Cambridge University Press, 2000), 199–216.

22. Barkan, "Beholder's Tale," 133–34.

23. Barkan, *Unearthing the Past*, 207.

24. Barkan, *Unearthing the Past*, 174.

25. Valverde, book 3, plate 1.

26. Barkan, *Unearthing the Past*, 191–92.

27. Valverde, book 3, plate 3.

28. Harcourt, 52.

29. Valverde, book 3, plate 2, p. 95; Vesalius, 360–64; see Harcourt, 61n60; and Nadalo.

30. Ulisse Aldrovandi, *Delle statue antiche, che per tutta Roma, in diversi luoghi, & case si veggono,* in Lucio Mauro, *Le antichita de la città di Roma* (Venice: Giordano Zileti, 1558), 72.

31. On the history of the trophies, see Giovanna Tedeschi Grisanti, *I "Trofei di Mario": Il Ninfeo dell'acqua Giulia sull' Esquilino* (Rome: Istituto di Studi Romani, 1977); Gilbert Charles-Picard, *Les trophées Romains: contribution à l'histoire de la religion et de l'art triomphal de Rome* (Paris: E. de Boccard, 1957), 350–524.

32. Grisanti, 52–55.

33. On trophies and their associated practices and meanings, see Charles-Picard, 16–133.

34. I draw here on Giorgio Agamben's argument about the sacred being both within and outside the law; see *Homo Sacer: Sovereign Power and Bare Life*, trans. Daniel Heller-Roazen (Stanford, CA: Stanford University Press, 1998), 91–99.

35. Cunningham, 102–14; Luke Wilson, "William Harvey's *Prelectiones*: The Performance of the Body in the Renaissance Theatre of Anatomy," *Representations* 17 (Winter, 1987): 73–74.

36. On anatomical demonstrations, see Wilson, 63–73.

37. Wilson, 63.

38. Klestinec, 82–87.

39. Harcourt, 35–38; Richter, 32–33.

40. Richter, 14.

41. Richter, 32.

42. Richter mounts this argument in relation to the avoidance of Marsyas in eighteenth-century aesthetic discourse on antiquity; see pp. 34–35.

43. For example, Valverde, book 3, plate 5.

44. Valverde, book 2, plate 2.

45. Bredekamp, 18.

REBECCA ZORACH

THE PUBLIC UTILITY
OF PRINTS

MANY INSCRIPTIONS FOUND on antiquarian engravings in the later sixteenth century speak of a certain pride in making. An engraving by Diana Mantovana, after a drawing by her husband Francesco, contains an unusual turn of phrase: on this acanthus scroll design appear the words "Francesco, Citizen of Volterra, formed it for public utility, and Diana His Wife engraved it in Rome in 1579"[1] [FIGURE 32].

In this essay I will explore an assertion that print-makers in the mid- to late sixteenth century started making about their work, an assertion evident in this print and in several items in the *Virtual Tourist* exhibition: the idea that prints served something artists and publishers called "public" or "common" utility. One way of thinking about prints and the public is in the very basic sense of publishing: these printmakers and publishers distributed their work to something we could call a public. I also mean it in a somewhat stronger sense: they produced a sense of that public with their evocation of it, and they claim to be producing a public good. Is this a public good that has utility beyond that of the artists, architects, and antiquarians who are the most obvious audience for such images?

The notion of a "public" first seems to appear in relation to this more limited group. Another print by Diana and Francesco is inscribed, "This volute from an ancient capital of a Numidian stone column of the composite order, in St. Peter's in the Vatican, was drawn by Francesco da Volterra and Baptista di Petra Santa for the common utility of scholars of this art. Diana Mantuana, wife of the same Francesco, engraved [it] in Rome. 1576" [FIGURE 33]. A late engraving by Antonio Salamanca announces itself as an image of Pyrrhus that Salamanca engraved on his own copperplate and "brought into the light," i.e., published, "for the public utility of scholars" [FIGURE 34]. Nicolas Béatrizet's impressive double-sheet print of a battle of men with Amazons has an inscription that reads, "A cleverly contrived battle of Amazons from a most ancient sarcophagus which is seen in the Campidoglio, and Nicolas Béatrizet engraved it in copper plates and brought them into the light in his own shop and at his own expense for the common utility of all those who delight in ancient things" [FIGURE 35, CAT. A100, A101]. Such statements often insist on the expenditure, which presents the printmaker/publisher as engaging in a sort of largesse; Béatrizet's instance is also interesting in its mention of the viewer's pleasure.

It was certainly not unusual for prints after antiquities to be expressly *marketed* for the use of other artists. Hieronymus Cock's 1551 *Praecipua monimenta*[2] are addressed (*designata*) for the imitation of the real ("ad veri imitationem"). The idea seems to be that these images will serve as direct designs or more indirect inspiration for artisans working in other media. A set of ruins published by another Antwerp publisher, Gerard de Jode, is presented even more explicitly as "useful to

FIGURE 32

Diana Mantovana (engraver), after Francesco da Volterra (designer). *Arabesque Scrolls.* Engraving, 1579. Bound with Antonio Lafreri, *Speculum Romanae Magnificentiae,* Exhibit B/Folio B/MR 512. Yale Center for British Art, Paul Mellon Collection.

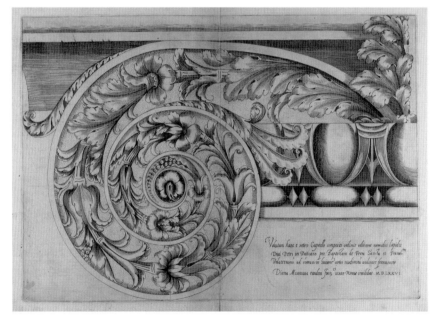

FIGURE 33

Diana Mantovana (engraver), after Francesco da Volterra (designer). *Volute from St. Peter's.* Engraving, 1576. Bound with Antonio Lafreri, *Speculum Romanae Magnificentiae,* Exhibit B/Folio B/MR 512. Yale Center for British Art, Paul Mellon Collection.

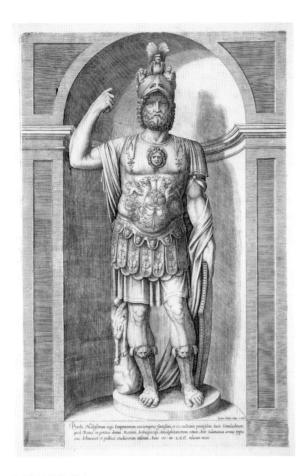

painters and other artisans."[3] This is a kind of "public"
or "common" utility, but it is a very specialized one.

We might simply understand these prints as having
been associated with knowledge. The language of
"public good" or "utility" is not unusual in dedications
and introductions to many antiquarian and scientific
books.[4] With regard to images, though, it seems to be a
new rhetoric in the second half of the sixteenth century,
and especially the last decades of the century. It seems
especially unusual that an ornamental print, like the one
with which I began, would be presented as a matter of
"public utility." In what way are such prints devised for
purposes of common good? What kind of an assertion
is it on the part of the designer and printmaker?

To help address this question I turn to a rather
neglected historical source for how prints were received
and understood in the sixteenth century: books that
incorporate copies of prints. Examining the practices and
statements of those who copied and incorporated prints
originally made by others into their own work can give
us information about the prints' reception, and about the
attitudes and practices of collectors. By looking at how
prints were reused in books, how they were framed and
discussed, we can get a better sense of how people
thought about collecting prints and about how the visual
image could be a contribution to knowledge—and
pleasure. For, certainly, along with assembling them into
albums, another way to "collect" prints was to copy
them. It is thus helpful to examine authors like Jean-
Jacques Boissard, whose volumes of the *Topographia* can

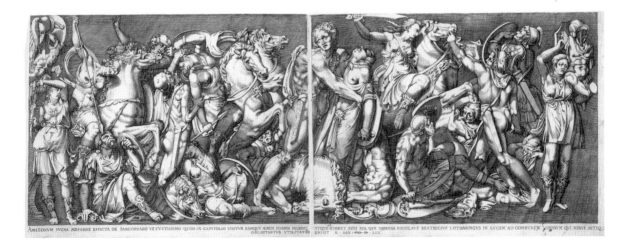

be considered a collection, of images as well as texts. Such projects offer us one of the best ways to get at what buyers and collectors might have been thinking about when they collected and viewed prints.

While artists drawing antiquities and disseminating them in print must have considered printed images as sources of knowledge and tools for practice much earlier—from the end of the fifteenth century—for learned antiquarians this acknowledgement came later, and with a dose of ambivalence about the pleasures of the visual. In the sixteenth century, especially in the first half of the century, it was not universally accepted that images could be a valid source of knowledge. Learned antiquarian guidebooks before the 1540s, when Lafreri began publishing his prints, were largely unillustrated. It has been argued that fifteenth-century scholarly authors like Leon Battista Alberti were especially suspicious of images because the accuracy of copying of images in manuscript culture could not be guaranteed.[5] Even early humanist culture's hostility to images as vehicles of knowledge can be exaggerated (manuscripts of Alberti's own *Ludi matematici,* for instance, are copiously illustrated).[6] It is true that many of the most prestigious antiquarian editions, particularly those written in Latin, often did not include images. And even if they did, they sometimes downplayed their historical value: In the first edition of Lazare de Baïf's essays on ancient material culture to include a comprehensive program of images drawn from ancient monuments [see CAT. 9], the publisher, Charles Estienne, suggests that, even though the images are derived from Roman monuments, the artisans who produced the monuments themselves may have worked more from their own fantasy ("ad libidinem artificis") than from "the truth." Thus the reader should trust the text—the modern text—whenever there is a discrepancy.[7] Around the same time, however, Thomas Elyot expressed the view that "a man shal more profite, in one wike, by figures and chartis, well and perfectly made, than he shall by the only reding or heryng the rules of that science."[8] Elyot almost seems to echo the Biblical passage Mark 8:36, "For what shall it profit a man, if he gain the whole world, and suffer the loss of his soul?"—as if images might be understood as the very soul of knowledge.

Thus, perhaps sixteenth-century authors were not so opposed to images when images operated appropriately to convey knowledge. In the vast panorama that is the landscape of printed antiquarian images in sixteenth-century Rome, tensions emerge between images made for purposes of knowledge and those that convey empty pleasure. From the mid-sixteenth century on, antiquarian images like those in the *Speculum* circulated in print among illustrated books, print series, treatises, guidebooks, and print collections. Among the earlier Latin guidebooks, Bartolomeo Marliani's *Vrbis Romae topographia* (Topography of the city of Rome) provides an index of the use of images. The book was first published in 1534, without images; François Rabelais had planned to produce his own guidebook to Rome but liked Marliani's so much that he had it reprinted in Lyon in the same year [see FIGURE 75, CAT. 62]. In 1543 and 1544 two nearly identical editions with woodcuts were printed in Rome by Valerio and Luigi Dorico. The second differed mainly in possessing a dedication to King Francis I of France. The woodcuts appear to have been a point of pride for the author and/or publisher; they are mentioned specifically in the papal privilege, which not only forbids pirated editions of the book, but also forbids the sale of images separately from the book.[9] The set of images did not comprehensively illustrate the volume, but rather offered paradigmatic examples of certain types (obelisk, triumphal arch, bridge, etc.), along with statues and reconstructed plans of some of the major monuments.[10] By the 1588 edition [FIGURE 36, CAT. 23], the text was endowed with many more images, now smaller woodcuts mostly copied from various sources (including Lafreri) and, in many cases, shared with the pilgrim guidebook also published in 1588 by Girolamo Franzini, *Le cose maravigliose* [see CAT. 43].

In the 1544 text, Marliani provides a defense of his particular method of representation in his bird's-eye map of ancient Rome. He justifies the absence of certain pleasurable features, notably perspective, arguing that his mode of representation is the best way to provide correct topographical information:

> if we had wished to erect this figure, and the following ones, according to natural perspective, it would have happened that, with all sides of the hills (except one) hidden, it would have been impossible to place the buildings on their sites. Therefore since we thought it better for the common use of all to facilitate consultation rather than to delight certain viewers with an inane picture, we placed the figures flat. We took care moreover to shade the sides of the hills according to their altitude, so that the valleys would thereby be easily distinguished.[11]

Writing in the wake of the High Renaissance, he responds to assumptions about what images should do, and especially what kinds of pleasure they should provide, but stakes a claim to the use of other representa-

LIBER

tur Senatus, arietesque immolabantur. Palatij vetus pòrta ad quam bello Sabino fusos esse Romanos commemorat Liuius, fuit prope Rostra, & si quis ad illius verba diligenter attenderit, nullibi, quam eregione ædis Diui Laurentij in Miranda existimabit. Quidam hanc Romuli portam appellant. Palatinus autem collis præter vnam, atque alteram domunculam, & ædem. S. Andreę prædictam, nullum nunc habet ędificium : totus enim vinetis plenus, aut pascuus ager, non onibus magis, quam caballis, & capris est relictus, vt verè Balantium possit nominari .

De Templo Iani, Augusti, & Faustinæ.
CAP. VIII.

VAR TAM partem situs Vrbis aggredientes, à rebus diuinis, diisque immortalibus principium facturi rite videmur, in primisque ab eo, qui omnium rerum ianua habetur, hoc est à Iano, cuius tęplū, præter Capitolinū, aliud in foro Trāsitorio fuisse, sic probat Ser. Captis Faliscis, ciuitate Thusciæ, inuentū est simulacrū Iani cum frontibus quatuor, (fuerat enim bifrons apud theatrum Marcelli) vnde quod Numa in-

FIGURE 36

Anonymous. *Temple of Antoninus and Faustina.* Woodcut in Marliani, *Vrbis Romae topographia* (1588). CAT. 64.

tional systems for purposes of providing correct information in contrast to "inane pleasure."[12] It is also noteworthy that he positions his approach in opposition to "natural" perspective: this image is artificial, but by that token is better able to serve didactic purposes.

After Marliani, the next event of note in illustrated guidebook publishing was the 1565 quarto publication of Bernardo Gamucci's *Antichità*. This was the first and best (in the sixteenth century, at any rate) of the vernacular illustrated type, and one of the more ambitiously illustrated guidebooks of the whole century, with a thoughtful program of illustrations that seem to have been based on drawings by Giovanni Antonio Dosio.[13]

The same woodcuts were also reprinted for the octavo edition of Gamucci's text [FIGURE 37, CAT. 47], in which many of them (originally produced for the larger quarto) are printed sideways.[14]

Gamucci and his publisher, Giovanni Varisco, provide a fair amount of commentary on the value of the image program, in terms of both pleasure and knowledge. Varisco indicates that the images (*disegni*) are a true portrait (*vero ritratto*) of Rome, provided for the greater satisfaction of the reader and clarity of the work.[15] In his dedication to Francesco de' Medici, Gamucci indicates that a major benefit of the marvel of printing is the dissemination of knowledge of the artifacts of the ancients, specifying statues, medals, and tombs.

He also addresses the value of eyewitness with respect to the actual monuments (one must thus make a distinction between the value perceived in viewing the monuments and that perceived in viewing images of them). Gamucci says in his dedication to Francesco de' Medici that he has derived the monuments "not only from the worthiest Authors, but from their relics dispersed in diverse parts, and from their dusty fragments, however much ravaged by voracious time and variable fortune."[16] Depending on the audience, guidebooks are *about* their images, because they have a function of allowing visitors to navigate by monuments and to recognize them as they go. Since many guidebooks were published in Venice, their authors and publishers were perhaps especially inclined to insist on the fact that their information was based on an actual visit to Rome, not just on other books, and on the actual visual perception of the monuments.[17] When he discusses the Circus Maximus, Gamucci seems to take direct aim at the approach of Pirro Ligorio, who had reconstructed the monument [FIGURE 38, CAT. A48]. Gamucci insists that he presents the monuments as they are, without attempting what he implies would be a questionable reconstruction. He says the same of the trophies of Marius: "The reader should not marvel if I do not show it complete, because my intention is to represent things as they appear now, not as they were supposed to have been in ancient times."[18]

Over time, one of the consequences of the dissemination of prints and their incorporation into books seems to have been a changing view of image-text relations and an increasing reliance on visual images as a form of knowledge. Readers became more accustomed to seeing them within texts, and authors and publishers to incorporating them. Discussion of the proper balance of scholarly knowledge and visual images appears in

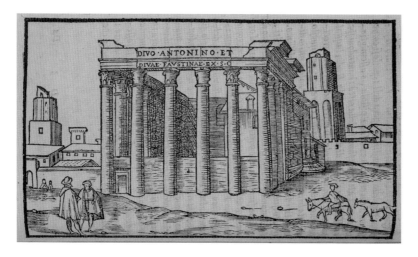

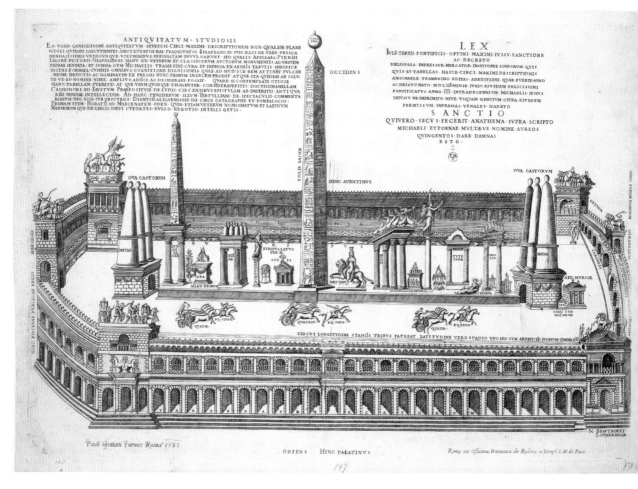

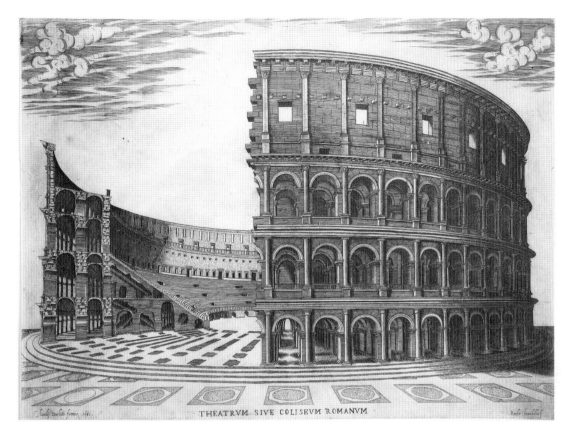

THEATRVM SIVE COLISEVM ROMANVM

FIGURE 39

Ambrogio Brambilla (etcher). *The Colosseum.* Etching, 1581. Claudio Duchetti, publisher. CAT. A29.

several other late-sixteenth-century books that appear in the exhibition. Cornelis de Jode, in his preface to Panvinio's *De triumpho,* states that only when the commentary is attached to the images will they give full satisfaction to scholars; Justus Lipsius acknowledges that his focus in *De amphitheatro* has been on historical accounts of ceremonies conducted in Roman amphitheaters, and not on architecture, but hastens to add that visual images have their place as well.[19] And the works of Vincenzo Scamozzi, Louis de Montjosieu, and Jean-Jacques Boissard engage even more directly with the question of utility in works of art.

Knowledge and Pleasure

The effects of the image in the realms of knowledge and pleasure are not necessarily (at least theoretically) in conflict: speaking of antique objects, many authors cite the Horatian topos of pleasure and profit, or the notion of "honest" pleasure. But in practice, tensions do arise.

Sometimes unreliability is also associated with the viewer's pleasure, as well as the artist's, and reliability with the renunciation of certain kinds of pleasure.

The prints published by Lafreri, certainly, seem designed for both purposes, but lean more heavily to the side of knowledge. They are not uniform in the approach to knowledge; as the title page notes, some of the monuments have been reconstituted in their ancient state, whereas others are presented as they are now. Gamucci, as we saw, makes a point of not reconstructing when there is too little information to go on. Dosio's title page also makes explicit the depiction "hodie cernuntur," as they are seen today, echoing Gamucci's statements in favor of representing monuments as ruins in the name of greater accuracy. On the further end of the spectrum are the views of ruins by northern artists such as Hieronymus Cock. These seem to convey a sense of moral decay even as they construct a world of wild, picturesque beauty into which the viewer can enter freely. They could hardly be more different from the clean outlines of the woodcuts in Marliani, or Lafreri's

COLOSSÆI RO A BARBARIS
DIRVTI , PROSPECTVS · I ·

·A·A·

CÓCK·FECIT·

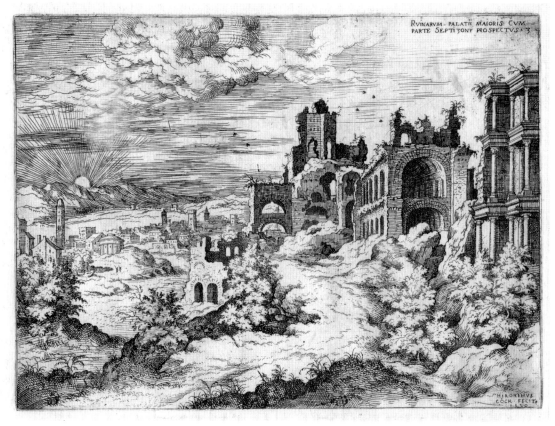

RVINARVM · PALATII MAIORIS CVM
PARTE SEPTIZONY PROSPECTVS · 3

HIRONIMVS
CÓCK·FECIT·

precise engravings [FIGURE 39, CAT. A29]; compare this to one of Cock's etchings of the Colosseum [FIGURE 40, CAT. B211]. Cock's works are *picturesque* in the most precise sense: they are designed to be reused by painters. They are also picturesque in the broader sense, proposing an atmospheric aesthetics of the ruin of a sort that modern art historians associate with eighteenth- and nineteenth-century art. Indeed, Cock's prints can look astonishingly modern: for instance, an etching of the Forum with the Septizonium [FIGURE 41, CAT. B222], with its dramatic burst of setting sunlight.

Cock emphasizes atmospheric qualities of sky and foliage and offers a landscape dotted with fragments and sometimes with fanciful inhabitants. These qualities are not entirely absent from Lafreri's production, though more often his prints are engravings based on very precisely measured drawings. The architecture is, generally speaking, "cleaned up" and geometrized so as to provide an unimpeded view of its features and proportions. The importance to the makers of these images of accuracy in measurement is manifest not only in exhaustive numerotation of dimensions and proportions of various kinds, but also in the textual inscriptions on the prints, which very frequently invoke accuracy with such phrases as *accuratissime delineata* ("drawn most accurately," for instance, in Étienne Dupérac's reconstruction of the port of Ostia[20]). Measured images often present reconstructed views of monuments, but some are views of relatively intact monuments such as the Vatican obelisk or the Pantheon. Measurements, whether real or conjectured, fueled debate on such topics as the authority of Vitruvius and the calendrical uses of the obelisks.[21]

With the sophistication of printed images themselves, sensitivity to their role in producing visual knowledge developed.[22] Eyewitness experience of the monuments themselves might be best, but Antonio Labacco provides a statement of the value of printed images in his book on architecture: his drawn reconstructions, he writes, "would be very useful for scholars

of architecture, as it is clear that the greater fruit is to be had in a short time with good exemplars [i.e., seeing them visually] than one would get from reading about them at much greater length."[23] As Peter Parshall has pointed out, if an image could be claimed as an objective rendering of a natural fact, an argument might be made (successfully or not) that it should exist in what today we would call the public domain.[24] It may be for this reason that Lafreri's prints sometimes include picturesque or folkloric elements [see FIGURE 14], populating their foregrounds with animals, passersby (sometimes in ancient Roman dress), and artists and antiquarians. This might have been a way of establishing authorial inventiveness (and thus intellectual property) while copying others' works and without sacrificing the reputation of antiquarian accuracy.

Cock's work seems to aim more for pleasure (if a kind of melancholic pleasure) than for knowledge, whether in the richly detailed irregularities of the landscape or in the dramatic possibilities of the spontaneous etched line. They depict, but they go beyond depiction into a very modern-seeming realm of painterly (designerly) abstraction, blurring the boundary between the natural and the artificial. Later iterations of this visual vocabulary produced in Cock's workshop would tone down the effects of line, as the van Doetecums submitted these motifs to a system of etched lines that more closely mimic the labor of engraving. Their views have a harder, almost enameled surface effect—still a world of fantasy, but a more rigid and protected form of fantasy. The status of the early Cock views as pure form—free beauties, to use Immanuel Kant's vocabulary—may, perhaps, have been uncomfortable to viewers.

These prints elicited not only copies but also learned commentary. Vincenzo Scamozzi's 1582 *Discorsi sopra l'antichità di Roma* can give us some insights into responses to visual pleasure and its relationship to architectural and antiquarian information conveyed in prints (or thought to be conveyable in prints) in the late sixteenth century. As the editor Girolamo Porro tells us in his dedication, he took prints by Giovanni Battista Pittoni—these were reversed and smaller copies, published in 1561 in Venice, of the *Praecipua monimenta*— and commissioned what today we would call a scholarly apparatus from Scamozzi [FIGURE 42, CAT. 81]. He suggests a priority of discourse over the image, or at least over a certain type of image: given the nobility of architecture and the marvelousness of the architecture of Rome,

FIGURE 40

Hieronymus Cock (etcher). *Roman Colosseum*. Etching, 1551. Hieronymus Cock, publisher. CAT. B211.

FIGURE 41

Hieronymus Cock (etcher). *View of the Palatine with the Septizonium*. Etching, 1551. Hieronymus Cock, publisher. CAT. B222.

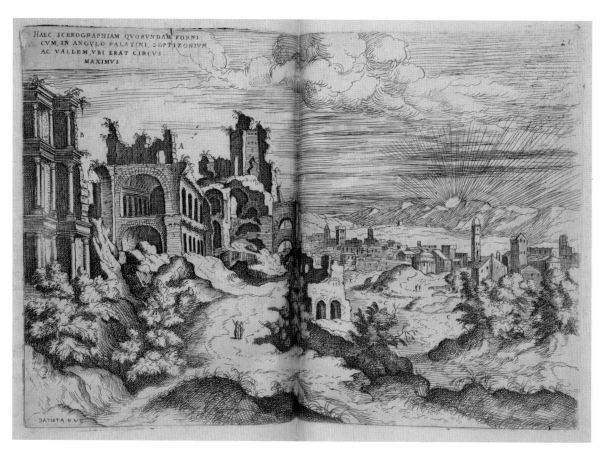

Within the image:
HAEC SCENOGRAPHIAM QVORVNDAM FORNI
CVM, IN ANGVLO PALATINI SEPTIZONIVM
AC VALLEM, VBI ERAT CIRCVS.
MAXIMVS

BATISTA P V E

FIGURE 42

Giovanni Battista Pittoni, the elder (etcher), after Hieronymus Cock. *View of ruins on the Palatine.* Etching in Scamozzi, *Discorsi sopra l'antichità di Roma* (1582). CAT. 81.

I resolved for the common benefit of the world to print some designs of ruins of the most famous edifices of triumphal Rome, drawn in copper by Messer Battista Pitoni of Vicenza, which up until this point have principally been able to serve those painters, who delight in imagining landscapes for their works.[25]

Porro's hope is to broaden the audience, providing a way to derive knowledge while experiencing pleasure. "It appeared necessary to me," he writes, further, "to give spirit to these designs with some declaration, so that they might help not only painters, but also architects."[26] For this reason he called on Scamozzi, who

> in a few days enriched these plates with beautiful discourses of the building of Rome. . . whence the work will be published not only for pleasure, but also to help scholars of venerable antiquity, since messer Vincenzo has countersigned with letters all the parts of the ruins of these buildings that are contained in forty plates. . .[27]

Scamozzi's annotations themselves often veer into theoretical abstractions and historical digressions that are not necessarily closely tied to the particular images on which he is commenting. Because the Cock/Pitoni prints often present multiple views of a single set of ruins, they leave Scamozzi by the end of the series at a loss for new things to say about them, since, in fact, they do not present a wealth of precise architectural information. It seems his approach is summed up in a statement he makes that one must trust reason as opposed to the senses in understanding ancient buildings, because the senses can be deceiving. Even so, the logic of the writing ends up being driven by the choice of pictures.

Scamozzi ends with one print that he cannot identify, which he can entitle only "some antique vaults."[28] And here he seems to allow pleasure to win out over knowledge. "It could be," he says, "that this plate was drawn from some antique thing which I have no memory of having seen, but it is much more likely

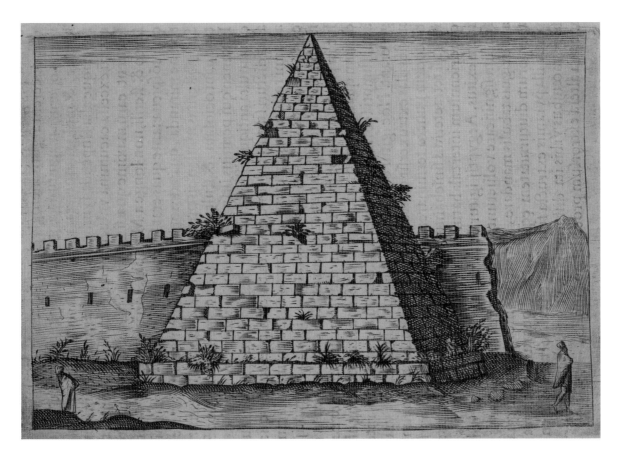

Anonymous. *Pyramid of Cestius.* Engraving in Montjosieu, *Gallus Romae hospes* (1585). CAT. 71.

that was made from pure caprice: for he who would never tire of drawing accurately every single thing from antiquity, would only be one who doesn't know how to invent anything beautiful."[29] Repeated precise rendering of antiquity turns out to be exhausting. Thus, Scamozzi's project is not merely one of rationalizing the ruin, but of allowing for fictive invention. He thinks these vaults might be "near the marina of Baia," where the terrain is rough; perhaps, he suggests, it was not possible for the artist to go there. So, Scamozzi conjectures, perhaps "he contented himself with drawing the invention, to which he added (as they say) more of himself, than of the truth; not really remembering the thing truly. We present it as it is, and we leave it to the judgment of the viewer to decide what's the case."[30] Scamozzi thus makes a concession to pleasure, an acknowledgement of the tedium of careful rendering of "the real." He adds, too, a pedagogy of viewing, but also of making. He shows how the picturesque can be rationalized,

then ends with a case that is left to the viewer's own judgment. This invitation to the viewer suggests that the picturesque prints are useful in their very *non finito*—they call out for completion, in the imagination, or in the form of an architectural inspiration that can reconstruct and use these ruins to its own ends.

The Uses of Monuments, The Animation of Prints

A French traveler to Rome, Louis de Montjosieu, though he takes a very different approach, echoes Scamozzi in his emphasis on usefulness. His 1585 *Gallus Romae hospes* [FIGURE 43, CAT. 71] provided idiosyncratic interpretations of certain Roman monuments, based in some cases on reconstructions drawn from Marliani in particular, as well as on illustrations taken from other prints [FIGURE 44]. In the first volume, Montjosieu

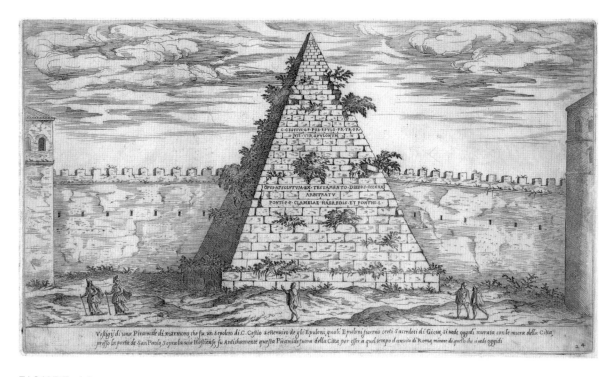

FIGURE 44

Etienne Dupérac (designer, etcher). *Pyramid of Caius Cestius,* in Dupérac, *Vestigi* (1575; 1621).

provides interpretations of Roman monuments; in others, he describes ancient painting and sculpture techniques, and reconstructs the Pantheon. Montjosieu employs images borrowed from Marliani, Dosio, and Dupérac. In some cases, he uses borrowed images to produce new knowledge.

As Montjosieu describes it, while wandering through the city of Rome, he marvels not only at the ruined monuments, but also at the fact that nobody seems to know what they were for. Montjosieu begins his text by describing his own experience as a visitor to the eternal city.

> While spending time in Rome I contemplate the relics and fragments of ancient works which everywhere are obvious to the wanderer. In some of them I praise the artifice, in others I admire the sheer size, and from many of them I recall to mind the customs of the ancients. But when I investigate the purposes of each one, I had this difficulty in the case of a good many, that when I turned my attention to some great monument made by the ancients, I saw that its use, still, was everywhere unknown. I am not speaking of obscure ones: but even of those celebrated by authors, and whose forms, published in print, are distributed [*versantur*] to the eyes of all.[31]

The forms may be familiar, but there is confusion about the *purpose* of the buildings. This purpose, then, Montjosieu sets out to investigate. He approaches antiquity with all the drama of a detective story. He reasons that monuments constructed at great cost and with admirable artifice could not have been without purpose, or only to serve imperial egos, as many believed. Speaking of the obelisks and pyramids, he describes Pliny's view on the pyramids: that they represent royal vanity. Montjosieu does not find this explanation plausible. "It doesn't seem likely to me, that over a long time and at immense cost such giant monuments were built for no purpose. And especially by the Egyptians, among whom learning flourished greatly."[32]

There are two possible purposes, he believes, that possess enough "mystery" and "dignity": *religion* and *time*. Quickly dispatching religion, he enters into a long discussion of the ancient calendar. Now, it is worth noting that, although Montjosieu does not once mention it, the Gregorian calendar was instituted in 1582.[33] The technicalities of timekeeping were, one might say, in the air. Our author claims that pyramids and obelisks, with their four sides terminating in one point, represent the corrections made to the calendar by the Egyptians,

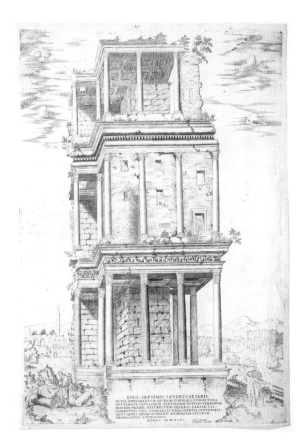

FIGURE 45

Anonymous. *The Septizonium*. Engraving, 1546. Antonio
Lafreri, publisher. CAT. A11.

FIGURE 46

Anonymous. *View of the Septizonium*. Engraving in
Montjosieu, *Gallus Romae hospes* (1585). CAT. 71.

adding a day to the calendar every four years to correct
for the lag caused by the solar year. Four sides, one point:
four years, one day. These monuments thus, Montjosieu
argues, served as a counting method.

The same turns out to be true of the Septizonium,
the mysterious monument built by Septimius Severus
that stood near the Roman forum until Sixtus V had it
demolished in 1588–1589 in order to quarry its marble;
it was used for building materials for many other mon-
uments in Rome. It appears in its ruined state in a large
print published by Lafreri [FIGURE 45, CAT. A11] and later
copied by Brambilla for Duchetti [see CAT. A34];
Montjosieu reconstructed it in his book [FIGURE 46,
CAT. 70].[34] Speaking of this building, Monjosieu begins
by complaining, "It's ridiculous the things that circulate
about the Septizonium."[35] He argues that it must be
possible to get to the bottom of the enigmas buried
within it, but first one must "reconstruct it graphically."

FIGURE 47

Anonymous. *Plan of the Septizonium*. Woodcut in Marliani, *Vrbis Romae topographia* (1550). CAT. 63.

FIGURE 48

Anonymous. *Plan of the Septizonium*. Engraving in Montjosieu, *Gallus Romae hospes* (1585). CAT. 71.

Montjosieu reconstructs it graphically via a direct copy of Marliani's plan of the building [FIGURE 47, CAT. 63] with the sole addition of one column [FIGURE 48, CAT. 71] for a total of nineteen. The nineteen columns, he asserts, refer to the Metonic cycle of the ancient calendar, nineteen years being the smallest number of solar years that corresponds very closely to a whole number of lunar months. Thus, the Septizonium served the function of indicating when it was necessary to add extra months to the calendar. This assertion rests on a borrowed image, creatively interpreted by the author via his altered version of it.

In spite of the fact that most of his images came from other sources, Montjosieu claimed a very specific printing privilege for the images. The privilege prohibits anyone from "printing the work or having it printed, or engraving or having engraved the figures already existing in the work or those which will be published separately by this same Louis, in copper or wood, or to sell the work or the images, or to hold for sale or display the work or the images."[36] In this respect he follows Marliani's lead, but in more explicit language that suggests that Montjosieu himself will print and distribute images separately from the book. Most of the images are copies. Yet in addition to considering buildings from the point of view of utility, Montjosieu also considers prints from the point of view of knowledge. His images are not merely depictions; they are arguments, especially in the case of images like the Septizonium one that reconstruct monuments according to his interpretive agenda.

Public utility is a growing theme in antiquarian texts and images in the last two decades of the sixteenth century. In part, this relates to architecture and public works, and a sense of the public domain. In terms of their public relevance, it is easy to make the argument that prints reached a more geographically diverse public than most paintings. At the same time, though, they were largely apprehended in private. Printmakers, I think, borrowed ideas about public utility from public sculpture and, particularly, architecture, as a way of asserting a new kind of public for themselves.

One analogy for this late-sixteenth-century discourse on the public utility of prints comes much earlier in the century, in a text that cites the benefits of the public use of mathematical knowledge, but also, somewhat surprisingly, relates to public space. Luca Pacioli, writing texts on mathematics in the vernacular, speaks of the *public utility* of doing so. The current shortage of good astronomers, he says, is the direct result of a

FIGURE 49

Nicolaus van Aelst (etcher). *Fountain of Marforio in the Campidoglio*. Etching, 1600. Biblioteca Apostolica Vaticana Stampe VI.2, plate 6. With permission.

FIGURE 50

Giovanni Maggi (etcher). *Fountain of Marforio in the Campidoglio*. Etching in Maggi, *Ornamenti di fabriche antichi* (1600), bound with CAT. 19.

general lack of mathematical knowledge. Moreover—perhaps more interestingly—he very clearly associates the best knowledge with public space. Practical mathematical methods like long division should be learned in the public square (*le piazze in luochi publici maxime da communita deputati*), not in some godforsaken village from the local ignorant "Abacook" (*abacotto*).[37] For Pacioli, putting information into the public domain ensures a certain quality control.

If it seems obvious that mathematical discoveries would be immediately considered common property (though not by everyone: Pacioli was himself accused of plagiarism), the fact that antiquities were prized both for the knowledge they imparted and also for their value as collectibles creates a certain tension. As collections of antiquities flourished in late-Renaissance Rome, many owners of these treasured objects made them available to scholars and travelers (and Boissard praises their public-spiritedness); others were not so generous.[38]

The language of city planning also feeds the theme of public convenience. One of Nicolaus van Aelst's large prints of Roman sights provides a good example of this discourse [FIGURE 49]. With their "visitur" headings ("it is seen") Van Aelst's prints highlight the act of seeing to an unprecedented degree; to many Renaissance viewers the word must have hinted at the touristic act of *visiting*, as well. The reinstallation of a reconstructed "Marforio," now appearing as a river god at the head of a fountain at one side of the Campidoglio in 1595, displays the monument's own inscription: "Clemente VIII pont max fontem aquae faelicis/Publice Comoditate MDLXXXXV" (Pope Clement VIII [placed] this fountain from the Aqua Felix for public convenience in 1595).[39] In its representation of an ancient ruin reconstructed and adapted to public usefulness, this image may have held special symbolic significance, for a copy of it was sometimes used as the frontispiece to Giovanni Maggi's *Ornamenti* [FIGURE 50].

FIGURE 51

Israël Silvestre (engraver). *View of the Vatican from the Gianiculum.* Engraving, ca. 1680. Avery-Crawford *Speculum Romanae Magnificentiae,* plate 27. Avery Architectural and Fine Arts Library, Columbia University.

Jean-Jacques Boissard, also a visitor from the north, takes yet another approach to the images he incorporates into his *Topographia*, working in collaboration with Theodor de Bry. In Boissard's case, he copies an eclectic mix of prints, including actual *Speculum* prints. Boissard was an antiquarian and poet who was, like Lafreri, from Besançon, and also lived for years in Rome before settling in Metz in Lorraine. Boissard's *Topographia urbis Romae* [see CAT. 12, 13] included engravings by de Bry, including many copies of *Speculum* prints—among others, the Sarcophagus of Constantia and the *Marforio* —reprintings of the texts of Fabio Calvo, Marliani, and others, and a series of engravings of Roman inscriptions. While staying in Rome as a young man, Boissard had come to act as an informal tour guide for French and German students who visited there, and eventually wrote up his observations of things to see (divided into four exceedingly lengthy "days") and circulated them in manuscript. Later, he compiled his guide with text and images by others and with engravings of inscriptions found in Rome, based on his own drawings. A striking feature of Boissard's text is the quantity of its front matter. Each volume contains multiple dedicatory letters and poems in his honor and that of the publisher and engraver de Bry. Many make reference to utility,[40] and also to revivification. Rome lives again in Boissard's work. This is hardly unique to Boissard's text; it is a frequent topos in antiquarian writing. For the authors

who contributed to Boissard's book, both text and image vivify. Over the seventeenth century, images came more and more to be viewed as central to antiquarian knowledge production. A striking late seventeenth-century print by Israël Silvestre, a panoramic view of Rome, suggests an ambitious direction for antiquarian images. The inscription, by "Scudéry" (either Georges or Madeleine de Scudéry), claims a kind of vivifying chain in which, by conjuring a vision of Michelangelo's Dome, the engraver brings the Caesars, too, to life [FIGURE 51]. Here, we are no longer speaking simply of the recreation or reconstruction of ancient archi-tecture—rather of a passionate historical sublime. A dramatic statement of the idea that it is images, specifically, that have the power to vivify comes in the preface to the 1681 German translation of Jean-Jacques Boissard's *Topographia* [see CAT. 14]. In the Renaissance, partly through the influence of Plato, images are sometimes described as shadows of reality, and often represented as being given life by texts or voice. But in the 1681 edition's introductory letter to the reader, the publisher states specifically that *without its images* the book would be a "mere shadow without life."[41] Here, it is the text that is but a shadow, and the image gives life.

In the uncertain political times of the early modern period, printing and prints served a very real function of the preservation of knowledge. Anton Francesco Doni,

FIGURE 52

François Perrier (designer and etcher). *Saturn gnawing on the Belvedere Torso (title page).* Etching in Perrier, *Illmo.D.D. Rogerio Dv Plesseis. . . magnarum artium eximio cultori. . .[Segmenta]* (1638). CAT. 73.

in his 1552 *Mondi,* discusses the marvelous invention of printing, which serves to preserve cultural knowledge from loss. It used to be, Doni says, that everything was destroyed in time, but this is no longer the case because of printing:

> But today it is no longer that way, because printing has been discovered in our age, . . . [therefore] if a book is finished, it will be impossible to lose half of what's printed. If the World doesn't come to an end all at once, it would be impossible to destroy all the books, containing our statues, paintings, names, families, cities, and all of our doings and knowledge, and you see in drawings [i.e., woodcuts] our faces and clothing, our cities, the instruments of our arts, and all the things, large and small, that we know how to say and do. Now everyone has them, they are printed and reprinted, whereby our discovery of printing is that Hydra of which, when one head is cut off, seven more sprout up.[42]

Doni perceives the printed image, as well as the printed text, as a major repository of knowledge, a means of guarding against loss (loss that, in the case of classical antiquity, the Renaissance felt keenly). A similar sentiment appears later in the title page of François Perrier's 1638 collection of statues [FIGURE 52, CAT. 73]. The image suggests that prints transcended distance in time by making ancient ruins and fragments live again; here Time (the cannibalistic Cronos or Saturn) gnaws on the Belvedere torso, while in the pages that follow, statues live again in print. In a European continent ravaged by wartime destruction and looting, long before the development of reliable methods of preservation for sculpture or paintings, prints guaranteed the permanence of antiquarian knowledge, reversing the depredations of Time.

Boissard's text, was, in part, motivated by personal loss. When the wars of religion raged through Lorraine, most of his collection of antiquities, kept at his sister's house in the county of Montbéliard, was lost or destroyed. "Their loss would have seemed more tolerable," he writes, "if they had come into the hands of some man who could have made use of them [*ex iis fructum facere*], and converted them to public utility."[43] He was able to produce the *Topographia* at all only because he had previously moved many of his drawings of inscriptions to Metz; the day-by-day guide to visiting Rome existed in multiple manuscripts, and he was able to get one from a friend. Perhaps among these salvaged items were prints had brought with him from Rome, or that friends sent to him. In this context, the reuse of images might commemorate the community of scholars and those collectors who allowed scholars generous access to their holdings. In a sense, the project is not merely a collection of images nor of texts but of images, texts, and people (in the form of friends and acquaintances who together form a public). In a similar vein Labacco identifies the deaths of Bramante and Sangallo as an impetus for the publication of his architectural reconstructions. In such times, the copying and reprinting of images might have seemed a way of keeping the image, and knowledge of it, alive.

Such projects thus promised reparative effects—of minds, bodies, morals, and cities. Prints contributed to architecture not only by publicizing building projects, but also by circulating imagery that could be appropriated and reused by builders. That this might have been considered a public good is apparent from a story Sebastiano Serlio presents, in which a miser who owned

an older palazzo, built in a medieval style, refuses to move or to update the style. The local prince rides by one day and is overcome with "nausea e fastidio" (nausea and disgust) in seeing this outmoded architecture. He lets it be known that the house should be updated, and the miser does not comply. Finally he confronts the miser directly and essentially exercises eminent domain: he says he will buy the house at its fair market value if the miser doesn't redo it—so he does. This prince, at least in Serlio's story, clearly feels that the decorum of buildings in his territory is a matter of public interest. As Gamucci puts it, "Vitruvius in his Architecture demonstrates all those things that befit a civil and well-planned city" (the phrase I have translated as "well-planned" is "bene intesa," which suggests harmoniousness but also a sense of rational understanding and intention).[44]

The view that the health of a polity might be reflected or even created by the decorum of its buildings is full-blown in John Evelyn's seventeenth-century writings. In the preface to his translation of Fréart's *Parallèle,* he says of London that

> It is from the *asymmetrie* of our *Buildings,* want of *decorum* and proportion in our *Houses,* that the irregularity of our *humors* and *affections* may be shrewdly discern'd. . . how infinitely were it to be *wished,* that whilest the *beautie* and *benefit* of the *City* increased in *one* part, the *Deformity* and apparent *Ruine* of it might cease on the *other:* But this we are to hope for, when, to bring this *monstrous Body* into shape, and scatter these ungovernable *enormities,* either the *restraint* of Building *irregularly* shall polish the *Suburbs,* or (which I rather could wish) some *royal Purchase* contract and demolish them. . . .[45]

Evelyn places this preface on a book of architectural prints, one that places images side by side and exhaus-

tively compares them. Only in the wake of projects like Lafreri's, I believe, was it possible to envision such comprehensive comparative projects—projects that not only collected architectural designs, but also allowed for the establishment of systematic judgment of them. A very material basis for the history of art history itself, therefore, can be found here. In its own way, it is as significant for the discipline as Vasari, for it begins a process of visual pedagogy and the training of discernment through comparison that carries through to modern textbooks. With this as a context, the notion of public utility carries all the more importance. And yet it is, perhaps, not—or not only—the product of a positive view of the craft. Printmakers such as Diana Mantovana and Nicolas Béatrizet gesture in this direction in emphasizing the public utility produced by their own publishing ventures. By publishing images based on ancient ornaments, they suggest the usability of their work not only for purposes of knowledge of antiquity, but also for building and, potentially, the reordering of public space. But it is worth noting that printmaking was not always seen as a beneficent profession: rather, it had the reputation of a highly competitive, even literally cutthroat industry (as in the case of the murder of Duchetti's apprentice, reviewed briefly in the introduction). When printmakers highlighted the public utility of their craft, perhaps they were responding, too, to such views. With their self-presentation, they sought to establish printmaking on a philanthropic plane—suggesting they were not motivated purely by profit, not stealing and copying the works of others, but generously providing the important public service of making antique images available, for the sake of the pursuit of knowledge, public decorum, and common good.

NOTES

1. "Franc. . . s, Ciuis Volaterranus publice utilitati formabat, et Diana Vxor incidebat Romae 1579." The use of "citizen" suggests an almost "republican" sense of the public, but it also has a specific personal meaning. See Evelyn Lincoln, "Making a Good Impression: Diana Mantuana's Printmaking Career," *Renaissance Quarterly* 50 (1997): 1101–47, especially 1114–15.

2. "Praecipua aliqvot Romanae antiqvitatis rvinarvm monimenta, vivis prospectibvs," which translates as "Several particular monuments among the ruins of Roman antiquity, in vivid views, cleverly chosen for the imitation of the truth."

3. Another set of ruins, this one published by Gerard de Jode, are presented as "useful to painters and other

craftsmen" ("Ruinarum variarum fabricarum delineationes pictoribus caeterisque id genus artificibus multum utiles Gerardus Judeus excudebat," that is, "Gerard de Jode published these drawings of various types of ruins, very useful for painters and other craftsmen"). The series appears in a volume in the British Library, C.46.k.1(1); see article cited in Introduction, note 34.

4. Public utility is, for instance, mentioned in Lucio Fauno's *Delle antichità della città di Roma, raccolte e scritte . . . con somma breuità, & ordine, con quanto gli antichi ò moderni scritto ne hanno, libri V* (Venice: Michele Tramezzino, 1548), A4r (Dedication to Giacopo de Meleghini by Michele Tramezzino) and in many publishing privileges.

5. Mario Carpo, *Architecture in the Age of Printing: Orality, Writing, Typography, and Printed Images in the History of Architectural Theory,* trans. Sarah Benson (Boston: MIT Press, 2001), especially pp. 18, 45, 119–124.

6. See Leon Battista Alberti, *Ludi matematici,* ed. Raffaele Rinaldi (Milano: Quaderni della Fenice, 1980). Luca Pacioli in 1494 made a point of noting (with a certain disappointment) that there were no images in a recent printing of Alberti's book. He clearly sees images as useful or necessary, which is borne out by his own books, which are packed with diagrams. Luca Pacioli, *Summa de arithmetica geometria proportioni & proportionalita: continentia de tutta lopera* (Venice: Paganino de Paganini, 1494), 68v.

7. Charles Estienne, letter to the reader, in Lazare de Baïf, *Annotationes in L. II de captivis* (Paris: Estienne, 1536), A3r.

8. Carpo, 46, citing Thomas Elyot (1531).

9. 1544 ed., p. 122v.

10. On Marliani's 1544 *Topographia,* see Rodolfo Lanciani, *Storia degli scavi di Roma e notizie intorno le collezioni romane di antichità* (1902; Rome: Quasar, 1990), 2:271–75.

11. Marliani (1544), 2v. "Si hanc figuram [map of early Rome], & sequentes, secundum naturalem prospectum attollere uoluissemus: contigisset ut omnibus partibus montium, una excepta, occultatis, aedificia in suo situ locari non potuisset. Qua propter cùm melius putaremus utilitati omnium esse consulendum, quàm inani pictura quosdam oblectare: figuras ipsas planas posuimus: curauimus tamen latera montium secundum illorum altitudinem ita inumbrare, ut conualles ab ipsis facile distinguantur."

12. Marliani echoes Serlio, who wrote about his image of the Pantheon, "No one should be surprised in those things pertaining to perspective, that one perceives no foreshortenings, neither depth nor plane: for I simply wanted to elevate it from the ground plan, to demonstrate its height by measures, such that it would not be hidden or diminished by foreshortening." Sebastiano Serlio, book three in *Tutte l'Opere d'architettura* (Venice: Heirs of Francesco de' Franceschi, 1584), 52r: "Non si marauigli alcuno se in queste cose che accennano alla prospettiva, non vi si vede scorcio alcuno, nè grossezze, nè piano: percioche ho voluto leuarle dalla pianta dimostrando slamente le altezze in isura, accioche per lo scorciare le misure non si perdino per causa de i scorci: ma ben poi

nel libro di prospettiua dimostrerò le cose ne' suoi veri scorci in diuersi modi, in superficie, & in corpi, in varie forme, & gran copia di varij casamenti pertinenti a tal arte: ma nel dinmostrar queste antichità per seruare le misure non vserò tal arte."

13. Published by Varisco in Venice, 1565, 1569, 1580, 1588. It appears that Dosio himself may have reduced at least some of his drawings to the proper size for use as woodcuts. In Dosio's Berlin sketchbook there is a drawing for the theater of Marcellus, gridded, of the same size as the woodcut, apparently a reduced copy of Dosio's own drawing in the Uffizi, vol. 2532; see Hülsen, *Das Skizzenbuch des Giovannantonio Dosio in Staatlichen Kupferstichkabinett zu Berlin* (Berlin: Heinrich Keller, 1933), plate CXIII, f. 86). Hülsen writes that it is "zur Vorlage für den Holzschnitt in B. Gamucci's Antichità di Roma (1565) p. 67, welcher genau di Größe der reproduzierten Zeichnung hat" (Hülsen, *Skizzenbuch,* 41). Gamucci mentions Dosio as a promising archaeologist in another context but not as the author of the images in his text: Gamucci (1565), 33r.

14. They were reduced and printed along with other woodcut copies in editions of the *Cose maravigliose dell'alma città di Roma,* a relatively low-budget (and best-selling) "pilgrim" guidebook. Many of the woodcuts in the Gamucci editions contain alphabetic notations connected to descriptions in the text (A, B, C, etc.). In many of the *Cose maravigliose* editions, this text-image relationship is respected; the same woodcuts were also reused in the 1588 Italian translation of Andrea Fulvio's *Antiquitates urbis,* in which the text makes no mention of the notations. Andrea Fulvio, *L'antichità di Roma* (Venice: Girolamo Franzini, 1588). Such variation—and loss of precision over time—is typical of the vicissitudes of print culture in the period.

15. Ibid., f. ★2v. "maggior sodisfattione del Lettore, & chiarezza dell'opera."

16. Gamucci (1569), 5r. "le quale ho tratte, & ritrouate, non pure da Scrittori dignissimi, ma dalle loro reliquie in diuerse parti sparte, & da'loro poluerosi fragmenti, cotanto oltra | giati dall'ingordo tempo, & dalla varia fortuna."

17. It was not necessarily obvious that books on *architecture* would contain images. Leon Battista Alberti did not include images in his *De re aedificatoria,* and it was many years before images were added to editions of his text; similarly, Vitruvius was unillustrated in the first printings of the text. See Carpo, *Architecture in the Age of Printing.*

18. Gamucci, *Libri quattro dell'antichità della città di Roma* (Venice, 1565), f. ★2r ("delle Fabbriche, delle Statue, delle Medaglie, & de gli antichi sepolcri"). On the trophies of Marius, "Non prenda marauiglia il lettore, se io non lo dimostro intero, perche il mio intendimento è di rappresentare solamente le cose che hora appariscono, & non come anticamente doueano essere." (f. 101r) Gamucci declines the Circus Maximus because "one does not see remains that have (sufficient) proportions to put into a drawing." ("non si veggon reliquie che habbino

proportione da mettere in disegno," f. 200r.) For other criticisms of Pirro Ligorio, see Section 3 of catalogue.

19. Cornelis de Jode, unpaginated preface in Onofrio Panvinio, *Veterum Rom. ornatissimi amplissimiq thriumphi* (Antwerp: Cornelis de Jode, 1596); Justus Lipsius, *Ivsti lipsi de amphitheatro liber* (Antwerp: Christophe Plantin, 1589), 6.

20. Ambrogio Brambilla's *Ostian Seaport* (Chicago A32) is a copy after Dupérac's engraving.

21. On the Vatican (Augustan) obelisk, see Samuel Ball Platner and Thomas Ashby, *A Topographical Dictionary of Ancient Rome* (London: Oxford University Press, 1929), 366–67.

22. On prints and/as knowledge, see Peter Parshall, "Imago contrafacta: Images and Facts in the Northern Renaissance," *Art History* 16 (1993): 554–79.

23. Labacco f. 4v. "essere molto utile per gli studiosi dell'archittetura, si come chiaro è che maggior frutto si caua de gli buoni essempi in poco tempo, che non si sarebbe leggendone i scritti in molto maggiore."

24. Parshall, 567–570.

25. Girolamo Porro, unpaginated dedication to Giacomo Contarino, in Vincenzo Scamozzi, *Discorsi sopra l'antichità di Roma* (Venice: Francesco Ziletti, 1582): "mi sono risoluto ultimamente, à beneficio commune del mondo, di stampare alcuni disegni di ruine de i più famosi edificii di Roma trionfante, disegnate in rame da Messer Battista Pitoni Vicentino, i quali fino à questo tempo hanno potuto principalmente seruire à quei pittori, che di fingere paesi nelle loro opere si dilettano."

26. Porro in Scamozzi. "Et parendomi necessario dare à questi disegni spirito con qualche dichiariatione, affine che giouino non solamente à i pittori, ma à gli architetti anco . . ."

27. Porro in Scamozzi. "in ispatio di pochi giorni arricchì queste tauole di bellissimi discorsi della edificatione di Roma, & del vario accrescimento suo, de'colli, i quali u'erano, & etimologie de'nomi loro, & delle quattordeci regioni, nelle quali essa città era anticamente partita: onde l'opera uscirà hora in luce non per dilettare solamente, ma per giouare à gli studiosi della veneranda antichità. Si perche detto messer Vicenzo hà contrasegnato con lettere tutte leparti delle ruine de gli edificii, che si contengono in quaranta tauole. . ."

28. Scamozzi, 40. "alcune volte antiche."

29. Scamozzi, 40. "Potria essere, che questa tauola fuisse disegnata da qualche cosa antica, & ch'io non hauessi memoria di hauerla veduta, ma molto più può stare, che ella sia fatta per vn bel capriccio: perche, chi non si stancherebbe à disegnare à punto ogni cosa dall'antico solo colui, che non sa fare niuna bella inuentione."

30. "Intorno alla marina di Baie, come nel resto di que'd'intorni, vi sono molte volte, doue erano gran numero di bagni naturali, & altri edificii molto lauorati, con compartimenti di stuchi, & pitture. Può stare, che non confidandosi costui in tutto, d'essere in quei lochi, (che in vero sono troppo siluestri) si riducesse altroue à disegnare l'inuentione, alla quale aggionse (come si dice) più del suo, che del vero; non ricordandosi cosi affatto la cosa. si mette tale quale è, & si rimette al giudicio di chi la vederà il giudicare, che cosa sia stata."

31. Montjosieu, 1. "Dvm Romae agens antiquorum operum reliquias, & fragmenta, quae exspatianti passim obuia fiunt contemplor: in quibusdam artificium laudo, in aliis molem suspicio, ex multis vero priscorum mores animo repeto. . . . Sed dum singulorum vsum exploro, hoc me in plerisque male habebat, quod ex iis quaedam magno molimine facta ab antiquis animaduerterem, in quem tandem vsum, passim videbam ignorari. Non de obscuris loquor: sed de iis etiam quae à scriptoribus celebrata sunt, & quorum formae typis excusae ob oculos omnium versantur."

32. Montjosieu, 1. "Atqui non fit mihi verisimile, longo tempore, immenso pretio, tam immanes moles sine causa fuisse extructas. Idque ab Aegyptiis, apud quos tum maxime studia florebant."

33. On this topic see G.V. Coyne et al., eds., *Gregorian Reform of the Calendar: Proceedings of the Vatican Conference to Commemorate its 400th Anniversary, 1582–1982* (The Vatican: Pontificia Academia Scientiarum; Specola Vaticana, 1983).

34. Records exist of where many of the stones went. Lanciani, 2:57–58, 4:150–52.

35. Montjosieu, 2. "De Septizonio, ridicula sunt quae passim circunferuntur."

36. Montjosieu, unpaginated privilege. "dictum Opus. . . figurasue in eodem opere existentes, aut quae ab eodem Ludouico seorsum edentur in lucem, aere aut ligno excidere, vel incidi facere, illudque & illas vendi, seu venale, & venales tenere, vel proponere possit."

37. Luca Pacioli, *Summa de arithmetica geometria proportioni et proportionalita* (Toscolano: Paganino de Paganini, 1523), 24r: "tengano per certo che non si troui meglior vie ne modi di quelli che hanno imparato in vn cantone da qualche ignorante: e vulgare abacotto (che chosi sonno denominare) e non per le piazze in luochi publici maxime da communita deputati. Le quali al bene publico: e comme sempre se ingegnano de hauere homini fontati deli megliori possino."

38. See William Stenhouse, "Visitors, Display, and Reception in the Antiquity Collections of Late-Renaissance Rome," *Renaissance Quarterly* 58 (2005): 397–434.

39. BAV Stampe VI.2 (the Ashby collection), 6. Renaissance builders did not always think in terms of public usefulness. Many thought of expressing the magnificence of their patrons—and in ways that were not necessarily in the public interest. An early-sixteenth-century treatise on all aspects of the life of cardinals suggests that the cardinal's lodgings must be magnificent because if they're not, "the people" are liable to rise up against him out of contempt. Paolo Cortese, *De cardinalatu* (Castel Cortesio: Symeon Nicolai Nardi, 1510), 53v. This is a very different notion from one in which a sovereign, or pope, spends on building projects for the public's benefit.

40. In the first volume, Boissard's friend Pierre Joly (Petrus Lepidus) writes, in his unpaginated preface to the reader, that "Everything we do should be for the good of our republic and our neighbors, because we are not born for ourselves, but for our country and friends." Boissard and de Bry's book will serve "the utility of many," he writes (*utilitatem multorum*). De Bry, in his role as publisher and engraver, "always has this goal in his sights, to promote matters of literature [*rem literariam*] by his studies, and to augment the convenience of the public with his infinite projects, joining delightful pleasure to usefulness ("semper hunc scopum sibi ante oculos proponeret, rem literariam suis studiis promouere, & publica commoda infinitis operibus augere; coniungens vtilitati iucundam delectationem").

41. Jean-Jacques Boissard, *Topographia Urbis Romæ* (Frankfurt: Matthaeus Merian, 1681), unpaginated preface: "Und ob wol solche Beschreibung neulich auss unser Lateinischen Topographia herauss geklaubet/und zu teutsch an Tag bracht worden/so ist solches doch nur ein bloser Schatten ohne Leben/weil keine Figuren oder Bildnüssen der gemeldten Antiquitäten dabey zu finden. Wir aber haben nicht allein/etliche der fürnehmsten Antiquitäten wie obgemeldt/sondern auch die eigentliche Controfacturen/beyde der alten und neuen Stadt Rom. . ."

42. Anton Francesco Doni, *I mondi* (Venice: F. Marcolini, 1552), 27. "Ma hoggi non e cosi, perche la stampa è un secolo ritrouato di nuouo, onde no ci staremo quanto l'altro mondo a suo dispetto, et se si finisce vn libro, non se ne spengano le migliaia che si stampano. Se'l Mondo non termina tutto a un tratto non è per distruggere tutte le scritture, nelle quali sono le statue, le pitture, I nomi, le famiglie, le Città et ogni nostro atto et sapere, et si vede in disegno I uolti et gli habiti nostri, le nostre ville, gli stromenti delle nostre arti, et tutte le minime et le maggior cose che noi sappiamo dire et fare. Poi ogni hanno, si stampa et ristampa, onde il nostro ritrouato della stampa, è quell' Idra, che tagliatogli vna testa ne nasceuano sette."

43. Boissard, *I. pars Romanae vrbis topographiae & antiquitatum*, vol. I (Frankfurt: Theodor de Bry, 1597), f. A2r. "Et certè eorum jactura mihi videri posset tolerabilior, si ea venissent in manus viri alicujus, qui ex iis posset fructum facere, & ad utilitatem publicam convertere."

44. Gamucci, 34. "E dimostrando Vitruuio nella sua architettura tutte quelle cose, che si conuengono a vna ciuile, & bene intesa città..."

45. John Evelyn, dedication, in Roland Fréart, *Parallel of the Ancient Architecture with the Modern*, trans. Evelyn (London: Tho. Roycroft for John Place, 1664), f. b1v.

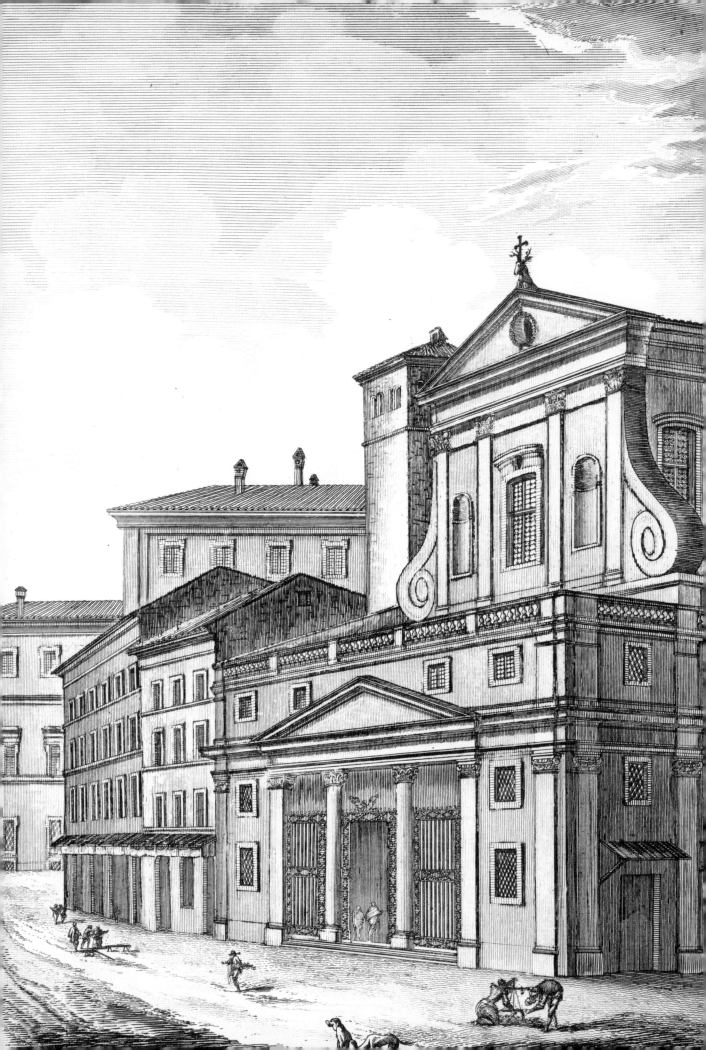

NINA L. DUBIN

ANTI-EDIFICE: JEAN BARBAULT'S *ROME MODERNE*

IN ADDITION TO MIRRORING Roman magnificence, the *Speculum Romanae Magnificentiae* in the collection of the University of Chicago reflects changing notions of the magnificent city. Two centuries of artistic responses to Rome are recorded in the *Speculum*, culminating in a selection of views that were produced by the French artist Jean Barbault (1718–1762) and published posthumously in his 1763 folio volume, *Les plus beaux édifices de Rome moderne*.[1] It is tempting to speculate that these prints were added to the *Speculum* soon after they first appeared, at a time when *anticomanie* promoted the consumption of views of ancient and contemporary Rome alike. Indeed, Barbault's contribution to the tradition of Roman *vedute*—of views of the city—reveals a distinctly eighteenth-century attitude toward the print trade, urbanism, and the Eternal City.

Barbault's arrival in Rome in 1747 coincided with a cultural turning point. A new interest in antiquity— driven by recent excavations at Herculaneum and Pompeii—was taking expression in the art of the *pensionnaires* of the French Academy in Rome whose ranks Barbault joined.[2] In 1749, Abel-François de Vandières, the future Director-General of Buildings, arrived in Italy to absorb the lessons of ancient architecture, and it was his two-year trip, according to the artist Charles-Nicolas Cochin, that cemented the establishment in France of *le bon goût*, or neoclassicism.[3] Thereafter, the number of French visitors to Rome escalated, promoting the expansion of the market in travel mementos as well as often lavishly illustrated guidebooks and antiquarian and archeological studies. The *pensionnaires* of the Academy were well placed to pursue the creative and commercial opportunities presented by the Grand Tour. Giovanni Paolo Panini, Rome's foremost painter of *vedute* and *capricci* (architectural fantasies), taught perspective at the Academy. And at a time when printmaking was considered a low art form and the Academy neither accepted printmakers as Academicians nor emphasized the graphic arts, French artists experimented with the medium in the studios of the foremost practitioners of topographical prints, Giuseppe Vasi and Giovanni Battista Piranesi. Under the spell of the architect-etcher Piranesi, who practiced etching as the ultimate high art form and was once deemed "too painterly to be an etcher," French *pensionnaires* overcame the disciplinary boundaries of the Academy and cast themselves as "painter-architects" and "painter-etchers."[4]

Though best known today for his *capricci* and portraits featuring colorful characters, the painter Jean Barbault also engraved approximately 500 views of Rome and was the artist in his milieu to have collaborated most closely with Piranesi. Two of his prints were published—alongside those of Philothée-François Duflos, Jérôme-Charles Bellicard, and Jean-Laurent Legeay—in the 1748 edition of Piranesi's *Varie vedute di Roma antica e moderna*, and he contributed extensively to the *Le Antichità Romane*, executing the figural elements in volumes 2 and 3 of the series. By 1756, when Piranesi solicited his participation, Barbault was no longer a student of the Academy, his checkered relations with

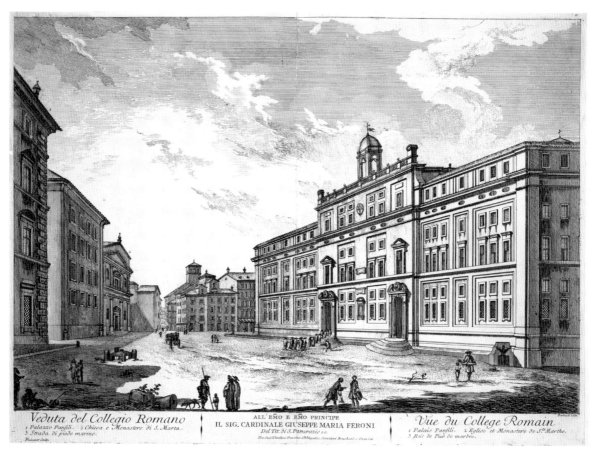

FIGURE 53

Freicenet (etcher), after Jean Barbault (designer). *View of the Collegio Romano*. Etching in *Les plus beaux edifices de Rome moderne*. Rome: Bouchard & Gravier, 1763.

the institution having culminated in his expulsion three years earlier. He possibly made Piranesi's acquaintance at the publishing house of Bouchard and Gravier, the French company on the Corso with which Piranesi was affiliated before setting up his own shop in the late 1750s. Following Piranesi's departure, Bouchard and Gravier effectively replaced him with Barbault, whose *Plus beaux monuments de Rome ancienne* appeared in 1761 in competition with Piranesi's *Vedute di Roma* (ca. 1748–1778). His relationship with Piranesi had thus shifted from one of collaboration to one of rivalry when Barbault began work on his *Plus beaux édifices de Rome moderne*, following the success of its predecessor.[5]

It is a measure of the influence of Piranesi's innovations—his bold use of chiaroscuro and atmospheric effects, his mobilization of compositional devices derived from theater designs, his deployment of decrepit idlers who contrast poignantly with Rome's enduring

majesty—that Barbault's *vedute* bear little trace of the conventions of the genre represented elsewhere in the *Speculum*.[6] Consider, for example, his *View of the Collegio Romano* [FIGURE 53] with its figures dwarfed to liliputian proportions, its monuments sequestered to the margins to make way for a vast and scarcely populated thoroughfare, its creeping shadows and enormous expanse of sky. Eschewing the tidy intimacy of Leonard Thiry's Rome, for instance, as well as the harmonious frontality characteristic of sixteenth- and seventeenth-century architectural *vedute*, Barbault's views belong firmly to the age of Edmund Burke, who specified "obscurity," "vastness of extent," and the illusion of "infinity" as key catalysts of the sublime.[7] Yet if Barbault's prints are haunted by the precedence of Piranesi, they retain little of the etcher's characteristic intensity: Barbault's Collegio Romano—sun-bleached and in retreat from the picture plane—is a spectral shell by

LES PLUS BEAUX
EDIFICES
DE
ROME MODERNE,
OU
RECUEIL DES PLUS BELLES VÜES
DES PRINCIPALES
EGLISES, PLACES, PALAIS,
FONTAINES, &c.
QUI SONT DANS ROME
DESSINÉES
PAR JEAN BARBAULT PEINTRE,
ANCIEN PENSIONNAIRE DU ROY A ROME,
ET GRAVÉES EN XLIV. GRANDES PLANCHES ET PLUSIEURS VIGNETTES ;
PAR D'HABILES MAITRES.
AVEC LA DESCRIPTION HISTORIQUE DE CHAQUE EDIFICE.

Vüe de l'Eglise de Saint Charles aux quatre Fontaines.

A ROME
Chez BOUCHARD & GRAVIER Libraires françois rüe du Cours
près l'Eglise de S. Marcel.

M. DCC. LXIII.
DE L'IMPRIMERIE DE KOMAREK.
AVEC PERMISSION DES SUPERIEURS.

FIGURE 54

Jean Barbault (designer). Title page. Etching in Barbault,
Les plus beaux édifices de Rome moderne. Rome: Bouchard &
Gravier, 1763. Research Library, The Getty Research
Institute, Los Angeles, California (84-B30675).

and clean air.[9] His essay marked a turning point in urban reform. As evidenced in the urban planning proposals that circulated thereafter in increasing numbers, the magnificence of a city was no longer perceived to reside solely in its monuments, but rather in its overall infrastructure. The ceremonial and decorative aspects of the city were demoted in favor of the largely invisible matters of circulation and functionality, in correlation with what Spiro Kostof has cited as a crucial feature of modern urbanism as it emerged in Europe around 1750: the demise of the autocratic figure.[10] Whereas Sixtus V's plans to remodel Rome entailed saturating the city with symbols, notes Charles Burroughs, the better to achieve the "coherent sanctification of urban space," eighteenth-century embellishment was an intrinsically secular enterprise that overturned absolutist notions of the city as locus of the "cult of the king."[11] The eclipse of royal splendor by the science of planning may be perceived in Pierre Patte's statement that "Essential to the beauty of a city. . . is that there be sufficient access from one quarter to the next. . . and all should be clear from the center to the circumference."[12] Even Sixtus had spared much of the built environment in his redevelopment of Rome.[13] Yet for the sake of unimpeded mobility, and of unobstructed urban "views," Patte—who dreamed of redesigning the whole of Paris—advocated the use of mass demolition. Indeed, by the end of the century—one that began, crucially, with the replacement of Paris's ramparts with boulevards—plans were afoot to enhance circulation by linking the capital's sidewalks to a national highway system.[14]

It is this vision of the city as a space of transit, rather than of monumental stasis, that characterizes the cover illustration of Barbault's *Rome moderne* [FIGURE 54]. The church at right is meaningfully abbreviated by the margin of the page and overtaken by the soaring velocity of the street. In so diminishing the centrality of Rome's "principal" architectural structures, Barbault's prints propose that though the monument may be beautiful, it is the street that is sublime. The artist's vision of urban magnificence thus appears to have been implicated in the contemporary discourse on planning—

the light of the concentrated density of Piranesi's monuments. Far from absorbing our attention, Barbault's edifices deflect it onto the street below.

Calculated to corner a competitive topographical print market, Barbault—whose prints bear French as well as Italian captions—appealed to the aesthetic tastes then in vogue. As stated in the introduction to the volume, Barbault's views presented Rome's "principal churches, palaces, plazas, fountains, and other public monuments" from "the most pleasing" and "diverse points of view," so as to compel the reader's unceasing "admiration."[8] Significantly, by the early 1760s, the desirability of a pleasing "point of view" was not only a hallmark of aesthetic treatises, but of an Enlightenment movement in Paris to beautify the city—one that had been underway since 1749, when Voltaire published a seminal essay, *Des embellissements de Paris*, lamenting the deplorable conditions of life in the capital. Voltaire called for a campaign of urban "embellishment" that included replacing the city's narrow and tortuous streets with wider ones to enhance the flow of goods, pedestrians,

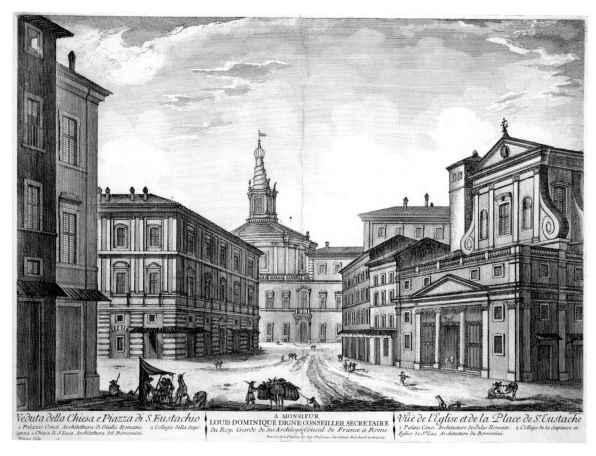

Veduta della Chiesa e Piazza di S. Eustachio
1 Palazzo Cenci Architettura di Giulio Romano. 2 Collegio della Sapi-
enza e Chiesa di S. Luca Architettura del Borromini.

A MONSIEUR
LOUIS DOMINIQUE DIGNE CONSEILLER SECRETAIRE
du Roy. Garde de Ses Archives Consul de France a Rome

Vüe de l'Eglise et de la Place de St. Eustache
1 Palais Cenci Architecture de Jules Romain. 2 Collego de la Sapience et
Eglise de St. Luc Architecture du Borromini.

FIGURE 55

Freicenet (etcher), after Jean Barbault (designer). *View of the Church and Piazza of S. Eustachio*. Etching in *Les plus beaux édifices de Rome moderne*. Rome: Bouchard & Gravier, 1763.

an impression that is reinforced by the recurrence in the text of the catchwords of urbanism. The Piazza Colonna, for example, is singled out for its quality of "regularité," as are the Piazza de Montecitorio and the Palazzo Farnese, while the Piazza Colonna Trajana is criticized for its lack thereof. Similarly, the Piazza del Popolo, along with the Piazza di Spagna, is praised for the beauty of its "point of view." If Barbault exaggerates the breadth and depth of city streets in keeping with the sensibilities of the day, so too does he "embellish" subjects that might otherwise offend. At a time when the clearing of congested urban quarters was a public rallying cry, Barbault's text faulted the Piazza della Rotunda for the quantity of vendors cluttering its already narrow space—an eyesore that is notably censored from the artist's view of the subject. Likewise, though the Piazza of S. Eustachio [FIGURE 55] is described in the text as the "small yet heavily trafficked" site of a fruit and vegetable market,

Barbault has opted to disencumber the quarter of its characteristic crowds. The "continual market" referenced in the text has been reduced to a single stall in the left foreground, and it is the nearly empty street, dynamized by track marks and centrally framed by the church and its neighboring structures, that absorbs our attention.[15]

Barbault's tendency to magnify urban magnificence by exercising crowd control is in striking contrast to the approach taken by his other great rival in the Roman printmaking scene, Vasi. The Sicilian artist, who had arrived in Rome in 1736, earned renown for his *Delle magnificenze di Roma antica e moderna*, an ambitious, ten-volume work featuring extensive description and 220 prints.[16] It was likely this series that Barbault's editors had in mind when they stated in the introduction to *Rome moderne* that the present study had the virtue of not comprising numerous volumes that required excessive amounts of time from the reader.[17] Indeed, Vasi's

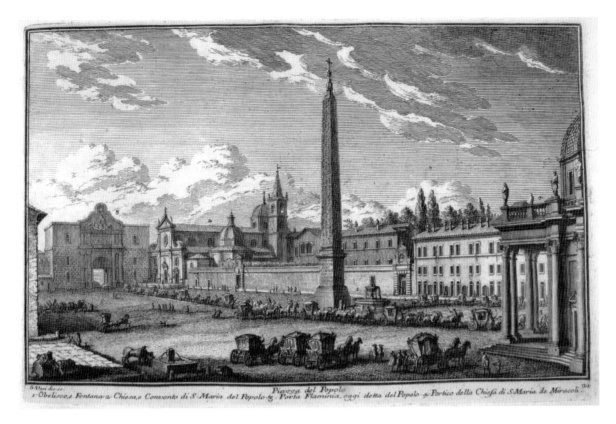

FIGURE 56

Giuseppe Vasi (etcher). *Piazza del Popolo* (plate 21). Etching in Vasi, *Delle magnificenze di Roma antica e moderna*. Rome: Chracas, 1747–1761. Courtesy The Newberry Library, Chicago.

Delle magnificenze amounts to an exhaustive catalogue of the uses that contemporary Romans made of their city, through sequential treatment of the capital's "walls and gates, piazzas, basilicas and 'ancient' churches, palazzi and streets, river and bridges, parish churches, monasteries, convents for women, colleges and hospitals, villas and gardens."[18] Vasi emphasized the role of his subjects as spaces of ritualized activity: A characteristic example is his view of the Piazza Navona, transformed on the occasion of the "Feste di Agosto" into the spectacular site of a nautical extravaganza and teeming with celebrants. A similar view is offered in his *Piazza del Popolo* [FIGURE 56], in which the entry gate to the left and the churches in the background and at right provide the frame for a religious procession. The caravan of carriages reiterates the horizontality of the architectural backdrop, in keeping with Vasi's tendency to integrate the life of the community with its surrounding built environment. It is notable that Barbault's treatment of the same subject—taken from the entryway to the piazza—could not

be more different [FIGURE 57]. In stark contrast to Vasi's portrayal of a festive urban quarter, Barbault's view is startlingly desolate and defined by the huge gash of space that cuts obliquely through the center of the piazza, as well as by the vast, overhanging sky that seems to flatten the distant churches below.

The relative lifelessness of Barbault's views departs markedly from contemporary perceptions of Rome as a city virtually synonymous with urban festivity: "Every evening in this city is a *fête publique*," observed a French visitor to Rome in 1785.[19] Barbault's treatment of the city seems rather closer in spirit to the disciplinary conception of urbanism advanced earlier in the century by the royal councilor and police official Nicolas de la Mare. In his four-volume treatise on police power, *Traité de la police*, de la Mare accounted for the sweeping control then exercised by the police over the city of Paris, and more specifically over the *voirie*, or public roads system.[20] According to de la Mare, the "embellishment" of the city—comprising the determination of the

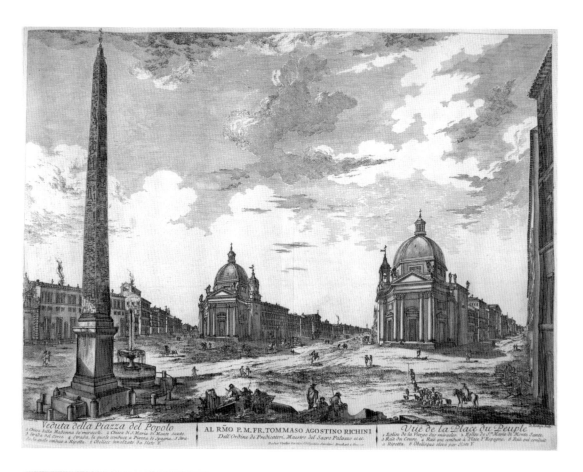

Veduta della Piazza del Popolo AL RMO P. M. FR. TOMMASO AGOSTINO RICHINI *Vüe de la Place du Peuple*

Dell'Ordine de Predicatori, Maestro del Sacro Palazzo et cc.

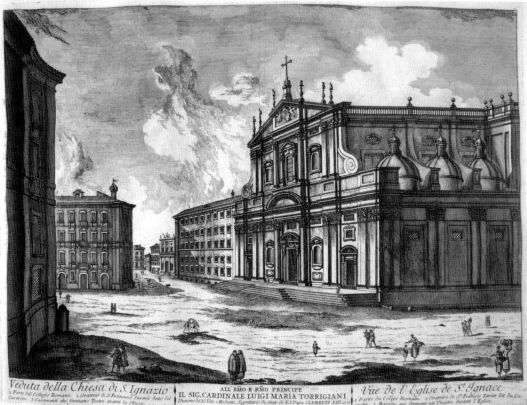

Veduta della Chiesa di S. Ignazio ALL'EMO E RMO PRINCIPE *Vüe de l'Eglise de S.t Ignace*

IL SIG. CARDINALE LUIGI MARIA TORRIGIANI

proper width of streets and the height and form of new buildings—was inseparable from the ability of the police to monitor and control the urban populace. The maintenance of uncluttered, clean, and well-constructed access routes, he noted, was a matter of public safety and necessary for the functioning of commerce; it also enabled the "advance of armies" and the operations of police circulation and surveillance. Though de la Mare identified the "paved street" as "the principal ornament of the city," with the expansion of police power the street was increasingly off-limits to merchants, market stalls, and social gatherings.[21] As Nicholas Papayanis has recently shown, "by the end of the century the police had defined the street in mostly functional terms, as a site for traffic flow rather than neighborhood socializing."[22]

A recent commentator has puzzled over Barbault's compositions—with their "amorphous" piazzas, remote buildings, and miniscule figures who seem "aimless in their actions"—as well as over the artist's "curious tendency to crop away the foreground margins of his prints"; thus impeded from entering the scene, the viewer "hovers above" it uncertainly.[23] Such features are amply on display in Barbault's view of the Church of S. Ignazio [FIGURE 58], with its colossal structure placed obliquely to the side of the page and facing onto a vacuous piazza whose edges bleed off at abrupt angles. Barbault has captured the scene from a slightly elevated perspective. However, unlike Vasi's *Piazza del Popolo*, which stations the viewer in the elite position of enjoying the action as if from an overhanging balcony, Barbault's view situates us at some mysterious, undisclosed vantage point, presumably one obscured by the gathering shadows in the foreground. In effect, the viewer is placed in a position of exercising surveillance over the scene. Far from the festive lifeworld of Vasi's crowd, Barbault's nearly empty piazza is punctuated by the occasional pairing of rigid bodies. Ironically, when Filippo Raguzzi designed the Piazza of S. Ignazio in 1735, he intended to showcase the spectacle of urban life as if before an audience gathered on the steps of the church.[24] Barbault, however, has brought the piazza into line with a "progressive" vision of the city as a site not of concentrated activity, but of human dispersal.

Barbault's topographical prints evidence the capacity of aesthetic trends to keep pace with the management of urban life. As recounted by Anthony Vidler, the French *philosophes* who agitated to straighten streets and demolish old medieval quarters dreamed, in the most extreme cases, of erecting a pristine capital in their own image.[25] In the Abbé Morelly's *Code de la nature* of 1755, for example, straight roads and uniform buildings effectively generate a unified, harmonious social order.[26] Though such notions of an ideal town continuous with the "underlying geometrical perfection of nature" may be traced to the Renaissance, it was in the eighteenth century that conviction in the built environment's capacity to remake society—to transform an unruly crowd into a self-policing, ordered citizenry—was powerfully articulated in architectural and aesthetic treatises alike.[27] In the spirit of abolishing "unprogressive" uses of the city, for instance, both Voltaire and Montesquieu condemned the wasteful extravagance of public spectacles, such as fireworks displays—mass-scale, retrograde magic tricks, according to the *philosophes*, that reinforced the basest impulses of a populace.[28]

In compliance with progressive notions of urban decorum, Barbault offers views neither of the Castel Sant'Angelo with the *Girandola*, a subject represented with relish in the *Speculum*, nor of the ritualized revelry that Vasi commemorates. *Rome moderne* disavows Rome's routine metamorphosis into a site of provisional extravagance in favor of conjuring the city rationalized. For this reason, Barbault's volume takes its place alongside the *Speculum* in a longstanding tradition of employing the printed page to mediate Rome's chaotic reality. In her study on late Renaissance France, Margaret McGowan notes that guidebooks subjugated Rome's heterogeneous and ruinous terrain to the modern technological advances of the printing press, thus facilitating the French absorption of Roman culture.[29] By the same logic that Serlio standardized the Classical orders for the use of French architects, collections like the *Speculum* promoted the adoption of architectural ruin motifs by

artists, furniture makers, and interior designers. For all their complex hybridity, series of ornament etchings such as Jacques Androuet Ducerceau's, McGowan suggests, furthered the refinement of Rome's anarchic remains into a systematized vocabulary of useful forms.[30] No less than his predecessors, Barbault translated Rome into a useful form. His topographical views packaged the city as an ideal model of urban magnificence.

Les plus beaux édifices de Rome moderne may be considered further useful insofar as it evidences the porousness of the illustrated guidebook trade to the movement of urban modernization. As the case of Barbault's volume suggests, the illustrated guidebook—even in the guise of a large folio—was an instrument of urban reform: Not only did it condition viewers to a modern apprehension of urban space, but it made the city manageable and traversable in ways that reformists could only imagine. The guidebook's pages literally integrated disparate urban quarters, overcoming the city's otherwise intransigent heterogeneity. The medium of the illustrated book thus served the interests of urban homogenization. And in this crucial respect, Barbault's volume deviates from the *Speculum*. For whereas the *Speculum* functioned as an instrument of conservation, Barbault's Rome models the city of the future. A peculiarly worded statement in the book's introduction informs readers that Barbault's dramatic "perspectives. . . compensate in some way for the injury of time which ravages the magnificence of ancient Rome."[31] The sentiment collapses modern into ancient Rome, thus accelerating time and suggesting that the modernity of Barbault's city is but a preview.

NOTES

1. Jean Barbault, *Les plus beaux édifices de Rome moderne* (Rome: Bouchard et Gravier, 1763). On Barbault, see Nathalie Volle and Pierre Rosenberg, eds., *Jean Barbault (1718–1762)* (exh. cat.) (Rouen: Imprimerie rouennaise, 1974); see also Pierre Rosenberg, "Quelques nouveautés sur Barbault," in Georges Brunel, ed., *Piranèse et les Français: Colloque tenu à la Villa Médicis 12–14 Mai 1976* (Rome: Edizioni dell' Elefante, 1976), 499–508, and the entry "Jean Barbault" in *Piranèse et les Français, 1740–1790* (exh. cat.) (Rome: Edizioni dell'Elefante, 1976), 43–48.

2. See the essays in Brunel, *Piranèse et les Français,* as well as the exhibition catalogue, *Piranèse et les Français, 1740–1790.*

3. Charles-Nicolas Cochin, *Voyage d'Italie, ou Recueil de notes sur les ouvrages de peinture & de sculpture, qu'on voit dans les principales villes d'Italie* (Paris: Jombert, 1758), v.

4. See Georges Brunel, "Préface," *Piranèse et les Français, 1740–1790,* 11–16 (here 15), and Victor I. Carlson, "The Painter-Etcher: The Role of the Original Printmaker," in *Regency to Empire: French Printmaking 1715–1814,* ed. Victor I. Carlson and John W. Ittmann (Baltimore: Baltimore Museum of Art; Minneapolis: Minneapolis Institute of Arts, 1984), 25–27. Vasi's comment to Piranesi—"vous êtes trôp peintre, mon ami, pour être jamais graveur"—is recorded in J. G. Legrand, "Notice historique sur la vie et les ouvrages de J.-B. Piranesi. . ." (1799), reprinted in Gilbert Erouart and Monique Mosser, "A propos de la 'Notice historique sur la vie et les ouvrages de J.-B. Piranesi': origine et fortune d'une biographie," in *Piranèse et les Français,* pp. 213–57 (here 223).

5. Volle and Rosenberg, 13, 19, 55–61; the published views of Barbault's fellow artists at the Academy are discussed in Werner Oeschlin, "Le groupe des 'Piranésiens' français (1740–1750): un renouveau artistique dans la culture romaine," *Piranèse et les Français,* 363–85, particularly 373–79.

6. It should be noted that Barbault died before he had the chance to translate his drawings for *Rome moderne* into prints; this work was completed by the printmakers Giraud, Montaigu, and Freicenet. See cat. no. 55 in Volle and Rosenberg, 60.

7. Edmund Burke, *A Philosophical Enquiry into the Origin of Our Ideas of the Sublime and Beautiful* (1757), ed. Adam Phillips (Oxford and New York: Oxford University Press, 1990), 54, 66, 67.

8. ". . .ce que Rome moderne a de plus magnifique en Edifices présente ici divers points de vuë les plus riants , qui frappent & jettent plus d'une fois dans l'admiration. . ." Barbault, *Les plus beaux édifices,* n.p.

9. François Marie Arouet de Voltaire, *Des embellissements de Paris* (1749), in *The Complete Works of Voltaire,* ed. Mark Waddicor (Oxford: The Voltaire Foundation, Taylor Institution, 1994), 213–33.

10. Spiro Kostof, "His Majesty the Pick: The Aesthetics of Demolition" (1982), revised and reprinted in *Streets:*

Critical Perspectives on Public Space, ed. Zeynep Çelik, Diane Favro, and Richard Ingersoll (Berkeley: University of California Press, 1994), 9–22 (here 17–18).

11. Charles Burroughs, "Absolutism and the Rhetoric of Topography: Streets in the Rome of Sixtus V," in *Streets*, 189–202 (here 195). On eighteenth-century urban planning as an assault on kingship, see Chapter 1 of Jean-Marc Dudot, Bernard Flouzat, Michel Malcotti, and Daniel Rémy, *Le devoir d'embellir: Essai sur la politique d'embellissement à la fin de l'Ancien Régime* (Nancy: CEMPA, 1978). The phrase "cult of the king" comes from Peter Burke, *The Fabrication of Louis XIV* (New Haven: Yale University Press, 1992), 158.

12. According to Patte, "pour la beauté d'une ville. . . L'essentiel est que tous ses abords soient faciles; qu'il y ait suffisamment de débouches d'un quartier à l'autre pour le transport des marchandises, la libre circulation des voitures, & que tout se dégage du centre a la circonference sans confusion." In Pierre Patte, "Des embellissemens de Paris," in *Monumens erigés en France à la gloire de Louis XV* (Paris: 1765), 222.

13. Kostof, 12, 16–17.

14. Nicholas Papayanis, *Planning Paris before Haussmann* (Baltimore: The Johns Hopkins University Press, 2004), 45. For an excellent account of Paris urbanism, see Isabelle Backouche, *La trace du fleuve: La Seine et Paris, 1750–1850* (Paris: École des Hautes Études en Sciences Sociales, 2000).

15. Barbault, 35, 39, 50, 33, 29, 36, 32, 28.

16. Giuseppe Vasi, *Delle magnificenze di Roma antica e moderna* (10 vols.) (Rome: Chracas, 1747–1761).

17. Barbault, n.p.

18. As noted by Allan Ceen in "Giuseppe Vasi," in *Art in Rome in the Eighteenth Century*, ed. Edgar Peters Bowron and Joseph J. Rishel (Philadelphia: Philadelphia Museum of Art, Philadelphia, 2000), 153.

19. Quoted in Maurice Andrieux, *La vie quotidienne dans la Rome pontificale au XVIIIe siècle* (Paris: Hachette, 1962), 165.

20. Nicolas de la Mare, *Traité de la police* (2nd ed., 4 vols.) (Paris: M. Brunet, 1719–1738). Discussed in Papayanis, 35–39.

21. De la Mare, 4:1, 4:168; quoted in Papayanis, 36.

22. Ibid., 38.

23. Malcolm Campbell, "Piranesi and Innovation in Eighteenth-Century Roman Printmaking," in *Art in Rome*, 561–67 (here 566).

24. John Pinto, "Architecture and Urbanism," in *Art in Rome*, 113–21 (here 114).

25. Anthony Vidler, "The Scenes of the Street: Transformations in Ideal and Reality, 1750–1871," in *On Streets*, ed. Stanford Anderson (Cambridge: MIT Press, 1978), 29–111, particularly 32–42.

26. Abbé Morelly, *Code de la nature; ou, le véritable esprit de ses lois* (Paris: 1755), discussed in ibid., 32–35.

27. Vidler, 34. On Renaissance theory concerning the social effects of ideal forms in architecture, see George L. Hersey, *Pythagorean Palaces: Magic and Architecture in the Italian Renaissance* (Ithaca: Cornell University Press, 1976). On disciplinary tactics in eighteenth-century architecture, see Anthony Vidler, "The Theater of Industry: Claude-Nicholas Ledoux and the Factory-Village of Chaux," in *The Writing of the Walls: Architectural Theory in the Late Enlightenment* (Princeton, NJ: Princeton Architectural Press, 1987), 35–49. On the coercive uses of space in Enlightenment France, see Scott Bryson, *The Chastised Stage: Bourgeois Drama and the Exercise of Power* (Saratoga, CA: Anma Libri, 1991).

28. See Werner Oechslin and Anja Buschow, *Architecture de fête: L'architecte metteur en scène*, trans. Marianne Brausch (Liège: Pierre Mardaga, 1987), 27.

29. Margaret M. McGowan, *The Vision of Rome in Late Renaissance France* (New Haven: Yale University Press, 2000), particularly 24–49.

30. Ibid., 94–96, 151–59.

31. "Ce sont autant de Perspectives qui compensent en quelque façon ce que l'injure des tems nous a ravi des magnificences de l'Ancienne Rome." Barbault, n.p.

CATALOGUE

Catalogue sections and intermezzi were authored by Ingrid Greenfield (IG), Kristine Hess (KH), Iva Olah (IO), Ann Patnaude (AP), Rainbow Porthé (RP), and Rebecca Zorach (RZ)

The Topography of New and Old Rome

From Francesco Albertini's 1510 *Opvscvlvm de mirabilibus nouae & ueteris Vrbis Roma* [FIGURE 59, CAT. 5] to Alessandro Donati's 1695 *Roma vetus ac recens* [see CAT. 29], artists and writers juxtaposed the new and old city, tracing continuities and identifying differences.[1] Lafreri's title page [see FIGURE 1, CAT. A1] echoes this idea, stating that some images in the *Speculum* corpus appear in the building or statue's modern (often ruined or fragmentary) form, and some in their ancient form, according to reconstructions produced by Renaissance archaeologists.

FIGURE 59

Title page, Francesco Albertini, *Opvscvlvm de mirabilibus nouae & ueteris Vrbis Romae* (1510). CAT. 5.

Travelers have always visited Rome with different goals in mind: to view Christian relics and follow a spiritual itinerary; to contemplate the picturesque landscape of past grandeur; to visit prestigious collections of antiquities on a scholarly mission. All needed maps and guidebooks to help them navigate the modern city, not just to study the remains of the ancient city. Some reader/viewers, in Rome or elsewhere, might collect maps to attain virtual mastery of the city.

Ancient monuments and statues had been mentioned in medieval guidebooks, but there had been little systematic effort at plotting the physical contours of the ancient city, and its change over time, until the fifteenth century, when Flavio Biondo composed his *De Roma Instaurata*.[2] Biondo's contemporary Leon Battista Alberti also composed a systematic method for measuring the topography of Rome, which exists in manuscript as the *Descriptio urbis Romae*.[3] No map by Alberti survives.[4]

In the sixteenth century, antiquarian scholars made efforts at reconstructing the geography of ancient Rome at various stages in its history. Although they could see the remains of later Roman monuments and city planning, they struggled to understand early phases of the city's growth. The results included the schematic, highly geometric maps made by Marco Fabio Calvo, a translator of Vitruvius and friend of Raphael. His maps showed the growth over time of the city's regions.[5] Calvo's ambitious project, entitled the *Antiquae urbis Romae cum regionibus simulachrum* ("Simulacrum of the ancient city of Rome with its districts"), a series of large folio woodcuts, was published in 1527, the year of the Sack of Rome. Because of the turmoil of that year, it did not make an immediate impact. It was, however, reprinted several times in succeeding years, and at the end of the century was incorporated into Jean-Jacques Boissard's *Topographia,* which also compiled numerous other texts and images.[6] Boissard reprints (as engravings) the schematic diagrams that had been printed as woodcuts in the *Simulachrum*. These diagrams convey the difficulty of visually establishing change over time: they are geometrically precise but have little relationship to historical reality. For instance, Calvo's third image [FIGURE 60, CAT. 13] shows sixteen regions within the city walls as divided by Augustus Caesar. Calvo, in his desire for a geometrically pleasing design, has added two regions to Augustus's actual fourteen.

Schematic maps like Calvo's displayed relationships and ideas more than physical space. Scholars hotly

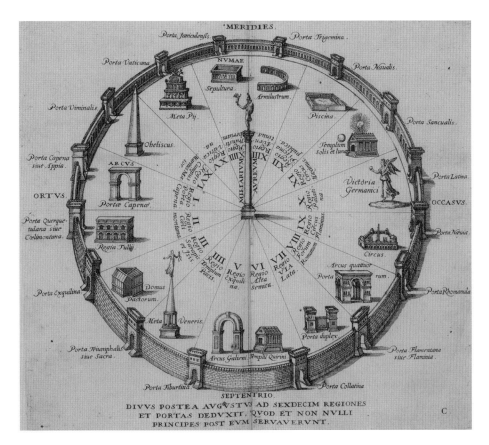

FIGURE 60

Anonymous. *Augustan Rome,* after a woodcut published by
Marco Fabio Calvo. Engraving in Boissard, *Romanae Vrbis
Topographiae & Antiquitatum. . .* (1627). CAT. 13.

debated the topographical history of the city. The only
woodcut in the text of the 1548 Italian vernacular
edition of Bartolomeo Marliani's *Topographia* is a map
[FIGURE 61, CAT. 61] presenting a view of the original
city walls built by Romulus and embracing only the
Capitoline and Palatine hills. Marliani states that
Romulus's city plan was square but that its exact outlines
are the subject of much debate among authors. Trust
this image, he tells his reader, in an appeal to visual
authority, and "leave aside the confused opinions of
authors."[7] Classical texts, existing monuments, the results
of excavations, inscriptions, and depictions on coins and
medals could all provide evidence for mapmakers (see
Section 3). As cartographic practices developed, some

FIGURE 61

Anonymous. *Rome in the time of Romulus.* Woodcut in
Marliani, *L'antichità di Roma* (1548). CAT. 61.

artists preferred to render buildings and streets as a flat ground plan. Others presented a sweeping, oblique bird's-eye view, as in Jacopo de' Barbari's aerial view map of Venice, published in 1500, which had a major influence on later publishing.[8] Pirro Ligorio and Etienne Dupérac, while treating the overall space of the city as a ground plan, presented modified elevations of monuments as they looked from the ground, thus combining two different points of view in one image, much as tourist maps still do. In this period, no single standard way of representing the relationship between monuments and the extended topography of the city existed.

The exhibition includes a copy [CAT. A4] by Ambrogio Brambilla of the earlier and smaller of Dupérac's two well-known maps of ancient Rome, published by Lafreri in 1573.[9] Dupérac was inspired by other cartographers of the city, including Leonardo Bufalini's woodcut map of the modern city, which showed the seven hills in relief; Pirro Ligorio's antiquarian maps with their elevations of ancient buildings; and the research of Onofrio Panvinio, a scholar with whom he worked closely.

In the sixteenth and seventeenth centuries, Rome presented a rapidly changing urban landscape, and mapmakers and publishers had to keep up. Mapmaking techniques developed in response to expanding global travel and local administrative needs. Antonio Lafreri and his competitors also published numerous maps; as with antiquarian prints and the *Speculum,* Lafreri's maps were often bound together into collections known as the *Geografia* based on a title page he produced.[10]

While printed images had existed in Europe since the fourteenth century, modern conventions for depicting topography in print took centuries to develop. In 1551, Leonardo Bufalini's large woodcut map of the modern city gave the outlines of the relief topography of Rome's seven hills to many other mapmakers, who used it as the basis for maps of the ancient city as well.[11] In 1562, the Forma Urbis Romae, a marble plan of the city dated to the time of the Emperor Septimius Severus, was discovered near the Church of Saints Cosmas and Damian and excavated by Giovanni Antonio Dosio. This Roman plan of the city soon influenced Renaissance mapmakers.[12] It is now the subject of a digital project, the Stanford Digital Forma Urbis Romae Project (http://formaurbis.stanford.edu).

A map of modern Rome, the *Novissima descriptio urbis Romae* ("newest plan of the city of Rome"), appeared in the 1597 edition of Boissard's *Topographia* and

then again in this 1681 edition, immediately following a map of ancient Rome that is similar in general appearance, but different in many details. It may also have been published as an independent print [CAT. B287]. De Bry, who engraved the map and published the first edition, was a prolific printmaker and publisher known for his travel books.[13] He and the later publisher, Matthaeus Merian, both incorporated copies of many previously published prints. It is also closely related to Ambrogio Brambilla's *Descriptio urbis Romae* [CAT. A5]. In it, prominent obelisks punctuate the urban landscape: recently reinstalled around the city at the behest of Pope Sixtus V, they loomed large in public awareness of the city.

Chicago's *Speculum* contains several other maps of modern Rome. The *Descriptio* etched by Ambrogio Brambilla was published by Claudio Duchetti, then republished by Giovanni Orlandi. It updates a 1582 map by Brambilla that drew on one published by Mario Cartaro in 1575.[14] This complicated genealogy was typical for prints, but even more so for maps, which were constantly in demand and needed to convey consistent information with small changes over time.

Early printed books for the traveler included itineraries that were simple lists of roads with their distances and intersections—a verbal account of space from the ground up, rather than a look down from on high. During the sixteenth century, the publishing of more extended narrative guidebooks also blossomed. A guidebook can be thought of as a kind of map, sequentially presenting a series of itineraries (often illustrated for additional navigational help) rather than a single, all-inclusive view.

The relationship of single-sheet or serial print publishing to Roman guidebook publishing was a close one. Michele Tramezzino, in Venice, was a competitor of Lafreri in the arena of large-scale antiquarian prints and maps; he also published guidebooks, travel literature, and antiquarian texts. Lafreri printed and sold books along with a wide variety of prints. Over the sixteenth century, guidebooks to Rome steadily developed from largely historical texts in Latin making reference to monuments but not illustrating them, to vernacular books, organized according to the visitor's movement through the city, and providing recognizable images of monuments to help navigate. Printed pilgrim guidebooks to Rome also established themselves in this period. These were compilations that often included several distinct texts, including day-by-day tours of both churches and ancient sites, lists of popes and emperors

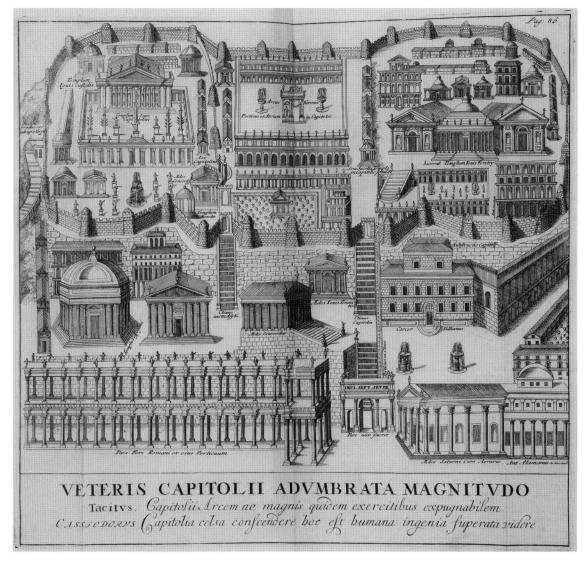

VETERIS CAPITOLII ADVMBRATA MAGNITVDO

Tacitvs. *Capitolii Arcem ne magnis quidem exercitibus expugnabilem*
Cassiodorvs *Capitolia celsa conscendere hoc est humana ingenia superata videre*

FIGURE 62

Antonius Alamanus (designer). *Outline of the magnitude of the ancient Capitol.* Engraving in Donati, *Roma vetus ac recens* (1695).
CAT. 29.

and kings, feast days, mail stations, catalogues of marvels like the seven wonders of the world, and chronicles. Even the pilgrims who came to Rome for religious reasons often also had profound interest in "pagan" antiquities, and guidebooks to antiquities were often also incorporated into books designed for pilgrims. These guidebooks were illustrated with images that helped visitors locate sights in the city. As with the publishers of individual antiquarian engravings, the publishers of guidebooks were largely not Roman by origin—in this case, many of them were Venetian (see Section 3 of catalogue). As is the case with travel guidebooks today, it

sometimes took a foreigner to sense what foreigners needed, in practical terms, to get around and understand the city.

Alessandro Donati's late-seventeenth-century book on ancient and modern Rome gives the Capitol pride of place: it occupies one of the four chapters in the book, with Rome's six other hills together constituting a chapter, another one on Christian buildings, and an introductory overview. Donati, a Jesuit, reconstructed his understanding of the layout of the ancient Capitol on the basis of many ancient texts, including Tacitus and Cassiodorus, cited at the bottom of the engraving

[FIGURE 62, CAT. 29] by Antonius Alamanus, entitled "Outline of the magnitude of the ancient Capitol." The image diagrams a particular site, the Capitol, purporting to present it in its ancient form. It was later copied in the Dutch edition of Deseine's description of Rome, the 1704 *Beschryving van oud en nieuw Rome* [CAT. 27]. Because of the centrality of this site to the political and cultural identity of Rome, the early modern period saw efforts at reconstructing its original layout as well as a series of interventions by the popes and Conservatori, slowly implementing (and altering) a design by Michelangelo.

Another way to represent place was to represent the treasures located there. A very fine engraving [CAT. B347], published by Lafreri without any artist's signature, depicts the famous bronze statue of a female wolf nursing Romulus and Remus, the founders of Rome. The wolf was moved to the Capitoline hill (known in Italian as the Campidoglio) in 1471 by Sixtus IV. The two infants were added to this ancient Etruscan statue in the fifteenth century, probably in order to reinforce its association with the city's origin myth and its power as a symbol of Rome.

Many of the Roman monuments depicted in Lafreri's prints appear in reconstructed form. Using the best archaeological knowledge available (often copying work done by Pirro Ligorio), Lafreri directed designers and printmakers to present an idealized form understood to be as close as possible to the monument's original state. Often the monuments are presented without bystanders, or with ancient Romans who suggest the historical difference between past and present. Other Lafreri prints represent monuments in their current, ruined state, sometimes including contemporary bystanders whose presence draws the viewer in to the colorful variety of (then-) present-day Rome.

The Lafreri and Duchetti prints of the mysterious monument built by Septimius Severus, a fragmentary façade known in the Renaissance as the Septizonium or Septizodium [FIGURE 45, CAT. A11; CAT. A34] offer one such subject. They are nearly identical, but betray small differences: Duchetti published an etched copy of the earlier print published by Lafreri. The earlier print is much lighter, showing significant wear on the plate. It may be that the copy was made because the original plate was simply too worn down to use—suggesting that many thousands of prints were made from it.[15]

The French artist and architect Etienne Dupérac was in close contact with Lafreri and other Francophone artisans and writers in Rome, as well as local scholars. After producing engravings for Lafreri, in 1575 he published his own book, the *Vestigi*, containing carefully observed views of Roman ruins. Dupérac presents the most important monuments in a panoramic view, their surroundings populated by Romans and visitors. The collection of forty views appears to divide evenly into prints produced with etching and prints produced with engraving (in fact, etchings that have been massively reworked with the burin). Etching was often considered a superior medium for landscape, perhaps because of its potential for spontaneity. But here, the landscapes are rather labored, displaying the effort involved in producing a very precisely rendered reproduction of the current state of the architecture in question—neither a loose, romanticized view nor an idealized reconstruction. Perhaps for this reason, the engraving technique is not the geometric style of hatching favored for sculpture, but a collection of many short, sharp strokes. One copy of Dupérac's *Vestigi* now in Chicago's collection [CAT. 32] was owned by an English collector who translated the Italian captions of the first few prints.

Dupérac's prints were panoramic and carefully rendered views of Roman monuments in their modern state—some ruined, others surrounded by much newer buildings [see FIGURE 16]. While not as fanciful or folkloric as those of the printer-publisher Hieronymus Cock, they were informed by longer experience in Rome and acquaintance with serious antiquarian scholarship. Dupérac labeled elements of his prints to help viewers navigate visually. The same copy is bound with engravings by Giovanni Maggi, the *Ornamenti di Fabriche Antichi et moderni Dell'Alma Citta di Roma con le sue dichiaratione fatti da Bartolommeo Rossi Fiorentino* (i.e., with textual commentary by Bartolommeo Rossi), published by Andrea della Vaccheria in 1600. (Dupérac's prints had been published by Andrea's father Lorenzo.) Most of the Maggi prints, which are reduced copies of prints by Nicolaus van Aelst, depict obelisks and other major sites. The Library's copies of these oblong books are in simple, utilitarian bindings, and appear to have been heavily used—whether as artistic inspiration or to navigate through the city, we cannot know.

It was a different printmaker-publisher and his colleagues who began to exploit fully, and systematically, the aesthetic potential of Roman ruins as an independent subject of art. Hieronymus Cock, based in Antwerp, produced a series of devastatingly beautiful scenes of ruins, depicting crumbling buildings as part of a landscape, with scattered fragments, tangled vegetation, scenes of seduction, and dramatic skies. Cock made full use of the

etching medium, concentrating on the evocative qualities of line and often using chiaroscuro (dramatic contrasts of light and shadow) to create looming, cavernous spaces, and inserting figures that make witty commentaries. His view [FIGURE 41, CAT. B222] of the "ruins of the Palatine with a side of the Septizonium" is vastly different from the Lafreri and Duchetti versions.[16] Here the Septizonium and the Palatine Hill ("Palatium maior") sprout vegetation and appear as rough, crumbling elements of landscape, sidelined in favor of the sky, the dramatic rays of the rising or setting sun, and the leafy expanse before them. The etching medium, which in Cock's hands allowed a more spontaneous and painterly touch than engraving, supports the untamed style of depiction. This is Cock's first series, probably inspired by a trip to Rome. His shop in Antwerp was to publish many etchings and engravings of Roman (and other) landscapes by other artists.

Though art historians often associate the term "picturesque" with the eighteenth century, all the qualities of the later picturesque are apparent in these landscapes. They highlight wildness and irregularity rather than cool symmetry, and they make their artfulness apparent. One can see stylistic transformations in Cock's own atelier that produce ever more fantastical scenes. An etching by the van Doetecum brothers appears to be a free copy in reverse of Cock's Forum etching, or a composite of several similar prints [CAT. B238]. The van Doetecums often worked for Cock, and perfected a method of variable biting with etching acid that allowed them to produce etchings that could pass for engravings. The landscape has less greenery but more relief in its rocky, rolling hills and pitted, cavernous depressions, like craters of the moon. The absence of the Septizonium (demolished in 1588 for use as building materials) might suggest that this print is a much later copy. But its presence in a 1561 collection suggests rather that the artists used prints as sources rather than on-site observation.[17]

Another "stream" of images—which meets up with the Cock and Lafreri streams in albums and when all are copied in smaller guidebook illustrations—is constituted by Giovanni Antonio Dosio's Roman landscape drawings. These views of monuments are the basis for the series of woodcuts in Bernardo Gamucci's guidebook, the *Antichità della città di Roma* [see FIGURE 37, CAT. 47], and for etchings published by Giovanni Battista Cavalieri presenting views of monuments (many are similar but not identical to the etchings and engravings published by Etienne Dupérac). They offer a more comprehensive

choice of monuments and a slightly less rugged atmosphere than Cock's etchings. In the exhibition, Dosio's views appear by themselves within small volumes, or, in one instance [CAT. 20], bound with two volumes of Cavalieri's statue series. These etchings have often been called engravings and attributed to Cavalieri's hand,[18] but, although deftly drawn and charming, they have not been the subject of much study. I propose here that the views—etchings with occasional burin engraving added—were actually drawn by Dosio himself directly on the coated plates. Evidence for this is both textual and stylistic. The description of the process on the title page ("Cosmo Medici duci Florentinor et Senens Vrbis Romæ aedificiorvm illvstrivmqvæ svpersvnt reliqviæ svmma cvm diligentia a Ioanne Antonio Dosio Stilo ferreo vt hodie cernvntvr descriptæ et a Io Baptista de Cavaleriis aeneis tabvlis incisis repræsentatae") is unusual and quite ambiguous. It tells us that Dosio drew the ruins (*reliquiae*) as they appear today (*ut hodie cernuntur*) with an iron stylus (*stilo ferreo*). Cavalieri's role is uncertain. Taking "repraesentare" to mean, roughly, "reproduce (images)," the second half of the sentence seems to state that the ruins were "reproduced by Cavalieri with (in, by means of) incised copper plates." The double ablative is somewhat ambiguous, but grammatically, the plates are to Cavalieri what the stylus is to Dosio, which suggests that Cavalieri printed them much more obviously than it implies he etched them.[19] And Dosio's avowed use of the iron stylus strongly suggests—with perhaps an antiquarian nod to the idea of the wax tablet—that Dosio drew with it directly on the plates. It was fairly common for painters and draftsmen to dabble in etching, a medium that did not require the specialized training of the engraver.[20] Perhaps Cavalieri provided the plates and the acid bath, and retouched them with the burin. But Cavalieri, in contrast to Dosio, does not seem to have been a gifted enough draftsman to have done these etchings himself, especially in some of their finer details [FIGURE 63, CAT. 30]. Nothing in his later work suggests it; one need only compare his engravings of statues and emperors (e.g., CAT. 21, and many more in the digital collection).[21] Neither the drawing style nor the handwriting in the inscriptions seems similar. While it may be that in his engravings he deployed a certain artlessness as proof of veracity—a strategy Dupérac also seems to have used—there is not, in his other work, a trace of the facility seen in details of these etchings.

All these prints were copied and put to use in other works. Picturesque scenes seemed to call for

FIGURE 63

Giovanni Antonio Dosio (designer, etcher). *Temple of Vesta* (detail). Etching in Dosio, *Cosmo Medici . . . Vrbis Romæ ædificiorvm illvstrivmqvæ svpersvnt reliqviæ* (1569). CAT. 30.

Lipsius, a Flemish scholar, wrote historically rigorous accounts of many features of Roman culture. His scholarly treatise on Roman amphitheaters was based on Roman authors (chiefly Vitruvius) and included a geometric cutaway view of the Colosseum, reminiscent of Serlio [FIGURE 64, CAT. 56]. It also, however, contained a "picturesque" image of the Colosseum [FIGURE 65] in the style made popular by Cock. Lipsius writes that although he focused on the ceremonial use of the Colosseum, he did not neglect the architecture, and aimed to present it via both text and image. The print is a close copy of one that often appeared in *Speculum* collections [see FIGURE 19].[22] Lipsius writes that in his volume "the image, face, and entire character of the Arena are expressed, now with my pen, now with the [artist's] paintbrush. For I did not neglect the forms and images of the work. And even if I admit that I deal more with the ceremonies than with the architecture. . . nonetheless the architecture was not scorned entirely by me, inasmuch as it seemed indeed to afford a certain pleasure or admiration."[23]—RZ

Lucio Fauno (fl. 16th century). *Compendio di Roma antica.* **Venice: Michele Tramezzino, 1552. Rare Book Collection. Cat. 35.**

The *Compendio* is an abridged version of a guidebook to the topography of ancient Rome originally published in Latin. Published a little later than the earliest *Speculum* prints, it evidences the ever-increasing interest in ancient Rome among a middle- and upper-class public whose literacy was limited to the vernacular. The text begins with Romulus and then discusses the seven hills, starting with the Capitoline. It blends discussion of ancient Rome with some mention of what is to be found *in situ* in the present.

Pomponius Mela. *De regionibus Vrbis Romae.* **Toscolano: Alessandro Paganini, 1521. John Crerar Collection of Rare Books in the History of Science and Medicine. Cat. 69.**

This tiny book is a compilation of various texts on ancient geography and urban topography. Its size makes it easily portable for reference on-site in Rome, but it is also a display of skillful printing technique. It includes a collection of classical Roman texts on world geography, the roads and sea-routes of the Romans, the boundaries of imperial provinces, and the streets and buildings of each of the areas of the city of Rome.

commentary; some scholars and learned printmakers attached commentaries or legends in order to reimagine them as rational documents of ancient architecture. Vincenzo Scamozzi was asked by his publisher to write a commentary on an edition of Giovanni Battista Pittoni's reversed copies of Cock's etchings (see FIGURE 42, CAT. 81). The aim was to make these picturesque images useful not only to painters (who find in them inspiration for landscape), but also to architects (who might thereby identify the buildings and understand their construction). The inscription informs us that this is a "View of certain vaults at the corner of the Palatine, the Septizonium and the valley of the Circus Maximus." Adding a legend (B at the far left edge indicates the Septizonium) and a textual commentary, Scamozzi thus tempered pleasure with serious knowledge.

By contrast, sometimes scholars were happy to incorporate "picturesque" versions of monuments in a more piecemeal fashion into their scholarly work. Justus

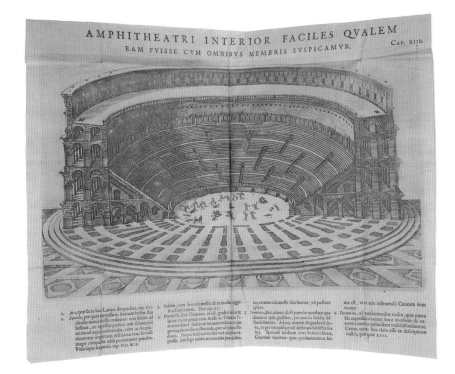

AMPHITHEATRI INTERIOR FACILES QVALEM
EAM FVISSE CVM OMNIBVS MEMBRIS SVSPICAMVR.

CAP. XIII.

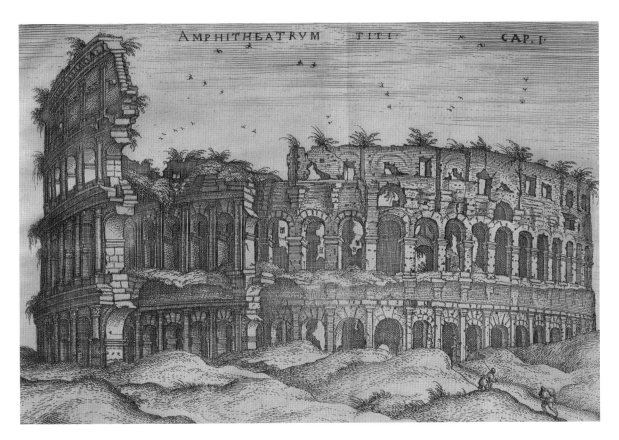

AMPHITHEATRVM TITI CAP. I.

FIGURE 66

Anonymous. *Roman imperial map.* Engraving in Welser, *Fragmenta tabulae antiquae* (1591). CAT. 92.

Marcus Welser (1558–1614). *Fragmenta tabulae antiquae, in quis aliquot per Rom. prouincias itinera.* **Venice: Aldo Manuzio, 1591. Rare Book Collection, Berlin Collection. Cat. 92, fig. 66.**

This book contains a fold-out image and extensive discussion of the "Peutinger tablet," a medieval painted copy on parchment of an ancient Roman pictorial itinerary, showing different portions of Roman territory. The original was a tool for Roman armies and provincial governors. In the Renaissance, the medieval copy came into the hands of Konrad Peutinger, an eminent German antiquarian and friend of the artist Albrecht Dürer, and afforded information on ancient mapmaking techniques.

Thomas Taylor (1576–1632). *A Mappe of Rome, Lively Exhibiting Her Mercilesse Meeknesse, and Cruell Mercies to the Church of God.* **London: Felix Kyngston, for John Bartlet, 1620. Rare Book Collection. Cat. 86.**

Though this book calls itself a map, it is a map of a different kind: a systematic critique of the evils of Catholicism from the point of view of a polemical Protestant. Protestants used many different kinds of metaphors to present their particular view of modern Rome.

Fioravante Martinelli (fl. 17th cent.). *Roma ricercata nel suo sito.* **Rome: Heirs of Giovanni Barbiellini, 1761. Rare Book Collection, Gift of Mrs. Edward A. Maser. Cat. 67, fig. 67.**

Along with maps and monuments, views of the Roman landscape helped travelers situate themselves within the city. This eighteenth-century guidebook copies many of its woodcut images from older prints, in this case, a much-copied view of the Forum by Giovanni Antonio Dosio. Here, the Roman Forum is presented in its guise as "Campo Vaccino," or cowfield—emphasizing, perhaps with irony, the modern use made of this ancient site.

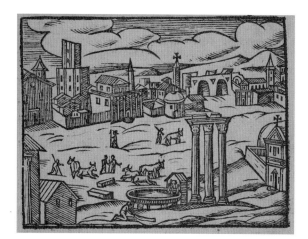

FIGURE 67

Anonymous. *Roman Forum.* Woodcut in Martinelli, *Roma ricercata nel suo sito* (1761). CAT. 67.

Considered a wonder to behold, the Colosseum was included in almost every guidebook to Rome. It became a symbol of Rome itself, indeed, of all of Western society. This notion was perpetuated by the oft-repeated saying:

> While stand the Coliseum, Rome shall stand
> When falls the Coliseum, Rome shall fall
> And when Rome falls—the world.[24]

The "Flavian Amphitheater" or "hunting theater," as it was called in antiquity, was built by the Emperor Vespasian beginning around 70–72 CE (Colosseum is a medieval term for the structure, perhaps based on a nearby colossal statue of Nero; Coliseum, another modern spelling, was a secondary Latin form). It was inaugurated by the Emperor Titus in 80 CE and remained in use until the sixth century. A series of earthquakes eventually took their toll, and the amphitheater descended into ruin. By 1855, the English botanist Richard Deakin recorded 420 species of plants growing within the structure.[25]

Prints played an important role in the way the Colosseum was perceived. Renaissance printmakers portrayed the Colosseum both as a contemporary ruin

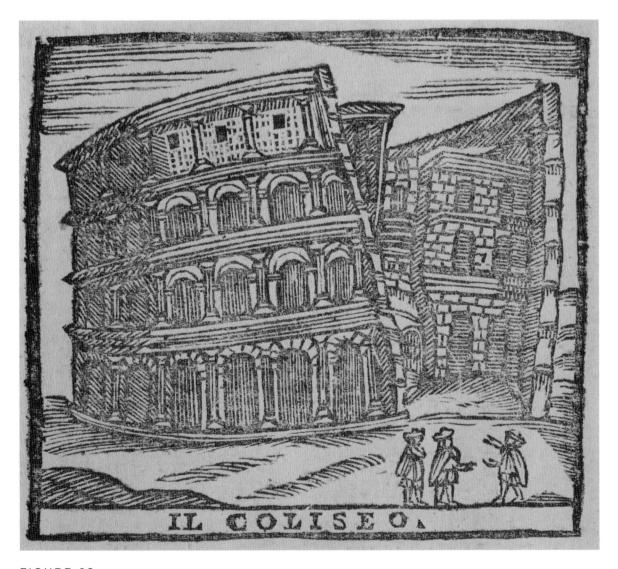

FIGURE 68

Anonymous. *View of the Colosseum*. Woodcut in *Roma ampliata, e rinovata* (1739). CAT. 2.

and as an intact monument, in each case purporting to offer the viewer an authentic experience of it. John Murray, in his nineteenth-century guidebook to Italy, underscores the significant effect of prints, writing of the Colosseum that "there is no monument of ancient Rome which artists and engravers have made so familiar to readers of all classes."[26]

Reconstructions allowed the viewer to glimpse the magnificence of Rome; ruins reminded the viewer of Rome's fall and of the inevitable decay of one's own historical moment. In the etching by Ambrogio Brambilla [see FIGURE 39, CAT. A29], the artist represents the Colosseum in a reconstructed state, though the cutaway view into the interior may have been inspired by its modern, ruined appearance.[27] The imaginary reconstruction offers the viewer a glimpse of the amphitheater as it would have stood in antiquity, suggesting an authentic experience of the monument. Ironically, the resurrected Colosseum is purged of its living elements. No people, plants, or landscape elements are to be found. Abstracted from reality, the Colosseum in this print exists only as a simulacrum of the original. In contrast, the inscription on the etching by Hieronymus Cock [see FIGURE 40, CAT. B211], emphasizes its ruined state, telling us that the Colosseum was "destroyed by barbarians." Jagged edges of broken stone protrude from the large gash in the side of the mammoth monument. Plants grow up from the cracks. This image of the Colosseum in its contemporary, ruined state offers a different, but no less "authentic," experience of the monument.

It was the image of ruins that later captured the imagination of the Romantics. Their sublime grandeur transported the visitor beyond him- or herself. Percy Bysshe Shelley was especially mesmerized by the amphitheater; for Shelley and other Romantic writers, the Colosseum was synonymous with the sublime. Upon his first visit to Rome, Shelley expressed his awe of the ruin in a letter of 1818: "I can scarcely believe that when encrusted with Dorian marble and ornamented by columns of Egyptian granite its effect could have been so sublime and so impressive as in its present state."[28] Describing it as "unlike any work of human hands I ever saw before," Shelley manifests an almost religious awe.[29] An unfinished poem by Shelley on the Colosseum [CAT. 85] echoes his description of the monument in his letter of 1818.[30] In the poem, a blind man and his daughter, Helen, visit the Colosseum, and Helen describes its ruined grandeur to her father. Enraptured

by his daughter's descriptions, the blind father offers his own purely Romantic ekphrasis on the sublime ruin.

Yet, despite its ruined state, the Colosseum was anything but deserted. Indeed, it was a vibrant part of Renaissance Rome. Hendrick van Cleve III's cross-section of the Colosseum [CAT. C534] portrays the monument as a lived space.[31] People travel through the interior of the Colosseum as they conduct their business. An amorous couple sits ensconced in a niche. They snuggle together as if no one else were around. The crumbling façade and the overgrown plants enhance the image of daily life amid the ruined structure. The Colosseum also became popular with Christian pilgrims who attended ceremonial commemorations of the Roman martyrdom of Christians there. The pilgrim guidebook published by Giorgio Roisecco [FIGURE 68, CAT. 2] reflects this notion. He introduces the Colosseum as "more celebrated for the triumphs of the holy martyrs, than for the excellence of its structure."[32] The woodcut reveals a cross-section of the great amphitheatre. Here, the Colosseum is a marker of pagan persecution of those early, faithful Christians. Traversed by locals, artists, lovers, tourists, and pilgrims, the Colosseum was alive with activity. In short, it had a pulse.—AP

Artists, Techniques, Uses

TECHNIQUE

The Renaissance saw the advent and use of several different printing techniques. The woodcut process, used in Europe from the fourteenth century and represented most notably here by Hubertus Goltzius's two-color title page [FIGURE 69, CAT. 48], is a relief printing technique. The raised lines of the design are inked, and then the image is pressed to paper, producing an image in reverse. Because of the difficulty of carving fine lines in wood, the images produced by woodblocks have a distinct look. Scholars have suggested that, in the west, woodblock printing began as an outgrowth of textile design. The lines tend to be thick and tapered at each end. Woodcut blocks have some longevity, but when the blocks have been used a great deal, the lines become round and flattened and resulting prints appear faded.

Goltzius's book represents an excellent example of early modern colored woodblock prints. Unlike a

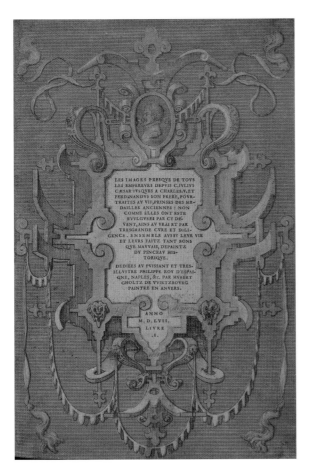

Anonymous. *Title page*. Etching and woodcut in Hubertus Goltzius, *Les images presqve de tovs les emperevrs* (1559). CAT. 48.

With engraving, on the other hand, printer-publishers could produce thousands of copies from a single plate. The process was adapted from goldsmithing and metalworking. Lines are cut deeply into a plate, usually copper, with a burin, a specialized tool that creates characteristic tapering lines. The burin allows for a high degree of control and, in turn, gives the artist the ability to design in great detail. The plate is inked, but rather than sitting on the surface of the plate as with a woodblock, the ink collects into the grooves created by the burin. The plate's surface is then wiped clean with a cloth, leaving only the ink in the grooves to print onto a sheet of dampened paper. Engravings were often re-incised to prolong their longevity. Plates of particularly popular prints were sometimes re-engraved many times before a new plate was made.

In examining engravings of sculpture, one can see the complex geometric hatching systems developed for conveying the relief (three-dimensionality) of musculature in particular, and lights and darks in general, with a netlike system of curved lines. Some engraving—done by less experienced artisans—was less systematic. With a magnifying glass or a digital zoom function, engraving lines can be recognized by their tapered, swelling appearance. Individual marks tend to be shorter, sharper, and tighter (less flowing) than in etching.[33]

Bosse's 1645 technical treatise, *Traité des manières de graver* [CAT. 16], also discusses another technique used in the period, etching.[34] In etching, an image is lightly incised onto the wax coating of a metal plate with a needle. The plate is dipped into acid that eats away at the exposed lines and leaves the wax untouched. The plate is then cleaned, inked, and printed like an engraving plate. Etched images, like the ones in Perrier's and Jan de Bisschop's books (and seen elsewhere in the exhibition in the work of Cock, Dosio, and Dupérac in particular), can be even finer and more detailed than engraved prints, with a looser, more spontaneous line. Seen up close, the line is more even in weight from start to finish than an engraved line (engraved lines often manifest the extra effort of the initial excavation of the plate).

Despite these design advantages, the etching technique was used less frequently than engraving. This is probably because the process is somewhat dangerous (acids can be unstable); more materials and space are needed to produce etchings, and etched plates also wear more quickly than engravings (producing editions in the hundreds, not thousands), and it is difficult to extend their use. Engravings required more labor and expertise,

single-color woodblock print, a multicolored print involves more than one block in the production process. Once the design (in this case, done in black ink with an etched plate) was laid down, additional colored blocks we added to the paper in sequence—darker colors first, then lighter. The process requires skill and great care in aligning the blocks, and it can be difficult to avoid overlapping and muddying the image.

Drypoint is another printmaking method used in the Renaissance. It involves scratching directly on a copper or iron plate with a needle. Rough ridges of metal (called the "burr") are pushed up from the needle's fine cuts. They catch the ink, resulting in a rich black line when printed. Drypoint is in evidence in this exhibition only as an occasional addition to prints produced with other techniques. Prints made entirely with drypoint can produce only a small number of good impressions, and were not suited to "mass" production.

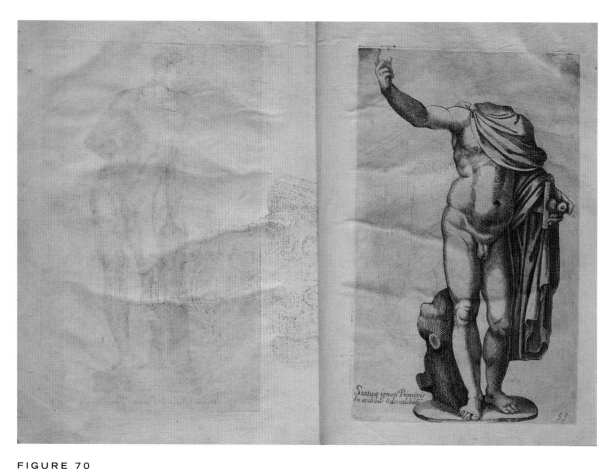

FIGURE 70

Giovanni Battista de Cavalieri (engraver). *Statue of an unknown prince in the Odescalchi gardens.* Engraving in Cavalieri, *Antiquarum statuarum urbis Romae* (1585–1594). CAT. 21.

and this was sometimes considered a value in and of itself. But etching was an available option for non-specialists, which gave it a certain appeal among painters and other artists.[35] In the context of the publishers of the *Speculum* and related images, they were frequently used to make quick copies of existing images.

In the exhibition, different printmaking techniques are specifically represented by prints in books, but they also all occur throughout the exhibition. Woodcuts appear almost exclusively in printed books (though a few woodcut maps appear among Chicago's *Speculum* collection). Etchings and engravings appear both as independent prints and in bound print collections and, only occasionally (as in the case of Valverde, CAT. 90), as illustrations in books.

Traces of the printmaker's method appear in several examples in the exhibition, from Giovanni Battista de' Cavalieri's collections of ancient statues (*Antiquarum statuarum urbis Romae. . .*) and François Perrier's *Segmenta.*[36]

Both volumes contain prints after prestigious statues in Rome, printed and published by artists as systematic collections. The opening in one of the University of Chicago copies of Cavalieri's *Antiquarum statuarum urbis Romae* labeled as a *Statue of an unknown prince in the Odescalchi gardens* shows an offset of a bust bearing an ornamental breastplate on the verso of the preceding sheet [FIGURE 70, CAT. 21]. Offsets are faint prints unintentionally created by stacking damp prints one on top of another. They are doubly reversed, i.e., oriented in the same direction as the plate. They can often give evidence about the practices of a print shop.[37] Moreover, the plate itself bears a much lighter and less visible design of a fragmentary drawing of a crouching figure in the upper portion of the print, showing that Cavalieri recycled his plate, engraving over a previously designed attempt.

Cavalieri's prints of statues are engravings; François Perrier's, on the other hand, are etchings. Perrier's *Segmenta* was first published in 1538 in Rome. Later

FIGURE 71

François Perrier (designer, etcher). *A muse.* Etching in Perrier, *Illmo.D.D. Rogerio Dv Plesseis. . . magnarum artium eximio cultori. . .[Segmenta]* (166—). CAT. 74.

editions include copies published in Rome by Giovanni de' Rossi and reprintings in Paris of the original plates by Perrier's widow, and by François de Poilly, who acquired the plates after her, in the late seventeenth century.[38]

One University of Chicago copy [FIGURE 71, CAT. 74] bears de Poilly's address. It also contains numerous prints pasted in by a collector on the versos of its pages. Some of them are unrelated prints of statues, but fifty-nine are counterproofs, a double reversal of a print made by pressing a newly printed impression onto a fresh sheet of paper. These impressions thus appear in the same orientation as the plate, and were used by printmakers to correct the plate. The counterproofs allow us to see that several plates have been renumbered; the original number was burnished out and re-incised. Identifiable by their reversed numbers, the counterproofs are dated a year before the first publication of the *Segmenta*. These facts suggest that Perrier added to and/or rearranged the set he proofed in 1637. It is not known what owner of this particular volume pasted in the counterproofs on the versos to face their counterparts.

Perrier's ambitious frontispiece (shown in a copy of the *Segmenta* [see FIGURE 52, CAT. 73] that is bound together with Jan de Bisschop's *Icones*) depicts Father Time as Saturn chewing on the Belvedere Torso. The much-admired canonical sculpture makes an important statement: as age eats away at the sculptures of the past, only printed depictions can preserve the ancient fragments. Perrier's etchings, not the actual ruins, are

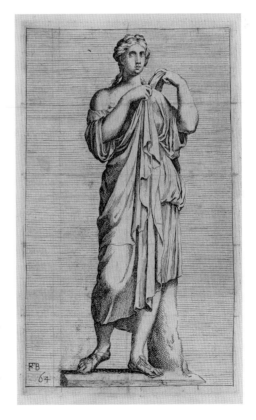

FIGURE 72

François Perrier, *Diana Venatrix in Hortus Marchionis Iunii.* Etching in Perrier, *Illmo. DD. Rogerio Dv Plessies. . . magnarum artium eximio cultori. . .[Segmenta]* Rome, 1638. Yale Center for British Art, Paul Mellon Collection. Modified to highlight gridding. CAT. 73.

objects that remain to be mined by other artists for information and inspiration. And we know that they were: a copy of Perrier's *Segmenta* once owned by Sir Joshua Reynolds, now at Yale's Center for British Art, demonstrates one particular artist's working method for using prints after antiquities. The gridded design drawn over the sculpture indicates that Reynolds intended to proportionately transfer the picture into another work. Several other female statues in this book have also been gridded for transfer, suggesting that Reynolds often returned to this book to mine it for models [FIGURE 72].

Prints were broadly disseminated and often served as models for other works of art. *Speculum* prints of antiquities were also often bound into books or albums, or used as models for new illustrations produced for books. Many different types of books incorporated these images as illustrations. They thus served a variety of purposes: as part of history and "text" books, pilgrimage and tour guides, and as records of antiquarian collections. Artists also put such images and collections of them to myriad uses. They copied images in order to learn from them, and quoted, reused, recreated, and reformulated them in whole or part.

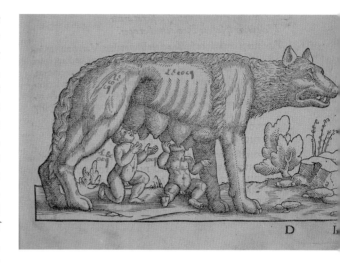

FIGURE 74

Anonymous. *Capitoline Wolf.* Woodcut in Marliani, *Vrbis Romae topographia* (1550). CAT. 63.

USES OF THE IMAGE

Artists understood that their images would be used and borrowed from by others. Hieronymus Cock's [CAT. B210] title page explicitly encourages other artists to use his images, whereas François Perrier's simply implies it. Lafreri's frequent collaborator Mario Cartaro does something slightly different in his etchings. His *Prospettive* [FIGURE 73, CAT. 18], often bound in small volumes with Giovanni Maggi's *Ornamenti*, are fantastical scenes of architecture that serve as demonstrations of mathematical perspective. Cartaro theatricalizes the ruined buildings that form the basis of his perspectives. He both leaves blank spots throughout and gives visual suggestions for how to use them by including small figures in incomplete scenes. Thus Cartaro blends his display of perspectival skill with a tacit invitation to copy and learn from him. At least one owner of the Chicago volume seems to have taken him up on the proposition; small drawings and tracings made throughout the book suggest that a previous owner was an artist or student.

As was frequently the case in the early modern period, many owners of these books and albums, inspired by such direct or implied suggestions, did make their own interventions on the pages of books and albums. *Speculum* albums were often annotated by hand. Drawn, traced, and written copies and "commentaries" can be observed in these books, some of whose prior owners are known. The Chicago copy of Bartolomeo Marliani's 1550 *Topographia,* an important guide to the antiquities

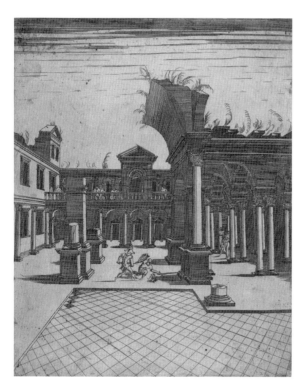

FIGURE 73

Mario Cartaro (designer and etcher). *Sword fight in a ruined courtyard.* Etching in Cartaro, *Prospettive diverse* (1578). CAT. 18.

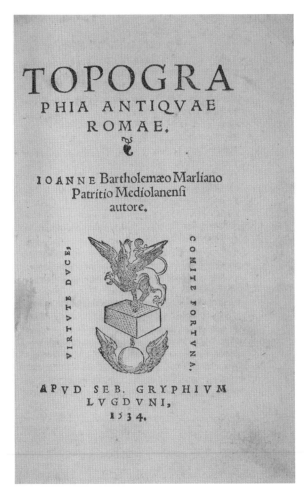

FIGURE 75

Title page of Marliani, *Topographia antiquae Romae* (Lyon, 1534). CAT. 63.

of Rome, displays the tracings and obsessive auto-graphing of an owner named Le Cocq [FIGURE 74, CAT. 63]. Pencil tracings show that Le Cocq was also interested in copying pictures.

Marliani's *Topographia* appears in the exhibition in many guises. It was first published, unillustrated, in 1534 [FIGURE 75, CAT. 62]. The small 1548 Antonio Blado edition [see FIGURE 61, CAT. 61] contains a map of Rome in the time of Romulus; the 1550 edition, a reprint of one first published in 1543–1544, featured large wood-cuts [FIGURE 74, CAT. 63]. Finally, a more portable version appeared in 1588 with a larger quantity of more utilitarian images [see FIGURE 36, CAT. 64; FIGURE 86, CAT. 65]. The woodcuts of the influential 1544 edition also served as a source of images for others; Louis de Montjosieu's idiosyncratic account of Roman antiquity,

Gallus Romae Hospes ("the French visitor in Rome"), drew on several of Marliani's images. He adapted Marliani's diagram of the floor plan of the Septizonium, adding a column to suit his theory that the building was a calendrical calculator [see FIGURE 48, CAT. 71].

Montjosieu also copied several images from other sources for use in his own book. He audaciously secured a papal privilege to publish them exclusively as his own, whether as part of the book or as independent prints.[39] Apart from the specificity of this text's author concerning himself to such a degree with the fate of these borrowed images, this was not unusual. The copying of prints originally produced by others was embraced quickly with the new technology, though it did not always please printmakers whose works were copied.[40] Printmaking was a competitive business, and copying works by others was an efficient way to turn a profit. Many artists made more or less precise copies of other prints in hopes of profiting from the cachet of the original's recognizable image. Conversely, the wide dissemination and profitability of prints spurred concerns about plagiarism. Even as protections of the rights of artists developed (mostly in the form of privileges, like Montjosieu's, granting exclusive rights to sell and reproduce books and prints), artists continued copying each other's work, believing it was their right, and indeed often a requirement of their education, to draw inspiration from many sources.[41]

Copying documentary images—prints that depicted well-known statues and monuments—may have seemed to pose fewer problems than purely fictive ones, whose "invention" could be identified with a particular artist. Yet because even documentary images involve a variety of artistic choices, the influence of such prints can often be traced. In *The Virtual Tourist,* we used two specific examples to demonstrate print "lineages," though similar examples can be found throughout the catalogue: images of the Temple of Antoninus and Faustina and of the "Roma victrix" statue group.

Views of Roman sites like the Temple of Antoninus and Faustina were copied again and again.[42] Since nothing prevented an artist from choosing a new point of view in depicting such monuments, the fact that one print uses the same vantage point as another suggests that the artists were copying from prints rather than going on-site to make their own independent drawings. The prints of this temple published by Cavalieri and Gamucci [FIGURE 76, CAT. 47] represent the monument from the same position because the artists (in the former case

possibly Dosio himself) worked from Dosio's original drawings. Dosio himself may have reduced the size of his drawings for Gamucci's high-quality woodcuts, and may have etched the larger prints himself (see discussion in Section 1). By 1569, thanks in part to Lafreri and Salamanca's experiment with engravings for Valverde's *Historia,* a printer-publisher might have chosen to use engravings for a high-quality illustrated book. But woodcuts were less expensive and, still, easier to print in combination with letter type. They could also produce very sophisticated results, as in Gamucci's guidebook.

Many of the somewhat lower budget woodcuts present in the 1588 edition of Marliani's *Topographia* were copied from Gamucci's (the same blocks were also used in pilgrim guidebooks that were put out by the same publisher, Girolamo Franzini, also in 1588). The image of the temple of Antoninus and Faustina was one of these. All three prints, the etching and the two woodcuts, conform to the same orientation and general set of details, though there are several small differences (a small chimney on the pitched roof visible through the rightmost columns of the façade is in a slightly different position in each print. Among other obvious examples of prints copied from other prints are the very exact copies produced by Duchetti after Lafreri's death, such as the large-scale Septizonium prints [see FIGURE 45, CAT. A11; CAT. A34]; the copies of *Speculum* prints that appear in Boissard's *Topographia,* along with republished texts; multiple copies of the ruined Colosseum; and many woodcuts that are based on *Speculum* prints (for instance, the *Mithras* and *Triclinarium* prints: see Intermezzo III and Section 5).

Not all copies are exact replicas, nor are they always identifiable as reproductions based on a single shared visual source. The *Roma victrix* sculpture group was a composite created out of several statues in the sixteenth century to symbolize Roman victory.[43] The large-scale, detailed engraving published by Lafreri [CAT. A90] put it in wide circulation and probably influenced later artists in a more indirect way. Roma's seat may have served as a reverse template for Cavalieri [FIGURE 76, CAT. 20], who copied certain features while adding some of his own observations. Often, because it was easier to copy directly from print to plate, copyists produced an image that was the reverse of the original print. Cavalieri's image might appear to be a reversal at first glance, but it was actually drawn from a different point of view.

The volume in which the Cavalieri print appears contains two different collections, bound together: Cavalieri's engravings of statues, and his publication of Dosio's Roman views. Plate no. 19 of the set of sculpture depicts the statue of *Roma victrix,* identifiable not only by the plate's engraved legend but also by her attributes: her laurel wreath, helmet, throne, and sword. Girolamo Porro copied his version of the celebrated statue from Cavalieri.[44] Girolamo Porro's *Statue antiche che sono poste in diversi luoghi nella Citta di Roma* [CAT. 77] contains fifty-two prints by Girolamo Porro after Cavalieri's earliest edition of his statue collection. (The University of Chicago's *Speculum* collection also includes 48 of them.) Porro's print is slightly smaller than Cavalieri's, and Roma has been shifted closer to the center of the page. A number of other details were reduced, simplified, or altered, such as the laurel wreath, the helmet's plumage, and the figure's facial features and head position. Sometimes technical challenges, the artist's skill level, or the haste with which an edition was assembled also account for variation in the copies.

ARTISTS' SELF-REPRESENTATION

Over the period covered by this exhibition, artists developed a new self-consciousness (both individual and

FIGURE 76

Giovanni Battista de Cavalieri (engraver). *Roma victrix.* Engraving in Cavalieri, *Antiquarum statuarum urbis Romae* (1585–1594). CAT. 20.

corporate) as artists. And in Rome, the quantity of artists who flocked there meant that they constituted a distinct subculture in the city. Many images of ruined landscapes are also self-representations, depicting artists drawing. Drawing was a fundamental aspect of art education during the Renaissance, and antiquity was first in the line of references: painters, sculptors, and architects alike filled their sketchbooks with images of ancient Rome.[45]

The genre of *vedute,* or views of Rome, thus comprised more than just simple, objective landscapes. These self-representations expressed the experiences of artists as a group and included the results of both direct observation and copying practices. Among Giovanni Antonio Dosio's views, published in 1569 by Giovanni Battista Cavalieri, some were drawn on-site, and others were copied from other prints.[46] As artists spent entire days, spring through autumn, sketching Roman sites, they naturally began to record and pictorially comment on their own activities. Dosio's collection, for example, comprises fifty views of Rome, a number of which include an image of the artist. In the etching of an *Artist sketching in the ruins of the Baths of Caracalla* [CAT. A420], the artist's sketch paper parallels the page of the print, and it is as if his pencil not only draws, but also produces the engraved text to his right. His print thus doubly—in written and visual language—records the view before him, while assuring the viewer of the image's truthfulness.

These images were not always about truth; sometimes they were about play. Various humorous and ambiguous activities take place in Hieronymus Cock's etching entitled *Colossaei Ro. Alius prospectus (Another View of the Roman Colosseum).* An artist draws the Colosseum before him, while his assistant gesticulates [CAT. B212]. They may be discussing the naked couple just a few feet away (a nearby dog might be read as a pictorial metaphor for the couple's carnal acts). Another suspicious character spies on the lovers, but his actions are ambiguous: he may be reading an inscription on the broken fragment he leans on—or defecating. Together, these figures create a theme of looking and lend the picture a cheeky playfulness. A different kind of playfulness appears in the vertically oriented etchings published by Jacques Androuet Ducerceau after designs by Léonard Thiry. Although loosely based on actual Roman sites, they offer fantastical ruined landscapes. The inclusion of artists drawing from the ruins plays on the notion of eyewitness account. Knowledgeable travelers, collectors, and other artists, however, would have recognized that the

etching is a composite of different sites. Thus, the group of different artists drawing different views serves as a clever visual witticism on the inventive process, a pictorial pun designed for the educated viewer [CAT. C436].[47]

Depicting oneself, or a proxy for oneself, in the act of drawing within a picture could make several artistic statements. First, it implied firsthand knowledge of monuments, ruins, and sculptures. Empirical knowledge was important during the Renaissance, and evidence of documentary accuracy could help guarantee print sales. An embedded self-portrait served as proof that the artist had been present at the scene, which in turn validated the idea that the print was an accurate record of what actually existed. Second, these vignettes could serve as playful commentary on artists' habits and activities—an insider's view on the working artisan.[48] Last, these embedded pictures served as evidence of the culture's interest in particular famous objects. A contemporary parallel might be a cartoon depicting the throngs of tourists crowded around the Mona Lisa, all flocking to the same site. In each case, the embedded portrait or generic depiction of an artist added an important intellectual element to the picture, contributing veracity to the print and value to the viewing experience.

Generations of prints of the famous sculpture known as Marforio subtly make this point. A 1547 engraving of *Marforio* by Giulio Bonasone presents Marforio (a fragmented statue that originally represented a river god) in a mock battle with Pasquino, another "speaking sculpture" (see Section 4). These Roman sculptures were often endowed with textual notes written in their (comic or serious) "voices." Prints that appear loosely based on the Bonasone print maintain Marforio in approximately the same position, but substitute, for Pasquino, an artist sketching and an onlooker reading inscriptions on the wall behind the statue. The print presented in the exhibition was published by Duchetti [CAT. A113], a copy of one published by Lafreri; soon after another copy, this one by Jacques Granthomme, appeared in de Bry's edition of Boissard's *Topographia* [CAT. 12].[49] All these later versions include the artist intently studying the ruined statue. Marforio may have been a popular subject with artists because of his ability to "speak" and his status as an "animated" artwork. Granthomme's engraving seems to reiterate de Bry's claim, in the publisher's introduction to the book, that images give life and voice to the text.[50] In all these versions, an embedded viewer near the back stands and looks at a blank wall. This may be another way of

FIGURE 77

Anonymous. *Arch of Janus.* Woodcut in Marliani, *Vrbis Romae topographia* (1550). CAT. 63.

FIGURE 78

Anonymous. Recto of *Arch of Janus* with tracing. Marliani, *Vrbis Romae topographia* (1550). CAT. 63.

emphasizing the importance of images, or suggesting the superiority of images over text. In other versions, including Duchetti's, text does appear on the wall: it describes the characteristics and personality of the statue, Marforio. It also loosely refers to the practice of pinning notes to the statue—making it "talk."—RP

Hieronymus Cock (ca. 1510–1570), Frontispiece of the *Praecipua monimenta.* Etching, 1551. Published by Cock. Cat. B210.

Cock's frontispiece tells the reader that his book contains "certain preeminent monuments of Roman antiquity cleverly designed in vivid views for (in) the imitation of the real" ("Praecipua aliquot Romanae antiquitatis ruinarum monimenta, vivis prospectibus, ad veri imitationem affabre designata"). There is ambiguity in the Latin phrase "ad imitationem"; it could be translated "*for* imitation" (suggesting that Cock wanted others to draw inspiration from his prints) or "*in* imitation" (meaning that the prints themselves are an imitation of truth).

Bartolomeo Marliani (d. 1560). *Vrbis Romae topographia.* Basel: Johann Oporinus, 1550. Rare Book Collection, Berlin Collection. Cat. 63, fig. 77.

A previous owner of the book, Gaspard Le Cocq, has scribbled his name under the Arch of Janus. Pencil tracings on the opposite page [FIGURE 78] show that Le Cocq was also interested in copying pictures. In copying the Arch of Janus, artists often omitted the top part of it, erroneously believing it to be a later addition to the structure. This picture more closely resembles what the arch looks like today than what it looked like in the Renaissance.[51]

Josse Bade (1462–1535). *Chalcidij viri clarissimi Luculenta Timaei Platonis.* [Paris: Josse Bade], 1520. Rare Book Collection, from the Library of Richard P. McKeon. Cat. 7, fig. 79.

The printer's mark of Josse Bade (Jodocus Badius) shows printers at work. Bade's monogram appears below and

FIGURE 79

Title page of Josse Bade, *Chalcidij viri clarissimi Luculenta Timaei Platonis* (1520). CAT. 7.

FIGURE 80

Robert Boissard (engraver). *Title page with an artist's workshop.* Engraving in Boissard, *Romanae Vrbis Topographiae* (1600). CAT. 12.

the shop's name adorns the press itself. During his thirty-five-year career in the early part of the sixteenth century, Badius printed more than 700 books at the Praelum Ascensianum in Paris. Most included this frontispiece.

Jan de Bisschop (1628–1671), *Paradigmata Graphices Variorum Artificum.* **Amsterdam: Hendrick de Leth, [1671]. Rare Book Collection, Berlin Collection. Cat. 11.**

Despite Bisschop's beautiful etchings and his influence, scholars have considered him an amateur, perhaps because he never traveled to Italy.[52] He referred to and copied elements from a variety of published sources including Perrier and Cavalieri. He was, however, fastidious, choosing images and representing them, to the best of his knowledge, in their contemporary state. The speed, accuracy, and agility of his studied and delicate etching technique are well beyond the capabilities of a mere "amateur."

Jean-Jacques Boissard (1528–1602). *Romanae Vrbis Topographiae & Antiquitatum, quâ succincte & breviter describuntur omnia quæ tam publice quam privatim videntur animadversione digna.* **Frankfurt: Sons of Theodor de Bry, 1600. Vol. III, pt. V. Rare Book Collection, Berlin Collection. Cat. 12, fig. 80.**

Artists' studios often contained antiquities intended for careful study. The title page of this volume of Boissard's text depicts a studio filled with statues and relief fragments, an artist, and an apprentice. The artist paints a bust and torso, giving us a simultaneous view of the sculptures and their painted replicas. The artist's tableau is contrasted with his assistant's, which remains an empty canvas. In a sense the portrait memorializes Theodor de Bry, who had died in 1598.

As fifteenth- and sixteenth-century archaeological excavations of Roman ruins revealed a treasure trove of antique design, such discoveries prompted a range of artistic reactions and initiated a new chapter in printmaking's creative relationship to the past. While the visual impact of ancient Rome on the Renaissance is undeniable, the increasingly inventive application of antique decorative motifs and subjects to modern imagery reflects a kind of liberation for the artist.[53] A number of works in the *Speculum Romanae Magnificentiae* faithfully represent Roman architecture in the damaged state in which it was often unearthed, or visually reconstruct fragmented sculpture. But imagination and invention often led to completely original designs based on ancient vocabulary. Imaginative combinations of mythology, eroticism, humor, and ancient and modern histories became the trademark of artists such as Giulio Romano, who used his study of the antique as inspiration in designs for architecture, large-scale programs of wall painting, and ornate silverware for banquet tables.[54]

Many different engravers, in turn, immortalized these designs that displayed both modern ingenuity and resourceful reliance on antiquity. Diana Mantovana, one of the most famous female artists of the sixteenth century, produced a three-sheet print after Giulio's *Marriage Banquet of Cupid and Psyche* in the Palazzo del Te (though she introduced a major modification in the rightmost image).[55] Diana's brother Adamo Scultori also trained as an engraver in Mantua, where their father worked with Giulio completing the Palazzo's decoration. Two prints attributed to Adamo, part of a larger series, exhibit elements of an antique-inspired language of ornamentation that could be imaginatively combined to fit the artist's needs.[56] One of the grotesque masks [CAT. C501] is composed of shell-like forms, fruit, and scrollwork, recalling similar prints by the Antwerp artists Cornelis Bos and Cornelis Floris.[57] The horns, goat-like ears, and untamed hair and beard of the other highly expressive head [CAT. C504] recall the satyrs that cavort in ancient Priapic or Bacchanalian festivities. Such wild characters were a popular subject in Renaissance art and literature, often representing a mythological Arcadian existence where humans and nature collided to riotous effect.

Claudio Duchetti demonstrated the enduring popularity of the racier side of imaginative ornamentation when he republished the priapic sacrificial scene that had been engraved by the artist known as the Master of the Die (or Master B in the Die) in the 1530s [CAT. B296].[58] In this print after Giulio Romano, an array of figures frolic around a figure of Priapus. Worshipped as a god of agricultural and human fertility, statues of Priapus were protective figures that kept watch over an owner's livestock, crops, and virility. Humorous in part because of large phallus, but also threatening, such figures achieved popularity in Renaissance architectural decoration due to their appealing blend of comic and creative potential. The print makes reference to the recurring imagery of garlands, acanthus leaves, hybrid animals, and masks that appeared on the elaborately painted walls and decorative objects uncovered during excavations of such subterranean ruins as the Domus Aurea (Golden House) of Nero.[59] Artists and antiquarians who explored the area recorded their findings in notebooks, to be copied in future works or adapted into a new language of design.

Antiquarian printmaking's variety of functions shows the breadth of its appeal. Nearly two centuries after the initial discovery of the Domus Aurea, the artist and excavator Pietro Santo Bartoli (1615–1700) published engravings of antique bronze objects collected from the subterranean remains of ancient Rome. While his purpose was categorical documentation, Bartoli's prints (for example, an oil lamp shaped as a satyr's head) may call to mind the ancient origins of popular Renaissance decorative motifs [CAT. 80]. A handle and lid protruding from the head of the lamp call attention to the ancients' remarkable merging of the functional with the ornamental to create useful items. The objects' subsequent rediscovery and engraving reflect an antiquarian interest in establishing categorical knowledge of ancient Rome, which could be organized and published as a pleasurable and informative source.—IG

Lazare de Baïf (1496?–1547). *Lazari Bayfii annotationes in L. II. De captivis, et postliminio reversis.* **Paris: Robert Estienne, 1536. John Crerar Collection of Rare Books in the History of Science and Medicine. Cat. 9, fig. 81.**

In a section called *Animaduersiones in tractatvm de avro & argento legato*, roughly translated as "remarks on the treatise on gold and silverplate," Baïf has illustrated a vase with the grotesque ornamental details of masklike human and animal heads, garlands, and vegetation. The

FIGURE 81

Anonymous. *Serving pitcher.* Woodcut in Baïf, *Lazari Bayfii annotationes in L. II. De captivis* (1536). CAT. 9.

inscription above reads "Urceoli ministratorii forma ex antiquis marmoribus desumpta," informing us that the small pitcher is based on an antique marble model.[60]

Enea Vico (1523–1567) after Polidoro da Caravaggio (designer), *Military Trophies*. Engraving, 1550–1553. Published by Antonio Lafreri. Cat. C608.

The shields, helmets, and other traditional military components of a Roman triumph are softened in this print by the Renaissance addition of hybrid animals, ribbons, masks, and vegetation. United in a fantastical arrangement that visually alludes to the grotesque decorations painted on ancient Roman interior walls, such a composition could have provided a visual record of a particular device or served as a point of reference in a series of artists' designs. This is one many similar prints published by Lafreri and by Salamanca.[61]

Antiquarian Publishing and Architectural Reconstruction

The Roman print and book publishing world in which Lafreri and his rivals and collaborators worked was still a fairly young industry. Book publishing had exploded across Europe following the introduction of Gutenberg's printing press in the mid-fifteenth century. In Rome, these industries often drew inspiration from cosmopolitan Venice to the north. In large part because of its position as an international trading hub, Venice was the major center of print production in Italy and a stopping point for many travelers who came from the north and the east. During the sixteenth century Venice could boast at least 450 booksellers, printers, and publishers.[62] Roman publishers, printers, and print and book dealers (functions often combined in a single enterprise) traded merchandise with their Venetian counterparts, and often competed with them as well.

The burgeoning culture of book production also meant the development of new print-related occupations such as editors, compositors, and pressmen. Renaissance printers hailed from mostly middle-class backgrounds, and most of these men (and a few women) gravitated toward the more lucrative book publishing industry. Apprenticeships were the most common route to the publishing profession. Latin was not only the language of the church but also the international language of scholars, and thus in addition to the vernacular, ambitious publishers had either to be literate in Latin or to hire intellectuals as editors. In general, both bookshops and print shops shared similar business operations and were subject to the regulations of the same privilege-granting official bodies such as the papacy and the Venetian Senate.[63]

Venice provided particular inspiration in the realm of antiquarian printing. The famous publishing house of Aldus Manutius (Aldo Manuzio) published both scholarly editions of classical texts and modern treatises on antiquarian topics. The selling of prints was considered to be a secondary pursuit to that of selling books, and was often pursued as a supplemental income. Book printers marked their publications with a printer's mark, their business insignia, on the title page. These woodcut images often took the shape of a motto paired with a

symbolic device. Here in the *Antiqvitatvm Romanarvm Pauli Manutii liber de legibvs* by Paulo Manuzio can be seen his father Aldus's famous "dolphin and anchor" device, expressing the motto *festina lente,* or "hasten slowly."

The sibyl, a female prophet and symbol of mystical ancient knowledge, was the printer's mark of Michele Tramezzino, one of the most prominent Venetian print publishers in the second half of the sixteenth century. He first established himself as a successful bookseller with his brother Francesco in Rome before branching out on his own in Venice, finding his niche in antiquarian publishing. By 1536 his publishing venture focused on vernacular romance novels and translations of the classics, as well as legal and historical texts. In the early 1550s his practice expanded yet again to encompass the production of maps, figural prints, and archeological views of classical Roman monuments. In this sense, Tramezzino's activities exemplify the business practice of augmenting one's publishing profits by offering prints in addition to books for sale.

With the Berlin collection, the Library acquired both a Latin and an Italian edition of Lucio Fauno's book, *De antiquitatibus urbis Romae* and *Delle antichità della città di Roma* [CAT. 36, 37]. Both display the sibyl frontispiece, with two slightly different woodcuts and mottos, expressing the idea that the book she carries preserves words more solidly than speech. The vernacular edition of Fauno's guidebook to Roman monuments benefits from a large font size and ample leading and kerning to allow for easier reading. The pocket-size edition can be carried while viewing the Roman ruins. The device of a sibyl reading a book is accompanied by a minimalist take on Tramezzino's maxim: "[That which is more steady] is my page, is my prediction." Another Fauno book, the *Compendio* [CAT. 35], is an abbreviated version sometimes bound together with the *Delle antichità,* sometimes separately.

In the realm of printmaking Tramezzino is credited with popularizing *intaglio* prints (mainly engravings, as opposed to woodcuts) in the Venetian market and facilitating commerce between Rome and Venice.[64] Tramezzino published many engraved reconstructions of important Roman monuments designed by Pirro Ligorio and other antiquarians. The Tramezzino specialization in the reconstructed monuments and topography of Rome earned the family such a reputation among antiquarians that their house in Rome was included among the stops made during antiquarian walking tours offered in the capital.

FIGURE 82

Anonymous. Title page, hand-colored woodcut in Ligorio, *Libro di M. Pyrrho Ligori Napolitano, delle antichità di Roma* (1553). CAT. 54.

It has been argued that, prior to the introduction of printed books, when scholarly texts had to be hand-copied, authors had an aversion to images, whose quality was difficult to control.[65] While this may be overstating the case—scientific manuscripts often had diagrams and other images—print did provide the possibility of a certain standardization.[66] Certainly, growing interest in ancient artifacts and architecture, which built on similar interest in ancient texts in the fifteenth century and beyond, required illustrations to convey their visual appearance. With the advent of humanism, the ruined classical monuments dotting Rome also fell under the gaze of architects and artists intent on reviving the ancient city of Rome. Those interested in the

reconstruction and topographic description of Rome included many of the preeminent scholars and artists of the Renaissance: Petrarch, Leon Battista Alberti, Francesco di Giorgio, Raphael, Giuliano da Sangallo, and, later, Palladio and Aldrovandi.

Ironically, the Renaissance interest in classical styles of architecture, when combined with the desire to express wealth, status, and style through building projects, posed a greater danger to ancient buildings than the damage sustained in military action and earthquakes during the Middle Ages. Renaissance construction projects regularly raided and tore down architectural ruins in order to appropriate building stone and other architectural pieces. According to David Coffin, the sixteenth century has been accused of wreaking "more havoc with the monuments and buildings of the Roman Forum than any other century."[67] Even as Renaissance builders (including the popes) hastened the demise of certain monuments, a culture of antiquarianism developed among individuals concerned with the preservation and documentation of classical buildings. A letter written by the painter Raphael to Pope Leo X around 1519 was a landmark statement of concern about their fate.[68]

The goals of Renaissance antiquarians heralded, but differed from, the modern science of historical preservation. Underlying the Renaissance restoration project lay the hope that the glory of a past civilization would be brought back in order to benefit the present. Through writing, sketching, collecting of antiques, transcription of inscriptions, and archaeological endeavors, activities furthermore often supported by patronage, antiquarians attempted to reconstruct the ancient city physically or conceptually.

Rome was a central focus for the activities of antiquarians. Drawing on the medieval guidebook format that textually described famous Roman sites, early Renaissance antiquarians like Flavio Biondo in his 1444 *Roma instaurata* began systematic topographical studies of Rome in order to rectify the inaccuracies of previous writers concerning Rome's ruins. Along with visual evidence gleaned from inscriptions and coins, the ruins were scrutinized, according to Roberto Weiss, "in order to discover their nature, their building techniques, the rules followed by their makers, [and] their meaning."[69] Mapping the city's architectural sites was one of the predominant ways to begin the visual reconstruction of ancient Rome, and these attempts were then disseminated by means of the flourishing publishing industry through books, guidebooks, and individual printed images of ruins and sculptures.

By the beginning of the sixteenth century, enthusiastic public and tourist response to the visualization of urban space in print form resulted in a niche market for engravings and etchings of antiquities. The mapping and visual reconstruction of Roman ruins commenced by Flavio Biondo and by Leon Battista Alberti was continued by later antiquarians such as the Neapolitan architect and antiquarian Pirro Ligorio. In the mid-1500s, Ligorio was considered one of the preeminent experts on ancient Roman culture. With at least forty preserved volumes of writing on antiquarian affairs, Ligorio wrote more than any of his artist and architect peers.[70] His book *Libro di M. Pyrrho Ligori Napolitano, delle antichità di Roma, nel qvale si tratta de' Circi, Theatri, & Anfitheatri*, deals with the antiquities of Rome and specifically circuses, theaters, and amphitheaters, topics of constant interest to him. It was published by Tramezzino; the sibyl frontispiece is hand-colored in the Chicago copy [FIGURE 82, CAT. 54]. This text deals with ancient Roman circuses, theaters, and amphitheaters, building types he also reconstructed in visual images.

Ligorio's work comprised architectural projects, Roman and Ferrarese encyclopedias of classical culture, and maps and individual reconstructions of ruined buildings. All of Ligorio's Roman views were printed by Tramezzino. Antonio Lafreri and his heirs also published myriad copies of Ligorio's engravings. An expert in numismatics, Ligorio relied to an unprecedented degree on images of buildings on antique coins and medals to ascertain the original appearance of ruined Roman buildings. Pirro's creative approach to reconstructing ruins also extended to his use of architectural inscriptions. In line with his imaginative restoration of antiques, Coffin notes that Ligorio did not balk at recreating missing sections of inscriptions on buildings or coins by borrowing passages from other classical texts.[71] He attracted criticism from some of his peers for this practice, and was even accused of being a forger.[72] One of the reasons put forward to explain his behavior is the widely held belief that Ligorio was unversed in Latin, or that at the very least he only possessed a very rudimentary knowledge of the language. Ligorio's practice of rendering missing inscriptions whole again by adding passages from other antique sources can also be seen as a transposition of Renaissance literary and artistic practices, in which erudite references or beauteous parts were combined into a new whole, to the realm of antiquity.

A vivid engraving of the Circus Maximus [see FIGURE 38, CAT. A48], which existed in Renaissance Rome only as a depression in the ground, was made by Nicolas Béatrizet after Pirro Ligorio's design and published in 1553 by Tramezzino. The sheet in the University of Chicago *Speculum* was also later published in 1582 (by Paulo Gratiano) and between 1691 and 1720 (by Gian Domenico de' Rossi).[73] It displays Pirro Ligorio's characteristic method of architectural reconstruction, which was unusual in appearing to disregard Renaissance perspective. Ambrogio Brambilla's copy of Ligorio's image of the *Circus Maximus* in Rome uses the oblique projection favored in ancient art and architecture, which allows for closer scrutiny of the monument's details than a linear perspective view would allow. To reconstruct the monument, Ligorio relied on texts, the ruined site of the *Circus Maximus,* and possibly ancient reliefs depicting the structure's interior.[74]

The Chicago *Speculum* also includes several prints copied from Ligorio/Tramezzino collaborations, etched and engraved by Ambrogio Brambilla and published by Claudio Duchetti. The plan and elevation of the Castle of the Praetorian Guard [CAT. A30] is one. Copied from Pirro Ligorio's original 1553 print (published by Tramezzino) in which the floor plan and aerial view were shown in reverse, this etching illustrates the Castle of the Praetorian Guard in Rome, which housed the imperial troops.[75] Though the camp was destroyed by the Emperor Constantine around 312 CE, the aerial plan on the right nevertheless imaginatively reconstructs the structure and facilitates its viewing through the use of a bird's-eye perspective. Another Brambilla print depicts the baths of Diocletian. Diocletian's Baths, inaugurated in 306, were Rome's largest and most sumptuous baths, and could be compared to a modern-day luxury spa resort, as they comprised sculpture gardens, libraries, and theatres in addition to water basins and gymnasia. The etching in Chicago's collection [CAT. A35] is a copy of one designed by Pirro Ligorio, engraved by Jacob Bos, and published by Tramezzino in 1557. The total reconstruction of the complex and the image's bird's eye view perspective are representative of Ligorio's mapping technique.

Ligorio remains relatively overlooked by history mainly because of Giorgio Vasari's neglect of him in his highly influential *Lives of the Artists*. But in his own time, Ligorio attained positions of prestige working with personages like Ippolito II d'Este, Cardinal of Ferrara, under whose auspices he undertook the study of Roman ruins such as the Emperor Hadrian's Villa Adriana in Tivoli. Ligorio published three tomes describing the Emperor's Villa. No actual drawing of the Villa has been attributed to his hand. In the eighteenth century, Francesco Mazzoni engraved a plan of the villa based on the data in Ligorio's study of the Villa Adriana, with which it was published [CAT. 55].

In the mid-sixteenth century, Ligorio was only one of many writers on classical architecture. A publishing fervor for architectural treatises appeared early in the Renaissance: from 1450 onward, writers such as Alberti, Filarete, Francesco di Giorgio, and Bramante wrote works that attempted to describe and systematize the architectural orders. Lafreri and others followed in their footsteps in publishing images of ancient buildings. Renaissance authors debated the usefulness of Vitruvius and the extent to which the Romans followed his rules in their building practices. The studies of ancient monuments conducted by printmakers provided new-found opportunities to compare styles by setting images of them side by side. Thus, the explosion of antiquarian publishing helped raise awareness of style and its cultural meanings and history.

The architectural orders used in Renaissance buildings derived their form and aspects of their symbolism from the classical Greek orders, systems of proportion and ornamentation that are most evidently associated with columns, but extend to all components of buildings. According to John Onians, the original columns can be understood as standardized pattern typologies that expressed civic, nationalistic, and religious values and meanings.[76] In the early sixth century, Greek buildings such as temples began to be built in a standardized way, following a proportional system based on the measure of a hundred feet, since the number 100 was considered an ideal quantity of victims for a sacrifice. The long-standing convention of associating specific units of measure with ideal proportions was derived from this architectural practice. In particular, Vitruvius's first-century BCE treatise *De architectura* advanced the idea that architectural proportion was derived from the harmonic proportions of the human body.

Early classical temples incorporated either an entirely Doric or entirely Ionic columnar décor that was believed at the time to hold racial and political associations following the Greek-Persian and Spartan-Athenian wars during the fifth century. In general during this period, the Athenian use of Ionic columns in a building was meant to communicate friendship toward rather than

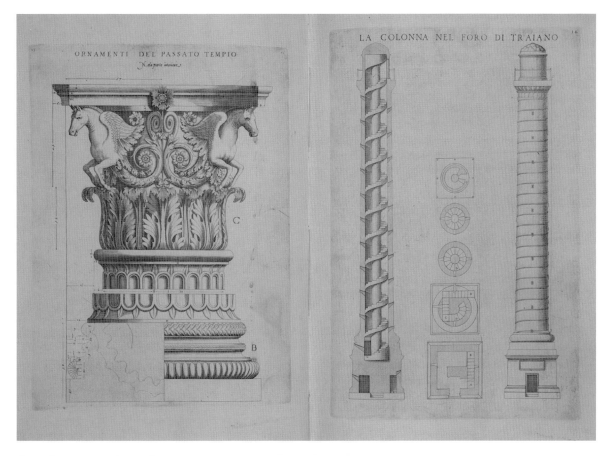

FIGURE 83

Mario Labacco (engraver) after Antonio Labacco (designer), *Capital from the temple of Mars Ultor* and *View and cross-sections of the column of Trajan*. Engravings in Antonio Labacco, *Libro d'Antonio Labacco appartenente a l'architettvra* (1552; 1640–1672). CAT. 53.

domination over the Eastern Greeks. The Parthenon was among the initial buildings that incorporated both Ionic and Doric columns as a governmental expression of the wish to unite both Eastern and Western qualities within a culturally and politically cohesive Greece.[77]

As Vitruvius tells it, the Greek scholar and poet Callimachus invented the Corinthian column after he saw a basket on a girl's tomb with an acanthus plant growing through it. Because of an etymological association, the acanthus plant was linked to notions of healing, and the Corinthian type was subsequently connected to ideas of death and renewal. This foliated and elaborate new columnar type was associated with the feminine sphere as a result of its connection with the girl's tomb. It eclipsed the Ionic column with its racial overtones as appropriate for indoor use in refined rooms.[78]

The three classical orders—Ionic, Doric and Corinthian—were canonized in the handbook of the Roman theorist Vitruvius, who described their origins and declared them appropriate to the temples of particular gods on the basis of gender. Vitruvius also mentioned a fourth order, Rustic (or Tuscan). This latter order was poorly described by Vitruvius, whose explanation of its form was limited to the information that one torus and a collar formed the base molding, while the column rested on a circular, as opposed to square, plinth as in the case of the three other orders. This vagueness accounted in large part for the oversight of the Tuscan order by architects from the later classical and throughout the medieval period.[79]

Vitruvius's text was rediscovered in 1414 by Poggio Bracciolini and subsequently circulated widely. The Tuscan order was thus reinscribed within the fold of orders in Renaissance architectural handbooks by the likes of Leon Battista Alberti, albeit in a cursory way. Comprehensive diagrams of the Tuscan column's form

and proportions were first published by Sebastiano Serlio, whose sources for the reconstruction were based on actual measurements of the very few antique ruins that bore such columns, such as the columns of Trajan and of Marcus Antoninus. In essence, the Tuscan order was the most simple and unornamented of the orders, its rough surface giving it a rustic look suitable for exterior constructions. The influential architect Andrea Palladio spurred the use of Tuscan columns in Renaissance architecture by including them in his own buildings such as the 1549 Thiene palace in Vicenza.[80] A fifth order, not recognized by Vitruvius, was identified by Alberti from his antiquarian observations of Roman triumphal arches: known as the Composite or Italic order, it was regarded as the most ornate of the orders, associated with Roman authority.[81]

Antonio Labacco, a student of Antonio da Sangallo, drew his own reconstructions of Roman ruins that his son Mario then engraved. The imaginative Corinthian column on the left [FIGURE 83, CAT. 53] incorporates the winged torsos of horses, and the text informs us that the design is derived from classical temple ornaments. On the right are floor plans and vertical views of Trajan's Column, one a cross-section revealing the circular winding stairs and the other an exterior image. Labacco's book—really a series of engravings that include both text and image—was first published in 1552, and seems to have been republished in small editions for many years thereafter. This edition was published by Giovanni Battista de' Rossi, a member of the famed de' Rossi printing family, in the seventeenth century. The book as published was only a small part of Labacco's planned project, which never came fully to fruition; according to his preface, he was advised by Mario to bring this portion out early for fear of plagiarists.[82]

Giovanni Montano, active later in the sixteenth and early seventeenth centuries, drew inspiration from Labacco's sometimes mannerist versions of Roman buildings for some of the designs published in his *Architettura*. The prints in the Chicago *Speculum* collection may be proofs *avant la lettre* (i.e., before the addition of text) for the 1636 edition of his architectural compendium.[83] They include engravings featuring elements of different architectural orders derived from antique buildings [CAT. C455, C457]; and several sheets of whimsical capitals said to be of classical design and dedicated to particular gods [CAT. C469]. Because the ancients believed that capital design could be visually identified with the gender-specific virtues of certain gods, the

FIGURE 84

Anonymous. Two-color title page, woodcut in Vitruvius, *Di Architettura* (1535). CAT. 91.

decorative capitals here were conceived to adorn monuments that aimed to attract the favors of particular gods. The viewer must keep in mind Montano's penchant for imaginative recreations in determining whether these architectural elements looked exactly as they are depicted here.—IO

Aldo Manuzio the younger (1547–1597). *De Qvaesitis per Epistolam Libri III.* Venice: Aldo Manuzio the younger, 1576. Rare Book Collection. Cat. 59.

This repository of classical Greek and Latin inscriptions was published by Aldo Manuzio the Younger, grandson of the founder of the famous Aldine press. Rather than the "anchor and dolphin" device on the title page, this one has a profile portrait of the original Aldo. His long hair and soft cap are typical of Northern Italian men's fashions of his time. The "author" portrait as printer's mark emphasizes the intellectual status of this family of humanist printers.

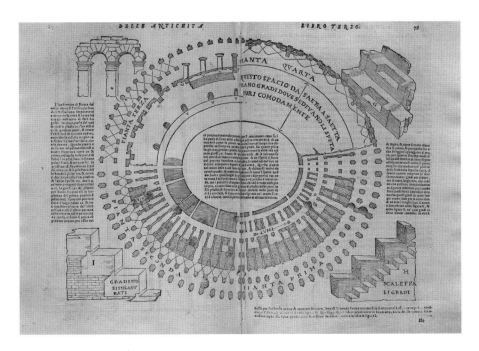

Anonymous. *Plan of the Colosseum*. Woodcut in Sebastiano Serlio, *Tutte l'opere d'architettura* (1584). CAT. 82.

Paolo Manuzio (1512–1574). *Antiqvitatvm Romanarvm Pauli Manutij Liber de Legibvs.* **Venice: Bernardo Torresano, 1557. Rare Book Collection. Cat. 60.**

Taking over the operations of his father's Aldine Press in 1533, Paolo Manuzio gravitated towards the publication of Latin texts that he edited and commented on. This is yet another book on Roman antiquities. He inherited his father Aldo's "dolphin and anchor" device, which illustrated the classical motto *festina lente,* or "hasten slowly," a paradox of a type popular in the Renaissance.

Dionysius of Halicarnassus. *Delle cose antiche della Citta di Roma.* **Venice: Niccolò Bascarini, for Michele Tramezzino, 1545. Rare Book Collection. Cat. 28.**

Tramezzino's version of Dionysius of Halicarnassus's history of Rome in the Tuscan vernacular uses a larger and rounder font than is used in his Latin editions, such as Lucio Fauno's *De antiquitatibus urbis Romae,* thereby pointing to the publisher's choice of a more legible font type for books aimed at the non-academic reader.

Vitruvius Pollio. *Di Architettura.* **Venice: Niccolò Zoppino, 1535. Rare Book Collection. Cat. 91, fig. 84.**

This edition of Vitruvius features a beautiful frontispiece printed in red. The woodcut medium of the print complements its Gothic look, characterized by simple, thickly outlined images. Overall the image presents a war motif, with famous generals of antiquity visible at the top and bottom, and spoils of war evident on the right and left of the central section.

Sebastiano Serlio (1475–1554). *Tutte l'opere d'architettura.* **Venice: Francesco de' Franceschi, 1584. Rare Book Collection. Cat. 82, fig. 85.**

The architect Sebastiano Serlio wrote four volumes of a treatise on architecture, contained in this edition. A plan of the Colosseum, along with other illustrations, formed part of Serlio's third volume on the antiquities of Rome. The meticulous illustrations are meant to complement the text, and subsequent editions, like this one, continued the tradition. Serlio typically gives precise measurements of the edifice using the ancient Roman palm as a unit of measure.

Roman religion was polytheist, and the Roman state easily assimilated new and foreign religions as long as their practice did not interfere or compete with political affairs. Different divinities were associated with every aspect of Roman life, such as the family, the state, and the environment; the domestic practice of religion occupied a separate sphere from national religious observances. In the realm of politics, which was closely reliant on religion, the Roman state appointed its own religious officials—such as augurs, skilled in the interpretation of the flight of birds—who were consulted before important events like wars or during periods of plague.[84]

During the Renaissance, much of the attraction of prints depicting ancient Roman religion and cult scenes hinged on the conflicting desire to observe orthodox Christian values while also studying pagan religion. Engravings of Roman religious scenes confirmed the moral uprightness of Christianity and at the same time fed cultural interest in popular beliefs. Lafreri's production includes a number of prints relating to ancient religion. In one etching published by Lafreri [CAT. A110], a male hog, a ram, and a bull are being led in procession to sacrifice by an officiant, veiled with his toga. Animal sacrifices to the gods were a cornerstone of Roman religious rituals. After prayers and libations of incense and wine were made in front of a temple altar, slaves performed the killing of the victims. For the Renaissance viewer, the bloodiness of the sacrifice would have reinforced the civility of Christian rituals.[85] This is one of two very similar prints of sacrificial friezes and was probably made by Etienne Dupérac; it is an etching that has been carefully made to look like an engraving.[86] Another print, this one an engraving republished (but not reincised) by Claudio Duchetti [CAT. A128], reproduces a frieze of sacrificial instruments from ruins near the Porticus Octaviae in Rome, a colonnaded edifice built by the Emperor Augustus. It represents the implements used by high priests during sacrificial rituals, such as the *simpuvium* or ladle (A) and the *aspergillum* or sprinkler (D). Renaissance artists borrowed Roman pictorial elements like the anchor and bow, seen at the bottom right, as emblematic symbols.

Several cults that operated in secrecy were popular during the Roman Empire. The cult of Bacchus, whose initiation rites supposedly encouraged homicidal and sexual debauchery, was suppressed during the second century CE and resulted in the death sentence of about

7000 participants and the destruction of Bacchic shrines across Italy. Another popular sect was the cult of Mithras, a sun god and bull-killer. However, despite the many visual depictions of Mithras that survive, little textual evidence about the cult exists today.[87] The esoteric nature of the Mithras cult appealed in particular to the taste of humanists, who treated the image's iconography as a collection of symbolic emblems to decipher. Antonio Lafreri's engraving [CAT. A104] is possibly the only precise copy based on the Ottaviano Zeno relief of Mithras sacrificing a bull, discovered during the early sixteenth century. In Lafreri's stocklist it was referred to as a *tavola marmorea di erudittione* (marble tablet of erudition).[88] The complicated iconography of Mithraic representations appealed to the Renaissance Neoplatonists' love of emblems, and here the image is (mis)interpreted as an allegory of agricultural labor. Nonetheless, the sacred context of the image as a pagan symbol of initiate viewing for worshippers of the Persian god Mithras was retained. Bartolommeo Marliani's 1588 edition of his Roman guidebook [FIGURE 86, CAT. 65] perpetuates Lafreri's fantastical interpretation of the Mithraic image: the image is a copy of the much larger engraving, and the text also includes the key invented under Lafreri's direction. In conjunction with the letters placed beside the elements in the image, the Renaissance viewer was invited to decipher the Mithraic iconography with the help of the accompanying text.—IO

Guillaume Duchoul (fl. 16th c.). *Discovrs de la religion des anciens Romains.* Lyon: Guillaume Rouillé, 1581. Rare Book Collection. Cat. 31.

Guillaume Duchoul (or Du Choul) was a French antiquarian who wrote on various topics in Roman culture, including religion, baths, and military exercises. He was also an acquaintance of Lafreri (see Rubach essay in this volume). His text is profusely illustrated. Several images of Roman sacrificial pomp serve as a reference point for the author's discussion of sacrificial rites, which fed Renaissance interest in pagan religion. Large slaughters such as the hecatomb, an ancient Greek sacrifice of 100 cattle, were accompanied by attendants playing trumpets and wearing leafy crowns. The *victimarii* were responsible for stunning the beasts with a head blow and plunging a knife into their throats. Feasting on the roasted meat followed.

FIGURE 86

Anonymous, after an engraving published by Antonio Lafreri. *Agriculture (Mithraic sacrifice)*. Woodcut in Marliani, *Vrbis Romae topographia* (1588). CAT. 65.

Pompilio Totti. *Ritratto di Roma antica nel qvale sono figvrati i principali tempij, teatri, anfiteatri, cerchi, naumachie, archi trionfali & altre cose notabili.* Second printing. Rome: Andrea Fei, 1633. Rare Book Collection. Cat. 88.

It is easy to forget that statues that we understand as models of classical style were often made for religious purposes. Among other topics addressed in Totti's volume are the size, placement, and artistic production of seven giant antique statues in Rome, such as a Colossus of Apollo in the Campidoglio.[89] These colossi were consecrated to gods like the sun and deified men. Though people in the Renaissance were wary of the threat of idolatry, they also embraced the production of statues. Renaissance sculptures conflated the size and civic purpose of the colossi with the similar public function of their own statues of leaders and deities.

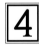

Sculpture

The unearthing of ancient statues throughout Rome fueled Renaissance interest in history and archaeology. As the past was literally emerging from the ground, Renaissance antiquarians and artists alike devoted themselves to the study and preservation of ancient sculpture.[90] Sought not just for their beauty, these objects were valued for information they could provide about ancient culture. The statues reflected Rome's illustrious past and served to enhance the glory of Rome's present.

In his *Lives of the Painters, Sculptors, and Architects*, Giorgio Vasari instructed Renaissance artists to emulate ancient works. Through such emulation, Vasari believed

that it would be possible for the Renaissance to surpass the greatness of the ancients. Prints were a vehicle for such emulation. The Apollo Belvedere, the Belvedere Torso, and the Laocoön were among the finest examples of ancient statues listed by Vasari. Each became famous for its classicizing naturalism. The Apollo Belvedere [CAT. A96] is one of the most celebrated ancient statues; already in 1523, Apollo was considered the most famous statue in the world.[91] The print published by Lafreri, after Marcantonio Raimondi's earlier engraving, was one of several that made the statue well known. Two centuries later, J. J. Winckelmann would claim that "the statue of Apollo is the highest ideal of art among all the works of antiquity."[92] Indeed, both Vasari and Winckelmann considered the Apollo to be the very apogee of the art of antiquity.

Although the circumstances of its discovery remain a mystery, the Belvedere Torso is first mentioned in the collection of Cardinal Colonna sometime around 1432–1435. The Torso received its acclaim from Renaissance artists. Most notably, Michelangelo's admiration of the Torso caused it to be known as "the School of Michelangelo" or "Torso of Michelangelo."[93] An engraving [CAT. B350] by Francesco Faraone Aquila, published around 1700 by Domenico de' Rossi, offers two views of the same sculpture. Such a portrayal suggests that the print was likely used for study by artists. In 1663 the French sculptor Jacques Buirette completed a marble relief entitled "Union of Painting and Sculpture."[94] In the relief, a woman representing Sculpture rests her right hand on the Torso while extending her left hand toward another woman, representing Painting.[95] Buirette presented his work to the Académie Royale de Peinture et de Sculpture as a reflection of the two disciplines.[96] In it, the Torso had become the very emblem of sculpture.

Fragments provided possibilities of imaginary reconstruction and many figures in Renaissance and later painting incorporate the Torso, with mixed results. Another famous fragmentary statue, Pasquino, best illustrates a different kind of Renaissance appropriation of ancient statuary. Known as a "talking statue," Pasquino offered (and still offers) Romans an anonymous mouthpiece with which to vent their frustrations at civic and papal authority. Satirizing poems and sayings were posted on or near the statue. Each year on St. Mark's Day (April 25), Pasquino was dressed as a different mythological figure. Poets would compete to compose the wittiest poem about Pasquino in his mythic garb.[97] Pasquino was also known to converse with other ancient statues throughout the city. Most famously, Marforio (see Section 2) asked Pasquino questions and Pasquino answered him. Two different prints from the same early seventeenth century statue collection depict Pasquino with and without his associated texts. In one print Pasquino is mute, portrayed on his street corner [CAT. C902] but devoid of all of his sayings. This silent image reminds the viewer that Pasquino is not always the speaker, but is often spoken to. The print seems to illustrate the saying: "I am Pasquino, made out of hard stone./I listen to everyone's talk, and I keep silent." Another version, filled with Pasquino's pithy sayings (CAT. C901), emphasizes his association of the visual and the verbal. By the mid-seventeenth century, the area near where Pasquino stands had emerged as the center of the printing industry.[98] Thus, his physical proximity to the printers' quarter reinforces his metaphorical role as mouthpiece of the Romans. Far removed from his ancient function, context and even identity, Pasquino is a paradigm for the way ancient statues acquired new meaning in the Renaissance.[99]

Pasquino was "completed" imaginatively by humorous texts; Laocoön, like many an architectural ruin, was reconstructed in print in an effort at finding the work's original, ideal state. Discovered in 1506 near Santa Maria Maggiore in Rome, Laocoön is one of the most famous statues to survive from antiquity. The story of Laocoön and his sons was known from Virgil's *Aeneid*. The Trojan priest, Laocoön, distrusted the wooden horse left by the Greeks outside Troy's city walls. Laocoön tried to warn the Trojans of his fears, but they did not listen, and in response Athena sent a pair of sea serpents to kill Laocoön and his sons for cautioning the Trojans. The statue's date remains disputed. Generally, it is considered a first-century CE Roman copy of a Pergamene original.[100]

Significantly, Laocoön was the first statue unearthed in the Renaissance that had been described by an ancient author. In his *Natural History*, the Roman author Pliny declares that the Laocoön is "a work superior to any painting and any bronze [sculpture]."[101] Based on the authority of Pliny's ancient text, Renaissance artists and antiquarians had discovered the greatest ancient sculpture ever made. When found, the statue was almost completely intact. Laocoön's right arm was missing, as were the right arm and lower leg of his eldest son (on the left). Additionally, the younger son was missing his right-hand fingers and some toes. The statue group was likely restored by the sculptor Baccio Bandinelli in the

1520s and by Michelangelo's protégé, Giovanni Angelo Montorsoli, in 1532–1533.[102]

Immediately after its rediscovery, the sculpture was also reconstructed in prints. Prints allowed Renaissance artists to re-present ancient ruins and fragmentary sculptures as they would have looked in antiquity. Such imaginary reconstructions claimed to offer an authentic experience of the statue. Laocoön was a favorite subject for prints; several still showed the statue with some breaks, even after Montorsoli had restored the group. Prints also allowed the artist to play with the location of the statue. The Laocoön was reimagined in various locales: sometimes in a niche, other times in the open air, or in an extended landscape. In an engraving published by Lafreri and later republished by Claudio Duchetti [CAT. A121], and probably copied from a version by Marco Dente, certain elements of the statue remain unrestored. The right arm of Laocoön's eldest son (on the left) is missing, as are the fingers on the right hand of his younger son. These unrestored details refer to the state of the statue group when it was first discovered in 1506. Significantly, the statue had already been fully restored when this print was published.[103]

Another version published by Antonio Lafreri [CAT. A107] portrays a fully intact group in a niche in the Belvedere courtyard. Here it is Laocoön's corporeal suffering that is on display. Laocoön's physical and emotional distress captured the imagination of Renaissance artists and scholars, and in this instance, the engraver has chosen to emphasize the Trojan priest's swollen veins pulsating with the venom of the snakes. Laocoön's muscles are dramatically exaggerated for effect. They violently contract at the same time that Laocoön's large, cordlike, distended veins expand, filling his vital organs with poison. One witnesses the toxin take effect underneath the rippling, undulating muscles and veins in his body. Interestingly, the muscles and veins are not as articulated in the actual statue of Laocoön as they are in Lafreri's engraving. J.J. Winckelmann would later describe the suffering that Laocoön's statue embodied. In his description, Winckelmann also emphasized Laocoön's painful, inflamed muscles and veins. He states, "As the pain swells his [Laocoön's] muscles and tenses his nerves, his fortitude of spirit and strength of mind are manifested in the distended brow. The chest strains upward with stifled breath and suppressed waves of feeling, so that the pain is contained and locked in."[104] Both Lafreri's engraving and Winckelmann's ekphrasis demonstrate the powerful effect the sculpted stone had on artists and scholars alike. The containment that Winckelmann describes is evident in Lafreri's print of the statue. Just as Laocoön's muscles contract and his veins swell, his fate is sealed. His pain and the deadly poison are both "contained and locked" within this image in stone.

This print published by Lafreri likely reflects the actual restorations made to the sculpture. Interestingly, a viewer has chosen to censor the piece. Ink drawing that improbably extends the snake's coils covers Laocoön's genitals, as well as his sons'. After Lafreri, this print was republished by several other publishers who added their marks.[105]

Laocoön, the Apollo Belvedere, the Belvedere Torso, and several different statues of Venus came to be considered models of bodily proportion for European artists and antiquarians in the centuries following the Renaissance. This story of ancient statuary and the codification of classical form did not begin with classical Greece; instead, it commenced with Giorgio Vasari's publication and subsequent enlargement of his Lives of the Painters, Sculptors, and Architects in the third quarter of the sixteenth century. Vasari provided a framework that was later to be superimposed onto the story of Western art history. His tale began with abstraction (as found in the works of Cimabue and Giotto), rose to the pinnacle of naturalism with the works of Michelangelo, and finished with a hint of decline in the work of Titian.[106] This teleological construct—abstraction (archaic), naturalism (classical), decline (Hellenistic/Roman)— would become the foundational narrative of Western art history. Indeed, it is the story of ancient Greek art. In the eighteenth century, J. J. Winckelmann solidified Vasari's tripartite narrative expressly for the study of Greek and Roman art.[107] The stylistic categories of dating that Winckelmann employed are still in use today, with the same connotations. Drawing on Vasari, Winckelmann established four categories: Archaic, Classical, Decadent (Hellenistic), and Decline (Roman).

Texts were not the only way statues were classified and codified. Prints also perpetuated classical form and the techniques for producing it. Antonio Lafreri's Speculum contributed to this codification of classical form in its systematic collection of the best that ancient and modern Rome had to offer. In it, an artist would have had access to all of the excellent examples of naturalism that could be copied and perfected. The Chicago Speculum also contains numerous prints that derive from other statue collections, in particular Giovanni Battista de' Cavalieri's collections of prints of ancient statues and

copies after them. These include information about location in particular collections as well as images of the statues themselves. One example is an engraving of Venus [CAT. c792] from a seventeenth-century republication of Cavalieri's collection. In the course of this reprinting, some of the engravings were altered to identify them with a different subject or new collection; in this particular case, the later state of the engraving has a new inscription to do both, as Bates Lowry noted in his article on the Chicago *Speculum*.[108]

The new inscription identifies the figure as the Callipygian Venus. According to legend, two peasant girls asked a traveler to decide which one of them had the loveliest buttocks. The girl the stranger chose became his bride; the other girl married his brother. On the occasion of their double marriage, the girls dedicated a statue to Venus Callipygos at Syracuse. Venus reveals her figure just as the girls revealed theirs.[109] The lifelike Venus in Cavalieri's engraving is shapelier than the statue. The inscription calls her "Callipygian Venus [i.e., Venus of the beautiful buttocks] another usage and name for Leucopygia [i.e., white-buttocks] in the Palazzo Farnese." The handwritten note added to this sheet explains that the inscription on the 1594 edition of Cavalieri's statues had described the statue differently, as "Cythereas posteritatem prospiciens in aedi Fabii Baverii" ("Venus looking backwards in the house of Fabius Baverius"). Cavalieri's statues and the many subsequent editions made statues known to connoisseurs, and their locations known to travelers who might desire to visit collections and see them in the flesh.

Such prints were also of use to artists. In his manual for artists, *Sentiments sur la Distinction des diverses manieres de peinture,* Abraham Bosse emphasizes the importance of first learning to copy ancient statues from prints. According to Bosse, it was only after one mastered the study of the antique from engravings that one was able to copy from nature. This process taught artists how to study the human figure before they ever saw a live nude model. His manual [CAT. 15] offers artists instructions for copying works of art. Handwritten notes appear throughout the margins of Chicago's copy, indicating its use. Bosse chose the statue of the Apollo Belvedere as the exemplary work, reproducing it in his publication with indications of its mathematical proportions. The image contributes to the establishment of a stylistic canon by instructing the artist how to exactly replicate the measurements of other works. This interest in measurement is elaborated further in Gérard Audran's

FIGURE 87

Gérard Audran (designer, etcher). *The Farnese Hercules.* Etching in Audran, *Les Proportions du Corps humain* (1683). CAT. 6.

1683 work, *Les Proportions du Corps humain, Mesurées sur les plus belles Figures de l'Antiquité*. Audran offers measurements of the most famous ancient sculptures, such as the Farnese Hercules [FIGURE 87, CAT. 6], in twenty-seven etched plates. Codification is made explicit in Audran's engravings: each image is dissected into its formal parts, and each part is then conveniently measured for the artist to emulate.

Working in the same period as Winckelmann, Giovanni Gaetano Bottari produced *Del Museo Capitolino*, which might be viewed as a later, more elaborate version of Cavalieri's statue compendium. This catalogue of the statue collections of the Capitoline Museums, which had housed ancient sculpture since the Middle Ages, contains two different versions of Antinoös, the famed consort of the Emperor Hadrian. A Hellenizing statue of the Capitoline Antinoös [FIGURE 88, CAT. 17]

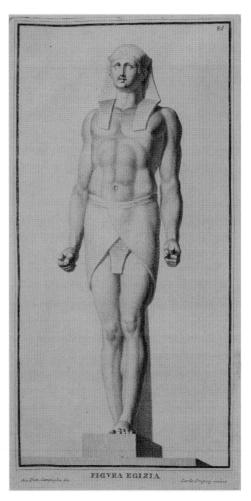

FIGURE 88

Carlo Gregori (engraver), after Giovanni Domenico
Campiglia (designer). *Antinoös*. Engraving in Bottari,
Del Museo Capitolino (1741–82). CAT. 17.

FIGURE 89

Carlo Gregori (engraver), after Giovanni Domenico
Campiglia (designer). *Egyptian figure (Antinoös in Egyptian
style)*. Engraving in Bottari, *Del Museo Capitolino* (1741–82).
CAT. 17.

provides an example of problems posed by Winckelmann's
categories of art. The Roman period, according to
Winckelmann an era of decline, produced this classi-
cizing masterpiece. Although Winckelmann had a
predilection for statues of beautiful young men, he does
not mention the Capitoline Antinoös in his "History of
the Art of Antiquity."[110] Apparently, his preference for
(what he believed to be) Greek works prevailed.

Moreover, whereas statues of Antinoös provide
examples of the Greek classicizing style of sculpture
under Hadrian, the Egyptianizing statues of Antinoös
[FIGURE 89] are essentially ignored or, at the very
least, treated separately by scholars and museums.[111]
Significantly, Hellenizing and Egyptianizing statues of
Antinoös likely stood together in Hadrian's Villa.[112] The

separation of the two types of statues is a purely modern
construct. Indeed, it has largely been a bias on the part
of twentieth-century scholars who have emphasized
Hadrian's taste for all things Greek.[113]—AP

Laocoön. **Engraving, 1614 or 1621. Orazio de Santis
(ca. 1568–1584)? or Cherubino Alberti (1553–1615)?
after Giovanni Battista de' Cavalieri, after Pierre
Perret. Published by Andrea and Michelangelo
della Vaccheria (1614) or Goert van Schayck
(1621). Cat. C868.**

The statue in this print is reversed, indicating that the
print was likely a copy of another print. The youngest
son's fingers are missing, as is the head of the serpent that
attacks Laocoön. Instead of a niche, the group stands near

a wall presumably in the Belvedere Court. The overgrown shrubbery and cracks in the wall emphasize the antiquity of the piece. Lifelike in this print, Laocoön and his son step off their statue base onto the ground. Orazio de Santis and Cherubino Alberti contributed other prints to this later edition based on Cavalieri's statue collection, but apart from a handful of signed prints, little is known about precisely who engraved each one.[117]

Giovanni Battista de' Cavalieri? *Farnese Diadoumenos.* **Engraving, before 1605 or 1619 or 1645. Published by Nicolaus van Aelst or Giuseppe or Giovanni Domenico de' Rossi. Cat. C811.**

The statue of an athlete binding a victory ribbon around his head is a Roman copy of a Greek original by Polykleitos. Polykleitos is famous for his (now lost) treatise on the perfect measurements of the human form. According to the print's inscription, the statue is unknown. This example of the Polykleitan Canon remained unidentified until the end of the nineteenth century.

Giovanni Battista de' Cavalieri (ca. 1525–1601). *Antiquarum statuarum urbis Romae.* **Rome: Goert van Schayck, 1621. Rare Book Collection, Berlin Collection. Cat. 22.**

In the edition of Cavalieri's collection of statues that was often bound with a republication of Dupérac's *Vestigi,* statues are printed two per oblong page.[115] In this edition, the small Laocoön print sits side by side with a reclining Cleopatra (now considered an image of Ariadne). Both statues resided in the Vatican's Belvedere Courtyard. Many of the prints in this album would have been included in larger print collections such as the *Speculum Romanae Magnificentiae.*

Federico Franzini. *Roma antica e moderna nella qvale si contengono Chiese, Monasterij, Hospedali.* **Rome: Giacomo Fei, 1660. Rare Book Collection. Cat. 2. See also cat. 40, fig. 94.**

In Franzini's guidebook to ancient and modern Rome, as in the van Schayck edition of Cavalieri's statues, Laocoön is again paired with Cleopatra. This might suggest that the woodcuts were copied from the engravings. The statue group is intact, yet Laocoön's appearance is different from the other versions. In the image, which appeared in numerous pilgrim guides, Laocoön is no longer muscular; his torso appears flabby, with his pectoral muscles swelling like female breasts.

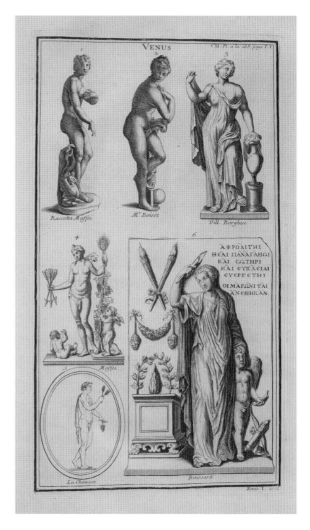

FIGURE 90

Anonymous. *Six Venuses.* Engraving in Montfaucon, *L'antiquité expliquée* (1722). CAT. 70.

Stripped of his genitals, he seems androgynous. The accompanying text informs the reader that the sculpture is one of the most beautiful statues in the Belvedere Court.

Bernard de Montfaucon (1655–1741). *L'antiquité expliquée et représentée en figures,* **2. éd., rev. et cor. Paris: Florentin Delaulne, 1722. Rare Book Collection. Cat. 70, fig. 90.**

Montfaucon's project had much in common with earlier anthologies such as Pirro Ligorio's unpublished volumes on antiquity (see Section 3). Each of his images compiles multiple versions of the same subject, allowing for comparisons and the training of the connoisseur's eye. In one engraving, Montfaucon portrays six

images of Venus as the goddess of love. Although not always correct (the statue in the top center is modern), Montfaucon's compendium is remembered for its encyclopedic nature. His "paper museum" would not have been possible without the engravings from collections like the *Speculum*. Montfaucon's images come from a variety of sources, including direct observation (the Venus in the Villa Borghese, apparently) and books such as Boissard, cited explicitly here.

Pompilio Totti. *Ritratto di Roma moderna.* **Rome: Mascardi, 1638. Rare Book Collection, Berlin Collection. Cat. 87, fig. 91.**

This image represents a larger-than-life Pasquino. The print is included in Pompilio's guidebook to ancient Rome and, as seen here, in his guide to modern Rome. This double representation reflects Pasquino's simultaneous role as an ancient statue and a modern mouthpiece. Both guidebooks also contain essentially the same text. Pompilio introduces Pasquino as "an ancient statue reputed to be as excellent as the Belvedere Hercules."[116]

FIGURE 91

Anonymous. *Remains of the statue of Pasquino.* Engraving in Pompilio Totti, *Ritratto di Roma moderna* (1638). CAT. 87.

INTERMEZZO IV: SEX AND CENSORSHIP

For artists, antiquarians, and collectors, the fascination with antiquity included the depiction of the human form displayed in the nude. Over the sixteenth, seventeenth, and eighteenth centuries, the nude, often modeled on ancient statuary, became the basic unit of painting and sculpture. For Europeans in this period, antiquity was also associated with frank depictions of sex and sexuality in both art and literature, whether Greek civic homosexuality or Roman debauchery, the loves of the gods or bawdy scenes (or both, as with figures like Priapus). We tend to take the nudity of ancient statues for granted, but to Renaissance viewers it might have seemed scandalous or idolatrous. Certain statues, like the bronze nude boy extracting a thorn from his foot, called the Spinario or "thornpuller," came to be associated particularly with prurient interest. Diana Mantovana produced an engraving of the Spinario [CAT. A114] that was published in 1581 by Claudio Duchetti and subsequently copied in Cavalieri's statue collection. The famed female engraver does not shy away from depicting the (young) male anatomy. Like many nude statues, this one elicited erotic interest from some viewers. When viewed from below, the statue appeared, to some, to present its genital area in an obscene manner—to the extent that one medieval viewer, Magister Gregorius, in his *Mirabilia Urbis Romae,* described it as a statue of Priapus.[117]

FIGURE 92

Anonymous. *Thornpuller (Spinario)*. Woodcut in Felini, *Trattato nuovo delle cose maravigliose dell'alma città di Roma* (1615). CAT. 39.

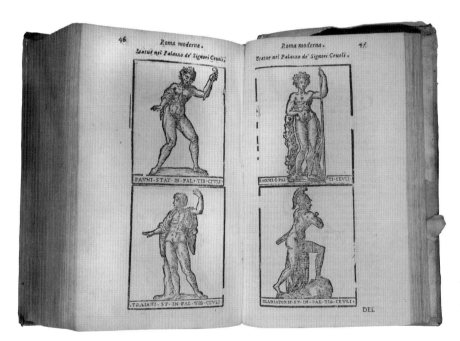

FIGURE 93

Anonymous. *Faunus, Trajan, Bacchus, and Gladiator*. Woodcuts in *Roma sacra, antica e moderna* (1687). CAT. 3.

FIGURE 94

Anonymous. *Laocoön, Cleopatra (Ariadne),* and *Belvedere Torso.* Woodcuts in Felini, *Tratado nvevo de las cosas maravillosas de la alma civdad de Roma* (1619). CAT. 40.

Another view of the thornpuller that circulated in engravings and woodcuts was more modest. The woodcut in a 1615 pilgrim guidebook is a copy of another of Cavalieri's engravings [FIGURE 92, CAT. 39]. This pilgrim guidebook does not hesitate to represent nude statues even while referring to them as images of "false gods." The thornpuller or Spinario is referred to as a "naked shepherd. . . worthy of consideration."[118] It is censored, in a sense, simply by the artist's choice of vantage point. In a late-seventeenth-century compendium of ancient, modern, and sacred Rome, *Roma sacra, antica, e moderna,* many woodcuts from previous guidebooks reappear [FIGURE 93, CAT. 3]. Though the text focuses on Christian Rome, it includes numerous nude statues in the "modern" section (because they are part of modern collections). On one opening, we see *Faunus, Trajan, Bacchus,* and a *Gladiator.* Presented with little if any scholarly commentary to explain their historical or mythological subject matter, these statues of male (and in other cases female) nudes function almost like pin-ups.

The Renaissance is often viewed as a moment of reawakening of interest in bodily beauty, but in Christian contexts, nudity itself was sometimes controversial—let alone overt erotica. Both Protestant and Catholic writers complained about nudity in art. The *I Modi* ("the positions") series of prints by Marcantonio Raimondi (based on drawings by the painter Giulio Romano) depicted sexual positions in an unadorned manner and were famously banned by the Pope.[119] Other artists found ways around the ban by dressing the couples in mythological guise and presenting them as the "Loves of the Gods," as in three engravings after Jacopo Caraglio in the Chicago collection. One of them, a copy by a French artist, possibly René Boyvin, depicts an erotic encounter between Neptune, god of the sea, and Doris, a nymph [CAT. C63o]. Thomas Lawrence, the nineteenth-century English painter whose collection mark appears on the print, seems to have taken a particular interest in erotic mythological themes; he also acquired the Rosso Fiorentino cartoon of *Leda and the Swan* after Michelangelo, now in the Royal Academy's collection, but he held onto it for his own collection, writing to a correspondent that "I know myself justified in saying, that were the work of art of which I am writing, as useful to the purposes of its Institution, as in its effect upon my mind, [as] it would be to me; nay if it were felt and understood by its Professors (Mr. Fuzeli alone excepted, and perhaps one more) as with its great author Michelangelo, [as] it is by me, I would at once surrender it as an act of imperious necessity and right."[120]

Some owners of prints and books responded to such imagery in a manner very different from

Lawrence's: they took matters into their own hands and intervened in engravings and woodcuts to "censor" them with a pen or pencil.[121] (Similar editing often befell printed religious images during the conflicts that infused the Protestant Reformation in this same period.) In the altered images presented in the *Virtual Tourist*, acts of censorship often seem to serve little purpose other than to draw attention to the offending anatomy. Chicago's impression of the engraving of the Belvedere Hercules, published by Lafreri in 1550 [CAT. A94], has suffered this fate: a viewer, at some point, covered the genital areas of both the hero and his young son with brown ink loincloths. The penned-in loincloth is carefully hatched to look like engraving; perhaps it was once a better match to the print's ink color and has faded from its original black. The statue was held in the most prestigious of collections: discovered in 1507, it was immediately claimed by Pope Julius II.[122] Strikingly, many of the statues censored by viewers belonged to the popes. Censorship appears in the form of odd extensions of the snake's coils on the statue of Laocoön (see Section 4); a cruder form appears in some guidebooks. In Chicago's copy of the 1619 Spanish edition of Felini's pilgrim guidebook, we can see multiple interventions by a reader [FIGURE 94, CAT. 40]. These pages depict famous statues of antiquity in the Belvedere collection—Laocoön, Ariadne (in the Renaissance, considered a statue of Cleopatra[123]) and the Belvedere Torso. Despite the fig leaf covering Laocoön's genitals, a reader has covered the area with pencil, and has given one of his sons similar treatment. Opposite, someone has created a hole in the page by vigorously rubbing Cleopatra's bare breasts.—RZ

FIGURE 95

Anonymous. *Statue of a man wearing a toga ("Marius").* Woodcut in Petrus Servius, *Romani Iuueniles feriae. . . Romanorum miscellanea* (1640). CAT. 83.

Telling History Visually

Renaissance humanists are especially known for their rediscoveries and promotion of ancient texts. But scholars employed many different tools to help them understand myriad aspects of Roman culture. Studying material culture—coins, medals, and tablets, as well as artworks—allowed them to define mysterious terms and references in texts. Studying texts also allowed them to suggest ways of representing the classical world as accurately as possible in images. Renaissance scholars studied Roman coins and calendars in order to understand how Romans valued different commodities, and to establish chronological orderings of historical events. They also worked with artists to convey information in visual ways.

Epigraphy, the study of ancient inscriptions, became an important area of scholarship in the Renaissance. Inscriptions in stone, even if fragmentary or mundane, offered the reliability of authentic age, where literary texts copied and recopied by hand could be expected to have accumulated errors over the thousand years that separated the Renaissance from the ancient Romans. Moreover, attention to the style of lettering was used both as a historical tool (for dating monuments) and as inspiration for Renaissance typography.[124]

Petrus Servius's miscellany [FIGURE 95, CAT. 83] includes chapters on Roman names, social rank, numerals, inscriptions, meals, and baths. A chapter on the form and usage of the toga worn by male Roman citizens is illustrated with a woodcut of an ancient statue in the collection of the Capitoline Museums; the reader is

directed to notice the manner in which it was worn.[125] The author thereby employs the statue as historical evidence. Lazare de Baïf [see FIGURE 81, CAT. 9] wrote on Greek and Roman ships, clothing, and vases. The few illustrations in Justus Lipsius's treatise on the Roman military, government, and culture [CAT. 57] are of arms and armor, specifically depictions of the equipment of Roman light infantry. The dedication states that Rome today appears full of ruins, but that one can reconstruct its ancient splendor through the monuments of its ancient authors. Throughout the Middle Ages and beyond, Europeans had remained deeply impressed by the military might of Rome, and political leaders often aspired to emulate it or to dress themselves in the mantle of its greatness. At its greatest extent, the Roman Empire covered a vast territory unmatched by any European power until Napoleon in the nineteenth century. Much of the literature the Romans bequeathed to later ages dealt with the history and strategy of battle; this resonated with the experience of sixteenth- and seventeenth-century Europeans, who experienced the devastation of many major wars.

Surviving ancient art often displayed military themes. Many Roman monuments commemorated military victory, from the Trophies of Marius, to the Columns of the emperors Trajan and Antoninus, to triumphal arches. In a more abstract sense the *Roma victrix* sculpture group also conveyed Roman victory that blended ancient empire and Christian triumph. Many of these monuments contained reliefs that narrated the circumstances of the victory. Sometimes the theme of warfare appeared in the form of *spolia,* real or fictive battle spoils applied to the surfaces of structures. Among Roman monuments, the Arch of Constantine, standing beside the Colosseum, was one of the most popular subjects of engravings—in its entirety [CAT. A37], and also in its details. Many of the details were published as individual engravings, and Renaissance artists and antiquarians began to note fine distinctions in the styles of different parts; Constantine's builders had reused sculpture of earlier periods in designing the arch, making it a kind of composite of artistic spolia. To later ages, the Arch also represented the melding of Roman power with Christian victory.

Many different versions of the printed Arch exist, probably copies of one another with only slight variations, like the checkerboard pattern at the base of this one. This image restores the arch to a pristine state—almost. It leaves out the heads of the four Dacian captives in the upper register. This may be a pointed comment on a controversy about the whereabouts of the heads; according to Benedetto Varchi, Pope Clement VII had accused the Cardinal de' Medici of stealing them.[126]

With the history of Rome as a guide, empire also implicitly suggested the potential for decadence and decline, and images of ruins often served to make this point. But often, the Roman empire was a model for imperial splendor and military might, put to use by kings and even lesser political leaders who did not themselves have convincing claims to empire. Roman military triumphs, as performances, had a major influence on the visual culture of the European Renaissance. Triumphs were marked by processions and by temporary or permanent arches that displayed dominance over conquered land or commemorated victory at home. Later European rulers often took these events and monuments as models for their own victory celebrations.[127] Antiquarian research was useful to artists and writers who helped plan such events and sought accuracy in their historical allusions. In France, King Henri II's entry into his own northern city of Rouen in 1550 was modeled after prints that were themselves inspired by the descriptions of victory celebrations in Julius Caesar's *Gallic Wars.* Such was the allure of Roman empire that a French king thus clothed himself in the guise of a Roman conqueror of France.

Scenes of triumph were popular in prints throughout the sixteenth century. The engravings in the *Amplissimi thriumphi* [FIGURE 96, CAT. 72] depict features of Roman triumph and give literary references to back them up. Onofrio Panvinio, author of the accompanying textual commentary, was a learned antiquarian author who had also worked with the engraver Etienne Dupérac. His commentary on Roman triumphs had been published originally as part of a larger work on the *Fasti* (ceremonies) of the Romans; it was republished with four plates depicting triumphs by Michele Tramezzino in 1571, soon after Panvinio's death.[128] There is some reason to think Dupérac may have made these plates, perhaps in collaboration with Panvinio, who often claimed authorship of the images accompanying his texts.[129] Gerard de Jode's eleven engravings may have been inspired by the Tramezzino edition, but are not direct copies from it. They were published in 1596 by his son, Cornelis de Jode, with Panvinio's text. The younger de Jode notes that the triumphs have been "selected from the most ancient monuments among books, stones, and coins." In the unpaginated preface to the text, he

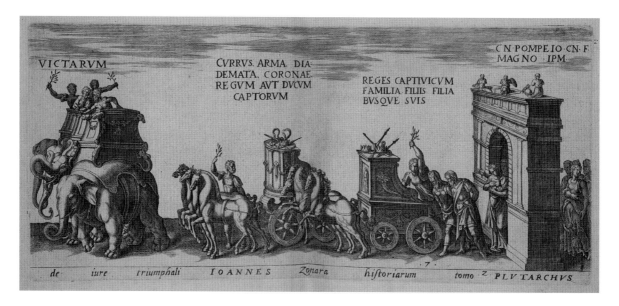

FIGURE 96

Anonymous. *Roman triumphal procession.* Engraving in Panvinio, *Veterum Rom. ornatissimi amplissimiq thriumphi* (1596). CAT. 72.

emphasizes the importance of bringing beautiful images of triumph together with textual commentary: "Since among other things in my workshop I also had these [plates], engraved separately by the burin, it was only in joining to them the commentary of the author that I judged I would give full satisfaction to scholars, and that the labor would be clearly completed."[130]

Reliefs and engravings after them often depicted the thick of battle as well as its outcome. Nicolas Béatrizet's engraving [see FIGURE 35, CAT. A100, A101] depicts a battle of men with Amazons, source of fascination to ancient and Renaissance viewers alike. This image, made up of two separate prints joined together to form a frieze, depicts a relief sculpture from an ancient sarcophagus. The subject is a battle of men with Amazons mounted on horseback. The sarcophagus was held in the collections of the Conservatori, the city government, at the Capitol. Having worked for Lafreri until the late 1550s, Béatrizet published this image himself, as he takes pains to explain in the inscription, in which he also announces the print's utility for all those who take pleasure in ancient things.

Coins and medals were another important source of historical information. Medals, in both ancient Rome and the Renaissance, were coins struck on special occasions, as souvenirs, gifts for ambassadors, or largesse to be distributed to the populace. Scholars used them as historical evidence to help understand Roman icono-

graphy, architecture, and culture. Pirro Ligorio, as we have seen, used depictions of buildings in them to reconstruct ancient architecture. Renaissance publishers put out numerous collections of medals, both woodcuts and *intaglio* prints, so that the challenge for this exhibition was to choose only a few examples of such books.

Most medals depicted a bust of an emperor on one face. Renaissance readers and viewers were fascinated by stories of the emperors and enjoyed connecting story to portrait. As with the empire as a whole, the biographies and portraits of emperors told a tale of rise and decline. Portraits of great men were viewed as models for virtuous behavior; portraits of emperors judged wicked by history provided examples of bad choices. Claiming that the true depiction of facial features was an accurate guide to the moral contents of the soul, scholars strove for accuracy—or at least purported to strive for it—in the depictions of emperors in their works. They used ancient Roman portraits as source material, though many also fabricated their images.

These books were printed throughout Europe in the sixteenth century; the idea of empire had widespread appeal. In particular, the Holy Roman Empire was seen as the continuation of the Roman imperial line. Since the later Empire's political center of gravity was in Germany (and had been since the middle ages), German publishers took special interest in Roman imperial history, but other European monarchs, including the kings of France,

Nullis euidentibus causis obiere dum calciantur matutino,
duo Cæsares prætor & prætura po. Ro.functus Dictato-
ris Cæsaris pater,hic Pisis exanimatus,ille Romæ.Plin.

Martia Iuliæ Cæsaris amitæ,mater,ex qua generis Regij
se esse dicebat,originem nempe trahens ab Anco Martio.
I I I I.Ro.rege.

P. Clodius muliebri habitu indutus ad sacra Bonæ deæ,
nocturno tempore ingressus honore captus Pompeiæ ,ab
hac Aurelia Cæsaris matre depræhensus,fugere coactus
est.

Cossutiam,ex familia equestri & diuitem admodum,Cæ-
sari adhuc puero,desponsatam,dimisit,L.patre amisso.

B 2

FIGURE 97

Anonymous. *Medals.* Woodcuts in Huttich, *Imperatorvm Romanorvm libellvs* (1525). CAT. 56.

also attempted to style themselves Roman emperors. In his 1525 book on the Roman emperors, Johann Huttich presents biographies and striking woodcut medals of them [FIGURE 97, CAT. 56]. As with many other authors, he views them as models of virtue.[131]

Another version of a book of medals appears in large-scale prints. Lafreri and his competitors and successors produced large grids presenting, in chronological order, the portraits of emperors, kings, Ottoman sultans, famous legal scholars, sibyls, and popes (and, in a more folkloric vein, street vendors of Rome). The sheets of popes seem to have been the most popular. Very often a few blank spots remained at the ends to enable owners to update their prints with tiny portraits of the latest officeholders, and examples can be seen in which subsequent popes have been pasted in.[132] The Chicago *Speculum* contains a print of the emperors that follows them from Caesar to the current Holy Roman Emperor, Rudolf II. Its title translates as "Images of all the emperors from C. Julius Caesar to the present year" [CAT. A163].

Along with his series of famous statues, Cavalieri also printed portraits of the emperors [CAT. 23]. His prologue states that, having printed images of all the popes, he thought it proper to do the same for Roman emperors, for purposes of both utility and pleasure.[133] He explains that he used statues, coins, and copies of them by experienced artisans to ensure that no fictions

would be substituted for the truth. Like the Duchetti copy of the large-scale print of all the emperors, he ends with Rudolf II.

The learned printmaker Enea Vico published a series on Roman emperors and followed it up with another collection of elegant engravings, this time of Roman empresses and their insignia [FIGURE 98, CAT. 89], drawn from ancient medals, with a title that proudly indicates its medium: *Le Imagini delle Donne Avgvste intagliate in istampa di rame* ("The images of the Augustan woman engraved in metal plates"). In his dedication to Cardinal Ippolito d'Este, he declares that "images and history are a very clear mirror which represents everything that should be followed or avoided."[134] Visual appearance, he adds, is "a portrait of the soul."[135] He discusses his sources and methods at length:

> I have not taken all of the aforementioned images. . . from antique examples, nor have I made them up from my head, because feigning things that do not exist is a thing unworthy of the name of history, but one part of them is taken from the book composed by several authors, and mostly Andrea Fulvio, and dedicated to Cardinal Sadoletti. Whether these were truly taken from ancient medals, or engraved gems, or statues, I do not know for certain.[136]

He then gives a list of those images taken from medals along with those taken from Fulvio's book, to allow readers to understand the relative reliability of his different sources. The image reproduced represents

FIGURE 98

Enea Vico (engraver). *Device of Agrippina.* Engraving in Vico, *Le Imagini delle Donne Avgvste* (1557). CAT. 89.

Agrippina, the mother of Nero. Antonio Lafreri listed Vico's book (as well as the Fulvio Orsini book to which Vico refers) among the items for sale on his stock list; a copy remained in his possession at his death.[137]

For scholars of Christian antiquity, Roman culture was also a link to the historical world of Christ and the apostles. The tools of historical and biblical research overlapped: both involved the close reading and comparison of texts and images to derive definitions of seemingly mundane details that might nonetheless help illuminate difficult historical questions.[138] Pedro Chacón's antiquarian text, *De triclinio, sive de modo convivandi apud priscos Romanos* [FIGURE 99, CAT. 24], was motivated by the Catholic Counter-Reformation of the later sixteenth century. He studied Roman dining habits in order to shed light on the circumstances of the Christian Last Supper with the goal of reforming its depiction in images.[139] As Catholics defended religious images against the criticisms of Protestants who believed that they constituted inappropriate worship of idols, scholars sought to unearth information that could allow painters to present historically accurate depictions and thereby deflect criticism. Chacón's text included a woodcut illustration of a Roman dining room based on the Capitoline

FIGURE 99

Anonymous. *Ancient Dining Room.* Woodcut in Chacón, *De triclinio, sive de modo convivandi apud priscos Romanos* (1590). CAT. 24.

Ikarios relief, likely a copy of the *Speculum* print of the same relief, which is now in the Louvre [CAT. A91].

Chacón's project serves as a reminder that scholars saw Christian and Roman antiquity as overlapping fields of inquiry. So too does one of the fanciful scenes of ruined monuments in Mario Cartaro's *Prospettive diverse*

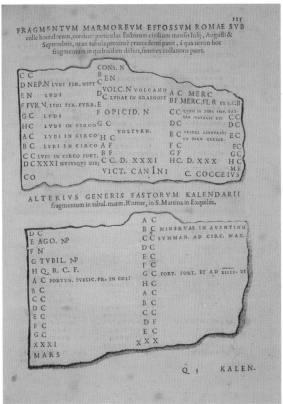

FIGURE 100

Mario Cartaro (etcher). *Augustus and the Sibyl.* Etching in Cartaro, *Prospettive diverse* (1578). CAT. 19.

FIGURE 101

Anonymous. *Fragments of Inscriptions.* Woodcut and type in Hubertus Goltzius, *Thesavrvs rei antiqvariae hvberrimvs* (1579). CAT. 49.

[FIGURE 100, CAT. 19], otherwise designed to display dramatic perspectival views. The one presented in the exhibition is the only one with an identifiable narrative: the story of Augustus and the Sibyl. In the lower right hand corner, a sibyl indicates to the Emperor Augustus the vision of the Virgin Mary and Child in the sky. The etching provides a Christian revisionist history of the Roman Empire within the context of engravings of fantastical perspectives. Rome appears already in ruins, even though, in the time of Augustus, it was nearing the peak of its grandeur.

In a technical sense, this print is interesting for its foul biting—drops of acid that have etched blotches on the plate. This establishes clearly that this is an etching rather than an engraving, a distinction that can be difficult to make. The evenness of the hatching lines is another clue: they do not swell in the middle, but maintain a constant thickness from beginning to end. This suggests the light, even pressure of an etching needle rather than the effort required to cut a line with the engraver's burin. Even if unintentional, the foul biting adds to the strong sense of disrepair—a moral reading of the empire rather than a strictly historical view.

In this volume, Cartaro's prints are bound with the *Ornamenti,* a group of reduced copies by Giovanni Maggi of Nicolaus van Aelst's large prints of obelisks and other Roman sights, published by Andrea and Michelangelo della Vaccheria. Cartaro was a close associate of Lafreri; he was called upon to divide Lafreri's estate after his death.[140]—RZ

Hubertus Goltzius (1526–1583). *Thesavrvs rei antiqvariae hvberrimvs.* Antwerp: Christophe Plantin, 1579. Rare Book Collection, Berlin Collection. Cat. 49, fig. 101.

This "very abundant treasury of antiquarian matters" drawn from inscriptions on Roman coins and marble reliefs serves as a reference guide to all aspects of Roman culture, from the military to holidays to geographical districts to spelling. On pages illustrating the unearthed fragments of marble tablets inscribed with the Roman

calendar, the printer cleverly combined typography with a woodcut frame to indicate the fragmented outline of the tablet.

Marcus Valerius Probus. *De notis Romanorvm interpretandis libellvs.* In *Hoc in volumine haec continentur. . .* Venice: Giovanni Tacuino, [1525]. Rare Book Collection, from the Library of Richard P. McKeon. Cat. 78.

This compilation on Roman culture includes short treatises on Roman weights and measures, methods of computation, laws, speech, prayers, and ceremonies. It also includes a chapter on Egyptian culture. Much of the book is taken up with a reference guide to the many abbreviations found on Roman monuments, and might have served as a handy reference guide for renaissance scholars deciphering ancient inscriptions.

Antonio Agustín (1517–1586). *I discorsi del S. Don Antonio Agostini sopra le medaglie et altre anticaglie.* [Venice: s.n., 159-?] Rare Book Collection, Berlin Collection. Cat. 5.

Agustín studied Roman medals in order to develop a more complete understanding of the cultural context in which Roman law developed. Because coins and medals were more portable and numerous than large-scale statues, they provided many a scholar or amateur with the beginnings of a collection—even if, as Agustín lamented in his preface, those who could afford collections of medals had little knowledge of them, and those who had knowledge of them could not afford them. Agustín also seems not to have cared much for the claims to scholarly knowledge of artists such as Ligorio, Vico, and Goltzius.[141]

Orazio de Santis (ca. 1568–1584)? or Cherubino Alberti (1553–1615)? after Giovanni Battista de' Cavalieri et al., *Equestrian Statue of Marcus Aurelius.*

Engraving, 1614 or 1621. Andrea and Michelangelo della Vaccheria or Goert van Schayck. Cat. C826.

Marcus Aurelius (121–180 CE) was famed as the philosopher-emperor, one of the "five good emperors." His *Meditations,* inspired by Stoic philosophy, were first published in print in 1558 and became even more popular in the seventeenth century. The equestrian statue of Marcus Aurelius became the centerpiece of the Capitol after it was moved there from the Lateran in 1538 on the order of Pope Paul III.[142]

An Ancient Dining Room. **Engraving, 1549. Published by Antonio Lafreri. Cat. A91.**

The triclinium was a dining room in a Roman house named for three slightly sloping couches on which diners reclined. The slightly broken relief sculpture on which this print is based depicts the obscure story of Ikarios welcoming Dionysus, hence the title "Ikarios relief" that this object is often given. The Latin inscription can be translated, "Graphic (i.e., visual) representation of a dining room, couches, three-footed table, and reclining diners drawn from marble tablets." In the Renaissance, such reliefs were mined for information on the cultural habits of Romans. Lafreri's inscription refers both to the couch or "lectum triclinarium" and to the tripod (the three-footed table in the foreground). The engraving style is well suited to the depiction of stone, using selective dots to give a sense of slightly textured surface.

INTERMEZZO V. THE GRAND TOUR

The Grand Tour (ca. 1670–1835), a series of stops throughout the continent, offered aristocratic young men (and their entourage) education, society, and political connections. Part of the allure of the Grand Tour was the opportunity to form a collection of art. Such a collection not only allowed one to recreate Rome at home, it both defined the elite and upheld their authority.[143] Already in the late sixteenth century, tourists from Northern Europe flocked to view antiquities in Rome. Jean-Jacques Boissard tells of leading impromptu tours of Roman collections for French and German student travelers. Because of the deadly religious wars between Catholics and Protestants, access to collections of ancient art (and indeed, Rome itself) came to be limited for much of the seventeenth century. Depending on the political situation, Protestants, and English Protestants in particular, had great difficulty traveling to the city.[144] The ancient statues themselves were sometimes viewed with suspicion: the title page of Fioravante Martinelli's *Roma ex ethnica sacra. . .* depicts Saints Peter and Paul hovering

FIGURE 102

Anonymous. *Saints Peter and Paul striking down pagan idols,*
title page. Engraving in Martinelli, *Roma ex ethnica sacra sanc-
torum Petri, et Pavli apostolica praedicatione profvso sangvine*
(1668). CAT. 66.

FIGURE 103

Andries van Buysen (designer and engraver). *Connoisseurs
viewing antiquities.* Engraving in Raguenet, *Les monumens de
Rome* (1701). CAT. 79.

over the city of Rome [FIGURE 102, CAT. 66]. In their
role as conquerors of pagan Rome, the saints hurl Jupiter-
like lightning bolts at antiquities. A destroyed statue of
Jupiter still holds his ineffective lightning bolt, under-
scoring the triumphant power of the two saints. This
image portrays the Catholic Church as the rightful owner
and heir of Rome, alluding to the Church's control
over access to Rome. Indeed, the best ancient statues in
Rome were owned by four families, each with strong
connections to the papacy: the Farnese, the Medici, the
Borghese, and the Ludovisi. J. J. Winckelmann, a German
Protestant, converted to Catholicism to gain entrée into
the papal court, libraries, and collections of ancient art.[145]
Without such access, he would not have been able to
write his *History of the Art of Antiquity.*

The relationship between antiquity and papal
authority manifests itself in prints, as well. In François

Raguenet's 1701 book on the monuments of Rome
[FIGURE 103, CAT. 79] he writes that he wishes to "revive
the reputation of the monuments of ancient Rome and
to consecrate for posterity the monuments of modern
Rome."[146] The engraving by Andries van Buysen oppo-
site the title page reflects Raguenet's goal. Ancient and
modern Rome mingle in the scene. Two pairs of
bewigged connoisseurs of antiquities stand on the banks
of the Tiber. Engrossed in conversation, they gesticulate
towards the surrounding magnificence. A symbol of
ancient and modern (papal) Rome, the Castel Sant'
Angelo prominently appears before them.

Along with depictions of individual antiquities, prints
also came to document their location in collections,

FONTANA DI MERCVRIO NEL GIARDINO DEL GRAN DVCA DI TOSCANA ALLA TRINITA DE MONTI ADORNATA DI STATVE DI METALLO AVANTI IL PORTICO DELLA FACCIATA INTERIORE DEL PALAZZO. *Architettura di Annibale Lippi . 9*
Gio. Francesco Venturini del. et inc. *G. Iac Rossi le stampa in Roma alla Pace con Priu: del S. Pont .*

FIGURE 104

Giovanni Francesco Venturini (engraver). *The fountain of Mercury in the garden of the Grand Duke of Tuscany.* Engraving in Falda, *Le fontane di Roma* (1691). CAT. 34.

and to depict Rome itself as a city of collections. The Cortile del Belvedere housed the most famous ancient statues in Rome [CAT. C547], some of which are included in Section 4. In the print by Hendrick van Cleve, the courtyard appears on the far left. The Belvedere Torso sits in the middle of the garden with two reclining river gods in front of him. Significantly, the panoramic scene provides a striking view of the Castel Sant'Angelo in the center of the print. An emblem of papal political power, the monument conspicuously anchors the scene, reinforcing the relationship between the antiquities in the courtyard, the Belvedere Mansion, and papal authority. In a more picturesque vein, an etching of ancient statues in a garden [CAT. B240], made by Jan and Lucas van Doetecum and published by Hieronymus Cock, evokes an abandoned Rome. Rome appears to be a large ruin filled with ancient statues that lie waiting for a collector to take them home. The inscription underscores the imaginary nature of the scene: it states that the fragmentary statues are in a certain noble's garden in Rome.[147] A collector's paradise, the garden's precise location remains unknown.

Many different antiquities appear both as collected objects (identified as belonging in particular collections) and as collectibles (via the proxy of print) in the long lineage of republications and copies of Cavalieri's statue collection. The relief of Hercules and the Nemean Lion represented in it first belonged to Cardinal Andrea della Valle, as indicated in the accompanying inscription. It was later purchased by the Medici family and displayed in their garden in Rome. A print that "reproduced" the relief offered the Grand Tourist a piece of the Valle-Medici collection to take home with them [CAT. C887]. In Falda's *Le Fontane di Roma*, one can see it depicted in a view of the Villa Medici's garden-side façade. The focus in this collection of engravings is on fountains throughout Rome "as they are at present"; in Giovanni Francesco Venturini's engraving [FIGURE 104, CAT. 34], the villa and its gardens provide a prestigious sceno-graphy for the Medici's fountain of Mercury. The print

also showcases the Medici's wealth of ancient objects. Cardinal Ferdinando de' Medici procured his large collection from the Valle-Capranica holdings. The scene evokes a lived environment where ancient and modern coexist. Here, the relationship between politics, religion, and art is made explicit. A view of St. Peter's is visible through the doorway of the villa's gardens, emphasizing the Medici's close ties with the papacy.

Gaining momentum in the late seventeenth and, especially, eighteenth century, the Grand Tour provided opportunities for study and collecting not only of antiquities but also of prints. *Speculum* prints and others like them had been collected by travelers to Rome from their beginnings. The Chancellor of France under Louis XIV, Pierre Séguier, owned a deluxe volume of *Speculum* prints.[148] Eighteenth-century English travelers including the architect James Adam (collecting on behalf of King George III) and the Duke of York acquired large quantities of prints in Rome.[149] The collection mark of the British artist, Sir Thomas Lawrence (1769–1830), appears as an indicator of his ownership on the bottom left edge of several prints after Caraglio's *Loves of the Gods* in the Chicago *Speculum* collection, and helps date the collection's final composition to the nineteenth century. Lawrence traveled to Rome in 1819 and almost certainly bought prints there. His initials, T.L., can be seen, for instance, on a print depicting Vertumnus, god of changing seasons, pursuing Pomona, goddess of fruit trees, as part of a series of prints representing the loves of the gods [CAT. C632].[150]

Prints played a seminal role in shaping foreign attitudes toward Rome. A Grand Tourist's experience in Italy was informed by seeing the city in print prior to seeing it in person. Upon his arrival in Rome in 1786, J.W. Goethe describes seeing the city that he only knew from images:

> All the dreams of my youth have come to life; the first engravings I remember—my father hung views of Rome in the hall—I now see in reality, and everything I have known for so long through paintings, drawings, etchings, woodcuts, plaster casts and cork models is now assembled before me. Wherever I walk, I come upon familiar objects in an unfamiliar world.[151]

Goethe's testimony is evidence of the effect that a collection of prints such as Lafreri's *Speculum* could have. Goethe makes it clear, however, that there is no substitute for the knowledge gained from traveling: "No one who has not been here can have any conception of what an education Rome is."[152]—AP

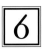

Obelisks, Egypt, and the Urban Space of Rome

While Rome was increasingly sought out by antiquarians, scholars, and artists from the sixteenth century onward, it had long provided a destination for Christian pilgrims. The importance of Rome's relics and indulgences was affirmed in the Catholic Counter-Reformation. Popes throughout the sixteenth century promoted a variety of building projects that affected both churches and ancient Roman monuments. Perhaps the most visible was the work on St. Peter's Basilica. *Speculum* prints also played a significant role in publicizing the Counter-Reformation and building projects in Rome. Events like the Council of Trent and papal benedictions and processions were documented by prints made for and sold by Lafreri and his successors. Toward the late sixteenth century similar prints published by Nicolaus van Aelst depicting the obelisks and other papal works like the Acqua Felice (a third-century aqueduct that Sixtus restored in order to provide water for Rome's public fountains[153]) and the Gesù (the "mother" church of the Jesuit order), bore a papal privilege "motu proprio," that is, of [the pope's] own accord. Thus the popes, especially Sixtus, carried out a concerted policy of using prints to publicize such projects. These images often constituted the only, or nearly the only, modern buildings in *Speculum* albums. Lafreri's print *The Seven Churches of Rome* was issued for the Jubilee Year of 1575 [FIGURE 105]. It was reissued during subsequent holy years and updated to keep pace with various building projects. Changes were notable in the depiction of St. Peter's Basilica, which was usually illustrated separately in each new edition of the pilgrim guide. The different designs for St. Peter's and the evolution of its progress were especially well publicized in print.

Some of the most prominent markers of urban space in Rome are neither Christian nor Roman in origin. Rome's obelisks, many of which were reinstalled throughout the city by the popes, arrived after Egypt had become part of the Roman Empire in 30 BCE. Imperial Rome acquired up to forty-eight of these monuments between the first and fourth centuries, utilizing their cultic and commemorative role in order to bolster claims of universal power.[154] By the Renaissance,

FIGURE 105

Anonymous, *The Seven Churches of Rome,* in the *Speculum Romanae Magnificentiae.* Engraving, 1575. Antonio Lafreri, publisher. MR 514, Yale Center for British Art, Paul Mellon Collection.

the only ancient obelisk that remained standing was located to the south of St. Peter's. This was brought to Rome in 37 CE by Caligula and erected in the Circus of Gaius and Nero. The Vatican obelisk, known as the Aguglia or Guglia (from the Latin *acus*, "needle"), is a monolithic shaft of red granite measuring eighty-three feet tall. Its four sides taper inward slightly toward a pyramidal top. Unlike many obelisks, it is not inscribed with hieroglyphs.[155]

Pope Nicholas V (1447–1455) suggested the project of moving the Vatican obelisk from its original location to the piazza in front of St. Peter's in order to celebrate the reunification of the church and the end of the papacy's exile in Avignon.[156] Various architects submitted their designs over the next century and a half. Lafreri's print of the Vatican obelisk [CAT. A16] demonstrates ongoing interest in the monument before its relocation to the center of St. Peter's Square (Piazza San Pietro) in 1586. The cartouche draws attention to the accuracy of the image: the proportions of the obelisk are given with detailed measurements. This same concern appears in the small woodcut illustration for the pilgrim guide also on display. The removal of the obelisk was not achieved, however, until the pontificate of Sixtus V (1585–1590). Sixtus appointed Domenico Fontana to the task of transporting the monument; he employed more than 900

men, seventy-five horses, and forty capstans for the job. Numerous contemporary publications and artistic media celebrated this incredible feat of engineering.[157]

The newly positioned Vatican obelisk represented the triumph of Christian Rome over its pagan past. In particular, Sixtus V wished to proclaim the recent successes of the Counter-Reformation.[158] The obelisk was dedicated September 26, 1586 with inscriptions commemorating the event. As it was raised in its new location, a bronze cross replaced the gilded ball at top. During the Middle Ages, this globe was believed to hold the ashes of Julius Caesar.[159] Ritual purification of the obelisk for its new setting included the exorcism of its pagan past. An indulgence was granted for anyone who venerated the cross now at the top of the obelisk. Giovanni Severano's guidebook [CAT. 84] contains a prayer and antiphone to be said for this purpose. Sixtus V placed other ancient obelisks at the churches of Sta. Maria Maggiore and S. Giovanni in Laterano, and by the Porta del Popolo on the Via Flaminia. The obelisks identified the most sacred of Christian sites in the city, helping to redefine the main avenues of access and circulation. The newly positioned monuments are highlighted by the panoramic view in Theodor de Bry's map of Rome [CAT. B287]. The transformation of Rome under Sixtus V included the widening of streets between

the major pilgrimage churches and the restoration of the Acqua Felice. Sixtus's projects, accomplished during a very short pontificate, provided a model of urban planning and papal administration for his successors.

The Catholic response to the Protestant Reformation involved a renewed emphasis on the spiritual well-being of ordinary Catholics. The promotion of pilgrimage, especially in Jubilee or holy years, coincided with greater access to Rome's many churches and changes in the spatial organization of the city. Lafreri's print of the "Seven Churches" [FIGURE 105] emphasizes the spiritual topography of Rome by erasing nearly all other contemporary structures and ancient monuments. Printed guidebooks were another means of encouraging devotion. At the same time, they helped to structure the pilgrim's experience, integrating him or her within a community of similar interests and goals.[160]

On arrival in Rome, pilgrims found the Renaissance version of a thriving tourist industry, with hostels, tour guides, and souvenirs available in different price ranges. Guidebooks had existed since the Middle Ages, but in this period, the printing of illustrated guidebooks took off along with the growing market.[161] A standard edition of the pilgrim guide, *Le cose maravigliose*, was established by 1575.[162] It consisted of a list of churches (often condensed in order to treat only the seven principal basilicas) and ecclesiastical calendar, as well as a guide to the antiquities of Rome. In 1588, it was supplied with an extensive series of illustrations.[163]

The visual program offered a contemporary portrait of the city reflecting Pope Sixtus V's strategies for urban renewal. Not surprisingly, the 1588 edition of the guidebook was dedicated to Sixtus. The text was also expanded to take into account names of patrons, artists, and architects in its description of each of the churches.[164] This descriptive aspect of the guide eventually replaced the lists of relics and indulgences.[165] By the seventeenth century, there were new guidebooks available that treated the monuments of the secular city, modern as well as ancient.[166] While the pilgrim guide incorporated a diversity of subjects, its main focus remained the opportunity for securing individual salvation. Access to saints' relics and the sacred sites of Rome were concerns likewise reflected in the prints illustrating the guidebook, and in the individual prints of saints' martyrdoms and relics sold separately, such as the engraving of the *Titulus* of the cross [CAT. B294]. This print reproduces the titulus from Christ's cross, a relic that was discovered in 1492 at Sta. Croce in Gerusalemme where it had been hidden

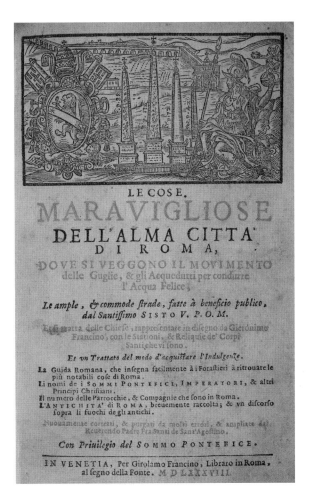

FIGURE 106

Title page. Woodcut in Franzini, *Le Cose maravigliose dell'alma Città di Roma* (1588). CAT. 43.

in a niche behind the wall mosaics.[167] The titulus preserves only *Nazarenus Re. . .* from the entire phrase, *Iesus Nazarenus Rex Iudaeorum* ("Jesus of Nazareth, the King of the Jews"), as given in the Gospel of John. The Greek and Latin letters are reversed following the direction of the Hebrew characters. Such devotional imagery made these relics available to a wider public than what was possible in their usual, liturgical context.

The title page of Franzini's extensively illustrated 1588 pilgrim guide, *Le cose maravigliose* [FIGURE 106, CAT. 43], mentions several projects of urban renovation undertaken by Sixtus V, to whom the book is dedicated. The frontispiece shows papal emblems opposite an armed personification of Rome. These frame portraits of the four obelisks that were set up in the city and the Acqua Felice. The set of woodcuts depicting the churches were

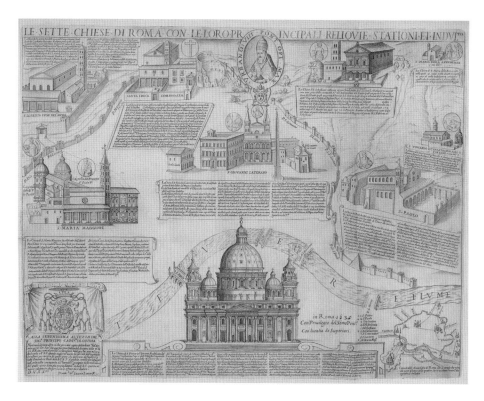

FIGURE 107

Giacomo Lauro
(engraver). *The Seven
Churches of Rome*.
Engraving, 1630,
bound with miscellany
containing, inter alia,
Pietro Ferrerio,
Palazzi di Roma (16—).
Special Collections,
Rare Book Collection.

then reused to illustrate Franzini's *Stationi delle chiese*. The printed images help integrate the list of churches with the liturgical calendar and with the pilgrim's experience of the contemporary city. Station 33, for example, takes place at St. Peter's Basilica, which is illustrated with the same woodcut as the one that introduces the pilgrim guide [CAT. 46]. The text refers to an earlier description of the altars and relics of the church. Many woodcuts that appeared in pilgrim guides were copied from other prints; the unfinished state of Michelangelo's dome in the *Stationi* is identical to its appearance in Lafreri's *Seven Churches* print. A version of Lafreri's *Seven Churches* print from the Chicago's de' Rossi miscellany depicts the churches in a later state [FIGURE 107].

While the *Cose maravigliose* included information on many other churches, some texts limited themselves to Rome's seven major basilicas. Severano's text on the seven major pilgrimage basilicas of Rome begins with Saint Peter's, then treats S. Paolo Fuori-le-Mura, S. Sebastiano, S. Giovanni in Laterano, Sta. Croce in Gerusalemme, S. Lorenzo Fuori-le-Mura, and Sta. Maria Maggiore. The second part of *Memorie sacre* provides specific modes of visiting each of these churches for the pious reader. The French translation of the pilgrim guide, *Les merveilles et antiquitez,* also focuses on the seven

principal churches of Rome. The illustration for S. Paolo Fuori-le-Mura [CAT. 38] includes a religious procession in front of the basilica. Saint Paul appears in the clouds at the upper right holding a sword, which was the instrument of his martyrdom. This guidebook uses a series of woodcuts introduced as an alternative program of illustration to those in the 1588 edition.[168]

Fioravante Martinelli dedicated his guidebook to Pope Alexander VII Chigi, whose emblems frame a fold-out view by Dominique Barrière of St. Peter's Basilica and the Vatican obelisk [CAT. 68]. It was under Alexander Chigi that Bernini completed the sweeping colonnades around the piazza between 1656 and 1667. The following illustrations draw attention to the Pope's architectural projects throughout Rome. In this way, the pope and his public works are acknowledged successors to the urban transformation achieved by Sixtus V.

A section on the obelisks of Rome also became a standard part of pilgrim guides. This was first introduced in the 1588 edition of Felini's book, where illustrations of the obelisks were shown with each of the churches they ornamented [FIGURE 108, CAT. 41]. Here we see the Vatican obelisk and its scaffolding, which Domenico Fontana designed to remove it from its place behind the church and successfully raise it once again in front of

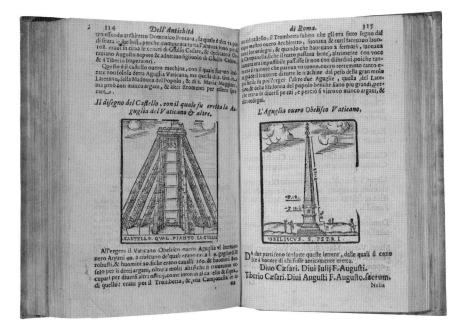

FIGURE 108

Anonymous. *Scaffolding structure* and *Vatican obelisk*. Woodcuts in Felini, *Trattato nuovo delle cose maravigliose dell'alma città di Roma* (1625). CAT. 41.

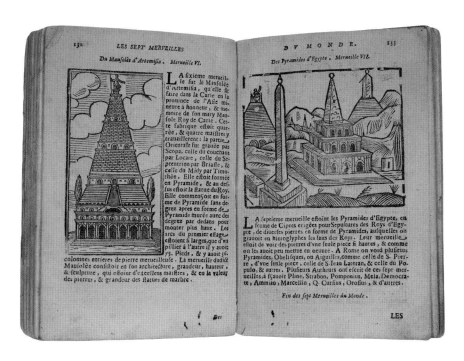

FIGURE 109

Anonymous. *Mausoleum of Artemisia* and *Pyramids of Egypt*. Woodcuts in Franzini, *Les merveilles de la ville de Rome* (1700). CAT. 44.

St. Peter's. This was a major feat of engineering that showcased papal power.[169] Beyond the inclusions of obelisks and other exotic monuments that actually existed in contemporary Rome and the historical lists of popes and emperors, guidebooks came to embrace material that might seem truly extraneous. The Seven Wonders of the World appear in an expanded version of Franzini's pilgrim guide to Rome published by Giovanni Francesco

Buagni in 1700. Woodcuts adorning this opening of the book display the Mausoleum of Artemisia and the Pyramids of Egypt [FIGURE 109, CAT. 44]. Like the frontispiece from Kircher's scholarly treatise (see below), the illustration juxtaposes obelisks and pyramids within an imagined landscape. The guide also comments on the number of pyramids visible in Rome, "called Obelisks or *Aiguilles,*" and lists the ancient obelisks that have been

FIGURE 110

Anonymous. *Hieroglyph*. Woodcut in Horapollo, *Hori Apollinis Selecta Hieroglyphica* (1606). CAT. 50.

re-erected and placed at major pilgrimage basilicas. Both the frontispiece engraving from Athanasius Kircher's *Sphinx Mystagoga* and an illustration of the pyramids as one of the Seven Wonders of the World demonstrate the impact of these monuments on later European perceptions of the East. Pyramids and obelisks are treated as interchangeable monumental forms (the two words were also used without a clear distinction between them in the sixteenth century). The resulting views of Egypt are thus more fantastical than accurate.

Antiquarians of the Renaissance and Baroque were fascinated by Egypt's ancient culture and religion. Much of their knowledge came from classical authors. Horapollo's *Selecta hieroglyphica* [FIGURE 110, CAT. 49] was accepted in the Renaissance as an authoritative interpretation of Egyptian hieroglyphs and their meanings. This treatise on hieroglyphs and their symbolism was composed in the late Roman Empire (fifth century CE) and reflects Hellenistic philosophy in its allegorical approach. On its rediscovery in the fifteenth century, it became highly influential for Renaissance Egyptological studies. Providing explanations of 189 pictorial symbols, it seemed a tantalizing source for understanding Egyptian hieroglyphs.[170] In one image, Egypt is represented with a burning censer and a heart. Horapollo compares the heart of a jealous man, always on fire, with the heart of Egypt, thought to be capable of generating all living things.

Rome also possessed Egyptian artifacts. After Egypt had been incorporated into the Roman Empire, Imperial Rome claimed many of its monuments as symbols of its own greatness, as seen in the discussion of Rome's obelisks. The Sepulcher of Caius Cestius is another example of Egyptian influence in the first century BCE. This pyramidal tomb was built for a Roman magistrate around 12 BCE on the Via Ostiense and later made part of the Aurelian walls. Inscriptions commemorate its patron and the speed of its construction—it was completed within 330 days. A popular subject of sixteenth-century prints and guidebook illustrations, by the period of the *Speculum*, the Sepulcher of Caius Cestius was the only pyramidal tomb surviving from Imperial Rome. For most artists and visitors to Rome, therefore, this monument provided their only point of reference for envisioning the Egyptian pyramids. The view by Brambilla, published by Claudio Duchetti in 1582 [see FIGURE 12, CAT. A33], is an etched copy of an earlier engraving. It is one of several depictions of the pyramid in the Chicago collection.[171]

Other well-known Egyptian antiquities in sixteenth-century Rome included numerous sphinxes, a pair of lions placed front of the Pantheon, and the Canopic Vase.[172] The Vase was first noted in the mid-sixteenth century in Rome in the collection of Gentile Delfini. The engraving by Dupérac, of which our example [CAT. A126] is a copy, restores the slightly damaged nose and base. The back of the figure and further inscriptions are depicted in another print in the *Speculum Romanae Magnificentiae*. Because there were also sketches made showing the statue in its damaged state, some publications included both versions as different objects. Such is the case in Athanasius Kircher's *Oedipus Aegyptiacus*. There were also some antiquities, like the Mensa Isiaca, thought to be Egyptian that were actually Roman imitations.[173] Many scholars sought to decipher the hieroglyphic code of their inscriptions. Renaissance scholars were eager to establish a universal language and drew on Neoplatonism and medieval traditions of allegory for their interpretations. They also freely constructed their own "hieroglyphic" emblems.[174] The pursuit of divine truth through such pictorial symbolism reinforced their perception of Egypt as a source for ancient wisdom and mystical knowledge.—KH

Giovanni Battista Cipriani. *Su i dodici obelischi egizj che adornano la città di Roma*. Rome: Alessandro Ceracchi, 1823. Rare Book Collection, Library of John Matthews Manly. Cat. 25, fig. 111.

All twelve of Rome's Egyptian obelisks are shown in a double-page etching in Cipriani's book on the obelisks.

The author-artist summarizes their history and patron-
age from the time of Sixtus V to the most recent inter-
vention by Pope Pius VII. As in Lafreri's print and the
pilgrim guide illustration of the Vatican obelisk, exact
measurements are an important means for conveying the
enormity of the monuments. Their very size underlines
the achievement of restoring them within the modern
topography of the city.

Filippo Pigafetta (1533–1604). *Discorso di m. Filippo
Pigafetta, d'intorno all' historia della Agvglia, et alla
ragione del muouerla.* **Rome: Bartolomeo Grassi,
1586. Rare Book Collection, Gift of Claire Dux
Swift. Cat. 75.**

Pigafetta's treatise is one of several contemporary works
celebrating the movement and rededication of the Vatican
obelisk. Domenico Fontana, the architect responsible for
Sixtus V's project, published his own account in 1590,
while Michele Mercati's *Gli Obelischi di Roma,* published
in 1589, was a history of all the ancient and modern
obelisks then known. Two diagrams accompany mathe-
matical exercises that demonstrate the natural pro-
portions and cubic mass of the obelisk according to
Euclidian principles.

Athanasius Kircher (1602–1680). *Sphinx mystagoga.*
**Amsterdam: Johannes Janssonius van Waesberge,
1676. Rare Book Collection. Cat. 52, fig. 112.**

Sphinx Mystagoga was written for antiquarian Fabri de
Peiresc after he purchased two mummies from Memphis.
It discusses burial practices in Ancient Egypt and provides

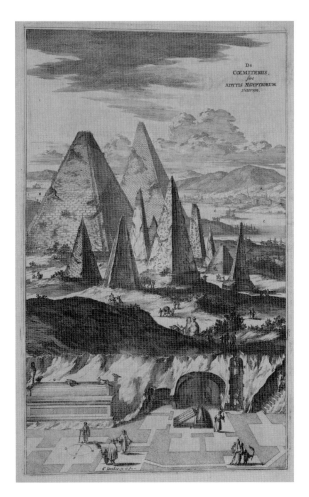

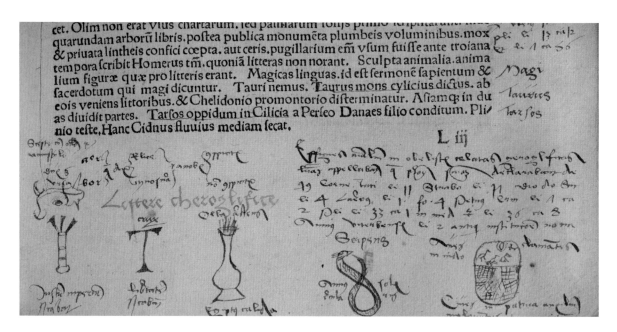

FIGURE 113

Anonymous. *Hieroglyphics.* Ink drawings added to lower margin, in Lucan, *Pharsaliae, seu belli ciuilis libri* (1509). CAT. 58.

FIGURE 114

Anonymous. *Saint Peter's Square.* Engraving in Pinaroli, *Trattato delle cose più memorabili di Roma* (1725). CAT. 76.

an interpretation of the newly acquired mummy cases. Kircher established his reputation in Egyptological studies with the four-volume *Oedipus Aegyptiacus* (1652–1654) and his translation of the hieroglyphs on the Piazza Navona obelisk. While Kircher claimed mastery of Egyptian hieroglyphs among twelve other languages, his interpretive efforts were largely creative.

Lucan (39–65). *Pharsaliae, seu belli ciuilis libri.* Strasbourg: Johann Prüss, 1509. Rare Book Collection. Cat. 58, fig. 113.

This copy of Lucan's *Pharsalia* has been heavily annotated. The epic poem describes the Roman civil wars during Julius Caesar's rise to power, and provides information on Egypt's culture and language within this account. The Latin hexameter is surrounded by printed commentary as well as by handwritten notes and marginalia. Examples of "Lettere cheroglifice" illustrate a discussion on the origins of writing. Lucan mentions Egyptian hieroglyphs in comparison with the Phoenicians, who, he writes, were the first to record the human voice in writing.

Giovanni Pietro Pinaroli. *Trattato delle cose più memorabili di Roma tanto antiche come moderne.* Rome: S. Michele a Ripa, 1725. Vol. 2. Rare Book Collection. Cat. 76, fig. 114.

In a view of St. Peter's Basilica in Pinaroli's text on the "most memorable things of Rome," we find the church and piazza fully completed. A group of pilgrims moves away from the Vatican obelisk at center. The text of the guide focuses on the many artists and patrons involved in the basilica's decoration. Although Pinaroli does not list them, he concludes by stating that the church is made all the more venerable by the indulgences and relics of the saints it contains.

Giovanni Baglione (ca. 1566–1643). *Le nove chiese di Roma.* Rome: Andrea Fei, 1639. Rare Book Collection. Cat. 8.

Baglione offered one of the first specialized guides to the churches of Rome, focusing on modern works of art in his descriptions of the history, architecture, and interior decoration of each church.[175] While contemporary with Severano's *Memorie sacre*, this pocket-sized book represents a very different set of interests and approach to visiting the pilgrimage churches.

Hermann Bavinck. *Wegzeiger zv den wunderbarlichen Sachen der heidnischen etvuan, nun aber der Christlichen Stat Rom.* Rome: Francesco Cavalli, 1628. Rare Book Collection. Cat. 10.

Bavinck's section on Sta. Croce in Gerusalemme includes an illustration of Helena and the Discovery of the True Cross, one of the feast days celebrated at the church. Sta. Croce also possessed important relics of the cross, including the titulus shown in an engraving [CAT. B294]. Bavinck compares these relics with the actual places associated with the life of Christ—Jerusalem, Bethlehem, and Nazareth are all locations represented by the pilgrimage churches of Rome.[176] A schematic diagram in the guide illustrates this point. Rome therefore becomes a substitute for the Holy Land.

INTERMEZZO VI: STAGING AND FRAMING SCENES OF ROME

A visitor's experience of Rome was a staged performance in one way or another. These performances included liturgical rites, papal appearances, and the public processions of confraternities and local charities. This case demonstrates the various kinds of theatricality represented in printed media and guidebooks; few of them are actual performances.

In an aquatint [CAT. A55] possibly from the nineteenth century contained in Chicago's *Speculum Romanae Magnificentiae* collection, the Arch of Titus provides a stage for the mysterious interactions of several cloaked gentleman. The exact subject remains unclear, but our attention is focused on the kneeling figure and man on horseback underneath the triumphal arch. The figures gathered beneath the arch are suggestive of the Commedia dell'Arte, whose companies offered impromptu street performances and flourished especially during the sixteenth and seventeenth centuries. The aquatint technique helps to create a more atmospheric setting around the ancient monument.[177]

FIGURE 115

Anonymous. *St Peter's Square*. Engraving in Franzini, *Les merueilles de la ville de Rome* (1725). CAT. 45.

Another enigmatic group occupies the Piazza of St. Peter's Basilica in an illustration from the French edition of Franzini's guidebook [FIGURE 115, CAT. 45], *Les merveilles de la ville de Rome*. This engraving provides an up-to-date illustration of St. Peter's for the pilgrim guide. However, the main figures in the square of the church are not ecclesiastical. A performer is shown with a monkey and a large dog; in fact, the proportions for all three figures are much larger than for the other bystanders excepting two reclining figures in the foreground. The text makes no mention of the entertainment taking place. The man with his monkey and a dog are surprising not only because of the contrast in scale, but also because of their secular presence within the precincts of the pilgrimage church. The reclining figures in the lower left corner may be admiring the church and its magnificent setting or focusing on the temporary circus entertainment. As spectators, they provide a model of viewing for the print.

The monuments of Rome provided numerous occasions for visitors to participate in their spectacle. Two woodcut illustrations from the same guidebook, depicting the Piazza della Rotonda and the Roman Pantheon turned Christian church [FIGURE 116, CAT. 45], offer two views that could not be seen simultaneously. The images require the reader/viewer to navigate them in a manner that imitates the actual, physical space. A visitor would have his or her back to the Piazza's fountain and obelisk in order to be able to look at the façade of the Pantheon. As the readers of the guidebook turn from one page to the next, they become performers, recreating this experience of urban space physically as well as in their imagination.

The 1704 and 1713 editions of François Deseine's *Description of Old and New Rome* include images in which Rome's ancient monuments become actors themselves. The porphyry sarcophagus of Constantia (ca. 350 CE) is the focal point of an illustration in the smaller French

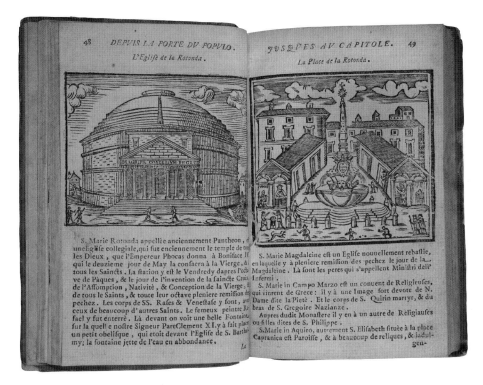

48 *DEPVIS LA PORTE DV POPVLO.*
L'Eglise de la Rotonda.

49 JVSQVES AV CAPITOLE.
La Place de la Rotonda.

FIGURE 116

Anonymous. *Pantheon* and *Piazza della Rotonda.* Woodcuts in Franzini, *Les merueilles de la ville de Rome* (1725). CAT. 45.

edition [FIGURE 117, CAT. 26]. Known as the Bacchic sarcophagus because of its relief decoration, it was housed in the church of Sta. Costanza (here labeled the "Temple of Bacchus") until it was moved to the Vatican museums in the late eighteenth century. The sarcophagus was often included in the pilgrim guide illustrations of antique statues. Here, it dwarfs the surrounding landscape and human observers. An opening from the Dutch translation of 1704 [FIGURE 118, CAT. 27] is typical of the arrangements used in the illustrations throughout this volume. Multiple levels of representation and frames set within frames contribute to a sense of self-conscious practice in reconstructing the antique past. On the left, the Meta Sudans is presented twice, first as an image on paper and then on a seal held up for comparison by a woman in antique dress. The Arch of Titus dominates the opening on the right-hand side. It is shown both in a restored state and within its contemporary, urban setting below. In contrast to the roughly contemporary aquatint, here the arch is not simply a stage for human drama. Rather, its transformation to an ideal state of preservation places it at the center of attention.[178]

Scenes of ruins by Hendrick van Cleve, published by Philippe and Theodoor Galle, likewise mediate between the contemporary viewer and the history of the city. The frontispiece [CAT. C533] to *Ruinarum varii*

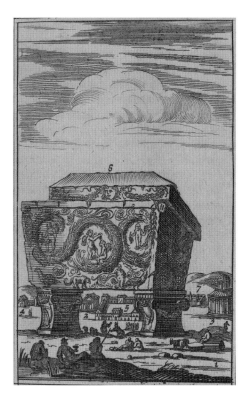

FIGURE 117

Anonymous. *Sarcophagus of Constantia.* Etching in Deseine, *L'ancienne Rome, La principale des Villes de l'Europe* (1713). CAT. 27.

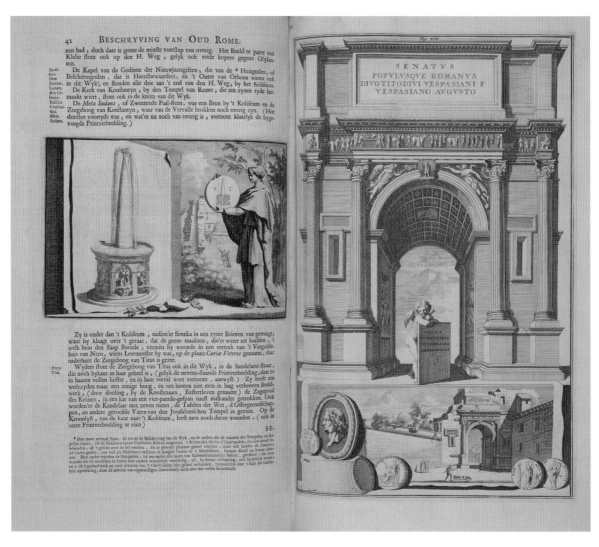

FIGURE 118

Jan Goeree? (designer). *Meta sudans* and *Arch of Titus*. Etchings in Deseine, *Beschryving van oud en nieuw Rome* (1704). CAT. 26.

prospectus ruriumque aliquot delineationes ("Views of various ruins and some sketches of landscapes") shows the Battle of the Milvian Bridge. It was this famous battle that allowed Constantine to proclaim himself sole Roman Emperor; later his victory was also attributed to intervention by the Christian God, thereby explaining Constantine's conversion to Christianity. The historical event is represented taking place before a view of the ancient city that brings together Rome's most recognizable monuments, some of which are already crumbling. The setting perhaps alludes to this spiritual conquest, the succession of pagan Rome by Christianity. The picturesque aesthetic is used throughout the series. Multiple scenes of such ruins allow viewers to place themselves within the same spaces once occupied by the great heroes and leaders of ancient Rome, inviting them to reimagine ancient Rome for their own purposes.—KH

1. The Topography of New and Old Rome

1. The title translates as "little work on the marvels of the new and old city of Rome," which makes it sound like a bit like an early Renaissance version of the earlier *mirabilia* books, but it also contains numerous references to recent archaeological discoveries. For a summary, see Rodolfo Lanciani, *Storia degli scavi di Roma* (1902; Rome: Quasar, 1990), 1:224–38.

2. On a fifteenth-century archaeological plan of Rome inspired by Biondo, see Gustina Scaglia, "The Origin of an Archaeological Plan of Rome by Alessandro Strozzi," *JWCI* 27 (1964): 137–63.

3. Alberti, in *Codice topografico della città di Roma,* ed. R. Valentini and G. Zucchetti (Rome: Tipografia del Senato, 1953), 4:212–22. See also Roberto Weiss, *The Renaissance Discovery of Classical Antiquity* (Oxford: Blackwell, 1969), 92.

4. Weiss, 95–98.

5. Philip J. Jacks, "The Simulachrum of Fabio Calvo: A View of Roman Architecture all'antica in 1527," *The Art Bulletin* 72, 3 (September 1990): 453–81. The Newberry Library possesses a copy of the 1532 edition published by Valerio Dorico.

6. On Calvo and the Sack of Rome, see Jacks, "Simulachrum"; Lanciani, 1:294.

7. Marliani, *L'antichità* (1548), f.4r: "lasciando da parte tutte le confuse opinioni de gli scrittori."

8. See Bronwen Wilson, *The World in Venice: Print, the City, and Early Modern Identity* (Toronto: University of Toronto Press, 2005), 25–30.

9. Amato Pietro Frutaz, ed., *Le piante di Roma* (Rome: Istituto di Studi Romani, 1957), map XXV (1:70, plate 57), a copy of map XXI (1:66, plate 36).

10. See David Woodward, *Maps as Prints in the Italian Renaissance: Makers, Distributors, and Consumers* (London: British Library, 1996); R.V. Tooley, "Maps in Italian Atlases of the Sixteenth Century, Being a Comparative List of the Italian Maps Issued by Lafreri, Forlani, Duchetti, Bertelli and Others, Found in Atlases," *Imago Mundi* 3 (1939): 12–47.

11. Frutaz, map CIX (1:168, plates 189–209).

12. Henri Jordan, *Forma urbis Romae: Regionum XIIII* (Berlin: Apud Weidmannos, 1874); Gianfilippo Carettoni et al., eds., *La pianta marmorea di Roma antica: Forma urbis Romae* (Rome: Commune di Roma, 1960).

13. On de Bry and Boissard, see Michiel van Groesen, "Boissard, Clusius, De Bry and the making of 'Antiquitates Romanae' (1597–1602)," *LIAS* 29, 2 (2002): 195–213. On de Bry in Antwerp, see van Groesen, "De Bry and Antwerp, 1577–1585: A Formative Period," in *Inszenierte Welten/Staging New Worlds,* ed. Susanna Burghartz (Basel: Schwabe, 2004), 19–45.

14. See Frutaz, map CXXXVIII (1:197, plate 278); it is dependent on the Brambilla-van Aelst map of 1590, Frutaz, map CXXXIII (1:192, plate 261); and on Cartaro small map of 1582, Frutaz, map CXXV (1:188, plate 237).

15. This print does not appear in Claudio and Stefano Duchetti's inheritance from Lafreri, itemized in the documents. Francesco Ehrle, *Roma prima di Sisto V: la pianta di Roma Du Pérac-Lafréry del 1577* (Rome: Danesi, 1908), 45–46.

16. On the Palatine in the Renaissance, see Lanciani, 2:40–59.

17. On the van Doetecums, see Henk Nalis, "The Van Doetecum Family," in *The New Hollstein Dutch & Flemish Etchings, Engravings and Woodcuts, 1450–1700,* ed. Ilja Veldman and Ger Luijten (Rotterdam: Sound & Vision Interactive in co-operation with the Rijksprentenkabinet, Rijks-museum, Amsterdam, 1998), 1:x–xxxiv and 2:41 cat. 206; and Timothy A. Riggs, *Hieronymus Cock (1510–1570): Print-maker and Publisher in Antwerp at the Sign of the Four Winds* (PhD diss., Yale University, 1972), 297, cat. 100 (fig. 70).

18. See, for instance, Carolyn Valone, "Giovanni Antonio Dosio: The Roman Years," *The Art Bulletin* 58, 4 (1976): 541.

19. The title page reads, "Cosmo Medici duci Florentinor et Senens Vrbis Romæ aedificiorvm illvstrivmqvæ svpersvnt reliqviæ svmma cvm diligentia a Ioanne Antonio Dosio Stilo ferreo vt hodie cernvntvr descriptæ et a Io Baptista de Cavaleriis aeneis tabvlis incisis repræsentatae."

20. Michael Cole, ed., *The Early Modern Painter-Etcher* (University Park, PA: Penn State University Press, 2006).

21. Dosio's drawing style can be seen in Ian Campbell, *Ancient Roman Topography and Architecture,* Paper museum of Cassiano dal Pozzo. Series A, Antiquities and architecture. part. 9 (London: Royal Collection: Harvey Miller, 2004). See also Christian Hülsen, *Das Skizzenbuch des Giovannantonio Dosio in Staatlichen Kupferstichkabinett zu Berlin* (Berlin: Heinrich Keller, 1933). Cristina Acidini argues ("Roma antica" pp. 83–86 in Franco Borsi et al., *Roma antica e i disegni di architettura agli Uffizi*) that some of the preparatory drawings were done by an anonymous French artist. This is a question worth pursuing, though their existence does not preclude Dosio's having transferred the drawings to the plate, or the drawings existing in some other relationship to the prints.

22. In Lafreri's stocklist, it is the "Altra forma del medesimo [the "Theatro di Vespasiano detto il Coliseo"], come si uede hora" (Chicago Speculum Number B181, Christian Hülsen, "Das Speculum Romanae Magnificentiae des Antonio Lafréri," in *Collectanea variae doctrinae Leoni S.*

Olschki (Munich: J. Rosenthal, 1921), 19Aa); it is also similar to one in Dupérac's *Vestigi*. Ehrle, 55.

23. Lipsius, 6: "hoc quod vides, De Amphitheatro, prius contexui: in quo imago, facies, habitus omnis Arenae expressus quà stilo meo, quà penicillo. Nam nec formas & imagines operum neglexi. et si fateor, maiorem me rationem rituum duxisse, quàm Architecturae. Illis enim haec nostra seruiunt & praelucent, vt illos volumus scriptoribus priscis. Tamen nec Architectura spreta à me prorsus, quatenus ea quidem ad voluptatem aliquid conferre videretur siue admirationem." On Lipsius's text, see John B. Gleason, "The Dutch Humanist Origins of The De Witt Drawing of the Swan Theatre," *Shakespeare Quarterly* 32, 3 (Autumn 1981): 324–38.

INTERMEZZO I: THE COLOSSEUM

24. Christopher Woodward, *In Ruins* (New York: Pantheon Books, 2001), 11. This quote appears in *Baedeker's Central Italy and Rome*, 1889 German edition and 1900 French edition.

25. Richard Deakin's publication *Flora of the Colosseum* (1855) is discussed in Woodward, 23–24.

26. John Murray, *Handbook for Travellers in Central Italy: Including the Papal States, Rome and the Cities of Etruria, with a Traveling Map* (London: J. Murray, 1843); quoted in Keith Hopkins and Mary Beard, *The Colosseum* (Cambridge: Harvard University Press, 2005), 1.

27. According to Hülsen, Lafreri's version, of which this one is a copy, is itself a copy of one engraved by Girolamo Fagiuoli for Antonio Salamanca (Hülsen, "Speculum," 146); Bury adds that the Fagiuoli engraving was published in 1538 (Michael Bury, *The Print in Italy 1550–1620* (exh. cat.) (London: British Museum, 2001), 138). Versions of each half of the two-sheet Lafreri/Duchetti prints exist in both orientations, possibly through the use of a counterproof, so that different composites could be created—some with the cutaway portion on the left, some on the right, some entirely intact, some open on both sides with an odd tower-like structure in the middle. See David Woodward, *Maps as Prints*.

28. Percy Bysshe Shelley, *With Shelley in Italy: A Selection of the Poems and Letters of Percy Bysshe Shelley*, arr. Anna Benneson McMahan (Chicago: A.C. McClurg & Co., 1905), 71.

29. Shelley, 71.

30. A reference I owe to Jonathan Sachs, who kindly spoke with the curatorial group about the British Romantic writers and their enthusiasm for Rome, especially for the Colosseum.

31. Hendrick van Cleve's monogram appears on the prints in this series, along with the indication ("Depingebat" or "inven") that he designed them, suggesting that he may also have engraved them. They were published by Philip Galle around 1585–1590, and republished, probably after 1600, by Theodoor Galle after he took over the family business. See Manfred Sellink, ed., *The New Hollstein Dutch & Flemish Etchings, Engravings and Woodcuts 1450–*

1700: Philips Galle (Rotterdam: Sound & Vision Publishers, 2001), 1:lxi–lxii, 1:lxv, 4:170.

32. Niccola Roisecco, *Roma ampliata, e rinovata, o sia nuova descrizione della moderna città di Roma* (Rome: G. Roisecco, 1739), 92. Translation my own. "Avete in vista il nobilissimo Anfiteatro Flavio, chiamato il Coloseo, più celebre per I Trionfi de'S.S. Martiri, che per l'eccellenza della fabrica."

2. *Artists, Techniques, Uses*

33. On printmaking techniques, see Anthony Gross, *Etching, Engraving, & Intaglio Printing* (London: Oxford University Press, 1970); and William Ivins, *Prints and Visual Communication* (Cambridge: Cambridge University Press, 1953).

34. Bosse's treatise includes instructions and how-to illustrations, such as an image that demonstrates how to pour acid on a wax-covered copper plate. Juxtaposing the picture next to the instructions reinforces the lesson and makes it easier for the reader to relate text to image. A print on the studio wall points the reader to an example of a finished product. On Bosse, see André Blum, *Abraham Bosse et la société française au dix-septième siècle* (Paris: Morance, 1924); Sophie Join-Lambert and Maxime Préaud, eds., *Abraham Bosse, savant graveur: Tours, vers 1604–1676, Paris* (Paris: Bibliothèque nationale de France; Tours: Musée des beaux-arts de Tours, 2004).

35. See Cole, *The Early Modern Painter-Etcher.*

36. On Cavalieri, see Thomas Ashby, "Antiquae Statuae Urbis Romae," *Papers of the British School at Rome* 9, 5 (1910): 107–58. On Perrier, see Alvin Clark, *François Perrier: Reflections on the Earlier Works from Lanfranco to Vouet* (Paris: Galerie Eric Coatalem, 2001); Jacques-Charles Brunet, *Manuel du libraire et de l'amateur de livre. . .* (Paris: G.-P. Maisonneuve & Larose, 1965–1966); J.G.T. Grässe, *Tresor des livres rares et precieux. . .* (Dresden: R. Kuntze, 1859–1869).

37. On offsets, see Peter Parshall, "Antonio Lafreri's *Speculum Romanae Magnificentiae*," *Print Quarterly* 23, 1 (2006): 3–27; Woodward, *Maps as Prints*, 52–55. Woodward's unidentified offset is an engraving of the goddess Flora frequently included in Speculum collections (e.g. Chicago Speculum Number A145).

38. The two lines of publication information added to the plate are as follows: "Chez la veuve de defunct Perrier" and "Et a present chez De Poilly rue StIacques a ljmage StBenoist auec priuil. du Roy." François de Poilly, who was an engraver as well as a publisher, took over the shop at this address ("rue St Jacques a l'image St Benoist") in 1669; he died in 1693. Some on-line catalogues date works published by him at this address before 1669, as early as 1660. This may reflect questionable assumptions based on style, or it may be that he was putting works out under his name before fully taking over the shop from his father-in-law. For more on the de Poilly family, see José Lothe, *L'oeuvre gravé de François et Nicolas de Poilly d'Abbeville* (Paris: Commission des travaux historiques de la Ville de Paris, 1994), especially pp. 10–11.

39. On Montjosieu, see Zorach essay in this volume.

40. On this topic see in particular Lisa Pon, *Raphael, Dürer, and Marcantonio Raimondi: Copying and the Italian Renaissance Print* (New Haven: Yale University Press, 2004).

41. See Eckhard Leuschner, "The Papal Printing Privilege," *Print Quarterly* 15, 4 (1998): 359–70; Christopher L. C. E. Witcombe, *Copyright in the Renaissance: Prints and the Privilegio in Sixteenth-Century Venice and Rome* (Leiden; Boston: Brill, 2004). On copying as learning process, see Thomas DaCosta Kaufmann, "The Nature of Imitation," *Jarbuch der kunsthistorischen Sammulungen in Wien* 82–83 (1986/1987): 163–77; Ernst Gombrich, *Art and Illusion* (Princeton: Princeton University Press, 1960); Ernst Gombrich, ed., *The Children of Mercury: The Education of Artists in the Sixteenth and Seventeenth Centuries* (Providence: David Winton Bell Gallery, 1984); and Patricia Rubin, *Giorgio Vasari: Art and History* (New Haven: Yale University Press, 1995), 369–401.

42. This temple, located in the Forum, was originally dedicated to the Roman Empress Faustina in 141 CE; it was rededicated in 161 CE to both her and her husband, the Emperor Antoninus Pius.

43. On the versions of Roma victrix, see Roger Cushing Aikin, "Romae de Dacia triumphantis: Roma and Captives at the Capitoline Hill," *The Art Bulletin* 62, 4 (December 1980): 583–97. On the Renaissance dating of the group's combined composition, see p. 589.

44. Ashby, "Antiquae Statuae," 116–17.

45. A substantial bibliography on drawing an artistic education exists of which the following is only a small part. See Francis Ames-Lewis, *Drawing in the Italian Renaissance Workshop* (London: Victoria and Albert Museum, 1983); Carmen C. Bambach, *Drawing and Painting in the Italian Renaissance Workshop: Theory and Practice, 1300–1600* (Cambridge: Cambridge University Press, 1999); Gombrich, *The Children of Mercury.* On academies, see Karen-edis Barzman, *The Florentine Academy and the Early Modern State: The Discipline of Disegno* (Cambridge: Cambridge University Press, 2000); Sir Nikolaus Pevsner, *Academies of Art, Past and Present* (New York: Da Capo Press, 1973). On copying from the antique see Leonard Barkan, *Unearthing the Past: Archeology and Aesthetics in the Making of Renaissance Culture* (New Haven: Yale University Press, 1999).

46. See Giovanni Antonio Dosio, *Roma antica e i disegni di architettura agli Uffizi,* ed. Franco Borsi et al. (Roma: Officina, 1976), 64–108.

47. On copying and invention, see Jill Dunkerton, Susan Forster, and Nicholas Penny, *Dürer to Veronese: Sixteenth-Century Paintings in the National Gallery* (New Haven: Yale University Press, 2000); Elaine Gazda, *The Ancient Art of Emulation: Studies in Artistic Originality and Tradition from the Present to Classical Antiquity* (Ann Arbor: University of Michigan Press, 2002); and Francis Haskell and Nicholas Penny, *Taste and the Antique: The Lure of Classical Sculpture 1500–1900* (New Haven: Yale University Press, 1981).

48. On artistic identity in the period, see Ernst Kris and Otto Kurz, *Legend, Myth and Magic in the Image of the Artist* (New Haven: Yale University Press, 1979); Gombrich, *The Children of Mercury.*

49. According to Hülsen, Lafreri's was itself a copy of a print published by Salamanca. Hülsen, "Speculum," 157 (70Bh); Paolo Arrigoni and Achille Bertarelli, *Piante e vedute di Roma e del lazio conservata nella Raccolta delle stampe e dei disetni* (Milan: E. Bestetti, 1939), 322n3179.

50. Petrus Lepidus (Pierre Joly), unpaginated prefatory material, Jean-Jacques Boissard, *I pars Romanae vrbis topographia* (Frankfurt: Theodor de Bry, 1597).

51. On the arch of Janus, see Samuel Ball Platner and Thomas Ashby, *A Topographical Dictionary of Ancient Rome* (London: Oxford University Press, 1929), 280. See also Lily Ross-Taylor and Louise Adams Holland, "Janus and the Fasti," *Classical Philology* 47, 3 (1952): 137–42.

52. See Jan G. Van Gelder and Ingrid Jost, *Jan de Bisschop and His Icones & Paradigmata: Classical Antiquities and Italian Drawings for Artistic Instruction in Seventeenth Century Holland* (Doornspijk, Netherlands: Davaco, 1985), and Renske Jellema and Michel Plomp, *Jan de Bisschop: advocaat en tekenaar* (Amsterdam: Museum Hey Rembrandthuis, 1992).

INTERMEZZO II: THE RENAISSANCE IMAGINATION

53. On the relationship of Renaissance creativity to antiquity, see Barkan, *Unearthing the Past,* and Madeline Viljoen, "Raphael and the Restorative Power of Prints," *Print Quarterly* 18, 4 (2001): 379–95.

54. On elaborate ancient silver of the type Renaissance artists might have been able to study, see Pietro Giovanni Guzzo, *Argenti a Pompei* (Milan: Electa/Ministero per i Beni e le Attività Culturali, 2006). On Renaissance design, see Beth L. Holman, ed., *Disegno: Italian Renaissance Designs for the Decorative Arts* (exh. cat.) (Dubuque, IA: Kendall/Hunt, 1997). See also Toby Yuen, "Giulio Romano, Giovanni da Udine and Raphael: Some Influences from the Minor Arts of Antiquity," *JWCI* 42 (1979): 263–72 and Innis Shoemaker, "Drawings after the Antique by Filippino Lippi," *Master Drawings* 16, 1 (Spring 1978): 35–43, 97–104.

55. On Diana Mantovana (or Mantuana), see Evelyn Lincoln, *The Invention of the Italian Renaissance Printmaker* (New Haven: Yale University Press, 2000) and "Making a Good Impression: Diana Mantuana's Printmaking Career," *Renaissance Quarterly* 50 (1997): 1101–47. The relevant prints in the Chicago collection are A147, A148, and A149.

56. For these two prints, see Paolo Bellini, *L'Opera incisa di Adamo e Diana Scultori* (Vicenza: Neri Pozza, 1991), 142–51 (Cat. A133, A136) and Valeria Pagani, "Adamo Scultori and Diana Mantovana," *Print Quarterly* 9, 1 (1992): 72–87.

57. On these artists see Marijnke de Jong and Irene de Groot, eds., *Ornamentprenten in het Rijksprentenkabinet,* vol. 1 (Amsterdam: Het Kabinet; 's-Gravenhage: Staatsuitgeverij, 1988).

58. Stefania Massari, *Giulio Romano pinxit et delineavit* (Rome: Fratelli Palombi, 1993), cat. 50, p. 58–60. The state with Duchetti's address is not mentioned by Massari (she has it republished only by Thomassin, not by Duchetti).

59. On the Domus Aurea, see Nicole Dacos, *La découverte de la Domus Aurea et la Formation des Grotesques à la Renaissance* (London: Warburg Institute, 1969).

60. Some of the designs for the book may have come from François de Diuteville. See Léon Dorez, "Extraits de la correspondance de François de Dinteville, ambassadeur de France à Rome (1531–1533)," *Revue des bibliothèques* 4 (1894): 86 (Cited by Lanciani, 2:17).

61. In addition to these trophies, Vico produced several prints often included in early *Speculum* collections: the column of Marcus Aurelius with the Vatican obelisk; Venus and Cupid; Flora; a bust of Aristotle. See Giulio Bodon, *Enea Vico fra Memoria e miraggio della classicità* (Roma: "L'Erma" di Bretschneider, 1997), 248, 260–61, 265–66, 270–72, 280.

3. *Antiquarian Publishing and Architectural Reconstruction*

62. Wilson, 3.

63. Deborah Parker, "Women in the Book Trade in Italy 1475–1620," *Renaissance Quarterly* 49, 3 (1996): 513; Pon, *Raphael,* 16; and Gert Jan Van der Sman, "Print Publishing in Venice in the Second Half of the Sixteenth Century," *Print Quarterly* 17, 3 (2000): 235.

64. On printmaking in Venice, and its emphasis on the woodcut, see David Rosand and Michelangelo Muraro, *Titian and the Venetian Woodcut* (Washington, DC: International Exhibitions Foundation, 1976), and David Landau, "Printmaking in Venice and the Veneto," in *The Genius of Venice, 1500–1600* (exh. cat.), ed. Jane Martineau and Charles Hope (London: Royal Academy of Arts, 1983).

65. Mario Carpo, *Architecture in the Age of Printing: Orality, Writing, Typography, and Printed Images in the History of Architectural Theory* (Cambridge: MIT Press, 2001), especially 18, 45, 119–124.

66. Elizabeth Eisenstein, *The Printing Revolution in Early Modern Europe* (Cambridge: Cambridge University Press, 1983), 81–83.

67. David Coffin, *Pirro Ligorio: The Renaissance Artist, Architect, and Antiquarian* (University Park: Pennsylvania State University Press, 2004), 11.

68. Raphael, "Letter to Leo X," in Caecilia Davis-Weyer, ed., *Early Medieval Art 300–1150: Sources & Documents* (Englewood Cliffs, NJ: Prentice Hall, 1971), 289–296; Raphael, *Il pianto di Roma: lettera a Leone X,* ed. Piero Buscaroli (Torino: Fògolae, 1984).

69. Weiss, 62.

70. Robert W. Gaston, ed., *Pirro Ligorio, Artist and Antiquarian* (Florence: Silvana, 1988), 12.

71. Coffin, 21.

72. Coffin, 21.

73. This is a state not known to Hülsen. The last he notes from this plate is 33Af, with the addresses of Nobilibus and "Pauli Gratiani formis Romae 1582" but no De' Rossi. Beatrizet's "fecit" has been burnished out. This sheet has a penciled "17 1/2" (a price?) penciled in the lower right and 105 in the lower left.

74. See Coffin, 76–77. Howard Burns, "Pirro Ligorio's Reconstruction of Ancient Rome," in Gaston, *Pirro Ligorio,* 19–92, 36. Marco Fabio Calvo used a similar "stacked" style of representation of buildings in his plans of Roman city regions. For a Roman relief like those on which Ligorio may have based his representations of ancient buildings, see Burns, 88, fig. 83.

75. Chicago A30 is a close copy of a print after Pirro Ligorio, published in 1553 by Michele Tramezzino with the inscription "Castrum Praetorium Cum Privilegio Summi Pon. Et Senat Venet. Michaelis Tramezini Formis M D L III." Vatican, Barberini.X.I.13A-B, 24.

76. John Onians, *Bearers of Meaning: The Classical Orders in Antiquity, the Middle Ages, and the Renaissance* (Princeton, NJ: Princeton University Press, 1988), 8.

77. Onians, *Bearers of Meaning,* 8.

78. Onians, *Bearers of Meaning,* 8–19.

79. James Ackerman, "The Tuscan/Rustic Order: A Study in the Metaphorical Language of Architecture," *The Journal of the Society of Architectural Historians* 42, 1 (1983): 16.

80. Ackerman, 25–27.

81. John Onians, "The System of the Orders in Renaissance Architectural Thought," in *Les traités d'architecture de la Renaissance,* ed. Jean Guillaume (Paris: Picard, 1988), 171.

82. For the various printings of Labacco's book including the de' Rossi one, see Ashby, "Il libro d'Antonio Labacco appartenente all'architettura," in *La Bibliofilia* 16 (1914): 289–309, especially 306–07; from the time of the original printing in 1552, there were many small-scale reprintings up to Carlo Losi's in 1773.

83. Giovanni Battista Montano published several volumes, including *Scielta di varii tempietti antichi con le piante et alzatte desegnati in prospettiva* (Rome: Giovanni Battista Soria, 1624) and *Architettura con diversi ornamenti* (Rome: Calisto Ferrante, 1636). Some prints in the latter are signed Jerome David or Camillo Cungi, but this is not enough to securely attribute our prints.

INTERMEZZO III: ROMAN RELIGION

84. On Roman religion, see Valerie M. Warrior, *Roman Religion: A Sourcebook* (Newburyport, MA: Focus, 2002); Elizabeth Chambless De Grummond, *Sacred Sites and Religion in Early Rome Eighth to Sixth Centuries BC* (PhD diss., University of Michigan, 2005); L. Michael White, *The Social Origins of Christian Architecture: Building God's House in the Roman World: Architectural Adaptation Among Pagans, Jews, and Christians* (Boston: Trinity Press International, 1996), 261–271. A wealth of information on Roman religion from a European Renaissance point of view is contained in works by Guillaume Duchoul.

85. On ancient and Christian sacrifice, see Sarah Iles Johnston, *Religions of the Ancient World: A Guide* (Boston: Harvard University Press, 2004), 346–347.

86. The other version is found, for instance, in the Vatican Library's volume Barberini X.I.13A-B, number 165b. The details are quite different; the inscription fits the same text on a much shorter second line. Under the inscription is "Antonii Lafreii formis Romae 1553." The attribution of the second plate to Dupérac is made in Emmanuel Lurin, *Étienne Dupérac, graveur, peintre et architecte (vers 1535?–1604). Un artiste-antiquaire entre l'Italie et la France* (PhD diss., Université de Paris-IV, 2006). Personal communication, Emmanuel Lurin, September 2007.

87. Many were also known in the Renaissance. A different Mithraic relief, in the collection of Andrea Cinquini, was drawn by an artist connected to Giovanni Antonio Dosio's workshop who also noted the quantity of such reliefs in Rome: "In Casa e[=a?] Cinquini be[n]che assai sene vegghino p[er] Roma" ("In the house of A Cinquini, though many of them are seen throughout Rome."). Emanuele Casamassima and Ruth Rubinstein, eds., *Antiquarian Drawings from Dosio's Roman Workshop* (exh. cat.) (Florence: Giunta regionale Toscana, 1993), 221. See also Richard Gordon, "Interpreting Mithras in the Late Renaissance, 1: The 'Monument of Ottaviano Zeno' (V. 335) in Antonio Lafreri's *Speculum Romanae magnificentiae* (1564)," *Electronic Journal of Mithraism Studies* 4 (2004): 12, http://www.uhu.es/ejms/papers.htm. Accessed September 4, 2007. See also Roger Beck, *The Religion of the Mithras Cult in the Roman Empire: Mysteries of the Unconquered Sun* (Oxford: Oxford University Press, 2006); Manfred Clauss, *The Roman Cult of Mithras: The God and His Mysteries* (Edinburgh: Edinburgh University Press, 2000); Franz Cumont, "The Dura Mithraeum," in *Mithraic Studies*, ed. J. R. Hinnells (Manchester: Manchester University Press, 1975), 1:151–214; and Franz Cumont and Mikhail Rostovtzeff, in *The Excavations at Dura-Europos: Preliminary Reports of the 7th and 8th Seasons of Work*, ed. M. I. Rostovtseff, F. E. Brown, and C. B. Welles (New Haven: Yale University Press, 1939), 104–116.

88. Ehrle, 56.

89. Pompilio Totti, *Ritratto di Roma moderna* (Rome: Per il Mascardi, 1638), 76.

4. Sculpture

90. On this topic, for example, see Barkan, *Unearthing the Past*.

91. Eugenio Albèri, "Sommario del viaggio degli Oratori Veneti che andarano a Roma a dar l'obbedienza a Papa Adriano VI 1523," in *Relazioni degli Ambasciatori Veneti al Senato*, VII, vol. III, 2nd ser. (Florence: 1846), 115; quoted in Haskell and Penny, 148.

92. Johann Joachim Winckelmann, *History of the Art of Antiquity*, introd. Alex Potts, trans. Harry Francis Mallgrave (Los Angeles: Getty Research Institute, 2006), 333.

93. Haskell and Penny, 311.

94. Haskell and Penny, 313.

95. Jacques Buirette, *L'Union de la Peinture et de la Sculpture*, marble, Musée du Louvre, Collections de l'Académie Royale, Département des Sculptures, M.R. 2677.

96. Haskell and Penny, 313.

97. Barkan, 217.

98. On Pasquino and his physical relationship to the printers' quarter, see Rose Marie San Juan, *Rome: A City Out of Print* (Minneapolis: University of Minnesota Press, 2001), especially 1–21.

99. Pasquino's ancient identity remains unknown. The statue is often reconstructed as Menelaos carrying the prone body of Patroclus. Without knowing Pasquino's actual identity, it is difficult to say what his ancient function was. For an excellent discussion of the sculpture's changing role from antiquity to the present, see Verity Platt, "'Shattered Visages': Speaking Statues from the Ancient World," *Apollo* 158 (2003): 9–14.

100. Haskell and Penny, 246; Phyllis Pray Bober and Ruth Rubinstein, *Renaissance Artists and Antique Sculpture: A Handbook of Sources* (London: Harvey Miller, 1986), 152.

101. Pliny, *Natural History*, 36.37.

102. Bober and Rubinstein, 153; Haskell and Penny, 246–47.

103. Though the date in the 1580s is not the original printing date, even that date was well past the restoration. Hülsen puts it between 1540 and 1565 and attributes it to Béatrizet. Hülsen, "Speculum," 154–55, n59.

104. Winckelmann, 313.

105. For more on censorship of prints, see *Intermezzo IV. Sex and Censorship*. In one volume in the Vatican, Stampe VI.3, this version (Chicago Speculum Number 107) appears with a small shell added—perhaps a mark of Hendrick van Schoel?

106. A point I owe to my discussions of Vasari with Jaś Elsner, as well as to Vasari's preface to part III: Giorgio Vasari, *The Lives of the Painters Sculptors and Architects*, ed. Ernest Rhys (London: J.M. Dent, 1927), 2:151–55.

107. Johann Joachim Winckelmann (1717–1768), *Anmerkungen über die Geschichte der Kunst des Alterthums* (Dresden: Waltherschen Hofbuchhandlung, 1767). A copy came to the University of Chicago Library through the Berlin Collection and now forms part of the Rare Book Collection.

108. Bates Lowry, "Notes on the *Speculum Romanae Magnificentiae* and Related Publications," *Art Bulletin* 34 (1952): 49.

109. The story is recounted by Athenaeus of Naucratis in his *Deipnosophistae*, 12:54.

110. For a thorough and concise analysis of Winckelmann's life and work, see Alex Potts, "Introduction" to Winckelmann, *History of the Art of Antiquity*, 1–53. On Winckelmann and homosexuality, see Whitney Davis, "Winckelmann's 'Homosexual' Teleologies," in *Sexuality in Ancient Art: Near East, Egypt, Greece and Italy*, ed. Natalie Boymel Kampen (Cambridge: Cambridge University Press, 1996), 262–76.

111. This separation, as Jaś Elsner observes, is due in large part to the fact that the sculptural finds from Hadrian's Villa have long been removed from their original archaeological context and scattered in collections throughout the world. Therefore, at least from a museological standpoint, it does make a certain amount of sense to group items together stylistically (i.e., Hellenizing statues together,

Egyptianizing items together, etc.). See Jaś Elsner, "Classicism in Roman Art," in *Classical Pasts: The Classical Traditions of Greece and Rome*, ed. James I. Porter (Princeton: Princeton University Press, 2006), 277, n29–30.

112. The Capitoline Antinoös is said to have been found at Hadrian's Villa, as were other Egyptianizing and Hellenizing styles of sculpture, for example, a head of Antinoö-Osiris. For an excellent discussion of Hadrian's "Egyptianizing Classicism" as manifested in statues of Antinoös, see Elsner, 270–97; on Hadrian and Antinoös, see especially 276–90.

113. See Elsner, 284n43–n49.

114. Ashby, 125.

115. Goert van Scayck republished both the Lorenzo della Vaccheria edition of Cavalieri's prints of ancient statues and Etienne Dupérac's *Vestigi*, and it seems to have been in his shop that the two sets were bound together.

116. Translation my own. Totti, 235: "Pasquino e una statua antica, per eccelenza reputata pari al famoso Hercole di Belvedere. . . ."

INTERMEZZO IV: SEX AND CENSORSHIP

117. For Magister Gregorius, see Roberto Valentini and Giuseppe Zucchetti, eds., *Codice topografico della città di Roma* (Rome: Tipografia del Senato, 1940–1953), 3:137–67 (here 150–51).

118. *Roma sacra, antica e moderna, figurata e divisa in tre parti* (Rome: Giovanni Battista Molo, 1687), 326: "Vn pastor ignudo di bronzo che si caua con vn'ago vn spino da vn piede, degno d'esser considerato."

119. For more on this, see Bette Talvacchia, *Taking Positions: On the Erotic in Renaissance Culture* (Princeton, NJ: Princeton University Press, 1999).

120. Royal Academy archives ANG/3. Lawrence to Mrs Angerstein [1821]. Kindly transcribed for me by Mark Pomeroy.

121. Leda and the swan have been censored in a historiated initial L in the Chicago copy of Valverde's *Historia*, f 2v.

122. Lanciani, 1:189.

123. See Henri Zerner, *L'art de la Renaissance en France: l'invention du classicisme* (Paris: Flammarion, 2002), 104.

5. Telling History Visually

124. On epigraphy in the Renaissance, see Alison Cooley, *The Afterlife of Inscriptions* (London: Institute of Classical Studies, School of Advanced Study, University of London, 2000). William Stenhouse, *Ancient Inscriptions* (*Paper Museum of Cassiano dal Pozzo*, Series A, Antiquities and architecture 7) (London: The Royal Collection; Harvey Miller, 2002).

125. In Bottari's *Del Museo Capitolino*, the statue is described as "Mario" (Tavola L).

126. Lanciani, 2:35.

127. This event is described and visually represented with a slew of fine woodcuts in *C'est la deduction du sumpteux order plaisantz spectacles et magnifiques theatres dresses. . . par*

les citoiens de Rouen. . . a la sacrée maieste du treschristian roy de France, Henry seco[n]d. . . et à tresillustre dame, ma dame Katharine de Medicis. . . (Rouen, 1551). On Renaissance festivals in general see Roy Strong, *Art and Power: Renaissance Festivals 1450–1650* (Woodbridge: Boydell Press, 1984); on Italy, Bonner Mitchell, *Italian Civic Pageantry in the High Renaissance: A Descriptive Bibliography of Triumphal Entries and Selected Other Festivals for State Occasions* (Florence: Leo S. Olschki, 1979).

128. Jean-Louis Ferrary, *Onofrio Panvinio et les antiquités romaines* (Rome: Ecole française de Rome, 1996), 206–12. The 1558 edition published by V. Valgrisi in Venice was the first acknowledged by the author, though there had also been one in 1557.

129. See Ferrary, 27–38.

130. "Proinde cum inter caeteras officinae meae tabulas & has ferro seiunctim exaratas haberem; iungendo auctoris Commentarium, tum demum (only then) me plenam studiosis satisfactionem daturum, ac absolutum plane fore laborem, existimaui." As was the case for plates done in Panvinio's lifetime, Gerard de Jode's frontispiece suggests that Onofrio contributed both the design (as inventor) and the plates (*aeneis formis*), but this seems unlikely, unless the plates are actually the same. The Merton College, Oxford, library holds a volume of Tramezzino's edition with an imprint of 1561, probably a misprint. More importantly, the text is followed by what the library catalogue describes as "six double plates" (which might correspond to de Jode's 11) of which the first and last are both dated 1580.

131. Huttich's dedicatee, Otto von Pack, may have taken the wrong Roman emperors as his model; his schemes nearly provoked war between Hesse and Saxony. For more, see Kurt Dülfer, ed., *Die Packschen Händel: Darstellung und Quellen*, Veröffentlichungen der Historischen Kommission für Hessen. Quellen und Darstellungen zur Geschichte des Landgrafen Philipp des Grossmütigen; 24, 3 (Marburg: N.G. Elwert, Kommissionsverlag, 1958).

132. An example of the papal history grid with two additional postage-stamp-sized popes (Urban VII, and Gregory XIV) pasted in can be found in BAV Riserva S.6, fol.106. Chicago's A165 includes a separate strip of paper with four additional papal portraits.

133. Giovanni Battista Cavalieri, *Romanorum imperatorum effigies* (Rome: Vincenzo Accolti, 1583), 4.

134. Enea Vico, *Le Imagini delle Donne Avgvste intagliate in istampa di rame* (Venice: Enea Vico and Vincenzo Valgrisi, 1557), a2v: "essendo le immagini, & la historia, come vno lucidissimo specchio, che ci rappresenta tutto quello, che seguire, o fuggire le debbe."

135. Vico, c2r: "un ritratto de' loro animi."

136. "Le imagine predette. . . non tutte ho trattate da antico essempio, ne meno ce ne ho fatte di mia testa, perche è cosa indegna di nome di historia, il fingere quelle cose, che non sono, ma una parte e tratta dal libro composta da diuersi, et in magior parte da Andrea Fuluio, et dedicato al Cardinale Sadoletti. . . Le quali, se ueramente da medaglie antiche, da intagli, o pur da statue siano state tratte, questo per certezza non ho: tuttauia per non

lasciare i luoghi uacui, non ho uoluto lasciare di pornelle, lasciando in quello, che è fuor dell'opera mia, l'opinione libera a ciaschuno, doue uedrete, che in alcune tauole, (c2v) habbiamo posta & la imagine del detto libro, & la nostra antica, si come piu di sotto si dimostrere à per registro. L'altra parte, non deuete dubitare, che non sia simigliantissima alle uere antiche medaglie loro, percioche à suoi luoghi ui si allegga il testimonio delle persone, che le possegono. Le imagini adunque, che noi habbiamo haute dal detto libro sono . . ."

137. Ehrle, 45, 59.

138. On the topic of ancient material culture and biblical scholarship, see Debora Shuger, *The Renaissance Bible: Scholarship, Sacrifice, and Subjectivity* (Berkeley: University of California Press, 1994).

139. See Anthony Blunt, "The Triclinium and Religious Art," *JWCI* 2, 3 (January 1939): 271–76.

140. Ehrle, 41.

141. Ferrary, 38n107.

142. See Lanciani, 2:75–102, "Le collezioni capitolini nel secolo XVI."

INTERMEZZO V. THE GRAND TOUR

143. See, for example, Bruce Redford, *Venice and the Grand Tour* (New Haven: Yale University Press, 1996), especially Chapter 1, "Perspectives."

144. Clare Howard, *English Travellers of the Renaissance* (London, New York: J. Lane, 1914), especially 72–100.

145. For a concise discussion of Winckelmann's life and work, see Potts, 1–53; for the circumstances of Winckelmann's conversion, see especially pages 8–9.

146. François Raguenet, *Les monuments de Rome* (Amsterdam: E. Roger, 1701), preface page 1. Translation my own. "Je vais essayer, dans cet Ouvrage, de faire reviver l'ancienne reputation des Monumens de la vieille Rome, et de consacrer à postérité ceux de la nouvelle. . . ."

147. Riggs, 297, cat. 102, fig. 73; Henk Nalis, ed., *The New Hollstein Dutch and Flemish Etchings, Engravings, and Woodcuts 1450–1700: The Van Doetecum Family, Part II* (Rotterdam: Sound and Vision, 1998), 41–42, no. 208. The inscription reads, "Nonuularum antiquarium statuarum reliquiae Romae in horto cuiusdam nobilis Romam." The Latin contains several errors that might be attributable to its having been copied by an artist with little Latin: nonu-ularum for nonnullarum; antiquarium for antiquarum; and Romam for Romani.

148. It is the one now owned by the Bibliothèque Nationale de France, Rés J 1052.

149. *Horace Walpole's Correspondence with Sir Horace Mann*, VI. Volume 22 of Horace Walpole's Correspondence. Mann to Walpole, 4 December 1762, p. 107; Mann to Walpole, 24 April 1764, p. 229.

150. We do not mean to suggest that Lawrence acquired this particular print in Rome; while possible, it seems unlikely. But it formed part of his large collection, which must have included items acquired in Rome.

151. Johann Wolfgang von Goethe, *Italian Journey: 1786–1788*, trans. W. H. Auden and Elizabeth Mayer (San Francisco: North Point Press, 1982), 116.

152. Goethe, 138.

6. Obelisks, Egypt, and the Urban Space of Rome

153. The Aqua Felice was named in honor of Sixtus V, born Felice Peretti. The aqueduct brought fresh water fourteen miles from Palestrina to the city.

154. Anne Roullet, *The Egyptian and Egyptianizing Monuments of Imperial Rome* (Leiden: E.J. Brill, 1972), 14–15. For an overview of the obelisk's cultic significance in ancient Egypt, see chapter 1 of Erik Iversen, *Obelisks in Exile* (Copenhagen: G.E.C. Gad, 1968).

155. On the Vatican obelisk, see Iversen, 19–46 and Cesare D'Onofrio, *Gli obelischi di Roma*, 2nd ed. (Rome: Bulzoni, 1967), 69–103.

156. Leone Battista Alberti may have played a role in the initial project for moving the obelisk. See Brian Curran, Anthony Grafton, and Angelo Decembrio, "A Fifteenth-Century Site Report on the Vatican Obelisk," *JWCI* 58 (1995): 234–48.

157. The treatise by Pigafetta is one such example; other accounts were published by Domenico Fontana (*Della transportatione dell'obelisco vaticano et delle fabriche di nostro signore Pape Sisto V*, 1590), Petrus Angelius Bargaeus (*Commentarius de Obelisco*, 1586), and Michele Mercati (*Gli obelischi di Roma*, 1589).

158. Sixtus placed statues of Sts. Peter and Paul on the top of the columns of Emperors Trajan and Antonius in a similar gesture of triumphant symbolism. On Sixtus V and his patronage, see Charles Burroughs, "Absolutism and the Rhetoric of Topography: Streets in the Rome of Sixtus V," in *Streets: Critical Perspectives on Public Space*, ed. Zeynep Çelik, Diane Favro, and Richard Ingersoll (Berkeley: University of California Press, 1994), 189–202; Giorgio Simoncini, *"Roma restaurata": rinnovamento urbano al tempo di Sisto V* (Florence: Leo S. Olschki, 1990); Helga Gamrath, *Roma sancta renovata*, Analecta Romana Instituti Danici, Supplementum XII (Rome: "L'Erma" di Bretschneider, 1987). See also Michael Cole, "Perpetual Exorcism in Sistine Rome," in *Idols in the Age of Art*, ed. Michael Cole and Rebecca Zorach (London: Ashgate, forthcoming 2008).

159. This legend was disproved when the gilded ball was taken down and inspected, as discussed by Pigafetta.

160. In the 1588 edition of *Le cose maravigliose*, Jubilee years listed in the chronology of the popes are all underlined. Similar markings can be found elsewhere, indicating different monuments and items of interest in the guide.

161. See E. S. De Beer, "The Development of the Guidebook until the Early 19th Century," *Journal of the British Archaeological Association* 3, 15 (1952): 35–46 and, specifically dealing with the sixteenth and seventeenth centuries, Rose Marie San Juan, "'Roma ricercata': The Pocket Guidebook and the City's Tourist Itineraries," in *Rome: A City Out of Print*, 57–93.

162. According to Eunice Howe, an early edition of *Le cose maravigliose* printed in 1532 exists in the New York Public Library, and a 1540 edition at the Biblioteca nazionale, Florence: Eunice D. Howe, *Andrea Palladio and the Churches of Rome* (Binghamton, NY: Center for Medieval and Renaissance Studies, SUNY Binghamton, 1991), 38–46. Ludwig Schudt and Luigi Pescarzoli give a date of 1541 for the earliest printed copy. Ludwig Schudt, *Le Guide di Roma: Materialien zu einer Geschichte der roemischen Topographie* (Vienna: Filser, 1930); Antonio Pescarzoli, *I libri di viaggio e le guide della Raccolta Luigi Vittorio Fossati Bellani*, 3 vols. (Rome: Edizioni di storia e letteratura, 1957). As the guidebook developed, its text borrowed significantly from Palladio's *Descritione de la Chiese di Roma* (Venice, 1554).

163. Stephan Waetzoldt surveys the history of the pilgrimage guide with special attention to its program of illustrations. "Trattato nuovo von 1610," in Pietro Martire Felini, *Trattato nuovo delle cose maravigliose dell'alma Città di Roma. . . 1610* (Quellen und Schriften zur bildenden Kunst 3) (Berlin: Bruno Hessling, 1969), 1–14.

164. Howe, 42.

165. Baglione's *Le nove chiese* (1639) was one of the first guides to specialize in modern artwork within the churches of Rome. De Beer, 41n1.

166. See especially San Juan, *Rome,* as cited above.

167. The account of its discovery is told in Claude Duret, *Thresor de l'histoire de cest universe*, 2nd ed. (Yverdon: Societe Helvetiale Caldoresque, 1619), 799. Our dating of the engraving to 1561 or earlier is based on the fact that in that year, the church was transferred from the community of Carthusian monks (mentioned in the inscription) to a Cistercian monastery. On this topic, see Raimondo Besozzi, *La storia della basilica di Santa Croce in Gerusalemme* (Rome: G. Salomoni, 1750), 186–99. In 1614, a print of the titulus appears in the stock list of Andrea and Michelangelo della Vaccheria. Ehrle, 60–61. (Biblioteca Civica di Mantova, Misc. B. 128, F. 7/13.)

168. There were two distinct visual programs associated with the pilgrim guide, while the text itself was largely recycled. San Juan, 59. See Howe, 44, on the collaboration and various partnerships between publishers.

169. The woodcuts may have been copied from prints in Domenico Fontana, *Della trasportatione dell' Obelisco Vaticano* (Rome: Domenico Basa, 1590) or from Natal Bonifacio's independent engraving, *Trasporto dell'obelisco vaticano*, published by Giovanni Guerra in 1586. See Lanciani, 4:166.

170. This was not achieved, of course, until the discovery of the Rosetta Stone in 1799 and its translation by Jean-François Champollion in 1822.

171. According to Hülsen, the Lafreri engraving published in 1547 is itself a copy of a 1546 engraving published by Salamanca. Hülsen, "Speculum," 39k. Other Chicago examples include B270 (Duperac 1621, listed under "Roman Antiquities") and C429 (Giovanni Battista Cavalieri 1569 after Dosio, listed under "Views of Ancient Rome").

172. See Roullet, Appendix II, "Egyptian Antiquities in Rome in the 15th/16th Centuries," 150–52.

173. The Mensa Isiaca is a bronze tabletop inlaid with silver, Egyptianizing designs. It was excavated from the site of the ancient Roman temple of Isis in the early sixteenth century and purchased by Pietro Bembo (it is sometimes called the "Tabula Bembina"). Carefully studied by Renaissance scholars trying to decipher Egyptian hieroglyphs, the table was actually produced in Rome by Roman craftsmen in the first century CE. Roullet, 143–44, cat. 324. Another important source for Renaissance hieroglyphics was a temple frieze representing sacrificial objects from San Lorenzo. This was also Roman in origin and iconography. Erik Iversen, *The Myth of Egypt and Its Hieroglyphs in European Tradition* (Princeton: Princeton University Press, 1993), 55, 66–67.

174. Iversen, 64ff. See Rudolf Wittkower, "Hieroglyphics in the Early Renaissance," in *Allegory and the Migration of Symbols,* (Boulder, CO: Westview, 1977), 114–28 and more generally Karl H. Dannenfeldt, "Egypt and Egyptian Antiquities in the Renaissance," *Studies in the Renaissance* 6 (1959): 7–27. Another example of the Renaissance creation of imaginary hieroglyphs is the *Hypnerotomachia Poliphili* printed by Aldus in Venice in 1499. The most recent treatment of the subject is Brian Curran, *The Egyptian Renaissance: The Afterlife of Ancient Egypt in Early Modern Italy* (Chicago: University of Chicago Press, 2007).

175. De Beer, 41n1.

176. On the close relationship of Jerusalem and Rome as major pilgrimage destinations and as a result of the translation of relics from the Holy Land, see Nine Miedema, "Following in the Footsteps of Christ: Pilgrimage and Passion Devotion," in *The Broken Body: Passion Devotion in Late-Medieval Culture*, ed. A. A. MacDonald, H. N. B. Ridderbos, and R. M. Schlusemann (Groningen: Egbert Forsten, 1998), 80–85. The caption for the illustration contrasts Christ's suffering in Jerusalem with his glorification and worship in Rome. *Ierusalem nimis afflixit, Cruci affixit. / Roma tam gloriasum magis glorificat.*

INTERMEZZO VI: STAGING AND FRAMING SCENES OF ROME

177. It may be the fact that aquatint was developed in the second half of the seventeenth century that prompted cataloguers of the 1960s and early 1970s to date this print to the later seventeenth century; some doubt persists.

178. The Dutch artist Jan Goeree signed many of the prints in the large Deseine edition as designer, and some as both designer and etcher. It seems likely he oversaw the print program in addition to designing many of the individual images. It was a large group effort: other artists who signed prints include Jacobus de Later, Lorenz Scherm, Peter Sluiter, Jan van Vianen, and one J. Baptist.

BOOKS

The book checklist was compiled by Catherine Uecker and Rebecca Zorach with assistance from Kerri Sancomb, Ingrid Greenfield, Kristine Hess, Iva Olah, Ann Patnaude, and Rainbow Porthé. Where a separate publisher's name is absent and no "s.n" (sine nomine) appears in the catalogue reference, we assume the author or printmaker was also the publisher. Books are presented alphabetically by author last name and numbered sequentially; the same numbers appear in the text as catalogue ("cat.") numbers.

ANONYMOUS

1. *Le cose maravigliose dell'alma Città di Roma.* Rome: Mascardi, 1644. Rare Book Collection.

2. *Roma ampliata, e rinovata, o sia nuova descrizione della moderna città di Roma.* Roma: Gregorio Roisecco, 1739. Rare Book Collection

3. *Roma sacra, antica e moderna, figvrata e divisa in tre parti.* Rome: Giovanni Battista Molo, 1687. Rare Book Collection.

AGUSTÍN

4. Antonio Agustín (1517–1586). *I discorsi del S. Don Antonio Agostini sopra le medaglie et altre anticaglie.* [Venice: s.n., 159-?] Rare Book Collection, Berlin Collection.

ALBERTINI

5. Francesco Albertini (fl. 1493–1510). *Opvscvlvm de mirabilibus nouae & ueteris Vrbis Romae.* Rome: Giacomo Mazzocchi, 1510. Rare Book Collection, Gift of John Fleming.

AUDRAN

6. Gérard Audran (1640–1703). *Les Proportions du Corps humain, Mesurées sur les plus belles Figures de l'Antiquité.* Paris: Gérard Audran, 1683. John Crerar Collection of Rare Books in the History of Science and Medicine.

BADE

7. Josse Bade (1462–1535). *Chalcidij viri clarissimi Luculenta Timaei Platonis.* [Paris], 1520. Rare Book Collection, From the Library of Richard P. McKeon.

BAGLIONE

8. Giovanni Baglione (ca. 1566–1643). *Le nove chiese di Roma.* Rome: Andrea Fei, 1639. Rare Book Collection.

BAÏF

9. Lazare de Baïf (1496?–1547). *Lazari Bayfii annotationes in L. II. De captivis, et postliminio reversis.* Paris: Robert Estienne, 1536. John Crerar Collection of Rare Books in the History of Science and Medicine.

BAVINCK

10. Hermann Bavinck. *Wegzeiger zv den wunderbarlichen Sachen der heidnischen etvuan, nun aber der Christlichen Stat Rom.* Rome: Francesco Cavalli, 1628. Rare Book Collection.

BISSCHOP

11. Jan de Bisschop (1628–1671). *Paradigmata Graphices Variorum Artificum.* Amsterdam: Hendrick de Leth, [1671]. Rare Book Collection, Berlin Collection.

BOISSARD

12. Jean-Jacques Boissard (1528–1602). *Romanae Vrbis Topographiae & Antiquitatum, quâ succincte & breviter describuntur omnia quæ tam publice quam privatim videntur anim-adversione digna.* Frankfurt: Sons of Theodor de Bry, 1600. Vol. III, pt. V. Rare Book Collection, Berlin Collection.

13. Jean-Jacques Boissard. *Romanae Vrbis Topographiae & Antiquitatum, quâ succincte & breviter describuntur omnia quæ tam publice quam privatim videntur anim-adversione digna.* Frankfurt: Matthaeus Merian (in Bibliopoleio Brÿano), 1627. Vol. I. Rare Book Collection, Berlin Collection.

14. Jean Jacques Boissard. *Topographia Urbis Romæ*. Frankfurt: Matthaeus Merian, 1681. Rare Book Collection.

BOSSE

15. Abraham Bosse (1602–1676). *Sentimens svr la distinction des diverses manières de Peinture, Dessein & Graueure, & des Originaux d'auec leurs Copies*. Paris, 1649. Rare Book Collection.

16. Abraham Bosse (1602–1676). *Traicté des manieres de graver en taille dovce svr l'airin*. Paris, 1645. Rare Book Collection.

BOTTARI

17. Giovanni Gaetano Bottari (1689–1775). *Del Museo Capitolino*. Rome: Niccolò and Marco Pagliarini, 1741–1782. Vol. 3. Rare Book Collection, Berlin Collection.

CARTARO

18. Mario Cartaro (active by 1560, died 1620). *Prospettive diverse*. Rome, 1578. Rare Book Collection, Berlin Collection.

19. Mario Cartaro, *Prospettive diverse*. Rome, 1578. Rare Book Collection.

CAVALIERI

20. Giovanni Battista de' Cavalieri (ca. 1525–1601). *Antiquarum statuarum urbis Romae*. Rome, 1585–1594. Vols. 1–2. Rare Book Collection, Berlin Collection.

21. Giovanni Battista de' Cavalieri. *Antiquarum statuarum urbis Romae*. Rome, 1585–1594. Vols. 3–4. Rare Book Collection, Berlin Collection.

22. Giovanni Battista de' Cavalieri. *Antiquarum statuarum urbis Romae*. Rome: Goert van Schayck, 1621. Rare Book Collection, Berlin Collection.

23. Giovanni Battista de' Cavalieri. *Romanorvm imperatorvm effigies*. Rome: Vincenzo Accolti, 1583. Rare Book Collection.

CHACÓN

24. Pedro Chacón (1527–1581). *De triclinio, sive de modo convivandi apud priscos Romanos*. Heidelberg: Pierre de Saint-André, 1590. Rare Book Collection.

CIPRIANI

25. Giovanni Battista Cipriani (1725–1785). *Su i dodici obelischi egizj che adornano la città di Roma*. Rome: Alessandro Ceracchi, 1823. Rare Book Collection, Library of John Matthews Manly.

DESEINE

26. François-Jacques Deseine (d. 1715). *L'ancienne Rome, La principale des Villes de l'Europe*. Leiden: Pieter van der Aa, 1713. Vol. 1. Rare Book Collection, Berlin Collection.

27. François-Jacques Deseine. *Beschryving van oud en nieuw Rome*. Amsterdam: François Halma, 1704. Vol. 1. John Crerar Collection of Rare Books in the History of Science and Medicine.

DIONYSIUS OF HALICARNASSUS

28. Dionysius of Halicarnassus. *Delle cose antiche della Citta di Roma*. Venice: Niccolò Bascarini, for Michele Tramezzino, 1545. Rare Book Collection.

DONATI

29. Alessandro Donati (1584–1640). *Roma Vetus ac Recens Utriusque Ædificiis Illustrata*. Amsterdam: Johannes Janssonius van Waesberge and Johannes Wolters, 1695. Rare Book Collection.

DOSIO

30. Giovanni Antonio Dosio. *Cosmo Medici Dvci Florentinor et senens Vrbis Romæ ædificiorvm illvstrivmqvæ svpersvnt reliqviæ*. Rome: Giovanni Battista de' Cavalieri, 1569. Rare Book Collection, Berlin Collection.

DUCHOUL

31. Guillaume Duchoul (fl. 16th cent.). *Discovrs de la religion des anciens Romains*. Lyon: Guillaume Rouillé, 1581. Rare Book Collection.

DUPÉRAC

32. Etienne Dupérac (1525–1604). *I vestigi dell' antichità di Roma*. Rome: Lorenzo della Vaccheria, 1575. Rare Book Collection, Elmer Truesdell Merrill Collection

33. Etienne Dupérac. *I vestigi dell' antichità di Roma*. Rome: Lorenzo della Vaccheria, 1575. Rare Book Collection.

FALDA

34. Giovanni Battista Falda (ca. 1640–1678). *Le fontane di Roma nelle piazza, e luoghi publici della citta, con li loro prospetti, come sono al presente*. Rome: Giovanni Giacomo de' Rossi, 1691. Rare Book Collection.

FAUNO

35. Lucio Fauno (fl. 16th century). *Compendio di Roma antica*. Venice: Michele Tramezzino, 1552. Rare Book Collection.

36. Lucio Fauno. *De antiquitatibus urbis Romae*. Venice: Michele Tramezzino, 1549. Rare Book Collection, Berlin Collection.

37. Lucio Fauno. *Delle antichita della città di Roma*. Venice: Michele Tramezzino, 1553. Rare Book Collection, Berlin Collection.

FELINI

38. Pietro Martire Felini. *Les Merveilles et antiquitez de la ville de Rome*. Rouen: Jean Oursel, 1730. Rare Book Collection.

39. Pietro Martire Felini. *Trattato nuovo delle cose maravigliose dell'alma città di Roma*. Rome: Bartolomeo Zannetti, 1615. Rare Book Collection.

40. Pietro Martire Felini. *Tratado nvevo de las cosas maravillosas de la alma civdad de Roma*. Rome: Bartolomeo Zanetti, 1619. Rare Book Collection.

41. Pietro Martire Felini. *Trattato nuovo delle cose maravigliose dell'alma città di Roma*. Rome: Andrea Fei, 1625. Rare Book Collection.

FEDERICO FRANZINI

42. Federico Franzini. *Roma antica e moderna nella qvale si contengono Chiese, Monasterij, Hospedali*. Rome: Giacomo Fei, 1660. Rare Book Collection.

GIROLAMO FRANZINI

43. Girolamo Franzini (ca. 1571–1589). *Le Cose maravigliose dell'alma Città di Roma*. Nuovamente corretti, & purgati da molti errori, & ampliata. Venice: Girolamo Franzini, [1588]. Rare Book Collection.

44. Girolamo Franzini. *Les merveilles de la ville de Rome*. Rome: Giovanni Francesco Buagni, [1700]. Rare Book Collection.

45. Girolamo Franzini. *Les merueilles de la ville de Rome*. Rome: Rocco Bernabò, [1725]. Nouellement corr. et amplificè. Rare Book Collection, Given by Bernard Weinberg in Honor of Herman H. Fussler.

46. Girolamo Franzini. *Stationi delle chiese di Roma per tutta la quaresima*. Venice: Girolamo Franzini, 1588. Rare Book Collection.

GAMUCCI

47. Bernardo Gamucci. *Le antichità della Città di Roma*. Venice: Giovanni Varisco, 1569. Rare Book Collection.

GOLTZIUS

48. Hubertus Goltzius (1526–1583). *Les images presqve de tovs les emperevrs depvis C. Ivlivs Caesar ivsqves a Charles. V. et Ferdinandvs son frere*. Antwerp: Gillis Coppens van Dienst, 1559. Rare Book Collection, Gift of Mr. and Mrs. Gaylord Donnelley.

49. Hubertus Goltzius. *Thesavrvs rei antiqvariae hvberrimvs*. Antwerp: Christophe Plantin, 1579. Rare Book Collection, Berlin Collection.

HORAPOLLO

50. Horapollo. *Hori Apollinis Selecta Hieroglyphica*. Rome: Carlo Vullietti, 1606. Helen and Ruth Regenstein Collection of Rare Books.

HUTTICH

51. Johann Huttich (1480?–1544). *Imperatorvm Romanorvm libellvs*. [Strasburg]: Wolfgang Köpfel, 1525. Rare Book Collection.

KIRCHER

52. Athanasius Kircher (1602–1680). *Sphinx mystagoga*. Amsterdam: Johannes Janssonius van Waesberge, 1676. Rare Book Collection.

LABACCO

53. Antonio Labacco (b. ca. 1495). *Libro d'Antonio Labacco appartenente a l'architettvra nel qval si figvrano alcvne notabili antiqvita di Roma*. Rome: Giovanni Battista de' Rossi, [1640–1672]. Rare Book Collection, Berlin Collection.

LIGORIO

54. Pirro Ligorio (ca. 1500–1583). *Libro di M. Pyrrho Ligori Napolitano, delle antichità di Roma, nel qvale si tratta de' Circi, Theatri, & Anfitheatri*. Venice: Michele Tramezzino, 1553. Rare Book Collection.

55. Pirro Ligorio. *Pianta della Villa Tiburtina di Adriano Cesare*. Rome: Barbiellini Heirs, 1751. Rare Book Collection, Berlin Collection.

LIPSIUS

56. Justus Lipsius (1547–1606). *Ivsti lipsi de amphitheatro liber*. Antwerp: Christophe Plantin, 1589. Rare Book Collection.

57. Justus Lipsius. *Roma illvstrata, sive antiqvitatvm romanarvm breviarivm*. Postrema editio. Amsterdam: Louis and Daniel Elzevier, 1657. Rare Book Collection, Berlin Collection.

LUCAN

58. Lucan (39–65). *Pharsaliae, seu belli ciuilis libri*. Strasbourg: Johann Prüss, 1509. Rare Book Collection.

ALDO MANUZIO THE YOUNGER

59. Aldo Manuzio the younger (1547–1597). *De Qvaesitis per Epistolam Libri III*. Venice, 1576. Rare Book Collection.

PAOLO MANUZIO

60. Paolo Manuzio (1512–1574). *Antiqvitatvm Romanarvm Pauli Manutij Liber de Legibvs*. Venice: Bernardo Torresano, 1557. Rare Book Collection.

MARLIANI

61. Bartolomeo Marliani (d. 1560). *L'antichità di Roma*. Rome: Antonio Blado, 1548. Rare Book Collection, Berlin Collection.

62. Bartolomeo Marliani. *Topographia antiquae Romae*. Lyon: Sébastien Gryphius, 1534. Helen and Ruth Regenstein Collection of Rare Books.

63. Bartolomeo Marliani. *Vrbis Romae topographia*. Basel: Johann Oporinus, 1550. Rare Book Collection, Berlin Collection.

64. Bartolomeo Marliani. *Vrbis Romae topographia*. Venice: Girolamo Franzini, 1588. Rare Book Collection, Gift of Harvard College Library.

65. Bartolomeo Marliani. *Vrbis Romae topographia nvnc denvo accvratissimé in lucem edita.* Venice: Girolamo Franzini, 1588. Rare Book Collection, Berlin Collection.

MARTINELLI

66. Fioravante Martinelli (fl. 17th cent). *Roma ex ethnica sacra sanctorum Petri, et Pavli apostolica praedicatione profvso sangvine.* Editio repetita. Rome: Fabrice di Falco, 1668. Rare Book Collection.

67. Fioravante Martinelli. *Roma ricercata nel suo sito.* Rome: Heirs of Giovanni Barbiellini, 1761. Rare Book Collection, Gift of Mrs. Edward A. Maser.

68. Fioravante Martinelli. *Roma ricercata nel suo sito & nella scuola di tutti gli antiquarij.* Rome: Mascardi, 1658. Rare Book Collection, Berlin Collection.

MELA

69. Pomponius Mela. *De regionibus Vrbis Romae.* Toscolano: Alessandro Paganini, 1521. John Crerar Collection of Rare Books in the History of Science and Medicine.

MONTFAUCON

70. Bernard de Montfaucon (1655–1741). *L'antiquité expliquée et représentée en figures,* 2. éd., rev. et cor. Paris: Florentin Delaulne, 1722. Rare Book Collection.

MONTJOSIEU

71. Louis de Montjosieu (fl. 16th cent.). *Lvdovici Demontiosii Gallvs Romæ hospes.* Rome: Giovanni Gigliotti, 1585. Rare Book Collection.

PANVINIO

72. Onofrio Panvinio (1529–1568). *Veterum Rom. ornatissimi amplissimiq thriumphi.* Antwerp: Cornelis de Jode, 1596. Rare Book Collection.

PERRIER

73. François Perrier (1590?–1650?). *Illmo. D.D. Rogerio Dv Plesseis . . . magnarum artium eximio cultori.* Rome: 1638. Rare Book Collection, Berlin Collection.

74. François Perrier. *Illmo. D.D. Rogerio Dv Plesseis. . . magnarum artium eximio cultori.* Paris: Chez la veuve de defunct Perrier ; Et a present chez De Poilly, [166-?]. Rare Book Collection, Berlin Collection.

PIGAFETTA

75. Filippo Pigafetta (1533–1604). *Discorso di m. Filippo Pigafetta, d'intorno all' historia della Agvglia, et alla ragione del muouerla.* Rome: Bartolomeo Grassi, 1586. Rare Book Collection, Gift of Claire Dux Swift.

PINAROLI

76. Giovanni Pietro Pinaroli. *Trattato delle cose più memorabili di Roma tanto antiche come moderne.* Rome: S. Michele a Ripa, 1725. Vol. 2. Rare Book Collection.

PORRO

77. Girolamo Porro (1520–1604). *Statue antiche che sono poste in diversi luoghi nella Citta di Roma.* Venice, 1576. Rare Book Collection.

PROBUS

78. Marcus Valerius Probus. *De notis Romanorvm interpretandis libellvs.* In *Hoc in volumine haec continentur.* Venice: Giovanni Tacuino, [1525]. Rare Book Collection, From the Library of Richard P. McKeon.

RAGUENET

79. François Raguenet (1660?–1722). *Les monumens de Rome.* Amsterdam: Étienne Roger, 1701. Rare Book Collection.

SANTI BARTOLI

80. Pietro Santi Bartoli (1635–1700). *Le Antiche Lvcerne Sepolcrali figvrate, Raccolte dalle Caue sotterranee, e Grotto di Roma.* Rome: Giovanni Francesco Buagni, 1691. Rare Book Collection.

SCAMOZZI

81. Vincenzo Scamozzi (1552–1616). *Discorsi sopra l'antichità di Roma.* Venice: Francesco Ziletti, 1582. Rare Book Collection, From the Library of Sir Shane Leslie, presented by Louis H. Silver.

SERLIO

82. Sebastiano Serlio (1475–1554). *Tutte l'opere d'architettura.* Venice: Francesco de' Franceschi, 1584. Rare Book Collection.

SERVIUS

83. Petrus Servius (d. 1648). *Romani Iuueniles feriae, quae continent antiquitatum Romanorum miscellanea.* Secunda editio castigate. Rome: Heirs of Francesco Corbelletti, 1640. Rare Book Collection, Berlin Collection.

SEVERANO

84. Giovanni Severano. *Memorie sacre delle sette Chiese di Roma e di altri luoghi, che si trouano per le strade di esse.* Rome: Giacomo Mascardi, 1630. Rare Book Collection.

SHELLEY

85. Percy Bysshe Shelley (1792–1822). *With Shelley in Italy, Being a Selection of the Poems and Letters of Percy Bysshe Shelley Which have to do with his Life in Italy from 1818 to 1822.* Chicago: A.C. McClurg & Co., 1905. Rare Book Collection.

TAYLOR

86. Thomas Taylor (1576–1632). *A Mappe of Rome, Lively Exhibiting Her Mercilesse Meeknesse, and Cruell Mercies to the Church of God.* London: Felix Kyngston, for John Bartlet, 1620. Rare Book Collection.

TOTTI

87. Pompilio Totti. *Ritratto di Roma moderna.* Rome: Mascardi, 1638. Rare Book Collection, Berlin Collection.

88. Pompilio Totti. *Ritratto di Roma antica nel qvale sono figvrati i principali tempij, teatri, anfiteatri, cerchi, naumachie, archi trionfali & altre cose notabili.* Second printing. Rome: Andrea Fei, 1633. Rare Book Collection.

VICO

89. Enea Vico (1523–1567). *Le Imagini delle Donne Avgvste intagliate in istampa di rame.* Venice: Enea Vico and Vincenzo Valgrisi, 1557. Helen and Ruth Regenstein Collection of Rare Books.

VALVERDE

90. Juan Valverde de Amusco (ca. 1525–ca. 1588). *Historia de la composision del cuerpo humano.* Rome: Antonio Salamanca and Antonio Lafreri, 1556. John Crerar Collection of Rare Books in the History of Science and Medicine, gift of Dr. Bayard Holmes.

VITRUVIUS

91. Vitruvius Pollio. *Di Architettura.* Venice: Niccolò Zoppino, 1535. Rare Book Collection.

WELSER

92. Marcus Welser (1558–1614). *Fragmenta tabulae antiquae, in quis aliquot per Rom. prouincias itinera.* Venice: Aldo Manuzio, 1591. Rare Book Collection, Berlin Collection.

PRINTS

Notes: *The print checklist was compiled by Ingrid Greenfield, Kristine Hess, Iva Olah, Ann Patnaude, Rainbow Porthé, Kerri Sancomb, and Rebecca Zorach. Prints in the exhibition have been listed by Chicago Speculum Number (A1, B287, etc.). These numbers are also used as catalogue numbers ("cat.") for prints in the text.*

Any print from the Chicago collection can be viewed online by adding the Chicago number to the URL http://speculum.lib.uchicago.edu/

For example:
http://speculum.lib.uchicago.edu/A1
http://speculum.lib.uchicago.edu/B287

Prints not included in the Essays have not been illustrated here because they are readily available on the Web site. Similarly, because plentiful and frequently updated cataloguing information (including bibliography and inscriptions) is available there, we have kept this information to a minimum.

A4

Map of ancient Rome
Etching
Ambrogio Brambilla (ca.
1579–1599), etcher, after a map
engraved by Etienne Dupérac
Claudio Duchetti, publisher
1582

A5

Map of Rome
Etching with engraving
Ambrogio Brambilla, etcher
Claudio Duchetti, publisher.
Republished 1602 by Giovanni
Orlandi
1590

A11

The Septizonium
Engraving
Antonio Lafreri, publisher
1546

A16

Vatican Obelisk
Engraving
Antonio Lafreri, publisher
1550

A29

The Colosseum
Etching with engraving
Ambrogio Brambilla, etcher
Claudio Duchetti, publisher
1582

A30

*Plan and Elevation of the Castle of the
Praetorian Guard*
Etching with engraving
Ambrogio Brambilla, etcher, after
Pirro Ligorio, designer
Claudio Duchetti, publisher
1581

A33

Pyramid of Caius Cestius
Etching with engraving
Ambrogio Brambilla, etcher
Claudio Duchetti, publisher
1582

A34

The Septizonium
Etching with engraving
Ambrogio Brambilla, etcher
Claudio Duchetti, publisher
1582

A35

Baths of Diocletian
Etching with engraving
Ambrogio Brambilla, etcher, after an
engraving by Jacob Bos designed by
Pirro Ligorio
Claudio Duchetti, publisher
1582

A37

Arch of Constantine
Etching with engraving
Claudio Duchetti, publisher
1583

A48

The Circus Maximus
Engraving
Nicolas Béatrizet (ca. 1507–ca. 1565),
engraver, after Pirro Ligorio, designer
Michele Tramezzino, publisher.
Republished 1582 by Paulo Gratiano
and between 1691 and 1720 by
Gian Domenico de' Rossi
1553

A55

Arch of Titus with figures
Etching and aquatint
19th century?

A90

Roma victrix
Engraving
Antonio Lafreri, publisher
1548

A91

An ancient dining room
Engraving
Antonio Lafreri, publisher
1549

A94

Hercules and Telephus
(Commodus as Hercules)
Engraving
Antonio Lafreri, publisher
1550

A96

Apollo Belvedere
Engraving
After an engraving by Marcantonio
Raimondi (ca. 1470–ca. 1534)
Antonio Lafreri, publisher
1552

A100, A101

Battle of Amazons
Engraving
Nicolas Béatrizet (ca. 1507–ca. 1565),
engraver, publisher
1559

A104

Mithras cult sacrifice (Ottaviano
Zeno relief)
Engraving
Antonio Lafreri, publisher
1564

A107

Laocoön
Engraving
Antonio Lafreri, publisher
1544–1565

A110

Ancient ritual sacrifice
Etching
Étienne Dupérac, etcher
Antonio Lafreri, publisher
Ca. 1570

A113

Marforio
Engraving
Claudio Duchetti, publisher
1581

A114

Thornpuller (Spinario)
Diana Mantovana, engraver, after an
engraving by Cornelis Cort
Claudio Duchetti, publisher
1581

A121

Laocoön
Engraving
After an engraving by Marco Dente
(ca. 1493–1527)
Republished by Claudio Duchetti
Between 1581 and 1586

A126

Canopic Vase (front view)
Etching
After an engraving by Etienne
Dupérac
Claudio Duchetti, publisher
Between 1581 and 1586

A128

Frieze of sacrificial instruments
Engraving
Republished by Claudio Duchetti
Between 1581 and 1586

A163

Images of all the emperors from C. Julius
Caesar to the present year
Engraving
Ambrogio Brambilla, engraver
Claudio Duchetti, publisher
1582

B182

Castel Sant'Angelo
Engraving
Antonio Lafreri or Claudio
Duchetti, publisher
Between 1575 and 1586

B210

Frontispiece of the *Praecipua*
monimenta
Etching
Hieronymus Cock (ca. 1510–1570),
etcher, publisher
1551

B211

Roman Colosseum
Etching
Hieronymus Cock, etcher, publisher
1551

B212

View of the Colosseum
Etching
Hieronymus Cock, etcher, publisher
1551

B222

View of the Palatine with
the Septizonium
Etching
Hieronymus Cock, etcher, publisher
1551

B238

View of the Palatine
Etching
Jan van Doetecum the elder
(d. 1605) and Lucas van Doetecum
(fl. 1554–1572), etchers
Hieronymus Cock, publisher
1561

B240

Ancient statues in a garden
Etching
Jan and Lucas van Doetecum, etchers
Hieronymus Cock, publisher
1561

B287

Map of Rome
Etching
Theodor de Bry (1528–1598), etcher,
after Ambrogio Brambilla
Theodor de Bry, publisher
1597

B294

The Titulus of the Cross
Engraving
Before 1562

B296

Sacrifice to Priapus
Engraving
Master of the Die (ca. 1510–ca. 1550),
engraver, after Giulio Romano
Republished between 1581 and 1586
by Claudio Duchetti
Ca. 1532

B347

The Capitoline Wolf
Engraving
Antonio Lafreri, publisher
1552

B350

Belvedere Torso
Engraving
Francesco Faraone Aquila
(ca. 1676–ca. 1740), engraver
Domenico de' Rossi, publisher
Ca. 1700

C394

*Façade of the Temple of Antoninus
and Faustina*
Etching with engraving
Giovanni Antonio Dosio (1533–ca.
1609), designer, etcher
Giovanni Battista de' Cavalieri,
publisher
1569

C420

*Artist sketching in the ruins of the
Baths of Caracalla*
Etching with engraving
Giovanni Antonio Dosio,
designer, etcher
Giovanni Battista de' Cavalieri,
publisher
1569

C436

Fragments of ancient construction
Etching
Jacques Androuet Ducerceau
(ca. 1515–1584), etcher, after
Léonard Thiry, designer
Jacques Androuet Ducerceau,
publisher
Ca. 1550

C455

Ionic capitals
Engraving
After Giovanni Battista Montano
(ca. 1540–1592), designer
Calisto Ferrante, publisher
Before 1636

C457

Elements of the Ionic order
Engraving
After Giovanni Battista Montano,
designer
Calisto Ferrante, publisher
Before 1636

C469

Composite capitals dedicated to the gods
Engraving
After Giovanni Battista Montano,
designer
Calisto Ferrante, publisher
Before 1636

C501

*Mask composed of shell-like forms, fruit,
and scrollwork*
Engraving
Adamo Scultori? (ca. 1530–1585),
engraver, after Giulio Romano?
After 1560

C504

*Satyr mask with decorative vegetation
and beard*
Engraving
Adamo Scultori? (ca. 1530–1585),
engraver, after Giulio Romano?
After 1560

C533

Battle of the Milvian Bridge
Engraving
Hendrick van Cleve III
(ca. 1525–1589), designer, engraver?
Philip Galle, publisher. Republished
after 1600 by Theodoor Galle
Between 1585 and 1590

C534

View of the Colosseum
Engraving
Hendrick van Cleve III, designer,
engraver?
Philip Galle, publisher. Republished
after 1600 by Theodoor Galle
Between 1585 and 1590

C547

The Cortile del Belvedere
Engraving
Hendrick van Cleve III, designer,
engraver?
Philip Galle, publisher. Republished
after 1600 by Theodoor Galle
Between 1585 and 1590

C608

Military trophies
Engraving
Enea Vico (1523–1567), engraver,
after Polidoro da Caravaggio,
designer
Antonio Lafreri?, publisher
1550–1553

C630

*Neptune and Doris, from the Loves of
the Gods*
Engraving
René Boyvin? (ca. 1525–ca. 1625),
engraver, after an engraving by
Giovanni Jacopo Caraglio designed
by Perino del Vaga
Ca. 1540

C632

*Vertumnus and Pomona, from the Loves
of the Gods*
Engraving
René Boyvin?, engraver, after an
engraving by Giovanni Jacopo
Caraglio designed by Perino del Vaga
Ca. 1540

C792

Callipygian Venus
Engraving
Giovanni Battista de' Cavalieri
(ca. 1525–1601), engraver, publisher
Republished first half of 17th
century by Nicolaus van Aelst or
Giuseppe or Giovanni Domenico
de' Rossi
1594

C811

Farnese Diadoumenos
Engraving
Giovanni Battista de' Cavalieri,
engraver, publisher
Republished first half of 17th
century by Nicolaus van Aelst or
Giuseppe or Giovanni Domenico
de' Rossi
1594

C826

Equestrian statue of Marcus Aurelius
Engraving
Orazio de Santis (ca. 1568–1584) or
Cherubino Alberti (ca. 1553–1615),
engraver, after Giovanni Battista de'
Cavalieri et al.
Andrea and Michelangelo della
Vaccheria or Goert van Schayck,
publisher
1614 or 1621

C868

Laocoön
Engraving
Orazio de Santis or Cherubino
Alberti, engraver, after engravings by
Giovanni Battista de' Cavalieri and
Pierre Perret
Andrea and Michelangelo della
Vaccheria or Goert van Schayck,
publisher
1614 or 1621

C887

*Hercules wrestling with the
Nemean Lion*
Engraving
Orazio de Santis or Cherubino
Alberti, engraver, after Giovanni
Battista de' Cavalieri et al.
Andrea and Michelangelo della
Vaccheria or Goert van Schayck,
publisher
1614 or 1621

C901

Pasquino (with text)
Engraving
Orazio de Santis or Cherubino
Alberti, engraver, after Giovanni
Battista de' Cavalieri et al.
Andrea and Michelangelo della
Vaccheria or Goert van Schayck,
publisher
1614 or 1621

C902

Pasquino (without text)
Engraving
Orazio de Santis or Cherubino
Alberti, engraver, after Giovanni
Battista de' Cavalieri et al
Andrea and Michelangelo della
Vaccheria or Goert van Schayck,
publisher
1614 or 1621

BIBLIOGRAPHY

ACIDINI, CRISTINA. "Roma antica." In Giovanni Antonio Dosio, *Roma antica e i disegni di architettura agli Uffizi,* edited by Franco Borsi et al. Rome: Officina, 1976.

ACKERMAN, JAMES. "The Tuscan/Rustic Order: A Study in the Metaphorical Language of Architecture." *The Journal of the Society of Architectural Historians* 42, 1 (1983): 15–34.

AGAMBEN, GIORGIO. *Homo Sacer: Sovereign Power and Bare Life,* trans. Daniel Heller-Roazen. Stanford, CA: Stanford University Press, 1998.

AGOSTI, GIOVANNI, AND VINCENZO FARINELLA. *Michelangelo: studi di antichità dal Codice Coner.* Turin: UTET, 1987.

———. "Nuove ricerche sulla colonna Traiana nel Rinascimento." In *La Colonna Traiana,* ed. Salvatore Settis. Turin: G. Einaudi, 1988.

AIKIN, ROGER CUSHING. "Romae de Dacia triumphantis: Roma and Captives at the Capitoline Hill." *The Art Bulletin* 62, 4 (December 1980): 583–97.

ALBÈRI, EUGENIO. "Sommario del viaggio degli Oratori Veneti che andarano a Roma a dar l'obbedienza a Papa Adriano VI 1523." In *Relazioni degli Ambasciatori Veneti al Senato,* VII, vol. III, 2nd ser. Florence: 1846.

ALBERICI, CLELIA. "Ambrogio Brambilla," in *Dizionario biografico degli italiani,* 729–30. 68 vols. Vol. 13. Rome: Istituto della Enciclopedia italiana, 1971.

ALBERTI, LEON BATTISTA. In *Codice topografico della città di Roma,* edited by R. Valentini and G. Zucchetti, vol. 4, 212–22. Rome: Tipografia del Senato, 1953.

———. *Ludi matematici,* edited by Raffaele Rinaldi. Milan: Quaderni della Fenice, 1980.

ALBERTI, LEON BATTISTA. *On painting and On sculpture: The Latin Texts of De pictura and De statua,* edited with translations, introduction, and notes by Cecil Grayson. London: Phaidon, 1972.

———. *On the Art of Building in Ten Books,* translated by Joseph Rykwert, Neil Leach, and Robert Tavernor. Cambridge, MA: MIT Press, 1988.

ALDROVANDI, ULISSE. *Delle statue antiche, che per tutta Roma, in diversi luoghi, & case si veggono.* In Lucio Mauro, *Le antichita de la città di Roma.* Venice: Giordano Zileti, 1558.

AMES-LEWIS, FRANCIS. *Drawing in the Italian Renaissance Workshop.* London: Victoria and Albert Museum, 1983.

ANDRIEUX, MAURICE. *La vie quotidienne dans la Rome pontificale au XVIIIe siècle.* Paris: Hachette, 1962.

ANONYMOUS. *Roma sacra, antica e moderna, figurata e divisa in tre parti.* Rome: Giovanni Battista Molo, 1687.

ARRIGONI, PAOLO, AND ACHILLE BERTARELLI. *Piante e vedute di Roma e del lazio conservata nella Raccolta delle stampe e dei disetni.* Milan: E. Bestetti, 1939.

ASHBY, THOMAS. "Antiquae Statuae Urbis Romae." *Papers of the British School at Rome* 9, 5 (1910): 107–58.

———. "The Bodleian Ms. Of Pirro Ligorio." *Journal of Roman Studies,* 9 (1919): 170–201.

———. "Il libro d'Antonio Labacco appartenente all'architettura." *Bibliofilia* 16 (1914): 289–309.

———. "Le diverse edizioni dei *Vestigi dell'antichità di Roma.*" *Bibliofilia* 16 (1915): 417–20.

AUDI, ROBERT, ed. *Cambridge Dictionary of Philosophy.* Cambridge: Cambridge University Press, 1999.

AXELROD, ROBERT. *The Complexity of Cooperation: Agent-Based Models of Competition and Collaboration* (Princeton University Press, 1997)

BACKOUCHE, ISABELLE. *La trace du fleuve: La Seine et Paris, 1750–1850.* Paris: École des Hautes Études en Sciences Sociales, 2000.

BAÏF, LAZARE DE. *Annotationes in L. II de captivis.* Paris: Estienne, 1536.

BAKER, CHRISTOPHER, CAROLINE ELAM, AND GENEVIEVE WARWICK, EDS. *Collecting Prints and Drawings in Europe, c. 1500–1750.* Aldershot, UK: Ashgate, 2003.

BAMBACH, CARMEN C. *Drawing and Painting in the Italian Renaissance Workshop: Theory and Practice, 1300–1600.* Cambridge: Cambridge University Press, 1999.

BARBAULT, JEAN. *Les plus beaux édifices de Rome moderne.* Rome: Bouchard et Gravier, 1763.

BARKAN, LEONARD. "The Beholder's Tale: Ancient Sculpture, Renaissance Narratives." *Representations* 44 (1993): 133–66.

———. *Unearthing the Past: Archaeology and Aesthetics in the Making of Renaissance Culture.* New Haven: Yale University Press, 1999).

BARTSCH, ADAM VON. *Le peintre graveur.* Vienna: J.V. Deggin, 1803–1821.

BARZMAN, KAREN-EDIS. *The Florentine Academy and the Early Modern State: The Discipline of Disegno.* Cambridge: Cambridge University Press, 2000.

BAVEREL, JEAN-PIERRE, AND FRANÇOIS MALPÉ. *Notices sur les graveurs qui nous ont laissé des estampes marquées de monogrammes, chiffres, rébus, lettre initiales, etc.* Besançon: Taulin-Dessirier, 1807/1809.

BAXANDALL, MICHAEL. *Giotto and the Orators: Humanist Observers of Painting in Italy and the Discovery of Pictorial Composition, 1350–1450.* New York and Oxford: Oxford University Press, 1971.

BECK, ROGER. *The Religion of the Mithras Cult in the Roman Empire: Mysteries of the Unconquered Sun.* Oxford: Oxford University Press, 2006.

BELLA, FRANCESCO, AND CARLO AZZI. "^{14}C Dating of the Titulus Crucis." *Radiocarbon* 44, 3 (2002): 685–89.

BELLINI, PAOLO. *L'Opera incisa di Adamo e Diana Scultori.* Vicenza: Neri Pozza, 1991.

BELLORI, G. P. *Le vite de' pittori scultori e architetti moderni.* Rome: Mascardi, 1672.

BERTOLOTTI, ANTONINO. *Artisti francesi in Roma nei secoli XV, XVI, XVII.* Bologna: Forni, 1975.

BESOZZI, RAIMONDO. *La storia della basilica di Santa Croce in Greusalemme.* Rome: G. Salomoni, 1750.

BIGNAMINI, ILARIA, ed. *Archives and Excavations: Essays on the History of Archaeological Excavations in Rome and Southern Italy from the Renaissance to the Nineteenth Century.* London: British School at Rome, 2004.

BLUM, ANDRÉ. *Abraham Bosse et la société française au dix-septième siècle.* Paris: Morance, 1924.

BLUNT, ANTHONY. "The Triclinium and Religious Art." *JWCI* 2, 3 (January 1939): 271–76.

BOBER, PHYLLIS PRAY, AND RUTH RUBINSTEIN. *Renaissance Artists and Antique Sculpture: A Handbook of Sources.* London: Harvey Miller, 1986.

BODON, GIULIO. *Enea Vico fra Memoria e miraggio della classicità.* Roma: "L'Erma" di Bretschneider, 1997.

BÖHM, WOLFGANG. *Das Bauwerk und die Stadt: Aufsätze für Eduard F. Sekler: The Building and the Town: Essays for Eduard F. Sekler.* Wien: Böhlau, 1994.

BOISSARD, JEAN-JACQUES. *I pars Romanae vrbis topographiae.* Frankfort: Theodor de Bry, 1597.

———. *III pars Romanae vrbis topographiae.* Frankfurt: Theodor de Bry, 1597–1602.

———. *Topographia Urbis Romæ.* Frankfurt: Matthaeus Merian, 1681.

BOORSCH, SUZANNE. *The Engravings of Giorgio Ghisi.* New York: Metropolitan Museum of Art, 1984.

———. "Mantegna and His Printmakers." In *Andrea Mantegna*, exh. cat. edited by Jane Martineau, 56–66. New York and London: Olivetti and Electra, 1992.

BOREA, EVELINA. "Stampa figurativa e pubblica dalle origini all'affermazione nel Cinquecento." In *Storia dell'Arte Italiana*, pt. 1, vol. 2, *L'Artista e il pubblico*, edited by G. Previtali. Turin: G. Einaudi, 1979.

BOTTARI, GIOVANNI GAETANO. *Del Museo capitolino.* Rome: Calcografia Camerale, 1741–1782.

BOÜARD, ALAIN DE. "Gli antichi marmi di Roma nel medio evo." *Archivio della reverenda società romana di storia patria* 34 (1911): 240–41.

BRANDI, CESARE. *Teoria del restauro.* Turin: G. Einaudi, 1977.

BREDEKAMP, HORST. *The Lure of Antiquity and the Cult of the Machine: The Kunstkammer and the Evolution of Nature, Art and Technology*, trans. Allison Brown. Princeton, NJ: Markus Wiener.

BRILLIANT, RICHARD. *My Laocoön: Alternative Claims in the Interpretation of Artworks.* Berkeley: University of California Press, 2000.

BRUMMER, HANS HENRIK. *The Statue Court in the Vatican Belvedere.* Acta Universitatis Stockholmiensis. Stockholm studies in history of art 20. Stockholm: Almqvist & Wiksell, 1970.

BRUNEL, GEORGES, ed. *Piranèse et les Français: Colloque tenu à la Villa Médicis 12–14 Mai 1976.* Rome: Edizioni dell' Elefante, 1976.

BRUNET, JACQUES-CHARLES. *Manuel du libraire et de l'amateur de livre. . .* Paris: G.-P. Maisonneuve & Larose, 1965–1966.

BRYSON, SCOTT. *The Chastised Stage: Bourgeois Drama and the Exercise of Power.* Saratoga, CA: Anma Libri, 1991.

BUDDENSIEG, TILMANN. "Criticism and Praise of the Pantheon in the Middle Ages and the Renaissance." In *Classical Influences on European Culture, AD 500–1500*, edited by R. R. Bolgar, 259–68. Cambridge: Cambridge University Press, 1971.

BURKE, EDMUND. *A Philosophical Enquiry into the Origin of Our Ideas of the Sublime and Beautiful* (1757), edited by Adam Phillips. Oxford and New York: Oxford University Press, 1990.

BURKE, PETER. *The Fabrication of Louis XIV.* New Haven: Yale University Press, 1992.

BURNS, HOWARD. "I marmi antichi." In *Raffaello architetto*, edited by Manfredo Tafuri et al. Milan: Electa, 1984.

———. "Pirro Ligorio's Reconstruction of Ancient Rome." In *Pirro Ligorio, Artist and Antiquarian,* edited by Robert W. Gaston, 19–92. Florence: Silvana, 1988.

BURROUGHS, CHARLES. "Absolutism and the Rhetoric of Topography: Streets in the Rome of Sixtus V." In *Streets: Critical Perspectives on Public Space*, edited by Zeynep Çelik, Diane Favro, and Richard Ingersoll, 189–202. Berkeley: University of California Press, 1994.

BURY, MICHAEL. "Beatrizet and the 'Reproduction' of Antique Relief Sculpture." *Print Quarterly* 13, 2 (1996): 111–26.

———. "On Some Engravings by Giorgio Ghisi Commonly Called 'Reproductive'." *Print Quarterly* 10, 1 (1993): 4–19.

BURY, MICHAEL. *The Print in Italy 1550–1620.* Exh. cat. London: British Museum, 2001.

———. "The Taste for Prints in Italy c. 1600." *Print Quarterly* 2, 1 (1985): 12–26.

CAMPBELL, IAN. *Ancient Roman Topography and Architecture,* Paper museum of Cassiano dal Pozzo. Series A, Antiquities and architecture, part 9. London: Royal Collection: Harvey Miller, 2004.

CAMPBELL, MALCOLM. "Piranesi and Innovation in Eighteenth-Century Roman Printmaking." In *Art in Rome in the Eighteenth Century,* edited by Edgar Peters Bowron and Joseph J. Rishel, 561–67. Philadelphia: Philadelphia Museum of Art, 2000.

CAMPBELL, MUNGO. *Ecco Roma: European Artists in the Eternal City.* Edinburgh: National Gallery of Scotland for the Meeting of the European Council of Ministers, 1992.

CARETTONI, GIANFILIPPO, ET AL., EDS. *La pianta marmorea di Roma antica: Forma urbis Romae.* Rome: Commune di Roma, 1960.

CARLSON, VICTOR I. "The Painter-Etcher: The Role of the Original Printmaker." In *Regency to Empire: French Printmaking 1715–1814,* exh. cat. edited by Victor I. Carlson and John W. Ittmann, 25–27. Baltimore: Baltimore Museum of Art, 1984.

CARPO, MARIO. *Architecture in the Age of Printing: Orality, Writing, Typography, and Printed Images in the History of Architectural Theory,* translated by Sarah Benson. Boston: MIT Press, 2001.

CASAMASSIMA, EMANUELE, AND RUTH RUBINSTEIN, EDS. *Antiquarian Drawings from Dosio's Roman Workshop.* Exh. cat. Florence: Giunta regionale Toscana, 1993.

CAVALIERI, GIOVANNI BATTISTA DE'. *Romanorum imperatorum effigies.* Rome: Vincenzo Accolti, 1583.

CAVALLARO, ANNA. "Una colonna a modo di campanile facta per Adriano imperatore: vicende e interpretazioni della colonna Traiana tra Medioevo e Quattrocento." In *Studi in onore di Giulio Carlo Argan,* edited by Silvana Macchioni and Bianca Tavassi La Greca, vol. 1, 73–74. Rome: Multigraphica, 1984.

CEEN, ALLAN. "Giuseppe Vasi." In *Art in Rome in the Eighteenth Century,* edited by Edgar Peters Bowron and Joseph J. Rishel, 152–53. Philadelphia: Philadelphia Museum of Art, 2000.

CERASOLI, FRANCESCO. "La colonna traiana e le sue adiacenze nei secoli XVI e XVII. *Bollettino della commissione archeologica comunale di Roma* (1901): 300.

———. "Usi e regolamenti per gli scavi di antichità in Roma nei secoli XV e XVI." *Studi e documenti di storia e diritto* 18 (1897): 149

CHARLES-PICARD, GILBERT. *Les trophées Romains: Contribution à l'histoire de la religion et de l'art triomphal de Rome.* Paris: E. de Boccard, 1957.

CHRISTIAN, KATHLEEN. "The De' Rossi Collection of Ancient Sculptures, Leo X, and Raphael." *JWCI* 65 (2002): 160–62.

CHRISTIE. *A Catalogue of the First Part of the Very Valuable and Extensive Collection of Engravings: In the Portfolio of Sir Thomas Lawrence.* London: Christie, 1830.

CLARK JR., ALVIN L. "François Perrier as a Draftsman." *Master Drawings,* 38, 2 (Summer 2000): 124–38.

———. *François Perrier: Reflections on the Earlier Works from Lanfranco to Vouet.* Paris: Galerie Eric Coatalem, 2001.

CLAUSS, MANFRED. *The Roman Cult of Mithras: The God and His Mysteries.* Edinburgh: Edinburgh University Press, 2000.

COCHIN, CHARLES-NICOLAS. *Voyage d'Italie, ou Receil de notes sur les ouvrages de peinture & de sculpture, qu'on voit dans les principales villes d'Italie.* Paris: Jombert, 1758.

COFFIN, DAVID. *Pirro Ligorio: The Renaissance Artist, Architect, and Antiquarian.* University Park: Pennsylvania State University Press, 2004.

COLE, MICHAEL. "Perpetual Exorcism in Sistine Rome." In *Idols in the Age of Art,* edited by Michael Cole and Rebecca Zorach. London: Ashgate, forthcoming 2008.

COLE, MICHAEL, ed. *The Early Modern Painter-Etcher.* Exh. cat. University Park, PA: Penn State University Press, 2006.

CONNORS, JOSEPH, AND LOUISE RICE. *Specchio di Roma barocca: una guida inedita del XVII secolo.* Rome: Edizioni dell'Elefante, 1991.

COOLEY, ALISON. *The Afterlife of Inscriptions.* London: Institute of Classical Studies, School of Advanced Study, University of London, 2000.

COOPER, RICHARD. "Epigraphical Research in Rome in the Mid-Sixteenth Century: The Papers of Antonio Agustín and Jean Matal." In *Antonio Agustín between Renaissance and Counter Reform,* edited by Michael H. Crawford, 95–111. London: Warburg Institute, 1993.

CORMACK, BRADIN, AND CARLA MAZZIO. *Book Use, Book Theory, 1500–1700.* Chicago: University of Chicago Library, 2005.

CORSI, STEFANO, AND PINA RAGIONIERI. *Speculum Romanae Magnificentiae: Roma nell'incisione del Cinquecento.* Exh. cat. Florence: Mandragora, 2004.

CORTESE, PAOLO. *De cardinalatu.* Castel Cortesio: Symeon Nicolai Nardi, 1510.

COYNE, G.V., ET AL., EDS. *Gregorian Reform of the Calendar: Proceedings of the Vatican Conference to Commemorate its 400th Anniversary, 1582–1982.* The Vatican: Pontificia Academia Scientiarum; Specola Vaticana, 1983.

The Crawford Papers, edited by John Vincent. Manchester University Press: 1984.

CRAWFORD, MICHAEL H. "Appendix II: The Epigraphical Manuscripts of Jean Matal." In *Antonio Augustín between Renaissance and Counter Reform,* edited by Michael H. Crawford, 279–89. London: Warburg Institute, 1993.

CUMONT, FRANZ. "The Dura Mithraeum." In *Mithraic Studies,* edited by J. R. Hinnells, vol. 1, 151–214. Manchester: Manchester University Press, 1975.

CUMONT, FRANZ, AND MIKHAIL ROSTOVTZEFF. In *The Excavations at Dura-Europos: Preliminary Reports of the 7th and 8th Seasons of Work,* edited by M. I. Rostovtseff, F. E. Brown, and C. B. Welles. New Haven: Yale University Press, 1939.

CUNNINGHAM, ANDREW. *The Anatomical Renaissance: The Resurrection of the Anatomical Projects of the Ancients.* Aldershot, UK: Scolar Press, 1997.

CURRAN, BRIAN. *The Egyptian Renaissance: The Afterlife of Ancient Egypt in Early Modern Italy.* Chicago: University of Chicago Press, 2007.

CURRAN, BRIAN, ANTHONY GRAFTON, AND ANGELO DECEMBRIO. "A Fifteenth-Century Site Report on the Vatican Obelisk." *JWCI* 58 (1995): 234–48.

DACOS, NICOLE. *La découverte de la Domus Aurea et la Formation des Grotesques à la Renaissance.* London: Warburg Institute, 1969.

DALY DAVIS, MARGARET. *Archäologie der Antike 1500–1700 aus den Beständen der Herzog August Bibliothek.* Exh. cat. Wiesbaden: Harrassowitz, 1994.

———. "Zum Codex Coburgensis: frühe Archäologie und Humanismus im Kreis des Marcello Cervini." In *Antikenzeichnung und Antikenstudium in Renaissance und Frühbarock,* edited by Richard Harprath and Henning Wrede, 185–99 (Akten des internationalen Symposions 8–10, September 1986 in Coburg). Mainz: Philipp. von Zabern, 1989.

DANNENFELDT, KARL H. "Egypt and Egyptian Antiquities in the Renaissance." *Studies in the Renaissance* 6 (1959): 7–27.

DAVIS, WHITNEY. "Winckelmann's 'Homosexual' Teleologies." In *Sexuality in Ancient Art: Near East, Egypt, Greece and Italy*, edited by Natalie Boymel Kampen. Cambridge: Cambridge University Press, 1996.

DE BEER, E. S. "The Development of the Guidebook until the Early 19th Century." *Journal of the British Archaeological Association* 3, 15 (1952): 35–46.

DE GRUMMOND, ELIZABETH CHAMBLESS. *Sacred Sites and Religion in Early Rome Eighth to Sixth Centuries BC.* PhD dissertation, University of Michigan, 2005.

DE LA MARE, NICOLAS. *Traité de la police,* 2nd ed. 4 vols. Paris: M. Brunet, 1719–1738.

DEAN, CLAY, THERESA FAIRBANKS, AND LISA PON. *Changing Impressions: Marcantonio Raimondi and Sixteenth-Century Print Connoisseurship.* New Haven: Yale University Press, 1999.

DEPARTMENT OF SPECIAL COLLECTIONS. *A Descriptive Catalogue of Engravings from the University of Chicago Library's Speculum Romanae Magnificentiae.* Chicago: University of Chicago Library, 1973.

DESWARTE-ROSA, SYLVIE. "Les gravures de monuments antiques d'Antonio Salamanca à l'origine du *Speculum romanae magnificentiae*." *Annali di Architettura* 1 (1989): 47–62

D'ONOFRIO, CESARE. *Gli obelischi di Roma.* 2nd ed. Rome: Bulzoni, 1967.

DONI, ANTON FRANCESCO. *I mondi.* Venice: F. Marcolini, 1552.

DOREZ, LÉON. "Extraits de la correspondance de François de Dinteville, ambassadeur de France à Rome (1531–1533)." *Revue des bibliothèques* 4 (1894): 84–87.

DOSIO, GIOVANNI ANTONIO. *Roma antica e i disegni di architettura agli Uffizi,* edited by Franco Borsi et al. Roma: Officina, 1976.

DUDOT, JEAN-MARC, BERNARD FLOUZAT, MICHEL MALCOTTI, AND DANIEL RÉMY. *Le devoir d'embellir: Essai sur la politique d'embellissement à la fin de l'Ancien Régime.* Nancy: CEMPA, 1978.

DÜLFER, KURT, ED. *Die Packschen Händel: Darstellung und Quellen.* Veröffentlichungen der Historischen Kommission für Hessen. Quellen und Darstellungen zur Geschichte des Landgrafen Philipp des Grossmütigen; 24, 3. Marburg: N.G. Elwert, Kommissionsverlag, 1958.

DUNKERTON, JILL, SUSAN FORSTER, AND NICHOLAS PENNY. *Dürer to Veronese: Sixteenth-Century Paintings in the National Gallery* (New Haven: Yale University Press, 2000)

DURET, CLAUDE. *Thresor de l'histoire de cest universe.* 2nd ed. Yverdon: Societe Helvetiale Caldoresque, 1619.

DURO, PAUL, ED. *The Academy and the Limits of Painting.* Cambridge: Cambridge University Press, 1997.

EAGLETON, TERRY. *The Ideology of the Aesthetic.* Cambridge: Basil Blackwell, 1990.

EHRLE, FRANCESCO. *Roma prima di Sisto V: la pianta di Roma Du Pérac-Lafréry del 1577.* Rome: Danesi, 1908.

EISENSTEIN, ELIZABETH. *The Printing Revolution in Early Modern Europe.* Cambridge: Cambridge University Press, 1983.

ELSNER, JAŚ. "Classicism in Roman Art." In *Classical Pasts: The Classical Traditions of Greece and Rome*, edited by James I. Porter, 270–97. Princeton: Princeton University Press, 2006.

EROLI, GIOVANNI. *Raccolta epigrafica storica bibliografica del Pantheon di Agrippa.* Narni: Petrignani, 1895.

EROUART, GILBERT, AND MONIQUE MOSSER. "A propos de
la 'Notice historique sur la vie et les ouvrages de J.-B.
Piranesi': origine et fortune d'une biographie. In *Piranèse
et les Français: Colloque tenu à la Villa Médicis 12–14 Mai
1976,* edited by Georges Brunel, pp. 213–57. Rome:
Edizioni dell' Elefante, 1976.

EQUINI SCHNEIDER, EUGENIA. *La Tomba di Nerone sulla Via
Cassia: Studio sul sarcofago di Publio Vibio Mariano.* Rome: G.
Bretscheider, 1984.

EVELYN, JOHN. *Evelyn's Sculptura, with the Unpublished Second
Part,* edited by C. F. Bell. Oxford: Clarendon Press, 1906.

———. *Sculptura: or, The History and Art of Chalcography, and
Engraving in Copper.* London: J. Murray, 1769.

FAUNO, LUCIO. *Delle antichità della città di Roma, raccolte e
scritte. . . con somma breuità, & ordine, con quanto gli antichi
ò moderni scritto ne hanno, libri V.* Venice: Michele
Tramezzino, 1548

FAVRO, DIANE. "'Pater urbis.': Augustus as City Father of
Rome." *Journal of the Society of Architectural Historians* 51,
1 (March 1992): 61–84.

FELINI, PIETRO MARTIRE. *Trattato nuovo delle cose maravigliose
dell'alma Città di Roma. . . 1610.* Quellen und Schriften zur
bildenden Kunst 3. Berlin: Bruno Hessling, 1969.

PAGDEN, SYLVIA FERINO. "Il morbetto, o la peste di Frigia."
In *Raffaello a Firenze: dipinti e disegni delle collezioni
fiorentine,* edited by Caterina Marmugi, 308–08.
Florence: Electa, 1984).

FERRARY, JEAN-LOUIS. *Onofrio Panvinio et les antiquités
romaines.* Rome: Ecole française de Rome, 1996.

FINDLEN, PAULA. *Possessing Nature: Museums, Collecting, and
Scientific Culture in Early Modern Italy.* Berkeley: University
of California Press, 1994.

FISCHER, MARIANNE. "Lafreris 'Speculum Romanae
Magnificentiae': Addenda zu Hülsens Verzeichnis."
Berliner Museen 19 (1969): 10–17.

FLETCHER, SHELLEY. "A Closer Look at Mantegna's Prints."
Print Quarterly 18, 1 (2001): 3–41.

FONTANA, DOMENICO. *Della trasportatione dell' Obelisco
Vaticano.* Rome: Domenico Basa, 1590.

FRANCESCHINI, MICHELE. "La magistratura capitolina e la
tutela delle antichità di Roma nel XVI secolo." *Archivio
della società romana di storia patria* 108 (1986): 141–50.

FRÉART, ROLAND. *Parallel of the Ancient Architecture with the
Modern,* translated by John Evelyn. London: Tho. Roycroft
for John Place, 1664.

FRISCHER, BERNARD. "The Digital Roman Forum Project:
Remediating the Traditions of Roman Topography."
In *Acts of the 2nd Italy-United States Workshop,* edited by
M. Forte, 9–21. BAR International Series 1379. Oxford:
Archaeopress, 2005.

FRUTAZ, AMATO PIETRO, ed. *Le piante di Roma.* Rome:
Istituto di Studi Romani, 1957.

FULVIO, ANDREA. *L'antichità di Roma.* Venice: Girolamo
Franzini, 1588.

GAMRATH, HELGA. *Roma sancta renovata.* Analecta Romana
Instituti Danici, Supplementum XII. Rome: "L'Erma" di
Bretschneider, 1987.

GASTON, ROBERT W., ed. *Pirro Ligorio, Artist and Antiquarian.*
Florence: Silvana, 1988.

GAZDA, ELAINE. *The Ancient Art of Emulation: Studies in Artistic
Originality and Tradition from the Present to Classical Antiquity.*
Ann Arbor: University of Michigan Press, 2002.

GLEASON, JOHN B. "The Dutch Humanist Origins of The
De Witt Drawing of the Swan Theatre." *Shakespeare
Quarterly* 32, 3 (Autumn 1981): 324–38.

GNANN, ACHIM. *Roma e lo stile classico di Raffaello, 1515–1527.*
Milan: Electa, 1999.

GOETHE, JOHANN WOLFGANG VON. *Italian Journey: 1786–1788,*
translated by W. H. Auden and Elizabeth Mayer.
San Francisco: North Point Press, 1982.

GOMBRICH, ERNST. *Art and Illusion.* Princeton: Princeton
University Press, 1960.

———, ed. *The Children of Mercury: The Education of Artists in
the Sixteenth and Seventeenth Centuries.* Providence: David
Winton Bell Gallery, 1984.

GORDON, RICHARD. "Interpreting Mithras in the Late
Renaissance, 1: The 'Monument of Ottaviano Zeno'
(V. 335) in Antonio Lafreri's *Speculum Romanae magnificentiae*
(1564)." *Electronic Journal of Mithraism Studies* 4 (2004): 12,
http://www.uhu.es/ejms/papers.htm.

GRAMACCINI, NORBERTO. "La prima riedificazione del
Campidoglio e la rivoluzione senatoriale del 1144."
In *Roma centro ideale della cultura dell'antico nei secoli XV e
XVI,* edited by Silvia Danesi Squarzina, 33–47. Milan:
Electa, 1989.

GRÄSSE, JOHANN GEORG THEODOR. *Tresor des livres rares et
precieux. . .* Dresden: R. Kuntze [etc., etc.], 1859–1869.

GRIFFITHS, ANTONY. "Print Collecting in Rome, Paris,
and London in the Early Eighteenth Century." In *Print
Collecting in Sixteenth and Eighteenth Century Europe,* 37–59.
Harvard University Art Museums Bulletin vol. 2, no. 3
(Spring 1994). Cambridge, MA: Harvard University
Art Museums.

GRIFFITHS, ANTONY, AND ANNE PUETZ. "An Album of Prints
c. 1560 in the British Library." *Print Quarterly* 13, 1 (1996):
3–9.

GROSS, ANTHONY. *Etching, Engraving, & Intaglio Printing.*
London: Oxford University Press, 1970.

GUIDONI, ENRICO. "Antico e moderno nella cultura urbanistica romana del primo Rinascimento." In *Roma centro ideale della cultura dell'antico nei secoli XV e XVI*, edited by Silvia Danesi Squarzina, 477–88. Milan: Electa, 1989.

GUZZO, PIETRO GIOVANNI. *Argenti a Pompei*. Milan: Electa/Ministero per i Beni e le Attività Culturali, 2006.

HARCOURT, GLENN. "Andreas Vesalius and the Anatomy of Antique Sculpture." *Representations* 17 (1987): 28–61.

HASKELL, FRANCIS, AND NICHOLAS PENNY. *Taste and the Antique: The Lure of Classical Sculpture 1500–1900*. New Haven: Yale University Press, 1981.

HERKLOTZ, INGO. *Cassiano dal Pozzo und die Archäologie des 17 Jh.* Munich: Hirner, 1999.

HERSEY, GEORGE L. *Pythagorean Palaces: Magic and Architecture in the Italian Renaissance*. Ithaca: Cornell University Press, 1976.

HEUER, CHRISTOPHER. "A Copperplate for Hieronymous Cock." *Burlington Magazine* 1247 (February 2007): 96–99.

HEUSER, PETER ARNOLD. *Jean Matal: Humanistischer Jurist und europäischer Friedensdenker (um 1517–1597)*. Cologne/Weimar/Vienna: Böhlau, 2003.

HOBSEN, ANTHONY. "The *iter italicum* of Jean Matal." In *Studies in the Book Trade in Honour of Graham Pollard*, edited by Richard William Hunt et al., 33–61. Oxford: Oxford University Press, 1975.

HOLMAN, BETH L., ed. *Disegno: Italian Renaissance Designs for the Decorative Arts*. Exh. cat. Dubuque, IA: Kendall/Hunt, 1997.

HÖPER, C. "Enea Vico." In *Dictionary of Art*, edited by Jane Turner, vol. 32, 412–13. London and New York: Grove, 1996.

HOPKINS, KEITH, AND MARY BEARD. *The Colosseum*. Cambridge: Harvard University Press, 2005.

HOWARD, CLARE. *English Travellers of the Renaissance*. London, New York: J. Lane, 1914.

HOWE, EUNICE D. *Andrea Palladio and the Churches of Rome*. Binghamton, NY: Center for Medieval and Renaissance Studies, SUNY Binghamton, 1991.

HÜBNER, EMIL. *Über mechanische Copien von Inschriften*. Berlin: Weidmann, 1881.

HÜLSEN, CHRISTIAN. "Das Speculum Romanae Magnificentiae des Antonio Lafréri." In *Collectanea variae doctrinae Leoni S. Olschki*. Munich: J. Rosenthal, 1921.

———. *Das Skizzenbuch des Giovannantonio Dosio in Staatlichen Kupferstichkabinett zu Berlin*. Berlin: Heinrich Keller, 1933.

IVERSEN, ERIK. *The Myth of Egypt and Its Hieroglyphs in European Tradition*. Princeton: Princeton University Press, 1993.

———. *Obelisks in Exile*. Copenhagen: G.E.C. Gad, 1968.

IVINS, WILLIAM. *Prints and Visual Communication*. Cambridge: Cambridge University Press, 1953.

JACKS, PHILIP J. "The Simulachrum of Fabio Calvo: A View of Roman Architecture all'antica in 1527." *The Art Bulletin* 72, 3 (September 1990): 453–81.

"Jean Barbault" in *Piranèse et les Français, 1740–1790*, 43–48. Rome: Villa Medici; Dijon: Palais des États de Bourgogne; Paris: Hôtel de Sully, 1976.

JELLEMA, RENSKE, AND MICHEL PLOMP. *Jan de Bisschop: advocaat en tekenaar.* Amsterdam: Museum Hey Rembrandthuis, 1992.

JOHNSTON, SARAH ILES. *Religions of the Ancient World: A Guide*. Boston: Harvard University Press, 2004.

JOIN-LAMBERT, SOPHIE, AND MAXIME PRÉAUD, EDS. *Abraham Bosse, savant graveur: Tours, vers 1604–1676, Paris.* Paris: Bibliothèque nationale de France; Tours: Musée des beaux-arts de Tours, 2004.

JONG, MARIJNKE DE, AND IRENE DE GROOT, EDS. *Ornament-prenten in het Rijksprentenkabinet*. Vol. 1. Amsterdam: Het Kabinet; 's-Gravenhage: Staatsuitgeverij, 1988.

JORDAN, HENRI. *Forma urbis Romae: Regionum XIIII*. Berlin: Apud Weidmannos, 1874.

KARPINSKI, CAROLINE. *Italian Printmaking, Fifteenth and Sixteenth Centuries: An Annotated Bibliography*. Boston: G.K. Hall, 1987.

———. "Preamble to a New Print Typology." In *Coming About—A Festschrift for John Shearman*, edited by Lars Jones and Louisa Matthew, 375–80. Cambridge, MA: Harvard University Art Museums, 2001.

———. "The Print in Thrall to Its Original: A Historiographic Perspective." in *Retaining the Original: Multiple Originals, Copies, and Reproductions*, edited by Kathleen Preciado, 101–03. Studies in the History of Art 20. Washington, DC: National Gallery of Art, 1989.

KAUFMANN, THOMAS DACOSTA. "The Nature of Imitation." *Jarbuch der kunsthistorischen Sammulungen in Wien* 82–83 (1986/1987): 163–77.

KLESTINEC, CYNTHIA. "Juan Valverde de (H)Amusco and Print Culture: The Editorial Apparatus in Vernacular Anatomy Texts." *Zeitsprünge: Forschungen zur Frühen Neuzeit, Band* 9 (2005): 78–94.

KOORBOJIAN, MICHAEL. "Pliny's Laocoön?" In *Antiquity and its Interpreters*, edited by Alina Payne, Ann Kuttner, and Rebekah Smick, 199–216. Cambridge: Cambridge University Press, 2000.

KOSTOF, SPIRO. "His Majesty the Pick: The Aesthetics of Demolition" (1982). Revised and reprinted in *Streets: Critical Perspectives on Public Space*, edited by Zeynep Çelik, Diane Favro, and Richard Ingersoll, 9–22. Berkeley: University of California Press, 1994.

Kragelund, Patrick. "Rostgaard, Fabretti and Some Paper Impressions of Greek and Roman Inscriptions in the Danish Royal Library." *Analecta Romana Instituti Danici* 29 (2003): 155–73.

Kraus, H. P. *Lafreri's Speculum Romanae Magnificentiale from the Library of the Earl of Crawford. The Most Extensive Copy Known.* Sale catalogue, n.d.

Kris, Ernst, and Otto Kurz. *Legend, Myth and Magic in the Image of the Artist.* New Haven: Yale University Press, 1979.

Lanciani, Rodolfo. "La via del Corso drizzata e abbellita nel 1538 da Paolo III." *Bullettino della commissione archeologica comunale di Roma* (1902): 229–30.

———. *Storia degli scavi di Roma e notizie intorno le collezioni romane di antichità* (1902). Rome: Quasar, 1990.

Landau, David. "Mantegna as Printmaker." In *Andrea Mantegna,* exh. cat. edited by Jane Martineau, 44–54. New York and London: Olivetti and Electra.

———. "Printmaking in Venice and the Veneto." In *The Genius of Venice, 1500–1600,* exh. cat. edited by Jane Martineau and Charles Hope, 303–54. London: Royal Academy of Arts, 1983.

Landau, David, and Peter Parshall. *The Renaissance Print 1470–1550.* New Haven: Yale University Press, 1994.

Lauro, Giacomo. *Meraviglie della Roma antica* (1637), edited by Cecilia Cametti and Cristina Falcucci. Rome: Dino Audino Editore, 1992.

Le Camus de Mézières, Nicolas. *The Genius of Architecture, or The Analogy of That Art with Our Sensations* (1780). Translated by David Britt, introduction by Robin Middleton. Santa Monica, CA: Getty Center for the History of Art and the Humanities, 1992.

Leuschner, Eckhard. "The Papal Printing Privilege." *Print Quarterly* 15, 4 (1998): 359–70.

Lincoln, Evelyn. *The Invention of the Italian Renaissance Printmaker.* New Haven: Yale University Press, 2000.

———. "Making a Good Impression: Diana Mantuana's Printmaking Career." *Renaissance Quarterly* 50 (1997): 1101–47.

Lipsius, Justus. *Ivsti lipsi de amphitheatro liber.* Antwerp: Christophe Plantin, 1589.

Lothe, José. *L'oeuvre gravé de François et Nicolas de Poilly d'Abbeville.* Paris: Commission des travaux historiques de la Ville de Paris, 1994.

Lowry, Bates. "Notes on the *Speculum Romanae Magnificentiae* and related publications." *Art Bulletin* 34 (1952): 46–50.

Lurin, Emmanuel. *Étienne Dupérac, graveur, peintre et architecte (vers 1535?–1604). Un artiste-antiquaire entre l'Italie et la France.* PhD dissertation, Université de Paris-IV, 2006.

Marder, Tod. "Alexander VII, Bernini and the Urban Setting of the Pantheon in the Seventeenth Century." *Journal of the Society of Architectural Historians* 50, 3 (1991): 273–92.

Martindale, Andrew. *The Triumphs of Caesar by Andrea Mantegna.* London: Harvey Miller, 1979.

Massar, Phyllis D. "Review of *L'opera incisa di Adamo e Diana Scultori* by Bellini, Paolo." *Burlington Magazine* 134, 1075 (October 1992): 670.

Massari, Stefania. *Giulio Romano pinxit et delineavit.* Rome: Fratelli Palombi, 1993.

Matz, Friedrich, and Friedrich Karl von Duhn. *Antike Bildwerke in Rom, mit Ausschluss der grösseren Sammlungen.* Leipzig: Breitkopf & Härtel, 1881–1882.

McDonald, Mark P. *Ferdinand Columbus: Renaissance Collector (1488–1539).* London: British Museum Press, 2005.

———. *The Print Collection of Ferdinand Columbus (1488–1539): A Renaissance Collector in Seville.* London: British Museum Press, 2004.

———. "The Print Collection of Philip II at the Escorial." *Print Quarterly* 15, 1 (1998): 15–35.

McGinniss, Lawrence, and Herbert Mitchell. *Catalogue of the Earl of Crawford's Speculum Romanae Magnificentiae, Now in the Avery Architectural Library.* New York: Columbia University, 1976.

McGowan, Margaret M. *The Vision of Rome in Late Renaissance France.* New Haven: Yale University Press, 2000.

Mercati, Michele. *De gli obelischi di Roma.* Rome: Appresso Domenico Basa, 1589.

Michaelis, A. de. "Michelangelos Plan zum Kapitol und seine Ausführung." *Zeitschrift für bildende Kunst,* N. F. II (1891).

Michaelis, Adolf Theodor Freidrich. "Storia della Collezione Capitolina di Antichita fino all'inaugurazione del museo nel 1734." Estratto dal *Bullettino dell'Istituto Archeologico Germanico,* vol. VI (1891), Fasc 1. Rome: Tipografia dei Lincei, 1891.

Miedema, Nine. "Following in the Footsteps of Christ: Pilgrimage and Passion Devotion." In *The Broken Body: Passion Devotion in Late-Medieval Culture,* edited by A. A. MacDonald, H. N. B. Ridderbos, and R. M. Schlusemann, 73–92. Groningen: Egbert Forsten, 1998.

Miglio, Massimo. "Roma dopo Avignone: la rinascita politica dell'antico." In *Memoria dell'antico nell'arte italiana,* edited by Salvatore Settis, vol. I, 73–111. Turin: G. Einaudi, 1984–1986.

Miller, Peter. *Peiresc's Europe: Learning and Virtue in the Seventeenth Century.* New Haven: Yale University Press, 2000.

MITCHELL, BONNER. *Italian Civic Pageantry in the High Renaissance: A Descriptive Bibliography of Triumphal Entries and Selected Other Festivals for State Occasions.* Florence: Leo S. Olschki, 1979.

MONTANO, GIOVANNI BATTISTA. *Architettura con diversi ornamenti.* Rome: Calisto Ferrante, 1636.

———. *Scielta di varii tempietti antichi con le piante et alzatte desegnati in prospettiva.* Rome: Giovanni Battista Soria, 1624.

MONTJOSIEU, LOUIS DE. *Ludouici Demontiosii Gallus Romae hospes: vbi multa antiquorum monimenta explicantur. . .* Rome: Apud I. Osmarinum, 1585.

MORELLY, ABBÉ. *Code de la Nature; ou, le véritable esprit de ses lois.* Paris: 1755.

MUÑOS VIÑAS, SALVADOR. *Contemporary Theory of Conservation.* Oxford: Oxford University Press, 2005.

MURRAY, JOHN. *Handbook for Travellers in Central Italy: Including the Papal States, Rome and the Cities of Etruria, with a Traveling Map.* London: J. Murray, 1843.

MYRONE, MARTIN, AND LUCY PELTZ, EDS. *Producing the Past: Aspects of Antiquarian Culture and Practice, 1700–1850.* Brookfield, VT: Ashgate, 1999.

NADALO, STEPHANIE. "Armed with Scalpel and Cuirass: Violence, Masculinity and Juan de Valverde de Amusco." http//anatomyofgender.northwestern.edu/essays01.html

NALIS, HENK, ed. *The New Hollstein Dutch and Flemish Etchings, Engravings, and Woodcuts 1450–1700: The Van Doetecum Family, Part II.* Rotterdam: Sound and Vision, 1998.

———. "The Van Doetecum Family." In *The New Hollstein Dutch & Flemish Etchings, Engravings and Woodcuts, 1450–1700,* edited by Ilja Veldman and Ger Luijten. Rotterdam: Sound & Vision Interactive in co-operation with the Rijksprentenkabinet, Rijksmuseum, Amsterdam, 1998.

NELSON, ROBERT. "Tourists, Terrorists, and Metaphysical Theater at Hagia Sophia." In *Monuments and Memory, Made and Unmade,* edited by Robert Nelson and Margaret Olin, 59–82. Chicago: University of Chicago Press, 2003.

NESSELRATH, ARNOLD. "Raphael's Archaeological Method." In *Raffaello a Roma,* 357–71. Atti del Convengno del 1983. Rome: Edizioni dell'Elefante, 1986.

NICHOLS, FRANCIS MORGAN, trans. and ed. *Mirabilia Urbis Romae: The Marvels of Rome* 2nd ed. New York: Italica Press, 1986.

OESCHLIN, WERNER. "Le groupe des 'Piranésiens' français (1740–1750): un renouveau artistique dans la culture Romaine." In *Piranèse et les Français, 1740–1790,* 373–79. Rome: Villa Medici; Dijon: Palais des États de Bourgogne; Paris: Hôtel de Sully, 1976.

OECHSLIN, WERNER, AND ANJA BUSCHOW. *Architecture de fête: L'architecte metteur en scène,* translated by Marianne Brausch. Liège: Pierre Mardaga, 1987.

ONIANS, JOHN. *Bearers of Meaning: The Classical Orders in Antiquity, the Middle Ages, and the Renaissance.* Princeton, NJ: Princeton University Press, 1988.

———. "The System of the Orders in Renaissance Architectural Thought." In *Les traités d'architecture de la Renaissance,* edited by Jean Guillaume. Paris: Picard, 1988.

ONUF, ALEXANDRA KIRKMAN. *Local Terrains: The Small Landscapes Prints and the Depiction of the Countryside in Early Modern Antwerp.* PhD dissertation, Columbia University, 2006.

PACIOLI, LUCA. *Summa de arithmetica geometria proportioni & proportionalita: continentia de tutta lopera.* Venice: Paganino de Paganini, 1494.

———. *Summa de arithmetica geometria proportioni et proportionalita.* Toscolano: Paganino de Paganini, 1523.

PAGANI, VALERIA. "Adamo Scultori and Diana Mantovana." *Print Quarterly* 9, 1 (1992): 72–87.

———. "Documents on Antonio Salamanca." *Print Quarterly* 17, 2 (2000): 148–55.

PANVINIO, ONOFRIO. *Onuphrii Panvinii de Triumpho commentarius,* edited by Joachim Johannes Madero. Helmstedt: 1676.

———. *Veterum Rom. ornatissimi amplissimiq thriumphi.* Antwerp: Cornelis de Jode, 1596.

PAPAYANIS, NICHOLAS. *Planning Paris before Haussmann.* Baltimore: The Johns Hopkins University Press, 2004.

PARKER, DEBORAH. "Women in the Book Trade in Italy 1475–1620." *Renaissance Quarterly* 49, 3 (1996): 509–41.

PARSHALL, PETER. "Antonio Lafreri's *Speculum Romanae Magnificentiae.*" *Print Quarterly* 23, 1 (2006): 3–27

———. "Imago contrafacta: Images and Facts in the Northern Renaissance," *Art History* 16 (1993): 554–79.

———. "The Print Collection of Ferdinand, Archduke of Tyrol." *Jahrbuch der Kunsthistorischen Sammlungen in Wien* 78 (1982): 139–84.

PARSHALL, PETER, AND RAINER SCHOCH. *Origins of European Printmaking: Fifteenth-Century Woodcuts and Their Public.* Exh. cat. Washington, DC: National Gallery of Art, 2005.

PARSLOW, CHRISTOPHER. *Rediscovering Antiquity: Karl Weber and the Excavation of Herculaneum, Pompeii, and Stabiae.* New York: Cambridge University Press, 1995.

PATTE, PIERRE. "Des embellissemens de Paris." In *Monumens erigés en France à la gloire de Louis XV.* Paris: 1765.

PEARSON, MIKE, AND MICHAEL SHANKS. *Theatre/archaeology.* New York: Routledge, 2001.

PESCARZOLI, ANTONIO. *I libri di viaggio e le guide della Raccolta Luigi Vittorio Fossati Bellani*. 3 vols. Rome: Edizioni di storia e letteratura, 1957.

PETRUCCI, ALFREDO. *Panorama della incisione italiana: il cinquecento*. Rome: C. Bestetti, 1964.

PEVSNER, SIR NIKOLAUS. *Academies of Art, Past and Present*. New York: Da Capo Press, 1973.

PICARD, GILBERT CHARLES. *Les Trophées Romains. Contribution à l'histoire de la Religion et de l'art triomphal de Rome*. Paris: E. de Boccard, 1957.

PINTO, JOHN. "Architecture and Urbanism." In *Art in Rome in the Eighteenth Century*, edited by Edgar Peters Bowron and Joseph J. Rishel, 113–21. Philadelphia: Philadelphia Museum of Art, 2000.

Piranèse et les Français, 1740–1790. Exh. cat. Rome: Edizioni Dell'Elefante, 1976.

PLATNER, SAMUEL BALL, AND THOMAS ASHBY. *A Topographical Dictionary of Ancient Rome*. London: Oxford University Press, 1929.

PLATT, VERITY. "'Shattered Visages': Speaking Statues from the Ancient World." *Apollo* 158 (2003): 9–14

PON, LISA. *Changing Impressions: Marcantonio Raimondi and Sixteenth-Century Print Connoisseurship*. New Haven: Yale University Press, 1999.

———. "Marcantonio and Raphael." *Print Quarterly* 16, 4 (1999): 368–70.

———. *Raphael, Dürer, and Marcantonio Raimondi: Copying and the Italian Renaissance Print*. New Haven: Yale University Press, 2004.

PORRO, GIROLAMO. Dedication in Vincenzo Scamozzi, *Discorsi sopra l'antichità di Roma*. Venice: Francesco Ziletti, 1582.

POTTS, ALEX. *Flesh and the Ideal: Winckelmann and the Origins of Art History*. New Haven: Yale University Press, 1994.

———. Introduction to *History of the Art of Antiquity* by Johann Joachim Winckelmann, translated by Harry Francis Mallgrave, 1–53. Los Angeles: Getty Research Institute, 2006.

QUARITSCH, BERNARD. *The "Speculum Romanae Magnificentiae" of Antonio Lafreri: A Monument of the Renaissance... Offered for Sale by Bernard Quaritsch*. London: Strangeways and Sons, 1925.

RAGUENET, FRANÇOIS. *Les monuments de Rome*. Amsterdam: E. Roger, 1701.

RAPHAEL. *Il pianto di Roma: lettera a Leone X*, edited by Piero Buscaroli. Torino: Fògolae, 1984.

———. "Letter to Leo X." In *Early Medieval Art 300–1150: Sources & Documents*, edited by Caecilia Davis-Weyer. Englewood Cliffs, NJ: Prentice Hall, 1971.

RE, EMILIO. "Maestri di strada." *Archivio della reverenda società romana di storia patria* 43 (1920): 54–60.

REDFORD, BRUCE. *Venice and the Grand Tour*. New Haven: Yale University Press, 1996.

RENFREW, COLIN, AND PAUL BAHN. *Archaeology: Theories, Methods, and Practice*. New York and London: Thames and Hudson, 2004.

RICHTER, SIMON. *Laocoon's Body and the Aesthetics of Pain*. Detroit: Wayne State University Press, 1992.

RIGGS, TIMOTHY A. *Hieronymus Cock (1510–1570): Printmaker and Publisher in Antwerp at the Sign of the Four Winds*. PhD dissertation, Yale University, 1972.

ROISECCO, NICCOLA. *Roma ampliata, e rinovata, o sia nuova descrizione della moderna citta' di Roma*. Rome: G. Roisecco, 1739.

ROLAND, FRANÇOIS. "Un franc-comtois editeur et marchand d'estampes a Rome au XVIe siecle: Antoine Lafrery." *Memoires de la Societe d'emulation du Doubs* 7 (1910): 320–70.

ROSAND, DAVID, AND MICHELANGELO MURARO. *Titian and the Venetian Woodcut*. Washington, DC: International Exhibitions Foundation, 1976.

ROSENBERG, PIERRE. "Quelques nouveautés sur Barbault." In *Piranèse et les Français. Colloque tenu à la Villa Médicis 12–14 Mai 1976*, edited by Georges Brunel, 499–509. Rome: Edizioni dell' Elefante, 1976.

ROSS-TAYLOR, LILY, AND LOUISE ADAMS HOLLAND. "Janus and the Fasti." *Classical Philology* 47, 3 (1952): 137–42.

ROSSI, ORIETTA. "Scultura antica e restauri storici." In *Memoria dell'antico nell'arte italiana*, edited by Salvatore Settis, vol. 1, 209–14. Turin: G. Einaudi, 1984–1986.

ROTH, MICHAEL S. *Irresistible Decay: Ruins Reclaimed*. Los Angeles: Getty Research Institute, 1997.

ROULLET, ANNE. *The Egyptian and Egyptianizing Monuments of Imperial Rome*. Leiden: E.J. Brill, 1972.

ROWLAND, INGRID. *The Culture of the High Renaissance: Ancients and Moderns in Sixteenth-Century Rome*. Cambridge: Cambridge University Press, 1998.

———. "Raphael, Angelo Colocci, and the Genesis of Architectural Orders." *The Art Bulletin* 76 (1994): 81–104.

RUBIN, PATRICIA. *Giorgio Vasari: Art and History*. New Haven: Yale University Press, 1995.

RUSHFORTH, G. McN. "Magister Gregorius de Mirabilibus Urbis Romae: A New Description of Rome in the Twelfth Century." *Journal of Roman Studies*, 9 (1919): 14–58

SAN JUAN, ROSE MARIE. *Rome: A City Out of Print*. Minneapolis: University of Minnesota Press, 2001.

SCAGLIA, GUSTINA. "The Origin of an Archaeological Plan of Rome by Alessandro Strozzi." *JWCI* 27 (1964): 137–63.

SCHOTTUS, FRANCISCUS. *Itinerarii Italiae rervmq. Romanarvm libri tres.* Antwerp: Moretus, 1600.

SCHUDT, LUDWIG. *Le Guide di Roma: Materialien zu einer Geschichte der roemischen Topographie.* Vienna: Filser, 1930.

SERLIO, SEBASTIANO. *Tutte l'Opere d'architettura.* Book III. Venice: Heirs of Francesco de' Franceschi, 1584.

SETTIS, SALVATORE, ed. *Memoria dell'antico nell'arte italiana.* 3 vols. Turin: G. Einaudi, 1984–1986.

SHEARD, WENDY STEDMAN. "Tullio Lombardo in Rome? The Arch of Constantine, the Venramin Tomb, and the Reinvention of Monumental Classicizing Relief." *Artibus et Historiae* 18, 35 (1997): 161–79.

SHEARMAN, JOHN. "Raphael, Rome and the Codex Excurialensis." *Master Drawings* 15 (1977): 107–46.

SHELLEY, PERCY BYSSHE. *With Shelley in Italy: A Selection of the Poems and Letters of Percy Bysshe Shelley*, arranged by Anna Benneson McMahan. Chicago: A.C. McClurg & Co., 1905.

SHOEMAKER, INNIS. "Drawings after the Antique by Filippino Lippi." *Master Drawings* 16, 1 (Spring 1978): 35–43, 97–104.

———. "Marcantonio and His Sources." In *The Engravings of Marcantonio Raimondi,* edited by Innis Shoemaker and Elizabeth Broun, 3–18. Lawrence, KS and Chapel Hill, NC: Spencer Museum of Art, 1981.

SHOEMAKER, INNIS, AND ELIZABETH BROUN, EDS. *The Engravings of Marcantonio Raimondi.* Lawrence, KS and Chapel Hill, NC: Spencer Museum of Art, 1981.

SHUGER, DEBORA. *The Renaissance Bible: Scholarship, Sacrifice, and Subjectivity.* Berkeley: University of California Press, 1994.

SIMONCINI, GIORGIO. *"Roma restaurata": rinnovamento urbano al tempo di Sisto V.* Florence: Leo S. Olschki, 1990.

SMITH, PAMELA H. *Art, Science, and Visual Culture in Early Modern Europe.* New York: The History of Science Society, 2006.

STENHOUSE, WILLIAM. *Ancient Inscriptions, Paper Museum of Cassiano dal Pozzo.* Series A, Antiquities and architecture 7. London: The Royal Collection; Harvey Miller, 2002.

———. *Reading Inscriptions and Writing Ancient History: Historical Scholarship in the Late Renaissance.* London: Institute of Classical Studies, University of London School of Advanced Study, 2005.

———. "Visitors, Display, and Reception in the Antiquity Collections of Late-Renaissance Rome." *Renaissance Quarterly* 58 (2005): 397–434.

STRONG, ROY. *Art and Power: Renaissance Festivals 1450–1650.* Woodbridge: Boydell Press, 1984.

SZLADITZ, LOLA. "The Influence of Michelangelo on Some Anatomical Illustrations." *Journal of the History of Medicine* 9 (1954): 420–27.

TALVACCHIA, BETTE. *Taking Positions: On the Erotic in Renaissance Culture.* Princeton, NJ: Princeton University Press, 1999.

TEDESCHI GRISANTI, GIOVANNA. *I "Trofei di Mario": Il Ninfeo dell'acqua Giulia sull' Esquilino.* Rome: Istituto di Studi Romani, 1977.

TOOLEY, R.V. "Maps in Italian Atlases of the Sixteenth Century, Being a Comparative List of the Italian Maps Issued by Lafreri, Forlani, Duchetti, Bertelli and Others, Found in Atlases." *Imago Mundi* 3 (1939): 12–47.

TOTTI, POMPILIO. *Ritratto di Roma moderna.* Rome: Mascardi, 1638.

UNIVERSITY OF CHICAGO LIBRARY. *The Berlin Collection: being a history and exhibition of the books and manuscripts purchased in Berlin in 1891 for the University of Chicago by William Rainey Harper, with the support of nine citizens of Chicago: the Joseph Regenstein Library, April–October, 1979.* Chicago: University of Chicago Library, 1979.

VALENTINI, ROBERTO, AND GIUSEPPE ZUCCHETTI, EDS. *Codice topografico della città di Roma.* vol. 3. Rome: Tipografia del Senato, 1940–1953.

VALONE, CAROLYN. "Giovanni Antonio Dosio: The Roman Years." *The Art Bulletin* 58, 4 (1976): 528–41.

VALVERDE DE AMUSCO, JUAN. *Historia de la composision del cuerpo humano.* Rome: Lafreri and Salamanca, 1556.

VAN DER SMAN, GERT JAN. "Print Publishing in Venice in the Second Half of the Sixteenth Century." *Print Quarterly* 17, 3 (2000): 235–47.

VAN GELDER, JAN G., AND INGRID JOST. *Jan de Bisschop and His Icones & Paradigmata: Classical Antiquities and Italian Drawings for Artistic Instruction in Seventeenth Century Holland.* Doornspijk, Netherlands: Davaco, 1985.

VAN GROESEN, MICHIEL. "Boissard, Clusius, De Bry and the making of 'Antiquitates Romanae' (1597–1602)." *LIAS* 29, 2 (2002): 195–213.

———. "De Bry and Antwerp, 1577–1585: A Formative Period." In *Inszenierte Welten/Staging New Worlds,* edited by Susanna Burghartz, 19–45. Basel, Switzerland: Schwabe, 2004.

VANDECASTEELE, MAURITS. "Two Presumed Drafts for Engravings Belonging to Antonio Lafrery's Speculum Romanae Magnificentiae." *Zeitschrift für Kunstgeschichte* 3 (2004): 427–34.

VASARI, GIORGIO. *Le vite de' più eccellenti pittori, scultori, e architettori. . .* Florence: Appresso i Giunti, 1568.

———. *Le vite de' più eccellenti pittori, scultori ed architettori,* edited by Gaetano Milanesi. 5 vols. Firenze: G.C. Sansoni, 1906.

———. *Le vite de' più eccellenti architetti, pittori, et scultori italiani: da Cimabue insino a' tempi nostri: nell' edizione per i tipi di Lorenzo Torrentino, Firenze 1550,* edited by Luciano Bellosi and Aldo Rossi. Turin: Einaudi, 1986.

———. *The Lives of the Painters, Sculptors, and Architects,* edited by Ernest Rhys, vol. 2. London: J.M. Dent, 1927.

VASI, GIUSEPPE. *Delle magnificenze di Roma antica e moderna.* 10 vols. Rome: Nella stamperia del Chracas, 1747–1761.

VERDI, ORIETTA. "Da ufficiali capitolini a commissari apostolici: i maestri delle strade e degli edifici di Roma tra XIII e XVI secolo." In *Il Campidoglio e Sisto V,* edited by Luigi Spezzaferro and Maria Elisa Tittoni, 54–62. Rome: Ed. Carte Segrete, 1991.

———. *Maestri di edifici e di strade a Roma nel secolo XV, fonti e problemi.* Rome: Roma nel Rinascimento, 1997.

VERTOVA, LUISA. "A Late Renaissance View of Rome." *Burlington Magazine,* 137, 1108 (July 1995): 445–51.

VESALIUS, ANDREAS. *De humani corporis fabrica libri septem.* Basel: I. Oporini, 1543.

VICO, ENEA. *Le Imagini delle Donne Avgvste intagliate in istampa di rame.* Venice: Enea Vico and Vincenzo Valgrisi, 1557.

VIDLER, ANTHONY. "The Scenes of the Street: Transformations in Ideal and Reality, 1750–1871." In *On Streets,* edited by Stanford Anderson, 29–111. Cambridge: MIT Press, 1978.

VILJOEN, MADELEINE. "Prints and False Antiquities in the Age of Raphael." *Print Quarterly* 21, 3 (2004): 235–47.

———. "Raphael and the Restorative Power of Prints." *Print Quarterly* 18, 4 (2001): 379–95.

VOLLE, NATHALIE, AND PIERRE ROSENBERG. *Jean Barbault (1718–1762).* Exh. cat. Musée départemental de l'Oise, Beauvais; Musée des Beaux-Arts, Angers; and Musée des Beaux-Arts, Valence, 1974–1975.

VOLTAIRE, FRANÇOIS MARIE AROUET DE. *Des embellissements de Paris (1749).* In *The Complete Works of Voltaire,* edited by Mark Waddicor, 213–33. Oxford: The Voltaire Foundation, Taylor Institution, 1994.

WAETZOLDT, STEPHAN. "Trattato nuovo von 1610." In *Trattato nuovo delle cose maravigliose dell'alma Città di Roma. . . 1610,* edited by Pietro Martire Felini, 1–14. Quellen und Schriften zur bildenden Kunst 3. Berlin: Bruno Hessling, 1969.

WALPOLE, HORACE. In *Horace Walpole's Correspondence with Sir Horace Mann,* edited by W. S. Lewis. vol. 6. New Haven: Yale University Press, 1954.

WARRIOR, VALERIE M. *Roman Religion: A Sourcebook.* Newburyport, MA: Focus, 2002.

WATAGHIN CANTINO, GISELLA. "Archeologia e 'archeologie': il rapporto con l'antico fra mito, arte, e ricerca." In *Memoria dell'antico nell'arte italiana,* edited by Salvatore Settis, vol. 1, 171–217. Turin: G. Einaudi, 1984–1986.

WEIL-GARRIS, KATHLEEN, AND JOHN D'AMICO. "The Renaissance Cardinal's Ideal Palace: A Chapter from Cortesi's *De Cardinalatu.*" *Memoires of the American Academy in Rome* 35 (1980): 45–123.

WEISS, ROBERTO. *The Renaissance Discovery of Classical Antiquity.* Oxford: Blackwell, 1969.

WEYL, MARTIN. *Passion for Reason and Reason of Passion: Seventeenth-Century Art Theory in France.* New York: Peter Lang, 1989.

WHITE, L. MICHAEL. *The Social Origins of Christian Architecture: Building God's House in the Roman World: Architectural Adaptation Among Pagans, Jews, and Christians.* Boston: Trinity Press International, 1996

WILSON, BRONWEN. *The World in Venice: Print, the City, and Early Modern Identity.* Toronto: University of Toronto Press, 2005.

WILSON, LUKE. "William Harvey's *Prelectiones:* The Performance of the Body in the Renaissance Theatre of Anatomy." *Representations* 17 (Winter 1987): 62–95.

WINCKELMANN, JOHANN JOACHIM. *Anmerkungen über die Geschichte der Kunst des Alterthums.* Dresden: Waltherschen Hofbuchhandlung, 1767.

———. *History of the Art of Antiquity,* introduction by Alex Potts, translated by Harry Francis Mallgrave. Los Angeles: Getty Research Institute, 2006.

WITCOMBE, CHRISTOPHER L. C. E. *Copyright in the Renaissance: Prints and the Privilegio in Sixteenth-Century Venice and Rome.* Leiden; Boston: Brill, 2004.

WITTKOWER, RUDOLF. "Hieroglyphics in the Early Renaissance." In *Allegory and the Migration of Symbols,* 114–28. Boulder, CO: Westview, 1977.

WOLF, SUSAN. "Peeling off the Skin: Revealing Alternative Meanings of Valverde's Muscle Man." http://www.bronwenwilson.ca/body.catalogue.

WOOD, CAROLYN. "The Morbetto." In *The Engravings of Marcantonio Raimondi,* edited by Innis Shoemaker and Elizabeth Broun, 118–19. Lawrence, KS and Chapel Hill, NC: Spencer Museum of Art, 1981.

WOOD, CHRISTOPHER. "Notation of Visual Information in the Earliest Archeological Scholarship." *Word and Image* 17 (January 2001): 94–118.

WOODWARD, CHRISTOPHER. *In Ruins.* New York: Pantheon, 2001.

WOODWARD, DAVID. *Maps as Prints in the Italian Renaissance: Makers, Distributors, and Consumers.* London: British Library, 1996.

WREDE, HENNING, AND RICHARD HARPRATH. *Der Codex Coburgensis: Das erste systematische Archäologiebuch. Römische Antiken-Nachzeichnungen aus der Mitte des 16. Jahrhunderts.* Exh. cat. Coburg: P. von Zabern, 1986.

WURM, HEINRICH. *Baldassare Peruzzi: Architekturzeichnungen.* Tübingen: Wasmuth, 1984.

YUEN, TOBY. "Giulio Romano, Giovanni da Udine and Raphael: Some Influences from the Minor Arts of Antiquity." *JWCI* 42 (1979): 263–72.

ZANNINI, GIAN LUDOVICO MASETTI. "Rivalità e lavoro di incisori nelle botteghe Lafréry-Duchet e de la Vacherie." In *Les Fondations nationales dans la Rome pontificale,* 547–66. Rome: Académie de France, 1981.

ZERNER, HENRI. *L'art de la Renaissance en France: l'invention du classicisme.* Paris: Flammarion, 2002.

ZORACH, REBECCA, AND ELIZABETH RODINI. *Paper Museums: The Reproductive Print in Europe, 1500–1800.* Exh. cat. Chicago: David and Alfred Smart Museum of Art, University of Chicago, 2005.